MEMORIALS AND MARTYRS IN MODERN LEBANON

PUBLIC CULTURES OF THE MIDDLE EAST AND NORTH AFRICA
Paul A. Silverstein, Susan Slyomovics, and Ted Swedenburg, editors

MEMORIALS & MARTYRS

IN MODERN LEBANON

LUCIA VOLK

INDIANA UNIVERSITY PRESS
Bloomington and Indianapolis

This book is a publication of

Indiana University Press
601 North Morton Street
Bloomington, Indiana 47404-3797 USA

www.iupress.indiana.edu

Telephone orders 800-842-6796
Fax orders 812-855-7931
Orders by e-mail iuporder@indiana.edu

∞ The paper used in this publication meets the minimum requirements of the
American National Standard for Information Sciences—Permanence of Paper for
Printed Library Materials, ANSI Z39.48-1992.

Manufactured in the United States of America

LIBRARY OF CONGRESS CATALOGING-IN-PUBLICATION DATA

Volk, Lucia.
 Memorials and martyrs in modern Lebanon / Lucia Volk.
 p. cm. — (Public cultures of the Middle East and North Africa)
 Includes bibliographical references and index.
 ISBN 978-0-253-35523-2 (cloth : alk. paper) — ISBN 978-0-253-22230-5 (pbk. : alk.
paper) 1. Martyrs—Monuments—Lebanon. 2. Memorials—Lebanon.
3. Lebanon—Ethnic relations. 4. Nationalism and collective memory—Lebanon.
I. Title.
 DS80.4.V65 2010
 956.9204—dc22

1 2 3 4 5 15 14 13 12 11 10

For Mary

CONTENTS

ILLUSTRATIONS

All photographs are by the author, unless otherwise noted in captions.

ACKNOWLEDGMENTS

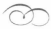

Although I visited the village of Qana in South Lebanon for the first time in April 1998, I did not begin the research for this book until after my appointment as Assistant Professor at San Francisco State University (SFSU) in 2003. I thank the College of Behavioral and Social Sciences at SFSU for providing much of the funding that enabled me to make four research trips to Lebanon between 2003 and 2008. I thank the Office for Faculty Affairs and Professional Development at SFSU for the mini-grant and summer stipend that supported my research and writing, as well as President Robert Corrigan for granting me writing and research leave through the Presidential Award in the fall of 2007. I acknowledge San Francisco State's support for full-time faculty in their professional development, despite budgetary challenges. I thank Deans Joel Kassiola and Paul Sherwin for their vision to create the Middle East and Islamic Studies (MEIS) Program at SFSU, and to my MEIS colleagues for providing intellectual support as well as good humor and understanding throughout my research venture. I also thank the Center of Contemporary Arab Studies at Georgetown University and, in particular, Michael Hudson, for the chance to spend a sabbatical semester as Visiting Scholar in Washington, D.C., where I was able to engage in many productive conversations with the Center's faculty, students, and staff.

I am proud to belong to the academic communities of Middle Eastern and Arab Studies in Lebanon, Europe, and North America that have provided me much food for thought. I thank Ossama Abi Mershed, Annemarie Afeiche, Belkacem Baccouche, Abdo Badwi, Carel Bertram, Annabelle Böttcher, Khaldun Bshara, Steven Caton, Rochelle Davis, Lara Deeb, Bruce Grant, Bassam Haddad, Jens Hanssen, Sune Haugbolle, Beatrice Hendrich,

Michael Hudson, Dina Ibrahim, Ahmed Kanna, Laleh Khalili, Laurie King, Mara Leichtman, Augustus Richard Norton, Roger Owen, Eugene Rogan, Kamal Salibi, Sherene Seikaly, Helga Seeden, Tamir Sorek, Nicole Watts, and Amy Young. I thank the Public Cultures of the Middle East and North Africa series editors Paul Silverstein, Susan Slyomovics, and Ted Swedenburg, whose academic work inspired me to do mine. I am indebted to Irene Bierman and Robert Nelson for inviting me to participate in the UCLA/Getty Summer Institute, "Constructing the Past in the Middle East," in Istanbul in 2004. The questions I learned to ask at the Summer Institute set many of the guideposts for this journey. I thank the many students in my Anthropology of Social Memory class for giving me the opportunity to discuss the ideas that appear in this book. I am grateful for the feedback I received from colleagues on drafts of the book chapters that I presented at various Middle East Studies Association and American Anthropological Association meetings over the past five years. Some of the material presented in chapter 4 appeared in "Re-Remembering the Dead: A Genealogy of a Martyrs Memorial in South Lebanon," *Arab Studies Journal* 15 (2007): 44–69; and a section of the discussions of chapter 5 appeared in different form in "Martyrs at the Margins: The Politics of Neglect in Lebanon's Borderlands," *Middle Eastern Studies* 45 (2009): 263–282.

To those who helped in my research efforts in concrete ways, by making introductions and opening doors, setting up appointments, granting interviews, allowing access to archives, sharing photographs, showing me sites, and verifying my Arabic translations over the past six years, thank you! This group of individuals includes Hana Abdallah, Hajj Abu Aziz, Sally Al-Daher, Hajj Ali, Alexandra Asseily, Ali Badwi, Khaled Barakat, Lara Challita, Nader El-Nakib, Azmi Fakhouri, Angus Gavin, Malik Ghandour, Jihan Harb, Mohammad Ismail, Fadia Juha, Walid (Beyk) Jumblatt, Oussama Kabbani, Ahmad Mahfouz, Abdel Majid Saleh, Hassan Makki, Zeina Moghrabi, Amal Mudallale, Meagan Mushammel, Hajj Qabalan Qabalan, Ayman Trawi, Ghassan Tueni, Lujina Zawideh, and Nasr Zaydan. I cannot express enough gratitude to the many Lebanese who invited me to their homes and fed me delicious food, cared for me when I became sick, patiently answered my questions, and, most important, encouraged me to keep writing. I am especially grateful to the Abi-Habib, Makki, Sinno, and Yazbeck families. The friendship and fictive kinship they so generously extended went a long way in advancing my academic work. I thank Fouad Yazbeck for answering all my little and big questions with generosity and wit. And I am forever grateful to Nadine Sinno, whose intellectual and moral support sustained me throughout: *ma fi mithlik.*

I express my deepest appreciation to my marvelous friends Ann Delmar and Kris Manjapra, who always said, wrote, and did just the right things to support me, and who kept reminding me of what is important in life. I am most fortunate to be part of a sisterhood of colleagues and friends, including Susan Aramayo, Mariana Ferreira, Jessica Fields, Susanne Fitch, Marianne Hoch, Cherie Lebow, Laurie Meschke, Maria Clemencia Ramirez, Stephanie Rupp, the Stanford Gang, Sheila Tully, Marsha von Duerckheim, Angelika von Wahl, Christa-Maria Weber, Kathy Wyer, and others, who cheered me on along this long and at times arduous road. Cleo Molinelli in San Francisco deserves special thanks. Thanks to my brother Markus for his regular visits to San Francisco and for supplying me with German treats that kept me going. Thanks to everyone who taught me the languages I needed to know to carry out my work. I am immensely grateful to all those who voluntarily, gladly, and constructively gave feedback on individual chapters and paragraphs, but I need to single out Julie Conquest who, gently yet firmly, gave the writing feedback that I needed in the final revision stages, and who helped me pull it all together. Without *all* their love and support, there would be no book.

Finally, a heartfelt thanks to my American parents, Carol and Kenneth Utter, for the innumerable ways in which they encouraged me over the past twenty years, as well as to my German parents, Maria and Werner Volk. I am continually mindful that I have come a long way from the quiet village of Spay/Rhine to the hallowed halls of academia in the U.S., and I know that the work ethic my parents instilled in me made it all possible. I cannot thank them enough.

NOTE ON TRANSLITERATION OF ARABIC

Throughout the book I use a simplified version of the *International Journal of Middle East Studies* (*IJMES*) transliteration guidelines. I use the diacritic ' for the glottal stop *hamza* and ' for the consonant *ayn*. Following the example of Lara Deeb (2006), I preserve phonemic differences between Modern Standard Arabic in written sources and the Lebanese dialect used in conversations. Therefore I drop diacritics for Lebanese dialect transcriptions, as well as the letter *qaf*; moreover, I use -*iye* rather than -*iyya* (i.e., *ahwe* instead of *qahwa* for "coffee"; *Nabatiye* instead of *al-Nabatiyya*). I indicate long vowels by adding a line above the letter (i.e., *ā* pronounced as in the English word far; *ī* as in see; and *ū* as in shoe). To enhance readability, I use the most common English spelling for all political groups, personal or place names (i.e., Shiites, Musa Sadr, Tyre, Sidon). If several English spellings are common, I chose the one that stays closest to the *IJMES* guidelines. For instance, I transliterate the Arabic letter *qaf* consistently with q, rather than k or c (i.e., Qana, Quran, Rafiq) and use Hizballah rather than Hezbollah. When citing book titles and using direct quotes, I preserve the transliteration used in the original text (i.e., *El Bourj, The Shi'is of Jabal 'Amil, Shi'ite Lebanon*).

MEMORIALS AND MARTYRS IN MODERN LEBANON

Introduction

It is quite likely, as Homer has said, that the gods send disasters to men so that they can tell of them.
—MICHEL FOUCAULT, *LANGUAGE, COUNTER-MEMORY, PRACTICE*

On a morning in February 2005 I walked into the lobby of the Center for Contemporary Arab Studies at Georgetown University and came to an abrupt halt in front of a television screen. Former Lebanese Prime Minister Rafiq Hariri had just been assassinated, and *Al Jazeera* reported the news while broadcasting images of young people who had climbed on top of the Martyrs Memorial in downtown Beirut, waving flags and chanting slogans in protest. The faces and bodies of the bronze statues were barely visible underneath the young people holding their banners and flags; but still, there they were: the bronze figure of a woman in flowing robes holding up a torch like the Statue of Liberty on Ellis Island and, next to her, the bronze of a young man, symbolizing the nation, at the center of political events. I had come to Georgetown to speak about this very monument, but I was going to show how it had been dwarfed by the large Virgin Mega Store that had been built next to it, and how it had almost become invisible amid the massive reconstruction projects of downtown Beirut. The statues would reappear on television in subsequent weeks, decked out in Lebanese flags, as massive protests were organized and carried out in Beirut's city center. It seemed, in the midst of the momentous political event, that the statues of the Martyrs Memorial were very much alive.

A majority of public monuments, whether in Europe, the Americas, or the Arab World, tell stories about death. They celebrate victories on battlefields or mourn defeat. They elevate generals on horseback or present allegories of liberty and patriotism. They also may express grief over loss such as a mother cradling her son close to her chest, but rarely do they display bloody corpses sprawled on the battlefield. Instead, they sublimate bodily horrors through displays of beautifully sculpted marble bodies or simple, dignified inscriptions in order to evoke sentiments of heroism or sacrifice. Unlike historians who strive to explain the root causes of the past, memorials rarely refer to the reasons for war or violence, for they tell stories that are meant to shape the memory of future generations. Because they are characterized by their immutability, memorials are crucial ingredients in the cultural reconstruction of societies that have undergone profound transformation. Public memorials "are meant to last, unchanged, forever. While other things come and go, are lost and forgotten, the monument is supposed to remain a fixed point, stabilizing both the physical and the cognitive landscape."[1] The debates that precede the construction of public memorials might be protracted and acrimonious, but once the memorials are inaugurated, they become permanent fixtures in space.[2]

Not so in Lebanon. As I will show, Lebanese public memorials need to be considered as "events" with a life of their own. They keep changing along with the physical and cognitive landscape around them, some are intentionally vandalized or accidentally damaged, others mysteriously disappear and reappear, are wounded and healed, and most of them keep expanding. They are important sites not only for the public expression of grief, and the creation of a space where the Lebanese gather, annually, to remember sacrifice; they also create and sustain the political legitimacy of their sponsors (who are leaders of parties and of ethno-religious communities), and they provide a platform for debates among citizens and elites about national identity and national values. Central to these debates in Lebanon are discussions aimed at the reconciliation of cultural and religious differences.

To speak of Lebanon and shared national sentiments in one breath will raise eyebrows in certain corners. Many argue that Lebanon's most pronounced characteristic is its sectarianism: age-old primordial hatreds between religious groups that erupt into armed conflict with regularity. Just as Balkanization entered our vocabulary in the aftermath of World War I, and described the disintegration of a country owing to a hardening of hostile ethnic divisions, "Lebanonization" made it into the English dictionary after the last protracted and costly Lebanese Civil War (1975–1991). It similarly denotes the dissolution of the national fabric in light of

religiously based factions, prepared to defend their own against everybody else. In the 1990s the word was used to describe the disintegration of Yugoslavia after the fall of the Soviet Union, and more recently political analysts have discussed the "Lebanonization" of Iraq and Palestine.[3] Thus to devote an entire book on Lebanon to the study of public sites of cross-sectarian solidarities is an ambitious undertaking. Nevertheless my work shows that over the course of Lebanon's history, repeated efforts have been exerted to actively, creatively, and publicly transcend the ethno-religious boundaries of Lebanese communities in the aftermath of violence (both international and civil) that led communities to fight one another. This work has been done in the public realm through cemeteries and martyrs memorials. Most surprising of all, commemorative activities are sponsored by actors blamed most frequently for perpetuating sectarianism: political elites.

Lebanon has gone through many wars, and some participants and victims continue to remember the violence with hurt and anger directed at other Lebanese; notwithstanding those real emotions that create and support divisions in Lebanese society, new post-violence narratives can be identified by looking at the construction and resonance of Lebanon's memorial spaces, and by comparing commemorative places and practices instituted in order to work toward cross-communal solidarities and reconciliation.

HISTORY, MEMORY, AND THE ANTHROPOLOGY OF LEBANON

This book traces some of the most tragic events in Lebanon's modern history. While Lebanon's violent past certainly does not compare to that of some European countries, where two world wars and a Holocaust killed more than 50 million in the first part of the twentieth century, a country three-quarters the size of the state of Connecticut with approximately 4 million residents has seen more than its fair share of violence. Lebanon became a French mandate[4] after World War I and obtained its independence from France during World War II. World War I is also remembered as a time of great famine, when as many as 150,000 are believed to have perished.[5] Since its independence, Lebanon has seen two civil wars, in 1958 and from 1975 to 1991. The latter killed more than 144,000 Lebanese and wounded another 200,000.[6] Since 1948 Lebanon has been host to waves of Palestinian refugees, uprooted from their homes as a result of repeated wars with Israel. The Palestinians settled both in Lebanese cities and in refugee camps with no possibility or right of return. Some Palestinians began to launch their armed liberation struggle from Lebanese territory, and, as a result, Lebanon has been repeatedly attacked as well as partially occupied by

neighboring Israel. Lebanon also came under Syrian military control during the 1975–1991 Civil War; and after the successful Islamic Revolution in 1979 Iran became increasingly involved in Lebanese affairs. Israel and Syria withdrew their militaries in 2000 and 2005, respectively, but both have remained involved in Lebanese politics. The United States has sent significant amounts of financial and military aid to Lebanon: $1 billion since 2006 alone.[7] Since 2005 a string of assassinations of political elites, riots in the streets of Beirut, another Israeli war on Lebanon, and fierce battles between the Lebanese army and heavily armed jihadists entrenched in a Palestinian refugee camp north of Tripoli have kept Lebanon on the front pages of the news. Glossing Lebanese history in these broad terms, it is easy to see why a much cited poem about Lebanon begins with the words "Pity the Nation."[8]

But not all these historical events were publicly remembered subsequently. Surprisingly, perhaps, the two events that cost the most Lebanese lives, the famine of World War I and the 1975–1991 Civil War, did not generate in their aftermath sizable public monuments that recognized the tremendous losses in human lives. Much has been written about the alleged civil war "amnesia" in Lebanon in the 1990s—an argument with which I engage in subsequent chapters—yet, comparatively little has been said about the public forgetting of the great hunger in Lebanon. A second book would be required to discuss the famine in a way that would do it justice; here I only point out that much ink has been spilled to decry one "amnesia," while very few speak about the other.[9] Many more Lebanese died during and after World War I than those executed in 1916, but they did not become the subject of future history lessons. Clearly it is not the magnitude of tragedy that determines subsequent public commemoration. Commemorative processes follow the law of intentional selection, which is why we study them under the heading of *the politics of memory.*

Although any study and writing of the past involves a process of selection—as most historians would agree—public memory exists to promote values rather than "facts." A memorial refers to an event in history not in a detached, analytical, backward-looking way but in a vested and forward-looking manner. Memorials result from discussions that include the question, "What do we want to teach our children?" And that is a very important question to ask, especially after war. By fully appreciating which memorials and monuments get built and which ones do not, we are able to understand the distribution of and struggle over power between political elites, the implicit and explicit value systems among those who seek to control the past, and the relationship between political elites and the people they govern. By looking at public monuments, we learn how politics

operates in cultural ways. Put differently, by looking at memorials, we can "enculture the state."[10]

The historical narrative of a country does not map neatly onto its commemorative landscape. Though my story unfolds in a chronological fashion, the length of time covered in each chapter does not follow the standard periodization in most Lebanese history books. It is customary to divide Lebanon's historical time according to its rulers: Ottoman (roughly 1500–1918), French (1920–1943), and Lebanese (1943 to the present); the latter time period is further subdivided along the six-year terms of subsequent presidents. Some record Lebanese time according to a "rise and fall" paradigm, juxtaposing nation building and the first civil war (1943–1958) with the "Golden Age" (1959–1974), followed by the second civil war (1975–1991) and the conflicted post–civil war reconstruction era (1992 to the present). Instead, my time line for Lebanese history is organized according to the importance given the commemoration of it. Some of Lebanon's most tragic events and the cemeteries and monuments that commemorate them define the beginning and end of each chapter, which creates different periods from the ones customarily used. I focus on Lebanon's two independence narratives from Ottoman and French rule, which coincide with World War I and World War II and gave shape to, and then radically altered, the memoryscape of Martyrs Square in Beirut (chapter 2). This is followed by the commemorative responses to Lebanon's two civil wars of 1958 and 1975–1991, both in Beqata and in Beirut (chapter 3). I then divide the post–civil war period into two segments, one anchored by the tragic events of Qana in 1996 (chapter 4), and the assassination of Rafiq Hariri in 2005 in Beirut and the second attack on Qana in 2006 (chapter 5). To those familiar with Lebanese history, this book will read differently from the narratives you know. To those new to the country and its past, I hope the narratives of Lebanon's memories will entice you to read further about Lebanese history.

Traditionally anthropologists study people's way of life. Their goal is to turn the mundane activities people engage in into a story worth telling, and to explain how individuals, families, and groups all over the world solve the challenges they encounter in their everyday lives. Often anthropologists work at the margins of societies in order to make visible and audible the faces and voices of members of the human family who are overlooked and neglected by those at the centers of power. Anthropologists who have produced work of this kind in Lebanon include Lara Deeb (2006) and Roschanack Shaery-Eisenlohr (2008), who both lived among members of the Shiite community.[11] The goal of both was to point out differences of belief and practice among members of the same community

in an effort to break down generalizations and misunderstandings. Other prominent recent work on Lebanon's forgotten and neglected includes studies of Palestinian refugee communities, conducted by Julie Peteet (2005) and Laleh Khalili (2007).[12] Both anthropologists discuss the Palestinians' changing strategies to obtain rights and nationhood in conditions of dispossession. A slightly more dated yet unique study by Michael Gilsenan (1996) investigates the lives of Lebanon's Sunni poor in the northern Akkar region.[13]

These colleagues have convincingly argued that significant differences exist not merely between the major religious groups in Lebanon but between members of the same marginal communities, thereby imploding rigid stereotypes or biases about them. My book contributes to the same goal, yet I take a different route by pointing out instances when Lebanese crossed communal divides in the search of common values, and created, however temporarily or (un)successfully, a narrative of national identity inclusive of their communal differences. As a political anthropologist, I situate my research comparatively across three different locales: the capital Beirut, Mount Lebanon, and southern Lebanon (al-janūb); on public plazas and cemeteries built with the express purpose of attracting attention; and among members of the Druze, Maronite, Shiite, and Sunni political elites and communities. My book, therefore, is an ethnography of Lebanese public culture and political authority.

BRIEF INTRODUCTION TO LEBANON'S ETHNO-RELIGIOUS AND POLITICAL DIFFERENCES

Lebanon is a country made up entirely of minorities. Currently eighteen distinct religious communities are officially recognized by the Lebanese constitution. These communities include a variety of Eastern (Orthodox) Churches, Maronites (originally one of the Eastern Churches), Protestants and Catholics, Shiites, Sunnis, and Druze. The last Lebanese census was taken in 1932 by French mandate authorities. They concluded that no single group had an absolute majority, and yet that all Christian communities combined had a slight advantage over Muslim communities. The five largest groups—and again, these are 1932 figures—were Maronites (29%), Sunnis (23%), Shiites (20%), Greek Orthodox (10%), and Druze (6%).[14] Population surveys are important tools of governing, as numbers do not only represent but also generate realities. In Lebanon today, 128 parliamentary seats are divided among Lebanon's religious communities, with Maronites holding 34, Sunnis 27, Shiites 27, Greek Orthodox 14, and Druze 8 seats.

Membership in any one of these religious communities may certainly imply that a person actively and devoutly practices their faith, but, more important, membership in these communities means cultural affinities and shared values. The best example can be drawn from the area of marital preferences. During my repeated stays in Lebanon, I heard many elders of different communities express the wish that their children or grandchildren marry someone from the same religious community so as to ensure the continuation of their traditions. Implicit is the belief that people from the same background get along more easily. Even if my interlocutors conceded that two adults with different backgrounds could fall deeply in love, how would they raise their children? The children would be confused (so it was claimed). What reinforces these cultural expectations for marriage is that only clergy can wed a couple in Lebanon. There are no civil marriage laws. A bride and groom from different religious groups, neither of whom wishes to convert before tying the knot, must go abroad to marry and then apply to have their marriage recognized upon their return to Lebanon. Although the number of inter-religious couples has been steadily rising in Lebanon, and though there have been repeated initiatives to introduce civil marriage in Lebanon over the years, so far the clergy and elders have been able to prevent them, citing the protection of their communities' cultural identities as the main rationale for preserving the status quo. Because of this stated marriage preference, which leads to relatively endogamous communities, I prefer to use the term "ethno-religious" rather than simply "religious" or "sectarian" to describe Lebanon's communities. My point is to emphasize that it is not primarily tenets of faith that separate the Lebanese but a mix of religious belief *and* cultural practices.

In addition to marriage preferences, ethno-religious identities are significant in politics. As indicated above, Lebanon's parliament is set up according to a quota system, a form of rule that political scientists describe as "confessionalism." After the French had completed their census in 1932, they divided up the available parliamentary seats reserving six seats for Christian politicians (an aggregate of all denominations) for every five seats for Muslims (Sunnis, Shiites, and Druze) in a parliament whose total number needed to be a multiple of eleven. In order to gain access to political power as well as state resources, the Lebanese have had to organize themselves according to their ethno-religious identities, regardless of how important their faith is to them individually. As any political system, it has served the interests of a certain segment of elites (who then were invested in maintaining it) at the expense of others (who have tried to change it). The confessional system is predicated on the belief, similar to the principle that undergirds marriage choices, that only a political leader of one's own

ethno-religious background will look out for one's best interests. Other political elites cannot be similarly trusted. As is the case with the traditional marriage preferences, many attempts have been made to abolish the confessional system by either introducing political parties with cross-community appeal or by demanding a rewriting of the constitution.

The Lebanese constitution was last rewritten in the Saudi city of Taif in 1989, as part of the efforts to end Lebanon's then still ongoing civil war. The Taif Agreement, as it would be known, changed the relative distribution of seats from a ratio of 6:5 to 50:50. This formula was not derived from a census, and hence the numbers are not linked to Lebanon's current demographic realities. Because of proportionally higher Maronite, Christian Orthodox, and Druze emigration from Lebanon and proportionally higher birth rates among Shiite and Sunni Lebanese, it is generally assumed that Shiites and Sunnis now significantly outnumber all Christian communities combined. This means that relative to their actual numbers, Sunnis and Shiites are underrepresented in parliament. During my most recent visit to Lebanon in 2008, I heard both Sunnis and Shiites claim, but in the absence of a census they could not prove, that *their* community now constitutes the *absolute* majority of Lebanon's population. Still, Muslim and Christian political elites agreed in 1989, and have reiterated since, to follow "the principle of Muslim-Christian parity."[15] In other words, political elites who are elected based on their ethno-religious affiliation paradoxically move on to conduct politics that emphasize shared Muslim and Christian values. Or at least some politicians do, and this book shows how they do it. Both memorials and cemeteries are central as dynamic sites in generating, circulating, contesting, and revising the politics, political ideology, and cultural practices of Muslim-Christian parity. Thus, throughout Lebanon's history, political elites from different ethno-religious backgrounds sponsored cemeteries and memorials because they wanted to give concrete shape to, and win political legitimacy through championing, a unifying national idea in a country that scholars have called "fragmented," "divided," and "shattered." By sketching faces, sculpting bodies, carving texts, and circulating photographs and banners that show Lebanon as a place where Muslims and Christians struggle and die together, Lebanese elites have used public art to create images of this national idea.

MAPPING LEBANON'S MEMORIALS ONTO
MUSLIM AND CHRISTIAN COEXISTENCE

The sites of public memory that form the basis of my inquiry are located in three distinct regions that are predominantly affiliated with one ethno-

religious group, although all three areas are inhabited by a mix of communities. The sites—Downtown Beirut; Beqata, Mount Lebanon; and Qana, South Lebanon—were chosen because each has a prominent public Martyrs Square with memorials and cemeteries clearly demarcated from their surroundings, continuously maintained (even if not in pristine condition), and regularly (if not continuously) visited.

Downtown Beirut

When Beirut was made a provincial capital by Ottoman decree in 1888, it was neither the largest nor historically most significant city in the region. For instance, the Mediterranean city of Sidon in South Lebanon appears in the book of Genesis, and the neighboring city Tyre is mentioned in the Books of Kings. For most of the Ottoman period, Beirut was an administrative region (*sanjak*) governed from Damascus, whereas the northern city of Tripoli was a provincial capital, like Damascus. But over the last one hundred years, Beirut firmly established itself as the country's undisputed center. Historically governed by prominent Sunni and Greek Orthodox merchant families, Beirut saw the influx of substantial numbers of Maronites from Mount Lebanon in the late nineteenth and early twentieth centuries. Subsequently Sunni and Greek Orthodox elites often stood on the same side of political debates, opposite the Maronites. It is in Beirut that Sunni and Maronite politicians concluded Lebanon's National Pact in 1943, which brought different ethno-religious groups into one national framework. Situated on the shores of the Mediterranean, Beirut used to be called the "Paris of the Middle East," a fabled tourist destination because of the city's once extravagant nightlife. Currently home to about half of Lebanon's population, Beirut is the commercial, educational, and political center of the country and is one of six *muhafazas* (a political unit similar to a state in the United States).[16]

Locally called Sahat al-Bourj (Tower Square) or simply al-Bourj (Tower) in reference to an ancient watchtower that once graced the ramparts of the Ottoman city, Martyrs Square is a public plaza in Beirut's city center. According to Lebanese sociologist Samir Khalaf, Beirut's downtown

> has served historically as the undisputed focal point and meeting place. Beirut without its "Bourj," as the center is popularly labeled, was unimaginable. Virtually all the vital public functions were centralized there; the Parliament, the municipal headquarters, financial and banking institutions, religious edifices, transportation terminals, traditional souks [markets],

shopping malls, entertainment activities, etc. kept the pre-war "Bourj" in a sustained state of animation day and night. People of every walk of life and social standing came together there.[17]

Martyrs Square is not only one of the capital's major transit centers but also "a convenient buffer zone between the city's red light district on one side and its major religious buildings on the other."[18] Bustling Martyrs Square turned into a virtual no-man's land during the 1975–1991 Civil War.

Beqata, Mount Lebanon

If Beirut's downtown has been called "the heart" of Beirut, then the region of Mount Lebanon that immediately surrounds the capital is the heartland of Lebanon. It gave the country its name. In the first place, Mount Lebanon is a mountain range that extends about one hundred miles from north to south Lebanon, with the highest peak over ten thousand feet. Mount Lebanon is also a location mentioned in the Old Testament as the source of cedar wood to build the Temple in Jerusalem. It was the seat of (Druze) Emir Fakhr ed-Din Maan (1572–1635 CE), an appointed Ottoman administrator of the *sanjaks* of Sidon and Beirut, who subsequently rebelled against the Ottoman rule. This act earned him, in some Lebanese history books, the title "historical founder of the Lebanese state."[19] Another "founder" of Lebanon, (Maronite) Bashir Shehab II (1767–1850 CE) also resided in Mount Lebanon and was similarly in the employ of the Ottoman Empire, yet in pursuit of local ambitions. Finally, Mount Lebanon was the site of an armed conflict between Maronite peasants and Druze landowners in 1860.[20] The Ottoman Empire, in collaboration with the Great Powers of Europe, intervened to stop the violence and created a semi-autonomous province with a majority Maronite population under the leadership of a non-Lebanese Christian official, called the *mutasarrif*. The *mutasarrifate*, as the political entity was called, remained in place until the outbreak of World War I. One Lebanese scholar called this fifty-year period in Mount Lebanon the "golden age of political and cultural Maronitism."[21] Mount Lebanon is currently one of the six *muhafazas* of modern Lebanon.

Both the Druze and the Maronites are religious minority communities that historically experienced periods of persecution but that were also able to obtain significant political power. The Druze are a heterodox offshoot of Shiite Islam, originating in Fatimid Egypt in the eleventh century. The name of the community is traced to an early leader of the community by the

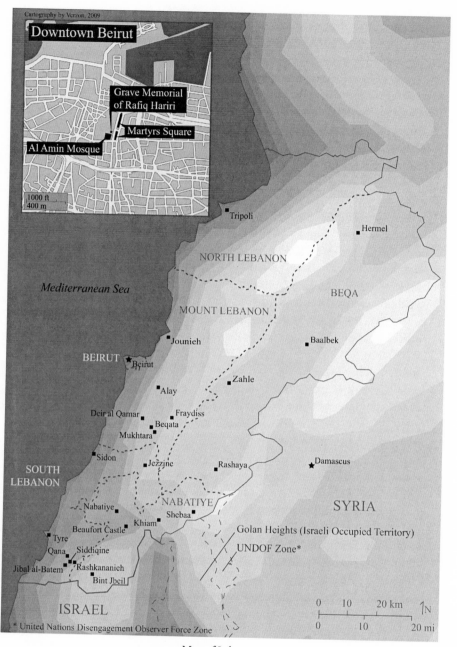

Map of Lebanon

name of Muhammad al-Darazi (?–1019 CE); however, many Druze prefer the title "Unitarians." The full extent of Druze doctrine is known only to a small number of initiates who obtain the knowledge after many years of study and practice. Druze dogma combines both spiritual/transcendental (esoteric) and textual (exoteric) religious knowledge.[22] The Maronites were originally part of the Eastern Church—what many in the West refer to as Orthodox Christianity—until their patriarch formally recognized the supremacy of the Pope in Rome in 1180 CE.[23] The name of the community is variously credited to a monk by the name of Maroun, who lived in the fifth century, and the community's first bishop Yuhanna Maroun, who lived in the seventh. Maronites follow Catholic Church doctrine, but they retain their own liturgy and church hierarchy. Its highest-ranking clergy, the patriarch, has wielded considerable political influence throughout Lebanon's history.

The southernmost region of Mount Lebanon, the Shouf district, is home to both Druze (who look to Fakhr ed-Din Maan as their "ancestor") and Maronites (who look to Bashir Shehab II as theirs). Many of modern Lebanon's political elites have come from the Shouf, including presidents Bshara al-Khoury, Camille Chamoun, and Fouad Shehab, and ministers in Lebanon's cabinet, most prominently Kamal Jumblatt, and now his son Walid. Lebanese historian Fawwaz Traboulsi argues that during the French mandate period, Mount Lebanon controlled Beirut politically and administratively, and Beirut was the undisputed economic center.[24] Some consider the violence between Maronites and Druze in the Shouf in 1860 to be Lebanon's first civil war, although Lebanon had not been created yet. The Shouf is also where the heaviest fighting of the 1958 Civil War took place.

Qana, South Lebanon

If downtown Beirut and Mount Lebanon are the metaphorical heart and heartland of modern Lebanon, southern Lebanon is one of its "extremities."[25] The area includes the flat coastal regions around the city of Tyre and the hilly region of Jabal Amil, which is the geographic northern extension of the Galilee. For most of the Ottoman period, the fertile soil of southern Lebanon was tended by peasants ruled by their own elites in a feudal land tenure system—not unlike the social organization of Mount Lebanon.[26] When the victorious European powers created the map of the Middle East after the end of World War I, the fate of the mainly Shiite region in Lebanon's southern borderlands was contested. The British considered the area part of the Galilee, which meant it belonged to their sphere of influence in Palestine, and the French wanted to create "Greater Lebanon," a national territory that included sufficient agricultural lands to make the country self-sustainable.[27]

In the end the French prevailed, bisecting a region whose communities had much stronger links to Palestinian towns and cities to the south than to Mount Lebanon or Beirut to the north.[28] Politically South Lebanon remained marginal for most of Lebanon's history (more on that in chapter 4). Some of the locals still call the area *al-jalīl*, the Arabic term for Galilee, and believe that it is part of New Testament geography, where Jesus performed his first miracle—turning water into wine at a wedding.[29] Although numerous Christian communities that trace their genealogies back to the original followers of Christ live in villages in southern Lebanon, the region features most prominently in histories of Lebanon's Shiites, who are clearly in the majority.[30] The official Lebanese administrative designations for the region are South Lebanon (the coastal areas, including Tyre) and Nabatiyye (the interior, including most of Jabal Amil).

In popular parlance, however, the territory of these two administrative units is currently called *al-janūb*, the South, a term that denotes a war zone. The southern borderlands of Lebanon became a militarized zone in the late 1960s, when Palestinian guerrilla groups created bases in the southeastern Arkoub region and began to engage Israeli forces.[31] The Israeli military created the South Lebanese Army (SLA) that served as their proxy force, and together they fought the Palestinian guerrillas and Lebanese who joined the Palestinian liberation struggle. Many of the officers in the SLA were Maronites, and a good number of the rank-and-file soldiers were Shiites, who came from southern villages that suffered from the violence escalating around them. In 1978 the United Nations deployed a multinational force that tried to establish a "buffer zone" to separate the fighting forces. Lebanon's armed resistance group, Hizballah, which emerged after the 1982 Israeli invasion and siege of Beirut, deployed to the south in the mid-1980s. The village of Qana—the name is also transliterated as Cana—is located inside the United Nations "buffer zone." Qana was targeted by Israeli aerial bombardment during the 1996 "Operation Grapes of Wrath" and the 2006 Lebanon War, sustaining heavy losses in civilian lives.

In sum, Beirut, Mount Lebanon, and *al-janūb* have followed different cultural, political and economic trajectories throughout history, and each has a distinct geography of violence. Traveling from the capital to the southern border is a trip from the "center" to the "periphery." Beirut and Mount Lebanon form the historical centers of political and economic power, and southern Lebanon has been mostly excluded. Beirut is now the most cosmopolitan and most populated area in all of Lebanon, home to almost half the country's population. Mount Lebanon used to be defined by village life, but many of the villages are now better characterized as suburbs of "Greater Beirut." The South remains the most rural and most remote of the

three regions under comparison. The city of Beirut was where Sunnis and Maronites concluded the National Pact of 1943; the Shouf district is mostly associated with the Druze community; and *al-janūb*, as stated earlier, is the region most associated with the Shiites. So I was not surprised when I found public memorials and cemeteries in those three locations that were sponsored by Maronite and Sunni, Druze and Shiite elites, respectively. What surprised me was that all memorials explicitly honor Christian *and* Muslim sacrifice. Central to all locations is the symbol of the martyr and the act of martyrdom. All three commemorate the deaths of civilians, not soldiers, and they claim to represent *national* sacrifice. And all three locations became sites for memory battles over their artistic representation of Lebanese identity and values as well as their narrative content.[32]

Following the categorization scheme established by social geographer Kenneth Foote, I call all three sites "sacred" or "sanctified." Foote listed four commemorative choices after tragedy occurs: sanctification, designation, rectification, and obliteration.[33] The sites I investigate are sanctified because they involved the planning and building of memorials, the execution of an official inauguration and subsequent commemorative ceremonies, and their audience is the wider public, not just relatives or those immediately affected by the deaths commemorated. Moreover, all three sites attracted additional memories "through a process of accretion," meaning that the original sites grew, either by incorporating additional space, grave markers, or monuments or by staging re-inauguration ceremonies that gave new meanings to the deaths of the past.[34]

A U.S.-EDUCATED GERMAN ANTHROPOLOGIST IN LEBANON

The researcher's position in relation to her research topic matters. Therefore the following remarks are in order: I am neither Lebanese nor related to any Lebanese, and thus I do not feel beholden to any particular Lebanese community's viewpoint or politics. Those who agreed to speak to me may have made comments they would not have said to another Lebanese; yet, at the same time, they may have withheld information they did not want to share with a European. Although I am clearly an outsider I am not in a position to claim neutrality, as my connections to Lebanon are not purely professional: I have made many Lebanese friends over the years, and it is those friendships that most inspired me to write this book. While I do not have a personal stake in Lebanon's present or future, I care about a lot of people who do.

I went to Lebanon for the first time in 1992–1993 as an English teacher at the International College (IC), one of Beirut's leading private schools. My

main qualifications for the job were that I carried a German passport and spoke English fluently. The IC had lost most of its American teachers after the U.S. State Department imposed a travel ban to Lebanon in the aftermath of a series of targeted bombings and kidnappings on its citizens in the early 1980s. By the summer of 1992, I had lived in the United States for five years, was in the middle of a master's program in Arab Studies at a prestigious university where I had acquired some Arabic skills, and I felt confident that I could teach English at the high school level. I decided to apply for jobs at private schools in various Arab countries to take a break from the classroom. Beirut's IC was the first to call me in for an interview and then offer me a job.

When I was not teaching Shakespearean sonnets and *Animal Farm*, I devoted myself to learning the Levantine Arabic dialect, so that I could say "*finjan ahwe, iza bitreed*" to get a cup of coffee instead of the Modern Standard Arabic "*uridu an ashraba al-qahwah*," which earned me quizzical looks or bouts of laughter. I learned to say "*yateeki-l-aafiye*" to honor someone's work. I now can make stuffed grape leaves from scratch and read fortunes out of coffee cups. I learned why it is important for women to wax their legs and straighten their hair. Some lessons I learned easily; others I did not. My German nationality garnered me much approval among Lebanese, who appreciated their Siemens or Miele kitchen appliances, who drove new or second-hand Mercedes or BMW cars, and who had relatives who lived and worked in (and sent remittances from) Germany. As an unmarried woman, I received multiple proposals to marry sons of different families so they could get a visa to emigrate. On my own, I traveled to the different regions of Lebanon by rental car, despite a lack of road signs and updated maps, and I came to appreciate the geographic diversity in a country of only four thousand square miles. When the school year was over, I realized that besides colloquial Arabic and cooking Lebanese food, I had learned a great deal about the lives of Lebanese families in and around Beirut. It was then that I decided to apply for a graduate degree in cultural anthropology; I wanted to come back and learn more. So, in a way, it is the Lebanese who turned me into an anthropologist, and it is the students at IC who gave me my first training in teaching.

I returned to Lebanon in the summer of 1996 and for a second full year in the fall of 1997 to conduct dissertation research among families of returnee Lebanese who had spent the civil war outside their country but now wanted to participate in (and benefit from) its reconstruction. As I was writing my dissertation chapters about "post–civil war society," the Lebanese kept dying. I became interested in martyrs memorials, because images of martyrs seemed to sprout out of the ground whenever I returned

to Beirut for follow-up visits. The billboards of martyrs were ubiquitous at the side of the road and on the walls of apartment and commercial buildings in the southern suburbs as well as in downtown Beirut. Because of my Catholic background, I found the commemoration of martyrs familiar, yet in this form it was also strange.

I devoted myself to researching Lebanon's politics of memory in 2003, after I began my tenure as Assistant Professor at San Francisco State University. Because of limited sabbatical opportunities, I had to divvy up my research work and do it piecemeal over several years. I returned to Lebanon four times during winter or summer breaks, as my teaching schedule permitted. My research methods included semi-structured interviews, field notes, photographs, and archival newspaper research. During each visit I would document cemeteries and public memorials through photographs and textual descriptions, and schedule interviews with their sponsors, designers, and the organizers of commemorative ceremonies. I also interviewed Lebanese historians and searched archival records of Lebanon's newspapers, *Al Nahar* and *Al Hayat,* to find materials on the early memorials. For the recent memorials I read *Al Nahar, L'Orient Le Jour,* and the *Daily Star* online, Lebanon's largest Arabic, French, and English newspapers, respectively. The persons I interviewed gave graciously of their time, as I could not remunerate them. All names are pseudonyms, unless they are persons in public office who spoke to me on the record. No one agreed to be taped, so all notes were taken by hand during the interviews and typed up later the same day or the next. Most of my Beirut-based interview partners preferred to speak in French or English, and persons I interviewed in Beqata, Qana, or Tyre preferred to speak in Arabic, with occasional recourse to French or English. Back in the Bay Area, I worked on translating the newspaper articles and interviews I had gathered and on finding the necessary secondary sources.

While writing this book about the cultural politics of memory and martyrdom, it was important to remember that actual people had died, and that there were, and are, real feelings of loss and anguish among friends and relatives. Regardless of how elites negotiated the telling of these tragic pasts, there are also individuals who (did) find meaning and solace in the narratives of martyrdom as they (tried to) cope with their grief. Therefore it is essential to emphasize the deep and personal suffering experienced by so many Lebanese families before I begin my story about how the dead were commemorated in public form, and how some of the memorials built in their honor, as I witnessed on the day of Rafiq Hariri's assassination, remained very much alive.

The Politics of Memory in Lebanon

Sectarianism, Memorials, and Martyrdom

Identities and memories are not things we think about, but things we think with.　　—JOHN R. GILLIS, "MEMORY AND IDENTITY"

We are martyrs, not 'suicides' or terrorists.
(Nihna shuhada, mish 'suicides' aw irhabiyeen.)
　　　　—HAJJ ABBAS, IN BEIRUT, AS CITED IN LARA DEEB,
　　　　"EXHIBITING THE 'JUST-LIVED PAST'"

In the Middle East, as elsewhere, governments and political elites have engaged in politics of memory in an attempt to take firm control of putative ancestors or origins that would help narrate, imagine, and legitimate the nation-state. National identities—defined as both stories and sentiments about "who we are"—and the political entities called nation-states, were established by excluding cultural differences and divergent histories. In the eighteenth and nineteenth centuries the identity category of the "national" came to challenge older, more traditional affiliations to tribes, clans, or religious communities. The cultural politics that accompanied military conquests and civil wars strove to create links of solidarity among members of diverse ethnic, religious, and linguistic communities by reaching selectively to a model of solidarity in their past. The narratives that turned history into memory were of two kinds: narratives of (internal) exclusion or narratives of (external) opposition. These narratives are told and retold during moments of political crisis when the social

fabric unravels, and when the "national" comes under attack, from within or without.

Narratives of exclusion selectively remember pasts where unity allegedly prevailed and where cultural differences of the present did not yet exist. For example, since the creation of modern Iraq, successive governments have constructed a historical memory of Iraq's Mesopotamian and pre-Islamic past in order to present a society united in language, religion, and culture.[1] By going back to pre-Islamic and pre-Christian times, it became possible to ignore religious differences between contemporary Iraqis, whether the differences were between Muslims and Christians or between Sunni Muslims and Shiite Muslims. By presenting the past as iconic—Iraq was the cradle of civilizations for the world—contemporary Iraqis were asked to identify with a glorious past and with one another. A similar attempt to construct an ancient past without religious or cultural differences underlies much of the archaeological work in Israel, where excavations of Old Testament sites have privileged the Jewish past. By producing material evidence of ancient Israelite heritage, state-sponsored archaeologists helped to justify the construction of a modern Jewish nation-state at the expense of non-Jewish residents.[2] In both cases the ancient past is made co-temporal with the modern nation-state in order to merge the imagined homogeneous past community with the present community, and to mediate or gloss over obvious and at times antagonistic differences.

The other kind of nationalist narrative, the narrative of opposition, is one that turns to epic battles of the past in order to conjure a shared enemy and thereby create sentiments of solidarity among diverse communities. Let me draw on the same two countries for further examples: during the Iran-Iraq War of the 1980s, Saddam Hussein commissioned the most expensive Arab movie ever made, *Saddam's Qadisiya,* about a seventh-century battle between Arab forces and the Persian Sassanians at Qadisiya, and he built a gigantic Monument to the Martyrs of Saddam's Qadisiya in Baghdad to commemorate the fallen soldiers of the still ongoing Iran-Iraq war.[3] Present-day Iranians were "the other," which made a statement about the enemy without, while also casting a shadow over the Shiite community within Iraq itself. Hussein thereby used the narrative of a past Arab victory in assigning meaning to, and eliciting support for, an increasingly unpopular war against Iraq's neighbor. A similar case of recasting an epic ancient battle occurred after the 1948 War of Independence in Israel. Here archaeologists excavated the ruins of the ancient fortress of Masada where a group of Jewish resisters committed suicide in 73 CE, rather than be taken captives by the advancing Roman army.[4] The ruins of the fortress became emblematic in the national

imagination of the early nation-builders. The slogan "Masada will never fall again" recast the battle of the ancients as a proto-national struggle.[5] Using this particular narrative frame, Palestinians and other Arabs became the new Romans against whom Israel had to defend itself. Following an "us" versus "them" paradigm, these particular state memory projects meant to create exclusive or oppositional national solidarities among the various groups and communities that made up each population. Memories are conjured so that history does (if a victory) or does not (if a defeat) repeat itself.

In Lebanon there are no state-sponsored memories of glorious battles won by putative ancestors or paradigmatic losses that require (pro)active vigilance. Lebanon's national heritage includes Nahr al-Kalb, a prominent site of ancient rock inscriptions made by a series of invaders who successively conquered what would become Lebanon.[6] In other words, Lebanon's history contains sufficient material from which to choose battles to memorialize, but it did not happen. Instead, the Lebanese have turned to Nahr al-Kalb to point to their multicultural past, and their heritage as a crossroads for and between ancient civilizations—but being a crossroads for others has not necessarily had a unifying effect. Therefore the modern Lebanese nation-state has throughout its history conducted a different kind of politics of memory that has focused on civilian struggles rather than epic battles, and that preserved religious and cultural differences as an integral part of the struggle: Lebanese heroes are national heroes because they died jointly as Muslims and Christians. Political elites conducted their politics of memory by appropriating the religious symbol of the martyr and casting civilian sacrifice as martyrdom for the nation. Memorials and cemeteries carried the names of the people who sacrificed their lives, along with the honorific title *shahīd* (martyr). Detailed narratives of how these martyrs met their fate would be retold in history or memory books, or at annual ceremonies. Some memorials became sites for symbolic battles over the meaning of "Lebaneseness," others were gradually or abruptly forgotten. Some of the symbolic battles pitted the political elites against "the people," other battles were between the elites themselves.

Throughout Lebanon's history, political elites have expended limited resources to create, visit, and maintain memorials after periods of violence, thereby creating public sites of mourning. They have actively engaged in a postwar politics that sought to recognize ethno-religious plurality as inherent in Lebanon's national community. The memorials and cemeteries I present are not monumental, that is, they do not impress by their size, but they are complex and multilayered. They received both acclaim and critique, and each one galvanized supportive publics for limited periods.

Looked at together, they created a large and interlinked web of national remembrance, where the sum is larger than its parts. Put differently, although each memory project was carried out individually, each became, for varying lengths of time, generative of a national idea of "Lebaneseness" that has Muslim and Christian communities together at its core.

With my discussion of the politics of memory in Lebanon, I therefore link several important scholarly discussions that have provided me with much food for thought. These conversations are about the tension between nationalism and "sectarianism" in the Arab world, and "sectarianism" in Lebanon in particular; the uses of public art in creating concrete images of the national community; and the meanings of martyrdom in religious and nationalist discourse. Two main questions underwrite my inquiry: How do societies that undergo repeated periods of violence rebuild a sense of unity? What images, values, or practices can transcend community boundaries and bring people together? I believe there are answers to these questions if we look very closely at martyrs memorials and cemeteries. Let me proceed by fleshing out these three separate lines of inquiry that drive my work, and thereby situate my research within the larger academic landscape.

"SECTARIANISM" VERSUS NATIONALISM

In their efforts to explain why Arab states fail to build strong nations, scholars of the Arab world, as well as pundits in the popular media, have argued repeatedly that Arabs have remained too attached to their families or clans; the adjectives most often used in this debate are "tribal" or "sectarian."[7] Scholars in this school of thought see the Arab world torn between two ideologies: the supposedly age-old belief in loyalty to one's clan versus the allegedly modern and progressive notion of allegiance to territorial nationalism. The two ideologies are considered to be fundamentally irreconcilable—because they are attributed to different temporalities or times zones: tradition and modernity. The friction created by imposing nationalism onto "sectarianism" explains for many political analysts and scientists why there is such a high incidence of violence in the Arab world, and why many of their regimes employ oppressive policies in order to govern. An example of this thinking about Arab societies appeared in an assessment in the *New York Times* of U.S. policy in Iraq, where policy analyst John Tierny proclaimed that "Iraqi family ties complicate American efforts for change."[8]

Not only foreign observers contribute to this kind of debate. In 1987, the twelfth year of Lebanon's second civil war, Lebanese sociologist Samir Khalaf published his book *Lebanon's Predicament*. In it, he argued that the

"primordial loyalties" of the Lebanese had made possible and prolonged the country's civil war. Khalaf stipulated that the Lebanese found a strong sense of security and belonging in their attachments to their families and communities, which protected them in war, yet at the same time these attachments furthered national disintegration.[9] Since these "primordial loyalties" were predicated on kinship ties based on the proverb "Blood runs thicker than water," familial metaphors helped promote the idea that Lebanese inherit their primordialism and therefore keep the Lebanese trapped by the past. A prolific writer, Khalaf has reused his theory in many subsequent publications, which have been cited in innumerous other publications to the point that "Lebanon's predicament" is a basic staple in scholarship about Lebanon. But there is a problem with this line of argument, as Owen and Pamuk, among others, have pointed out. It assumes that "the so-called 'traditional' categories of tribe, sect or clan remain fixed and unchanging."[10] It also locates blame for Lebanon's civil war in the undifferentiated social and cultural unit of "the family."

The alleged sectarian nature of Arabs in general or the Lebanese in particular has created a scholarly countercurrent. Most prominent is Ussama Makdisi's now classic work, *The Culture of Sectarianism*, in which he traces the origins of Lebanon's confessional system to the end of the Ottoman Empire and the beginning of European intervention in the Levant. Makdisi argues that sectarian identities were the product of attempts to modernize Arab subjects under late Ottoman and subsequent European mandate rule. In other words, modernity and sectarianism are very much part of the same time zone: one sustains the other.[11] Ottoman functionaries, in collaboration with increasingly influential European powers, imposed a secular and rational mode of governance based on quotas, a system that the French adopted and continued. From the beginning, certain groups of people received more privileges than others, which created competition over resources within a confessional framework. Recent anthropological literature supports Makdisi's claim that the dichotomy between the "modern" and the "sectarian" is false and that both coexist and codepend on each other.[12] Put differently, "sectarianism" was *created,* not inherited. Once created, sectarianism was perpetuated by the political elites who had obtained access to power through the system. Critics of the Lebanese political system say that sectarianism has reduced Lebanese politics to a game in which politicians "fight for their chairs" (*yatkhana'u ala karasi*) and pursue very narrow interests that preclude a larger vision of national solidarities.

I am not sympathetic to Khalaf's argument that Lebanese ethno-religious identities have deep, subconscious roots. Instead, similar to Owen

and Pamuk, I believe that human beings are adaptable to their given circumstances and are agents of historical change. Of course, Lebanese families matter greatly in the lives of Lebanese individuals. Yet some families become more prominent than others, and some have access to more resources than others. In other words, not all families are created equal in terms of class or status. It is important to keep this in mind because, by casting the "Lebanese family" as a central explanatory variable, Khalaf perpetuates a deterministic kinship ideology without explaining how certain families benefit from confessional politics and others do not. Moreover, Khalaf's thesis of the withdrawal of the individual within the fold of the extended family during war does not necessarily hold up against empirical evidence, because many Lebanese emigrated, which, de facto, broke up close-knit family structures. It is also too easy to assume that Lebanese family members act in political unison; as in families elsewhere, ideological fault lines run across and through generational divides. And although I agree with the scholars who argue that "sectarianism" is fundamentally a cultural construct first and a lived reality second, I propose that we move beyond discussions of *origins*, and onto the specific historical and contemporary conditions that produce ethno-religious difference. Basically I suggest that we move away from questions about whether the Lebanese are "sectarian" in their identities, and look at when and how ethno-religious identities are deployed in interactions between members of the same community and across community lines.

By looking at "sectarianism" through the lens of politics of memory, it is possible to argue that religious differences matter greatly in the aftermath of war, but they matter in complex and complicated ways. Religious differences can translate into symbols that confirm national solidarity. Muslim and Christian communities do not only withdraw into themselves, but they also fight, suffer, and sacrifice together. By choosing to remember religious differences, Lebanese elites turned narratives of exclusion into narratives of inclusion, and thereby created discursive and material spaces to honor the "national" that is represented by members of more than their own ethno-religious community.[13]

Those who argue that politicians in Lebanon try to suppress public acknowledgment of ethno-religious difference usually point to the political formula "No Victor, No Vanquished" (*lā ghālib wa lā maghlūb*).[14] The phrase circulated among political elites and in the media after Lebanon's 1958 Civil War, when Lebanon's prime minister invited political leaders from the groups that had just fought each other to join his postwar cabinet. Officially bygones were bygones, and everybody was to forget their

differences. The spirit of this formula can be traced back even further, long before Lebanon's independence, to the conflict between Druze and Maronites in Mount Lebanon in 1860. When the peace accord was signed on July 19, 1860, it required from all signatories the "oblivion of the past."[15] This "oblivion" indemnified all parties and was meant to "promote conciliation, good-will, and union between the two nations [sic] and the welfare and tranquility of all." The same formula would resurface again after the 1975–1991 Civil War. Lebanon scholars are generally critical of this state-advocated policy of forgetting, based on the assumption that recovery from war requires some sort of engagement with the past, and that traumatic experiences, if not actively addressed, will have long-lasting negative consequences for individuals and communities.[16]

However, I believe that this standard assessment of the politics of "No Victor, No Vanquished" as a problematic exercise in suppressing communal differences requires a second look. I argue that this formula does not stand alone but that Lebanon's political elites have actively used a politics of memory that makes this compromise formula possible: they build memorials to honor joint Muslim and Christian martyrdom, thereby creating narratives of Muslim and Christian parity. Therefore I propose that we move "No Victor, No Vanquished" out of the category of purposeful and irresponsible forgetting and into the category of a politics of memory aimed at reconciling ideological differences in a society marked by political and ethno-religious diversity. The policy of "let bygones be bygones" became a deliberate postwar strategy of public reconciliation alongside the construction of memorials and cemeteries to honor shared Muslim and Christian sacrifice. Lebanon's case study might offer valuable lessons on how culturally plural societies may work toward reconciliation after periods of violence. Much depends on political elites: they make important choices when they publicly appropriate, narrate, and circulate violent pasts for the benefit of present and future generations.

With my study of elite memory productions that are both "sectarian" and "national" in nature, I not only want to contribute to a better understanding of postwar governance in Lebanon or the Middle East. Additionally an epistemological issue is at stake: if scholars who disagree with the proponents of "primordial" Arab identities remain focused on "sectarianism" and questions of identity, they can leave us with the mistaken belief that once the origins are unearthed and the frameworks are deconstructed, we get to the truth of the matter. Put differently, if we only succeed in deconstructing "sectarianism," it will be possible to arrive at "true (read: nonconfessional, nonsectarian) Lebaneseness." But we need to be mindful that we do not

make this imaginary "Lebaneseness" the default position to which the Lebanese will return once they have overcome their alleged "sectarian" attachments. Communal or cross-communal solidarities are cultural constructs, which have their place in time and are subject to change. Edward Said, a master of the method of deconstruction, reminded us in his classic treatise, *Orientalism*, that at the end of the day, when all Orientalist distortions about the Arab world have been exposed, we would still not be able to see "the *real* Orient" because there is no such thing.[17] In other words, by talking about symbols and practices commemorating joint sacrifice and communal coexistence, I am not according those sites of political and cultural production more truth-value than the beliefs and practices more narrowly shared by only members of the same community. But by showing the efforts, challenges, and struggles of Lebanese elites to build national symbols inclusive of ethno-religious difference—despite opposition and violent conflict—I want to shift the framework of discussions concerning Lebanese identities. Ultimately I want to suggest that unmooring identity from existential questions of who they *are*, and reconnecting them to questions of what they *do* with identity, will help us better understand Arab societies.

POLITICS THROUGH PUBLIC ART: SHAPING NATIONAL BODIES

Since it requires financial and cultural resources to design and build memorials and large cemeteries, memorial makers are often agents of state, that is, cultural and political elites. Volunteers play an important role on commemorative committees, as they maintain the site and help organize public commemorations. Elites sponsor memorials because they afford them public visibility, support their claims for political legitimacy, and thereby help them govern. Public commemorative processes, the building of memorials and the holding of ceremonies, are an important facet of political life in the Arab world. For instance, Saddam Hussein built gigantic monuments in Iraq to celebrate military victories he had yet to achieve, and Syria's Hafez al-Asad, expended significant effort to erect statues, billboards, and posters of himself and his family, and demanded that his subjects pay him public obedience.[18] Neither Hussein nor al-Asad had to convince anyone to vote for them at election time—there were no other candidates—yet both used significant government resources to shape public space. By creating public plazas and decorating them with art, political elites exercise what French sociologist Pierre Bourdieu called "the power of 'world-making.'"[19]

Public memorials engage us both cognitively and physically. Specifically, they do political work in three distinct ways: they are "rhetorical

spaces" where citizens and political elites debate images and symbols, values and identities; they are "real physical spaces" where people congregate to hold commemorative ceremonies and conduct rituals of remembrance; moreover, after the public ceremonies took place, they appear as reports in newspapers and other media where they have a second life as texts.[20] Benedict Anderson, a veteran of the study of nationalism, theorized that the simultaneous reading of newspapers and novels was one of the cultural roots of modern nationalism, as it allowed people who had never met to imagine themselves as part of the same reader-community.[21] A public commemoration of the dead connects the anonymous reader-community to the embodied and experienced community of hundreds or thousands of fellow citizens walking alongside coffins or standing beside graves to lay wreaths or flowers. Activities of public remembrance are therefore central to modern nation-making ventures.

Cemeteries and Memorials as Rhetorical Spaces

It is perhaps counterintuitive to think of cemeteries as "world-making," when they are built to bury the dead. But besides being sites to process grief, public cemeteries teach important lessons of civic duty and solidarity to members of present and future generations. They connect the living to the dead, and thereby ensure that the dead remain part of the community. This connection is achieved, in part, through the cemetery's design: "repetitious epitaphs and repeated gravestones" lead to the "unavoidable visual counting of gravestones," which highlights the communal aspect of the dead.[22] That imagined community of the dead then becomes a template, or cognitive map, for the community of the living.

National cemeteries saw their debut in the United States after the American Civil War. Survivors buried soldiers where they had fallen, instead of sending their bodies back home to their families. Battlefields became national cemeteries, where soldiers could be honored for fighting bravely and bringing the ultimate sacrifice—regardless of the side on which they had fought. It was no coincidence that Abraham Lincoln's most important Civil War speech was the official dedication of the Gettysburg cemetery "as the final resting place of those who here gave their lives that that nation might live." Burying bodies as soldiers, rather than as members of their home or religious communities, created a powerful space to imagine community that transcends ethnic, racial, and religious boundaries. Individual graves are arranged in a uniform fashion, as if the soldiers were still standing at attention, saying, "United we stood, united we rest."[23] Whatever else

the dead person did in his lifetime is subsumed under the narrative of a communal sacrifice.[24] A symbolic extension of the national cemetery—or perhaps its crystallized essence—is the Tomb of the Unknown Soldier. According to Benedict Anderson, "no more arresting emblems of the modern culture of nationalism exist than cenotaphs and tombs of Unknown Soldiers. The public ceremonial reverence accorded these monuments precisely *because* they are either deliberately empty or no one knows who lies inside them, has no true precedents in earlier times."[25] The less we know about the bodies, the more national they become.

Another way to commemorate the dead is to create public art in their honor, sometimes as part of the cemetery but often in public squares away from the graves. Located on large pedestals, the message of public memorials can be quite different from that of cemeteries, as, in the former, mourning for the dead is mixed with feelings of patriotic pride. The latter replaces the message of uniformity with one of distinction, by combining sculpture (allegories of liberty, representations of soldiers, etc.), inscription ("To the Dead," "Eternal Glory to our Heroes" etc.), and national symbols (laurels, flags, army insignia, etc.).[26] Of those three visual elements, human sculpture is the most costly, which is why public memorials make not only statements about artistic conventions and taste but also about money and power. All memorials are built to draw public attention, and they demand respect. After war they convey a sense of permanence and provide a space to mourn the tragic loss of life as a sacrifice for the living.

In Lebanon there are no national cemeteries that commemorate soldiers in the way that Gettysburg or Arlington cemeteries do, but there are public cemeteries of civilians who sacrificed their lives for the nation. Lebanon also has a tomb of Unknown Soldiers. Yet, notably, the ceremony that takes place at that site on each November 22, Lebanon's Independence Day, is staged by and for the military only. The tomb honors sacrifice but, for historical reasons, it does not translate into a message of national sacrifice. Lebanon's army was created under the French mandate in the early 1920s and, at its inception, was staffed with a majority of Christian (mostly Maronite) officers and soldiers. The staffing imbalance changed only slowly throughout Lebanon's history and tainted the reputation of the army, so when the 1975–1991 Civil War broke out, it was called a "Christian army" and treated as another militia force.[27] As a result, the task of generating national narratives fell to Lebanese civilians, even though they do not wear uniforms and their ethno-religious differences remain an important part of their remembered identities. The visual and textual representations of shared civilian sacrifice relied on representations of human bodies—whole

and dismembered, veiled and unveiled, Arab and Western. These public representations subsequently became sites for public contestations of national identity and "Lebaneseness."

At the same time that European nationalism emerged and solidified, sculpture was the preferred medium of monument makers in the nineteenth and early twentieth centuries.[28] The repertoire of sculptable bodies in nationalist art was rather narrow: the body had to be Greek. For various reasons some pseudo-scientific, some philosophical, European artists considered the ancient Greek body a model of perfection. As art historian Athena Leoussi showed in her study of the classical body as national symbol, "for a nation to have a Greek body meant that it could be perfect in all spheres of life, for this distinction did not only confer on its possessor the prestige that went with high birth; it also guaranteed conformity with God's will, with promise of salvation, beauty and intellect; and finally superior strength, ensuring victory in battle."[29] Beautiful Greek bodies thus connected aesthetics to moral values. Allegories, especially personifications of liberty, freedom, or patriotism, became popular themes in public sculpture, drawing on both the male and the female body.[30]

Although both male and female bodies appeared in idealized form, they emphasized different characteristics. Male bodies often revealed muscle tissue and carried an upright posture suggesting determination and strength. Female bodies in public sculpture (seated or standing) are usually more covered, even if muscular and strong, implying sexual restraint and purity. One particularly popular allegorical female figure to emerge on European pedestals was the "mother of the nation," a symbol that projected the image of the cultural and biological reproducer—the mother—onto the larger national community.[31] In this way the nation itself became a woman, and individual citizens became her children. It is important to establish the larger context that shaped national art in order to appreciate the particular forms it took in Lebanon. Lebanese artists who trained in classical sculpture did not choose Greek bodies but instead strove to sculpt other idealized bodies that reflected or resonated with local beliefs and practices. Sculpting against European conventions became a national act, especially while under colonial rule or postcolonial influence. Arab artists, as Jessica Winnegar has shown in her study of the art world in modern Egypt, took into account local artistic traditions, European modernism, and anticolonial sentiments, and created art forms that "reckoned with"—in the sense of working out, arranging, or thinking through—larger ideological debates.[32]

The connection between creating national ideas and idealized bodies changed profoundly with the invention of the artistic medium of

photography. Now bodies were rendered realistically, rather than ideally, and it is this realistic, documentary trait that became photography's biggest selling point. Through photographs, new bodies appeared in national memorial projects, with the distinct objective to present "the real," creating a new aesthetic of the mutilated and injured. National Lebanese bodies now are shown after they are ripped to shreds by bombs to the point that they are barely recognizable. It is the inversion of the sculpted ideal. The break between neoclassical conventions of bodily perfection and the disintegrated, abject body was not as abrupt as it may seem. As I will show, the sculpted body became a site for mutilation and injury, before photographs of corpses after bombing attacks took the message to the next level. Ironically the more mutilated the bodies became, the more unifying their effect.

Cemeteries and Memorials as Ritual Spaces

In addition to inculcating specific values, identities, and beliefs through sculpted or photographed bodies, memorials and cemeteries, public sites of memory teach bodily disciplines through prescribed commemorative ceremonies.[33] Memorials and cemeteries demand reverent postures (bowed heads and folded hands), measured language (whispered speech or respectful silence) or ritual language (prayers or anthems), as well as gift exchange (wreaths, flowers, candles, etc., in return for their sacrifice).[34] Sculptures are often installed on pedestals in order to elevate them, which results in visitors standing below and training their gaze upward, thereby making the mourners and visitors subordinate to the persons and values honored.

Memorials create sacred landscapes and, as mentioned earlier, provide the stage for official commemorations. During national holidays, political elites gather at memorials to conduct ceremonies that place them and "the state" on public view. Ceremonies are controlled events that impress through repetition, not innovation. The backdrop of the memorial lends the impression of permanence to the proceedings. When the President of the United States lays wreaths at the Tomb of the Unknown Soldier in Arlington Cemetery on Memorial Day, he follows a particular ceremonial script. He not only honors sacrifice, but he enacts the state. When the President of Lebanon deposits a wreath before the Martyrs Memorial on May 6, he similarly enacts the state. When commemorative ceremonies stop, as they did in Lebanon during the civil war, the state loses an important stage on which to present itself to the public. When two memorial ceremonies are held concurrently, or on competing dates, to honor the same event, it can be read as an attack on the state. When ceremonial protocols or the

actual memorials change, the state may reveal the contingency and precariousness of its power.

The participation of the public is crucial at these commemorative ceremonies. The authenticity of an event, or strength of shared sentiment, is measured by the number of attendees. Those who attend official or unofficial ceremonies may either participate by engaging in specific public acts of mourning or reverence, or they simply display community solidarity by adding their body to the many other participants. Photographs of the officials in front of mourning or cheering crowds are then reproduced in newspapers and archives as a visual proof of solidarity between the state and its subjects. It is ceremonies that make memorials and graveyards powerful political places; they bring the living to the dead and circulate the dead among the living.

MARTYRDOM AS NATIONAL SACRIFICE

Historian John Gillis has argued that "one of the peculiarities of the national phase of commemoration [is] that it consistently preferred the dead to the living."[35] After the imperial practice of honoring victorious generals and kings with imposing victory arches and columns, memorials to recognize the sacrifice of non-elites became popular with the emergence of nation-states. They conjured an ideal community based on "deep, horizontal comradeship" of men who gave their lives for the larger community.[36] This sacrifice is usually attributed to soldiers (who are most often men), but it need not be. Martyrdom of civilians can become the foundational national sacrifice as well. While the narrative of soldierly sacrifice is strongly tied to transcendent values of hard-fought liberty and freedom, the narrative of martyrdom follows a slightly different plot line. In the telling of martyrdom, *how* a person dies matters as much, and sometimes more, than *what* the person died *for,* and it is this narrative convention that makes for powerful stories of unity. Stories of martyrdom are, first of all, stories of human suffering, which includes the suffering of women and men, adults and children. If those who suffer and die together and those who subsequently remember them make Muslim and Christian identities explicit as part of their sacrifice, clearly the goal is not to die for one specific idea of God or belief but for something that cuts across these religious divides while not erasing them.

Historical and Contemporary Meanings of Martyrdom

Martyrs are important figures in all three monotheistic religions, where believers have died to give the ultimate witness to their faith.[37] The word

"martyr" originally comes from the Greek *martis, martyr* (from the verb "to remember"), from which early Christian leaders derived the term *martirium* to describe the deaths of persecuted members of their faith.[38] In Catholic school I was taught how early Christians chose to be quartered, speared, beheaded, or otherwise tortured to death by nonbelievers, rather than give up their faith. I distinctly remember stories of the repeated, failed attempts to kill true believers, who finally, after reciting prayers or receiving communion, *willingly* gave up their lives. Christians of all denominations believe that Jesus himself brought the ultimate sacrifice, his crucifixion preceded by a long and painful story of his way to the cross. In some Catholic countries, passion plays during the season of Lent enact Christ's sacrifice, during which some believers let themselves be crucified. In other words, it is the way in which the martyrs—and Jesus—died that demands constant retelling among surviving generations. This does not mean that Christian doctrine teaches believers that they should kill themselves but rather that they honor those who gave their lives for the faith, thereby preserving the community.

In Islam the most important duty of a Muslim is to witness publicly that there is no God but God. The *shahada,* as this testimony is called in Arabic, is simply a spoken statement of faith, but it is so powerful that uttering it with sincere conviction constitutes the act of conversion to Islam. Extreme conditions of persecution and forced renunciation of the faith, as happened to some of the early converts to Islam, may require the sacrifice of one's life.[39] However, because of the history of the spread of Islam, Muslim martyrs increasingly became also those who died in battle, defending and expanding the faith. A third category of martyr that emerged at the same time consisted of civilians who died tragic deaths that were not the result of persecution, that is, those who died during the plague, childbirth, or other sickness.[40]

Martyrdom within Islam took on a special significance among Shiites because of a particular incident in history. In 680 CE, Hussayn, the grandson of Prophet Muhammad, met Yazid, a contender for leadership of the Muslim community, in battle outside Karbala in current-day Iraq. Hussayn's forces were vastly outnumbered and he was killed, along with many members of his family. Yazid took the leadership mantle of what would later become known as the Sunni community, and those who remained loyal to the descendents of Hussayn took the name Shiites. Similar to Catholic passion plays, Shiites annually commemorate the death of Hussayn in a public performance that, over the course of ten days, reminds contemporary believers of the pain and suffering experienced by the

person who should have been the righteous leader of the Muslim community.[41] In some parts of the Shiite world these commemorations are accompanied by believers "hitting *haydar*," a practice that draws blood from incisions made on the skull.[42] Shiite and Catholic passion plays make physical, embodied memory a central part of religious faith and often move their audiences to tears.

In Judaism there are no annual passion plays of the kind just mentioned or weekly celebrations of sacrifice as is practiced by Christians all over the world. Nevertheless, martyrdom was a topic of much debate in rabbinical literature throughout the ages in response to Jewish persecution by non-Jews. Some religious leaders considered voluntary death preferable to the forced violation of specific divine commandments (idolatry, adultery, murder).[43] One of the most monumental sites of memory in contemporary Israel, the archaeological heritage site of Masada, mentioned earlier, honors Jews who chose to kill themselves rather than being taken hostage by the Roman army. The story of their heroic resistance to the military onslaught, but final recognition of their impending defeat, is remembered in the retelling, with men tragically killing their own wives and children before killing themselves. Appropriated by the Israeli state, Masada engendered national rituals, for instance, the reburial of bodies of alleged Masada defenders at the fortress, or military ceremonies where soldiers took their oath of allegiance inside Masada's walls. Bodily rituals, hikes up a steep mountain or standing at attention and saluting the flag and the martyrs inside the ruins of the fortress, were central to the message that Israelis were ready to defend the land made sacred by Jewish sacrifice.

Martyrs live on in the memory of subsequent generations not only as a "lesson" but also as a profound reassurance of group survival against the odds. What makes martyrs powerful figures is that, at the moment of their deaths, they were often outgunned or outnumbered. Martyrs lose their individual lives in order to preserve a larger order or safeguard a larger cause. It is the specific circumstances that led up to the martyrs' death, the tragedy that precedes the dying, that makes for a narrative worth (re)telling. This explains why a powerful religious icon was adapted into many leftwing, secular, anticolonial liberation struggles in Latin America, Africa, and Asia: martyrs were to inspire members of revolutionary groups to fight against professional armies or other well-armed agents of states.[44] Similarly, in Lebanon, martyrs became central to the secular nation-building enterprise begun under French rule. And, significantly, the fact that Muslims and Christians died together remained at the heart of the commemorative exercise, as civilian bodies are interred jointly in marble graves in

public cemeteries, and as their sacrifice is made immortal through public monuments and commemorative ceremonies.

As Laleh Khalili has shown in her *Heroes and Martyrs of Palestine,* a detailed study of the commemoration of martyrdom among Palestinians in refugee camps in Lebanon, the meaning of sacrifice for the nation has undergone significant change in a community still struggling to obtain national independence. During the 1960s and 1970s the image dominating Palestinian memory was that of the armed fighter-heroes, the *fidā'iyīn.* After 1982, the year the Israeli army laid siege to Beirut and expelled Palestinian fighters from Lebanese territory, the commemorative focus shifted to noncombatants—Palestinian women and children—who died innocently and involuntarily as bystanders in ongoing fighting. In other words, as the nature of the struggle changed, so did the symbolic representation of the dead. The Palestinian struggle used to be commemorated as heroic, manly, and bold; now the values that are praised are steadfastness, resilience, and suffering, which are often represented through the faces and bodies of women and children. Khalili importantly shows that the meaning of martyrdom is not fixed but is responsive to larger political and historical contexts, and that we are presently living in an era that values martyrdom after an era of the valorization of heroic armed liberation struggles. In my studies of Lebanese national memorials, I find similar trajectories from the heroic to the tragic, but I also find narratives of tragedy in ongoing competition with narratives of heroism. The figure of the unarmed civilian, contrary to Khalili's observations in Palestinian camps, remains at the center of the commemorative enterprise throughout most of Lebanon's history. The most dramatic changes occur in the realm of public representations of the bodies of these civilian martyrs. Over time, in statuary, poetic narrative, or photographs, the bodies become increasingly dismembered and mutilated. Precisely through their dismemberment, however, martyrs unite the nation.

Martyrdom in the Lebanese Context

The discourse about Lebanese martyrdom precedes the creation of the nation-state. As discussed by Edward Said in *Orientalism,* European travelers wrote copiously about the Arab world they encountered during the eighteenth and nineteenth centuries. Often they referenced one another's books, or they projected their own standards or categories onto "the other." An example of this is Alfred d'Ancre's *Silhouettes orientales,* published in Paris in 1869. He had passed through Lebanon after the conflict

between members of the Druze and Maronite communities in 1860, and, in his writings, he compared the Lebanese to the French. In flowery language he asserted that "there lives a people that knows how to die for the same ideas that we defend" but, unlike French soldiers, who know that "every drop of blood they shed is a pearl on the crown of glory that History intends for them," the people in Mount Lebanon "die as martyrs and ignored under the sword of fanaticism" (*mourir martyr et ignoré sous le yatagan du fanatisme*).[45]

D'Ancre emphasized that when European soldiers die in their battles they die assured that their sacrifice will make history with a capital H. In contrast, in Lebanon, "a people who knows how to die for the same ideals we defend,"—in other words, who share the same goals, values, and dispositions—"die as martyrs and [are] ignored." Put simply, the French and the Lebanese die for the same reasons, but they die in different ways and their deaths have different consequences for history. At the very end of his lengthy exhortation, the author names the people thus martyred and ignored: Mount Lebanon's Maronites. Although d'Ancre does not mention the Druze, it is implied that they are responsible for the Maronite martyrdom, as the people who wielded the "sword of fanaticism." Significantly the author does not allow for any civilizational divide between the French and this group of Christian Lebanese, and yet the French become heroes and the Lebanese become martyrs. Becoming a martyr, in this particular narrative, is equated with being ignored on the official pages of history. It is therefore striking that, sixty years later, the French would lend a helping hand in placing martyrs at the very center of the Lebanese nation-building project by supporting and ceremoniously inaugurating Lebanon's first Martyrs Memorial in downtown Beirut.

The Lebanese publicly remember many different kinds of martyrs (*shuhadā'*). The Lebanese tomb of the Unknown Soldiers carries the inscription "Glory and Eternity to our Martyr-Heroes" (*Al-majd wa al-julūd li-shuhadā'ina al-abtāl*). The fourteen civilians hung from the gallows in 1916 became "martyrs of independence" (*shuhadā' al-istiqlāl*). The fighters and civilians who died in Lebanon's 1958 Civil War were martyrs of a popular uprising. The civilians who died in attacks in 1996 and 2006 in Qana were called "child-martyr" (*al-shahīd al-tifl*) or simply martyr, and clearly differentiated from Resistance fighters who were "fighter-martyrs" (*al-shahīd al-mujāhid*). The former prime minister Rafiq Hariri was called "president-martyr" (*al-ra'īs al-shahīd*) right after his assassination in 2005.[46] Obviously these Lebanese martyrs were people from different backgrounds, who died at different times and under different circumstances.

Soldiers of the Lebanese army and the fighter-martyrs of the Resistance are remembered as having died in battle. Giving their lives voluntarily, they become exceptional, patriotic citizens who deserve to be honored. When civilians die in war, they mostly die involuntarily by being caught in the wrong place at the wrong time. Not only is their dying different from that of soldiers, but it is an arbitrary death that could have happened to anyone. In other words, when soldiers die, it is "them" dying for "us"; when civilians die, it is "us" dying. If the "us" is further defined as Muslim *and* Christian, civilian deaths can elicit strong bonds of solidarity.

In each case mentioned above, "martyr" is an honorific title given to the dead which explains the exclamation by Hajj Abbas, a member of the Shiite political group Hizballah, at the beginning of this chapter. When he tells anthropologist Lara Deeb in an interview, "We are martyrs, not 'suicides' or terrorists," it is clear that he understands martyrdom as an honorable sacrifice as opposed to other less honorable forms of violence. Though speaking in Arabic, he used the English word "suicides," showing that he is aware of, but emphatically dissociates himself from, Western perceptions of martyrdom in the Muslim world. At a time when martyrdom has become synonymous with the idea of Islamic radicalism, it is important to take a fresh look at the origins and meanings of this particular category of sacrifice, and to understand how martyrdom has been deployed in specific historical contexts as a unifying, co-religious, national act.[47]

In order to understand martyrdom as a unifying trope of remembrance of the dead, it is important to look at the practices of mourning that are similar in both Muslim and Christian communities in Lebanon. When a member of their family dies, Lebanese Muslims and Christians traditionally bury the body in a cemetery that belongs to their religious community. But the family of the deceased additionally observes three days of public mourning at their homes, during which time they accept condolences from their neighbors and friends. Additional commemorative gatherings take place after a week, forty days, and a year of the person's death.[48] Visiting a bereaved family during at least one of these designated periods of mourning is considered an obligation (*wājib*) by all Lebanese, regardless of their religious affiliation. In people's homes members of the respective clergy will recite prayers or suras from the Quran. During these times of public mourning, family, friends, and neighbors have the opportunity to exchange memories of the deceased, as well as other neighborhood news. Through these gatherings, the community displays its cohesion despite the loss of one of its members. After a year the remembrance of the dead follows different trajectories. Christian tradition designates one day in early

November for believers to congregate in cemeteries and honor the dead. There is no similar official Muslim day of mourning; indeed, Orthodox Islam speaks against believers visiting graves or shrines. Yet it is a cultural practice in many Arab countries to congregate at graves of family members during Muslim holidays (Eid al-Adha and Eid al-Fitr).

Traditional funeral practice in all religious communities in Lebanon requires that the last rites and burial be officiated by a member of their clergy. Last rites bestow upon the dying not only consolation and absolution, but they reaffirm the membership of the individuals in their community of faith. Burial procedures differ between communities: Muslims bury the dead, wrapped only in shrouds, as soon as possible, whereas Christians customarily hold a wake before they bury their dead in coffins. Religious cemeteries only admit members of their own faith, and because they are usually enclosed, sanctified areas, they create in death a more concrete and coherent community than there might have ever been in life. It is therefore of great symbolic significance when bodies are taken outside the confines of religious burial grounds and laid to rest together in a public cemetery. Instead of being buried under the symbol of a cross or a crescent, Lebanon's national heroes are buried under the same title: *shahīd*.

FITTING MEMORIALS

But not only religious practices provide a framework for national commemoration; there are also larger political (read: ethno-religious) considerations and practices that have an influence on Lebanon's sites of memory. War memorials or national cemeteries teach lessons about sacrifice for the larger community and therefore fall, in the broadest sense, under the category of public education. Public schools, like national cemeteries and memorials, are sites meant to inculcate citizens with a sense of national belonging.[49] Schools, like memorials, are "rhetorical" and "physical" spaces that teach knowledge and discipline. In a poignant example from France, a country which early on centralized its educational bureaucracy and school curriculum, students were issued, in 1877, a book titled *La tour de la France par deux enfants* (Two children's travels through France). As indicated by the title, two children traverse the various regions of their country and report the marvelous sights they see, as an exercise to teach students about the geographic diversity and beauty of their country. The book was taught in classrooms across the country in such a way that "the minister of public instruction could take out his pocket watch at 8:05 AM a certain day of the year and confidently declare, 'All our children are just crossing the

Alps."[50] The story, whether true or not, illustrates the intended homogenizing effects of public schooling.

On the contrary, Lebanon does not have a standard school curriculum. Article 10 in the French-sponsored Lebanese constitution enshrined that each ethno-religious community in Lebanon was to retain the right to open private schools and decide on their own curriculum in order to ensure that their community's heritage and values would be transmitted to future generations. As late as 1940, only Lebanese private schools offered secondary education and public schools were limited to the elementary level.[51] When the French left Lebanon after the end of World War II, they left behind 267 public schools (attended by 21,056 students) and 986 private schools (attended by 73,603 students).[52] Fifty years later a study conducted by Lebanon's French-language newspaper *L'Orient Le Jour* showed that private schools absorbed two-thirds of Lebanon's primary and secondary student body.[53] Lebanon's public school system, like public educational systems in other countries, is vastly underfunded, so parents prefer to send their children to a private school, often at great personal expense. Because Christian private schools were established earlier, and have historically been better funded than Muslim schools, Muslim families with the necessary means have sent their children to Christian schools. The great diversity of private educational institutions in addition to fewer public institutions in Lebanon has led to a multiplicity of school curricula that manifests itself most clearly in the subject matter of history.

In 1996 the Arabic-language newspaper *Al Safir* presented a detailed report under the headline "More than fifteen history books, and each sect drums to its own beat."[54] According to the report, Lebanese children do not jointly "cross Mount Lebanon"; instead, they each learn different historical narratives, populated by a different cast of heroes and villains. Similar to repeated attempts to bring about civil marriage and a non-confessional political system, Lebanese from different backgrounds have argued that Lebanon's educational system must be properly nationalized and standardized. But despite several efforts—the most recent were undertaken in the late 1990s—no unified Lebanese history book has yet been issued. Within that larger context of education and the protection of cultural difference, martyrs memorials "fit in" in the sense that the ethno-religious differences are preserved and publicly displayed, and that the makers and sponsors of memorials are representatives of specific communities. But the public commemoration of martyrdom breaks out of the educational framework in that the display of ethno-religious difference serves to emphasize shared suffering.

As outlined in the introduction, this book proceeds chronologically. Therefore I take the reader first to Beirut, then to the Shouf, back to Beirut, then on to Qana, and again to Beirut, before returning to Qana. Beirut's Martyrs Square is the oldest so named square in Lebanon, and therefore it receives more attention than the other sites. During the two times when the memorial to the 1916 martyrs disappeared from downtown Beirut, the other two martyrs' cemeteries were installed. The cemetery memorial in the Shouf has seen the least amount of change, and it is presently a site visited almost exclusively by locals. The cemetery memorial in Qana saw the most change in the shortest amount of time; additionally, a second memorial was built in Qana after another attack killed more civilians. The two memorials mentioned in chapter 5 were, at the time this book went to print, still under construction; the 1916 Martyrs Cemetery still awaits the completion of the restoration work begun in 1994.

In each chapter I provide historical background and discuss the violent event that led to the creation of each martyrs memorial. By alternating between historical and commemorative narratives I hope to show overlaps and convergences between "facts" of history and "fictions" of memory. French historian Pierre Nora most prominently contrasted and separated memory and history, claiming that memory is an embodied and authentic way of experiencing the past—he uses the words "all-powerful, sweeping, unself-conscious"—whereas history is "a matter of sifting and sorting," in an analytical and detached way.[55] However, the boundaries between history and memory are significantly more blurred than Nora wants us to believe. I intend to probe this dichotomy by introducing times when memory loses its power and when history—especially in texts that recount martyrdom— can become quite powerful. Over time some memorials lose their draw, are forgotten, or disappear, but others are reinvented and re-inaugurated in the aftermath of subsequent historical events. To capture this dynamic landscape, I worked both historically and comparatively, and in my discussions linked memorials and cemeteries not only to the historical events that engendered them but also to each other.

As you start the journey through Lebanon's sacred landscapes in the chapters that follow, I would like you to take along the various discussions—or roadmaps—presented in this chapter. Political elites in Lebanon build memorials after war and tragedy to exercise their "power of worldmaking." In particular, memorials have played an important part in creating shared values and meanings in a society marked by cultural and

political divisions. In creating commemorative narratives, political elites have sought to transcend competing narratives of division and hatred ("sectarianism"). In Lebanon, in the aftermath of civil or international war that showed ideological divisions between different communities, some political elites chose to remember joint Muslim and Christian martyrdom as a means to validate national identities as well as to endorse ethno-religious difference. The public plays an important role in bringing sites of memory to life by attending funerals and subsequent commemorations; if the public loses interest in the commemorative site or event, they can transform a memorial into a piece of art or a cemetery memorial into a municipal park. Despite their look of permanence, memorials are ephemeral spaces. Bodies become important sites to make the national community visible, and on Lebanon's various pedestals or graveyards, images of the martyrs changed significantly over time—not just as a result of changing media but also because of the detailed narratives of dying, which focus on specific kinds of bodily injury. Memories of injury rather than narratives of transcendence have come to define the nation.

While it is important to appreciate the possibilities of transcendence afforded by public memorials—they can be beacons of a "Lebaneseness" that is inclusive of ethno-religious difference—I highlight the changing nature of public sites of memory and recognize that they exist in a universe informed by, but different from, history. In order to "read" memorials and the martyrdom they honor, one has to identify relevant actors and show their relationship to one another, as well as describe the physical sites and their relationship to one another as well as to the political center, Beirut. Memorials can tell us how political elites and the communities they govern "reckon with" political turmoil and violence.[56] Therefore they merit a closer look.

TWO

Sculpting Independence

*Competing Ceremonies
and Mutilated Faces
(1915–1957)*

*How could I forget al-Arayssi and the two Mahmassanis and Sheikh
Martyr Ahmad Tabbara . . . how could I forget Said Aql, and Petro Pauli
and the two Sheikhs Philip and Farid al-Khazen and many others who
died at the gallows, where Muslims and Christians embraced to get our
independence through great sacrifice and death for the nation? No, I will
not forget.*

—MUHIEDDINE NSOULI, LEBANON'S MINISTER OF INFORMATION,
ADDRESSING THE CROWDS IN MARTYRS SQUARE, BEIRUT, MAY 6, 1955

"Il n'existe pas, madame. Ne perdez pas votre temps. Il n'existe pas!" ex-
claimed a man who identified himself as a descendant of Emir Fakhr ad-
Din Maan in the Esquire Bookshop in Beirut's Hamra shopping district.[1] I
had walked into the store to buy a newspaper and had found the septuage-
narian shop owner in conversation with two men who appeared to be regu-
lars at his store. All three were impeccably dressed and were discussing with
great animation the news of the day. As I was paying, I asked them if they
knew the location of the graveyard of the 1916 martyrs for Lebanon's inde-
pendence. The descendant of the Emir vehemently proclaimed that I was on
a wild goose chase. He told me not to waste my time. The cemetery did *not*
exist! Or, as he repeatedly said in French, "Il n'existe pas!"

Meanwhile, the shop owner handed me back my change and walked
to a shelf in the back of his store where he picked up a Lebanese history
book. He started leafing through the pages hoping to find an answer to my

39

question. His friend told him in no uncertain terms that he would find nothing, so the shop owner re-shelved the book and gave me a resigned smile. I thanked the gentlemen for their time and walked out the door, wondering how the final resting place of the men who had died for Lebanon's independence could have become a mystery to people who were clearly educated and knowledgeable about Lebanese affairs?

A few days later, after a tour of Lebanon's archaeological treasures displayed in Beirut's National Museum, I asked a museum employee if she knew the whereabouts of the final resting place of Lebanon's national heroes. She nodded and pulled a street map of Beirut out of a drawer, so she could show me the way. Warning me that the area was "*sha'bī,*" which means "popular"—a polite characterization of a low-income neighborhood—she directed me to one of Beirut's last remaining cemeteries in the neighborhood of al-Horj across the street from the Pine Forest, Beirut's largest urban park.[2] When I arrived at the cemetery gates, I asked two elderly guards if they could show me the graves of the martyrs of 1916. They shook their heads and said they knew nothing about such graves. Noticing the disappointment on my face, they said they would be happy to show me the graves of French, British, Turkish, and Polish troops who had been killed in Lebanon during the French mandate period and during World War II. Realizing that the European graves must have been the reason the museum employee had sent me here, I followed one of the guards across the spacious civilian cemetery to the military cemeteries on the opposite side of the enclosure. On the way I explained to him that I was studying how the Lebanese remembered their national heroes. He nodded his approval and said that there were national heroes in this cemetery: those killed in 1958. He became quite animated as we went past rows and rows of marble graves. Pointing in different directions just beyond the cemetery walls all around us, he said that he still remembered when the first shots of Lebanon's 1958 Civil War were fired "over there," so-and-so was killed "over there," and then trouble broke out "right next to my house over there." The dead were later buried among the civilians within the enclosure he guarded, their graves indistinguishable from others around them. Obviously not all heroes received an official burial in Lebanon, and those who did were not necessarily remembered.

The elusiveness of the cemetery to honor men who in 1916 gave their live for Lebanese independence struck me as rather curious. I knew that the story of their execution formed part of every public and private school history curriculum as far as I could ascertain from talking to my Lebanese acquaintances, taxi drivers, teachers, and former students, and from leafing

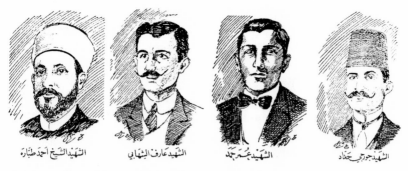

FIGURE 2.1. Four of the martyrs for Lebanese independence. From right to left: Martyr George Haddad (with tarbush), Martyr Omar Hamad (with bow tie), Martyr Arif al-Shehabi (with tie) and Martyr Sheikh Ahmad Tabbara (with turban). *Reprinted with permission of Dar an Nahar, Beirut.*

through history textbooks myself. That fact was notable, in light of the many different history books in circulation in the country. Lebanese schoolchildren often had to memorize the names of the fourteen national heroes who were killed on May 6 by the Ottoman ruler Jamal Pasha, nicknamed "the butcher" (*al-jazzār*) for various alleged acts of cruelty during World War I. The faces of the heroes appear in some Lebanese history textbooks as well as a recently published, widely popular illustrated history of Martyrs Square by two prominent Lebanese intellectuals, Ghassan Tueni and Fares Sassine. The martyrs' portraits are based on the engravings in a 1955 tome elaborately titled (in Arabic) *The Conference of Martyrs: The Conference That Spread National Aspirations and Dragged its Members to the Gallows.*[3] Written by Yussef Ibrahim Yazbek (1901–1981), who witnessed the executions himself, *The Conference of the Martyrs* is one of the main sources for subsequent history textbook writers. Yazbek describes the heroes' aspirations for independence and gives a detailed account of the events leading up to the martyrs' court martial, their incarcerations, and their way to the gallows. At the end of the book, after an exhortation not to forget their sacrifice, Yazbek printed portraits of the martyrs (figure 2.1).

The martyrs' portraits are carefully typeset to match one another in size and style. The men's faces reveal solemn determination, as most of their gazes are fixed on some distant horizon to the left of the viewer. Each one of the men appears fashionably dressed. Most of them wear Western attire: a three-piece suit and a tie is the most prevalent form of dress in these images, but we also see Hamad in a black jacket, a white shirt, and a bow tie. Ahmad Tabbara's white collar under what appears to be a long black robe and his turban mark him as a member of the clergy (although he also

ran a newspaper in Beirut). The men sport short haircuts, their hair cleanly parted on one side. The men who have mustaches present them perfectly groomed, the ends waxed and twirled upward. Tabbara's beard is neatly trimmed, whereas Hamad's face is cleanly shaven. Next to Tabbara, two of the martyrs are bareheaded, while George Haddad wears a tarbush.

The Ottoman administration introduced the tarbush (or fez) in the early nineteenth century "as a replacement for the turban, whose various colors differentiated subjects according to their sectarian allegiance. The fez, by contrast, marked its wearer simply as an Ottoman subject."[4] While the tarbush served to erase religious differences, it emphasized another: it was predominantly worn by members of the urban middle class. Not all of the Lebanese martyrs in Yazbek's portraits wore a tarbush; some who wore European suits did not wear any headdress at all. Yet, despite their different choices of attire and grooming, all "traitors" sentenced by Jamal Pasha clearly belonged to the educated, urban elite. The men came from prominent local families and included delegates to the 1913 Arab Congress in Paris (where representatives of various Arab subject territories had demanded that the Ottoman grant them some form of self-rule), officers in the Ottoman army, members of the clergy, lawyers, writers, and journalists. They were remembered as middle-class individuals with separate identities, visually expressed through sartorial differences. What did visually unify them in the printed, commemorative display was the choice of portraiture, and the fact that the artist labeled each image with the person's name after the title al-shahīd.

Yussef Ibrahim Yazbek, in whose 1955 book these sketches originally appeared, was a teenager when he witnessed the events of 1916. He had spent most of his childhood in Mexico, where he met and became an apprentice to Lebanese journalist Said Aql. Mexico, a favored destination for Maronite migrants at the end of the nineteenth and early twentieth centuries, would only be their temporary home, however, as Yazbek and Aql both returned to Lebanon before World War I and joined local intellectuals who were mobilizing opposition against Ottoman rule.[5] Yazbek's narrative reveals a strong personal connection to the martyrs, who are without doubt his heroes. His personal views on the execution explain the last page of his book, which features a sketched portrait of Jamal Pasha, subtitled in bold type with just one word, "the murderer" (al-saffāh), followed by an exclamation mark. Evidently Jamal Pasha acquired a series of unflattering nicknames from his Arab subject population. Yazbek's version of Jamal Pasha's executions became the basis for subsequent history lessons taught to generations of young students, which were meant to instill in

them the memory of their country's foundational sacrifice. May 6 was officially declared Martyrs Day and became a national holiday: schools and banks closed, government officials gathered to hold a public ceremony in Martyrs Square, and the president laid wreaths to honor the dead. Yazbek himself became a regular participant in these annual May 6 celebrations, his tall figure appearing next to Lebanon's political dignitaries in several of the photographs that accompanied the annual newspaper reports of the commemorations.[6]

Yazbek's narrative, as I found out, was not uncontested. During an animated conversation with Arab University's history and sociology professor Hassan Halaq about the meaning and significance of the events of 1916, Halaq asked a staff person to bring us Yussef Ibrahim Yazbek's book from the library. After he returned to the professor's office and handed me the book, Halaq instructed me to turn to the very last page to read out loud the famous epitaph under Jamal Pasha's portrait, which I did. In response, the person who had brought us the book asked if it was necessary to call Jamal Pasha *that* (*"daruri bisammuh haik"*)? At which point Halaq smiled at me and said, "Did you hear that? People still love Jamal Pasha." A few days after my visit to the Arab University, I met with another distinguished Lebanese history professor, Kamal Salibi, who used to teach at the American University of Beirut. When I asked him about the 1916 martyrs and subsequent commemorations, he began to reminisce about his own childhood. He told me that he remembered May 6, 1938; he had been nine years old and his family had just moved to Beirut from their mountain village. He heard from his school friends that there was going to be a parade and he asked his parents if he could go. His father looked at him sternly and said, "Absolutely not! We don't celebrate traitors!" Salibi chuckled at the recollection. Shrugging his shoulders, he looked at me and said that later on, after conducting his own research as an adult, he had come to agree with his father on his verdict that the men were traitors for collaborating with the French. But at age 9—and he smiled—all he wanted was to go see the parade.

WORLD WAR I IN LEBANON:
FAMINE, EXECUTIONS, AND ARAB NATIONALIST TREASON

The year 1915 was a grim year for residents of what would become Lebanon, who suffered through a Great War and famine as well as Ottoman court-martials and subsequent executions. Lebanon had been hard hit by a locust invasion and subsequent food shortages, which were exacerbated by wartime interruptions of food shipments and a breakdown in the food

distribution system. The famine and accompanying epidemics would end up claiming between 100,000 and 150,000 lives by the end of World War I.[7] The existing food shortages became even worse because of the military requisitioning of supplies by the Ottoman army. Additionally Ottoman conscription led to labor shortages in many agricultural communities in Mount Lebanon. Ottoman conscription was so unpopular, that Jamal Pasha began to order public executions for deserters, hoping to stem the tide through the display of brute force. Jamal Pasha's wartime policies undoubtedly fueled resentment among many Arab subjects, and they set the stage for the public acts of defiance against Ottoman rule by a group of civilians, who went on to become Lebanon's foundational martyrs.

According to Kamal Salibi, the group of "so-called martyrs" had plotted against their Ottoman rulers in collusion with the French, who had their own colonial designs for the Levant region. Salibi did not consider the martyrs heroes who had liberated their country but traitors who had brought about colonial rule. The evidence for their treasonous activities was compromising letters that had been exchanged between anti-Ottoman Arab nationalists and French diplomats in Beirut. The Ottoman ruler Jamal Pasha was subsequently tipped off by a member of Lebanon's political elite who had no sympathies for the plotters and felt threatened by one of their leaders, Abdel Karim al-Khalil.[8] Although the exact chain of events remains shrouded in some mystery, the fact is that Jamal Pasha found the incriminating letters in the French consulate in Beirut and used them to round up hundreds of suspects who were later tried at military tribunals in 1915 and 1916 in Alay, a town near Beirut. As a punishment for their treasonous activities, he handed down sentences of summary execution. The severity of Jamal Pasha's punishment can at least partially be explained by the fact that he felt personally betrayed, since he had worked with many of the arrested men who had been in Ottoman employ.[9]

Many of the condemned men had been members of Arab nationalist societies, which had begun to form in the late nineteenth century.[10] During that period, which historians call the *Nahda* (Awakening), Arab elites in various Ottoman subject territories began to meet to produce a variety of Arab newspapers, magazines, and literary works that generated and spread the idea of an Arab state. Inspired by the modern nation-state idea of self-rule based on a shared language and ancestry, and witnessing the Turkish nationalist movement that culminated in the Young Turk Revolt against the Ottoman sultan in 1908, members of Arab elites in the territories of present-day Iraq, Syria, Jordan, Lebanon, and Palestine/Israel began to promote anti-Ottoman sentiments and plan for an Arab revolt.[11] Ottoman authorities

tried to quell the rebellious Arab sentiments by appealing to the shared Muslim heritage of Ottoman Turks and Arabs, and they also used their police force to arrest and exile Arab nationalists. Some of the Arab nationalists found sympathetic ears among French politicians, which explains why Paris was chosen as the meeting place for Arab nationalists. This also explains why the first publicly executed "traitor," the priest Yussef Hayek, defiantly exclaimed "Vive la France!" (Long live France!) as he stepped onto the gallows in Damascus on March 22, 1915, and why Jamal Pasha searched the French consulate for incriminating evidence. But the French were not the only ones with influence and interest in the region at the time.

George Antonius (1891–1941), whose book *The Arab Awakening* is considered to be the first history of Arab nationalism, discussed how British and American politicians and diplomats saw the existing Arab nationalist societies as a convenient way to advance their own anti-Ottoman agendas.[12] In the early stages of World War I British diplomats contacted Sharif Hussayn in Mecca, who guarded Islam's holiest shrines and claimed to be a direct descendant from the Hashemite family of Prophet Muhammad. The British promised him support for a future Arab state in return for his commitment of Arab troops to the British war effort against the Ottomans. Sharif Hussayn, and his son Faysal, agreed and organized an armed Arab revolt, and they coordinated their efforts with some of the existing Arab nationalist societies in different parts of the Ottoman Empire. The borders of the promised Arab state were not precisely defined, but it was to span a large territory—some called it *Bilad al-Sham*—inclusive of various Arabic-speaking communities—Muslim, Christian, and Jewish—east of the Mediterranean and west of Iran. Troubling to some independence-seeking elites was that the Arabic language was also the sacred language of Islam, and therefore they feared that this envisioned Arab state was to be a Muslim state (especially if it was to be ruled by a descendent of the Prophet Muhammad).[13] Nevertheless, Christian Arabs, Greek Orthodox most prominent among them, were also some of the strongest proponents of Arab nationalism, as the emphasis on shared Arab identity allowed them to shed their Christian minority status and become part of an imagined secular and modernizing majority.

In addition to different alliances between independence-seeking Arab elites and two European powers (who had their own agendas), there were two distinct, if occasionally overlapping, local ideas of what the desired independence would look like. When referring to "the nation" in their speeches, the condemned men used both Arabic terms *al-watan* and *al-umma*. The word *al-watan* translates literally to "homeland," and *al-umma*,

which shares the same root with the word for mother (*al-umm*), literally means "people" and "generation." Of the two terms, the first carries a secular connotation, and the second is more religiously inflected because Prophet Muhammad spoke of the Muslim community as "*al-umma al-islāmiyya.*" In other words, Arab nationalism, in addition to having competing European sponsors, was envisioned in competing ways. It might not have mattered greatly to Muslim Arabs if they expressed their demands for independence from Ottoman rule through the words *al-watan* or *al-umma*, yet it mattered to some non-Muslims who did not want to become independent of the Ottoman Empire to become part of yet another political entity that defined itself in Muslim terms. That this apprehension was also present on the gallows in 1916 can be gleaned from the last words of one of the martyrs, Farid Khazen, who reportedly died to redeem "dear Lebanon" (*lubnān al-habīb*), rather than a larger, Arab nation.[14]

It is impossible to recapitulate each martyr's personal motive that propelled him to join an anti-Ottoman political organization at the turn of the twentieth century. But clearly Lebanon's independence heroes were not a cohesive group of nationalists with a clearly defined goal. George Antonius claimed that the martyrs died for an independent state comprising Syria, Palestine, and Iraq, but he conveniently ignored some of the martyrs' proclamations of "Vive la France!" and "dear Lebanon." We have to assume that some of the condemned men favored the British-supported plan for an Arab state under Sharif Hussayn, while others envisioned a different ruler over a more narrowly defined territory. It is unlikely that any of the men died for the Lebanon that the French created in 1920, since those borders were the outcome of drawn-out negotiations between the French and the British. Notably these details did *not* prevent Lebanon's cultural and political elites, who appropriated the story of their executions, from building their narrative of national unity through shared sacrifice.

NARRATING SACRIFICE:
STORIES OF DEFIANCE AND TRANSCENDENCE

The subsequent tale of the men's executions focused both on the words they uttered and the way they carried themselves in the face of impending death. A shared feature among the men was their public defiance. For instance, in the retelling of their executions of May 6, 1916, the condemned were proudly singing nationalist songs on their way from the prison in Alay to the gallows in Beirut.[15] In 1915 and 1916 they demonstrated their bravery as they stood beside their executioners, insulting and ridiculing

their Ottoman guards. Abdel Karim al-Khalil called the supervising Ottoman police chief a representative of an uncivilized nation that did not even know that he had to grant condemned men their last wish before hanging them. Salim Bakr Al-Jazairy famously taunted his Ottoman guard, "Tell that pig Jamal that he should not rejoice in my death, for my spirit will remain alive to teach the Arabs from the depth of the grave a lesson of nationalism (*dars al-wataniyya*) and hatred of the Turks."[16] Beiruti Omar Hamad prefaced his address to his executioners with the explanation, "I am talking to you in French, because you do not understand Arabic," and he defiantly proclaimed, "Tell your tyrannical government that what you are doing now is going to be the reason for its demise." He then looked at the crowd and said, in Arabic, "I am dying without fear for the sake of the Arab nation (*al-umma al-ʿarabiyya*). May the treacherous Turks fall and long live the Arabs!"[17] Not only did he display his linguistic skills and point out the Ottomans' limitations and thereby their cultural inferiority, Hamad even threatened them with their own demise. Other martyrs publicly ridiculed the Ottoman executioners for not knowing how to apply a noose or even speeded up their own executions by kicking away the chair they were standing on.

Those defiant deeds—later anthologized in Yazbek's *Conference of the Martyrs,* Tueni and Sassine's *El Bourj,* and Lebanese school history books—were, of course, not reported in the Ottoman press at the time. Jamal Pasha used newspapers to spread the word of his executions immediately, as well as photographs of the dangling bodies, as he hoped they would intimidate other would-be traitors. Within two hours of the executions on early May 6,

> *Al Sharq* [an Arabic-language newspaper] was being distributed free, in which the charges, the trials, the sentences and the executions were announced in the same breath. The charges were defined as "treasonable participation in activities of which the aims were to separate Syria, Palestine and Iraq from the Ottoman Sultanate and to constitute them into an independent State."[18]

From George Antonius we know that of the twenty-one men killed on May 6, 1916—fourteen in Beirut and seven in Damascus—seventeen were Muslim and four were Christian.[19] Four more Christian "traitors" were hanged on different dates: Father Yussef Hayek on March 22, 1915, in Damascus, and, in Beirut, Yussef Hani on April 5, 1915, and Farid and Philip Khazen on June 5, 1916. Antonius mentions these differences to show that

nationalist sentiments were so strong that they managed to cut across eth-
no-religious boundaries. The religious affiliation of the men—but not their
exact numbers—surfaced in Lebanese commemorative narratives in vari-
ous ways, either by linking religious language to the language of national-
ism or by making explicit statements about religious transcendence for the
sake of the nation.

The condemned men requested, and were able to receive, their last rites
from a member of their clergy. When a sheikh approached Abdel Ghanni
al-Arayssi and asked him to make his last confession, al-Arayssi reportedly
said, "I give witness that there is no God but God, and that Muhammad
is God's prophet, and I give witness that the caliphate (*khilāfa*) belongs to
the Arabs, God willing."[20] Caliph is the title given to the successors of the
Prophet Muhammad, and the institution of Islamic political and religious
rule was called the caliphate. Ottoman sultans inherited or claimed the
title from Arab rulers of the Ummayad and Abbasid Empires that preceded
them. In other words, right after proclaiming the *shahada,* which is the
first of the five pillars of Muslim faith, al-Arayssi professed his politics,
proclaiming that the Muslim nation belonged to, and should be ruled by,
Arabs, not Turks. It is significant that al-Arayssi defined the caliphate in
ethnic (Arab) terms. He does not advocate for an Islamic state—the Turks
were Muslims after all—but an Islamic state inflected by ethno-linguistic
nationalism.

Al-Arayssi's public proclamation that emphasized ethnic difference over
shared religious belief to distinguish Arab nationalists from the Turks who
ruled them was the confession of a Muslim nationalist. Christian national-
ists similarly confessed their allegiance to Arabism but via the transcen-
dence of religious difference. A Maronite priest had stepped forward to
administer the last rites to members of his faith, but no Orthodox priest
appeared to address Petro Pauli and George Haddad. At first Pauli and
Haddad insisted that they had to see a member of their own clergy, but
when it became clear that none could or would be found, Pauli turned to
Haddad with the words,

> and what harm is it to us, my brother, if we confessed in front of a
> Maronite priest? We are performing our religious duty, and our God will
> grant us forgiveness at the hands of a Maronite priest like he would at the
> hands of an Orthodox priest. And, by God, if I was destined to fulfill this
> religious duty at the hand of a Muslim sheikh, I would not hesitate because
> religion is above matter (*al-dīn fawq al-mādda*).[21]

After receiving his last rites, Petro Pauli reportedly urged the executioner who read his death sentence out loud to hurry up, and he kicked away his own chair, effectively hanging himself. With his statement, Pauli acknowledged the religious differences among the condemned, beginning with differences between Christian communities, but concluded that, in the end, there was a unifying spirit or spiritual principle that transcended the different rituals practiced by different religious communities. Pauli publicly affirmed his willingness to give his last confession in front of the Maronite priest who was present and, even more emphatically stated his readiness to confess before a Muslim sheikh. Ethno-religious differences did not matter; fundamental (religious and national) principles did.

Another public execution was carried out on June 5, 1916. Two more martyrs, the brothers Philip and Farid Khazen, mounted the gallows and used their last wish to grant public forgiveness to those who were about to kill them—something Jesus did when he was crucified. Further, Philip Khazen asked that his suffering be prolonged, because, in doing so, he would be able "to redeem dear Lebanon's pain" (*takhuffu bihi ālām lubnān al-habīb*).[22] Again, in reference to Christ's passion and crucifixion that redeemed Christian believers from their sins, Khazen saw his sacrifice as one to redeem the Lebanese oppressed by Ottoman rule. With his proclamation, Khazen connected his martyrdom specifically to "dear Lebanon," which is the most concrete expression of Lebanese nationalism of all those who spoke at the gallows. Yet it also shows that Lebanon's independence heroes reconciled and performed both their civic duty *and* their individual faiths.

But the story of ethno-religious transcendence did not end on the gallows. Eyewitnesses of May 6, 1916, reported that the bodies were taken to be buried in the Druze cemetery in the neighborhood of Sanayiah, where "their brothers," martyrs of earlier executions, had already been laid to rest.[23] Yazbek gleefully reported that the Ottomans had hoped to get rid of the bodies in "abandoned ditches" (*hufar muhmala*) without any ceremony, but, instead, the place the martyrs were buried became a site for annual remembrance.[24] An alternative version of the story told by Robert Fisk, a longtime analyst of Lebanese affairs, has the bodies of the martyrs thrown by the Ottoman authorities into a mass grave near the beach. Yet two years later, the French unearthed the remains and decided to give a proper burial to the men who had defiantly opposed the Ottomans. Because of the decomposed state of the corpses it was impossible to identify them, and the French were reportedly unable to find either Christian or Muslim clergy willing to rebury bodies that might belong to another religious community at their communal cemeteries. The French therefore turned to "the

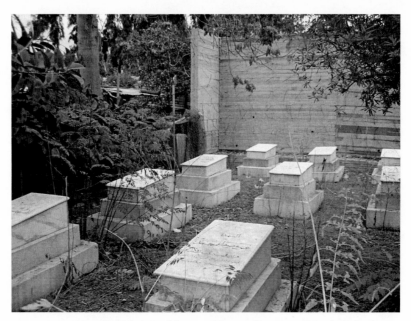

FIGURE 2.2. Partial view of the 1916 Martyrs Cemetery, Beirut, 2008.

mystical Druze [who] allowed them to find their resting place on land they owned in central Beirut."[25] When I told Fisk's version of the story to Druze guards and employees at Tell ed-Druze, Beirut's largest Druze community center, they did not confirm the French intervention at the end of World War I but simply said that the Druze had been the only ones brave enough to defy Jamal Pasha's order to ditch the corpses. The dead bodies of the martyrs thus engendered further stories of bravery, whereby Druze buried non-Druze on Druze land in open defiance of the feared Ottoman ruler.

On a cold January morning in 2008, following a different lead from a former Lebanese colleague at the International College, I finally found the cemetery of the national heroes and realized why it had been so difficult to locate (figure 2.2). Not only were the graves locked behind an iron gate, but the entire cemetery was located about fifty yards up an incline, which made it impossible to see the gravestones from the main street level. Standing on the sidewalk of Rome Street in front of another tall gate, I could only see an overgrown driveway and a stack of unused construction equipment and cement bags. I had walked past the cemetery multiple times without realizing it was there. I had thought the driveway was someone's private property, rather than the path to the 1916 cemetery enclosure farther in. No sign was affixed on the main street to indicate to passersby that here was a national

cemetery. This was curious in light of the fact that only a few yards down the street, someone had affixed a commemorative sign marking the very place where Lebanese President Rene Muawwad gave his life (*istashhad*) on November 22, 1989. Since the 1916 cemetery plot was part of the main Druze community center area, it was inside the same tall walls surrounding the Druze compound. Yet the cemetery had a separate entrance and its own gate that opened onto the main street. As I walked up what I had thought was a driveway, I noticed the corrugated iron roof of a small makeshift hut surrounded by the thick vegetation of an overgrown garden. Someone did live in this enclosure. Yet, instead of human beings, I only saw a rooster and a cat stepping out of the garden to eye me curiously. The driveway led me to a stairway and finally I came to a halt before a locked cemetery gate.

Through the iron bars of the gate, I could see the graves of the martyrs of 1916 on a plot that looked both abandoned and in disarray. Freely growing vegetation had taken over parts of the cemetery, but there were also signs of an abandoned construction project, which meant that someone had been here and tried to restore the site to some respectability. The cemetery was now enclosed on two sides by ten-foot walls of raw concrete with the supporting iron rods still exposed. The third side was a netted fence next to the garden of the ramshackle residence. Standing beside the locked, iron gate on the fourth side of the square plot, I counted eighteen graves of martyrs of the 1915 and 1916 executions. The names I could make out included Abdel Karim al-Khalil, Abdel Qader al-Kharsa, Naif Tillu, and Omar Hamad. The al-Khazen brothers were buried together in one grave, as they reportedly refused to be executed unless they died exactly at the same time, to spare either brother the pain of seeing the other killed.[26] In Beirut's martyrs cemetery each marble grave bore a simple inscription giving the martyr's name beneath the title *shahīd,* followed by the place and year of birth. One grave marker carried an additional poem. Omar Hamad, who is also credited with composing the song the condemned men sang on their way to the gallows, had the following verses carved on the marble surface of his grave:

Write on my grave, you people of my nation (*watanī*),
a verse that will be repeated by the mouths of the envious;
this is the grave of a martyr of his country (*shahīd mawtin*);
this is the martyr to his love of Arabs.

His executioners had been unable to silence him: he continues to speak even from his grave. By burying the men together in one cemetery, rather than in the cemeteries of their religious communities, the Lebanese had created

their first national memorial site. Religious cemeteries are said to foster and sustain group identities because "the dead become a surrogate community for the living."[27] National cemeteries replicate the same commemorative mechanism of the religious cemeteries, turning individuals who sacrificed their lives for the greater good into a community apart from and greater than the ethnic or religious communities to which they belong.

The exact genesis of the 1916 Martyrs Cemetery is unfortunately unknown. As the competing funeral stories above indicate, it is unclear who buried the bodies and when. The burial grounds are a significant walking distance from Martyrs Square, which indicates that those who wanted to bury them did not easily find a resting place for the independence heroes. The plot where they were buried belonged to the Druze community at the time, but there were no buildings and no community center. There are no records in the current center that shed light on the matter. The municipality of Beirut became the caretaker of the space, as indicated in subsequent newspaper articles admonishing city officials to take better care of the independence heroes' last resting place.[28] The organization of annual commemorations fell to the League for the Commemoration of Martyrs (LCM) ('usbat takrīm al-shuhadā'), a group that included municipal officials, interested citizens, and relatives of the martyrs.

The graveyard enclosure was clearly a limited space that could not accommodate large crowds, which would explain the creation of an additional martyrs memorial in a public square. The narrative of the 1916 martyrdom, with its joint Muslim and Christian sacrifice, was important enough to political elites to place it at Lebanon's symbolic core. Actually they had been Sunni *and* Shiite, Orthodox *and* Maronite, *and* they had been buried by the Druze. Their deaths and burial defined a historical moment in which members of different ethno-religious communities, motivated by their desire for independence or their opposition to Ottoman rule, joined ranks and performed acts of public defiance. Kamal Salibi told me, not hiding the irony of his words, that Jamal Pasha initially could not believe there was a revolt afoot against him, since he was sure that his Arab subjects would never agree on anything. In other words, Jamal Pasha believed that his Arab subjects were too divided by "sectarianism" to pursue a common goal. What became central in the public memory of the events of 1916 were the individual acts of bravery of renowned civilians, who stood proudly together and, as they faced death, declared their allegiance to each other and to independence, freedom, and nation—however imagined. Even their last rites became a national act, as they willingly left their confessional mandates behind and said their last confession to

a member of the clergy of a different religious group. They stood by one another in solidarity, a lesson worth teaching to future generations.

CREATING A SPACE FOR NATIONAL REMEMBRANCE: BEIRUT'S MARTYRS SQUARE

Fares Sassine's French introduction to the book *El Bourj* carries the title "One Square, but So Many Names!"[29] In the article he gives an overview of the plaza's many appellations, beginning with Sahat al-Bourj (Watch Tower Square) in reference to a watch tower on the medieval city ramparts. Sahat al-Bourj became Sahat al-Madāfiʿ or, in French, Place des Canons (Cannon Square) for a set of heavy artillery whose origin is variously traced to Russian, English, or French navy vessels that came to the port of Beirut in the eighteenth and nineteenth centuries. The square briefly became Sahat Hamidiyye in honor of the Ottoman Sultan Abdul Hamid II (1842–1918). Photographs from that time show a pretty oval-shaped garden planted around gazebos and a small fountain, enclosed by a three-foot decorative iron fence.[30] It was next to this manifestation of urban beautification that Jamal Pasha erected his gallows and exercised his justice in the very early morning hours of August 21, 1915, and again on May 6, 1916. At that time residents called the square both Sahat al-Ittihād (Unity Square) and, ironically, Place de la Liberté (Liberty Square).[31]

When the French began their mandate rule in 1920, they immediately set to reorganize Beirut's urban fabric, and they turned Sahat al-Bourj into a fairground, for which they cut down many of the existing trees.[32] Their goal was to showcase the country's economic activities. In 1925, a few years after the fair ended, the plaza was rebuilt into a rectangular park, with two symmetrically landscaped gardens facing each other across a square sunken pool and fountain in the middle. At the same time the French began to rebuild other parts of the downtown area. They created a star-shaped road grid similar to ones found in Paris, due east of Martyrs Square (see map in the introduction to this volume). Sahat al-Nejme (Star Square) was comprised of a traffic circle around a clock tower, from which six main arteries radiated symmetrically. Eight roads were originally planned, but two were not executed because it would have required razing religious buildings. The Lebanese parliament building was at the center of the circle. In 1930 they inaugurated both Star Square and the newly renamed Sahat al-Shuhadā' (Martyrs Square). Currently the area around both squares is frequently called by the anglicized term "downtown," or the French acronym "Solidere," which is the name of a Lebanese company that oversees

the post–civil war reconstruction of Beirut (more on that in chapter 3). But Martyrs Square remains its official designation.

The French supported the creation of a memorial honoring those who were killed in 1916. After all, it was in the French interest for the Lebanese to remember publicly an act of Ottoman cruelty, since it was the French who had helped defeat them. The monument itself was paid for by money collected from the public.[33] A committee of members of Beirut's municipal council oversaw the design and building of the statue. The committee members, after some false starts and delays, decided unanimously (istaqarr al-ra'i) to commission sculptor Yussef Hoayek to create a statue to the martyrs.[34]

Yussef Hoayek (1883–1962) was a nephew of Maronite patriarch Eliyas Hoayek, the highest-ranking clergy in the Lebanese Maronite community. The elder Hoayek had led a Lebanese delegation to Paris after World War I to urge the French to create a "Greater Lebanon" inclusive of Mount Lebanon, the coastal cities of Tripoli, Beirut, Sidon, and Tyre, and surrounding agricultural areas—the map that was realized in 1920. We do not know if the nephew shared his uncle's political views, but we know that he accepted the commission for a piece of nationalist public art at short notice. Yussef Hoayek belonged to the second generation of Lebanese artists who had received their training abroad but then worked for the Lebanese art market—mostly commissions by political and religious elites.[35] He had earned his credentials in art schools and studios in Italy and France, and was a friend of renowned Lebanese artist and writer Gibran Khalil Gibran. In pre–World War I Paris, they both studied sculpture under French artist Auguste Rodin.[36] In 1929 Hoayek settled permanently in Lebanon and opened his studio in the Beirut neighborhood of Furn al-Shebbak. One of his most acclaimed works in Lebanon is an equestrian statue of Yussef Karam, a prominent leader of the Maronite community in the second half of the nineteenth century. The bronze was installed in 1932 in Karam's hometown, Ehden.

Though clearly versed in the artistic language and convention of heroic sculpture, Hoayek chose to represent the 1915 and 1916 martyrs' sacrifice for independence from Ottoman rule through the medium of local limestone. According to art critics in the local journal Al Ma'rad, there was no piece of art more beautiful than his, since it was entirely Lebanese: "The stone was Lebanese, the hand that sculpted it was pure Lebanese, and the thought that created it and the imagination that realized it were Lebanese."[37] Hoayek's statue was inaugurated in a grand ceremony on September 2, 1930, ten years after the French had created "Greater Lebanon." The festivities took

place in downtown Beirut, in the same square where the Ottomans had executed their prisoners fourteen years earlier. Lebanon's first president, Charles Debbas, who had assumed office on September 1, 1926, presided over the inaugural ceremonies, standing beside French high commissioner Henri Ponsot and other Lebanese and foreign dignitaries, including a representative from the Vatican.[38] Amid the trappings of national pageantry—a military marching band playing the national anthem, soldiers standing at attention, and flags draped along the sides of the Martyrs Memorial—President Debbas honored the dead as Lebanese nationalists who had given their lives in pursuit of Lebanon's independence.

SCULPTING NATIONAL SACRIFICE

Yussef Hoayek's sculpture was unveiled on the southern end of Martyrs Square. It stood on the pedestrian walkway that formed the outer perimeter of the now rectangular municipal park, which was surrounded on all sides by streets. Sculpted in limestone were two women of equal height standing across from each other, their arms outstretched toward each other with their hands resting on a bowl-shaped vessel that sat between them. Perfectly balanced and symmetrical, the women's body postures and the downcast gazes of their eyes created a strong visual frame around the urn. Moreover, each woman was similarly dressed in a loose tunic over a floor-length gown. The only discernible difference was in their headdress: one woman wore a scarf tied into a turban, from which a separate piece of cloth descended to cover her hair. She also wore a face veil that covered her features beneath the eyes. The woman across from her wore a loose-fitting scarf that partially covered her hair. Thus marked by their dress, one woman represented the Muslim and the other the Christian communities of Lebanon. Their eyes focused on the urn at the center of the sculpture, a symbolic container of the martyrs' ashes. It is noteworthy that the sculptor did not represent the martyrs themselves. Their individual fates and names are subsumed under the unifying image of motherhood, as well as the singular final resting place of their ashes, the urn. Although cremation is not a traditional practice in the Arab world, cinerary or burial urns are part of Lebanon's Phoenician, Greek, and Roman ancient heritage and many such vessels had been found in various archaeological digs in different parts of Lebanon.[39] By including the urn as a symbolic center between the two women, Hoayek was able to include an ancient historical referent that was outside Muslim and Christian tradition. The urn was filled with the ashes of *both* Muslim and Christian martyrs—one nation was created.

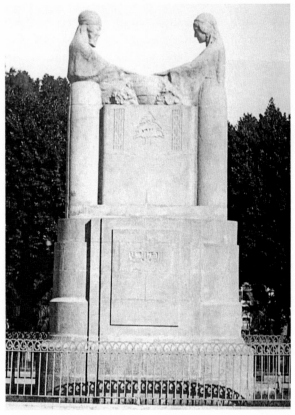

The sculptor thus celebrated both ethno-religious difference and national unity.

The statue had been installed in three separate parts, each made of an individual piece of stone. The top third featured the women's upper bodies as well as the urn between them. It sat on top of a second piece that was half sculpture, half pedestal, since it completed the lower part of the two women's bodies, which were their long gowns as well as a flat surface on which Hoayek had carved the image of a cedar tree framed by two fasces on either side. Fasces are bundles of rods or sticks tied together by leather string that Roman soldiers used to carry in victory processions. Paintings and carvings of fasces have since appeared worldwide on memorials and state insignia. For instance, Abraham Lincoln is framed by two fasces attached to the front of both arms of his chair in the Lincoln Memorial

in Washington, D.C. The French include fasces in their national emblem. Fasces send a powerful message of strength through unity, which is why they became popular symbols in nationalist political movements. On the Martyrs Memorial in Beirut, they added a decorative frame around the cedar tree, but they also symbolically strengthened it. The cedar tree was carved right underneath the urn which drew the women's gaze, making the symbolic link between the ashes of the dead heroes and the nation. The lines of the fasces paralleled the sculpted floor-length robes of the two women, smooth cylindrical shapes without any additional sartorial detail. The third section of the sculpture was the pedestal, a foundation built out of large limestone bricks of the same color as the other solid stone sections above it. On this foundation representatives of the government and of civic organizations would hang their flags and wreaths during annual celebrations.[40] The entire memorial measured about eighteen feet from the pavement to the top, and a decorative iron fence separated it from the street on one side and the sidewalk on the other. Two palm trees were planted within the decorative fence, one next to each woman, thereby making the memorial an integral part of the larger design of Martyrs Square, which was entirely surrounded by palm trees.

Hoayek envisioned the newly created national Lebanese community via the bodies of two standing women representing the main ethno-religious differences in the country. Through the reference of the central cinerary urn that held the ashes of their sons, these women were cast as mothers, which introduced a unifying theme. The mother-mourns-son motif is not unexpected in the context of national remembrance, where it is permitted for women, but not men, to show their grief publicly.[41] The iconic mother-mourns-son sculpture is Michelangelo's marble statue of Mary cradling the dead body of her son Jesus, the *Pietà*. An example of a nationalist adaptation of this motif is Käthe Kollwitz's bronze statue of mother and son, displayed in a building that used to honor soldiers in Nazi Germany in Berlin. The Kollwitz sculpture stands alone in an otherwise empty memorial hall, next to the inscription "To the Victims of War and Tyranny," thus turning the building that celebrated militarism into a symbol of pacifism.[42] Here the two figures melt into one, with the mother holding her son in a firm embrace. Kollwitz's mother visibly grieves her loss, thereby reminding the viewers of the personal cost of war. Given Hoayek's Maronite background and European artistic training, it would have come as no surprise if he had sculpted a *Pietà*-like memorial. Yet he did not. In contrast, Hoayek's mothers stand tall and poised, there is no figure of the son, and instead there are *two* mothers. This is a highly unusual choice for a national monument. It significantly

alters the traditional familial metaphor of the nation as the mother (singular) of her citizen-children, who are expected to love the nation as they love their mother. Hoayek broke the artistic conventions for representations of the nation through the female body, so he could emphasize Muslim and Christian difference, at the same time that he was able to show their solidarity. Of course the sons, whose ashes mingle in the urn, are physically one, thereby adding a second—invisible, but implied—narrative of unity.

Unfortunately Yussef Hoayek did not leave records that explained his artistic choices. But we know what he chose not to do. As discussed above, he did not seek inspiration in Catholic or standard European nationalist art. Moreover, he neither used bronze nor marble but worked with yellow Lebanese mountain limestone, the traditional building material for most Lebanese homes. Although the bodies of his two figures stand tall, as would those of Greek victory goddesses, he did not sculpt Greek bodies. Hoayek's figures do not convey messages of victory or heroism, but neither do they embody loss or defeat. He sculpted bodies that were recognizably Lebanese, but the figures were not doing a recognizably Lebanese task. As noted earlier, cremation is not part of either Muslim or Christian traditional burial custom, and by introducing the urn as a symbol Hoayek turned the two women into mythical figures of mother-guardians who mourn the dead. Further, Hoayek did not sculpt women in traditional peasant garb. Images of peasants and peasant life feature importantly in many nationalist narratives, since peasants are said to be rooted in the soil. In Beirut's Martyrs Memorial, the two figures are fashionably dressed as members of the urban middle class. The veil of the Muslim woman was de rigueur among middle-class Muslim urbanites in the early twentieth century. The loose scarf covering the Christian woman's hair was a fashion accessory as much as a sign of modesty.

Significantly, Hoayek chose to represent two women who covered their hair (completely or partially) at the time when veils began to come off in Lebanon and other parts of the Arab world. As early as 1914 Lebanese Muslim women were seen without their veils shopping in the outdoor market of Beirut's Sahat al-Bourj.[43] After they made their purchases, they would don their veils again before returning to their neighborhoods. The iconic act of unveiling took place when Egyptian feminist Huda Sharawi publicly removed her veil at Cairo's train station upon her return from an International Women's Congress in Rome in 1922. In front of the same train station, in 1928, Egypt's King Fouad presided over a lavish inauguration ceremony of a monumental granite sculpture titled *The Awakening of Egypt* (*Nahdat Misr*).[44] A testament to the 1919 Egyptian Revolution against the

British, artist Mahmud Mukhtar sculpted the imposing figure of an Egyptian peasant woman, who, standing right next to a seated Sphinx, lifted her veil off her face. Here the veil symbolizes colonial slumber, from which the Egyptians awoke in revolt.

In the debates among reform-minded (male) Arab nationalists, the issue of veiling was complicated. On the one hand, the veil was symbolic of traditions that needed to be changed for the sake of "progress" and a secular "modernity," but, on the other, it was also the symbol of indigenous cultural values that needed to be preserved to give the nation an identity. As women started to participate in nationalist movements, some of them began to unveil, thereby setting a trend that caused great alarm among traditionalists, but also among some nationalists. According to Samir Kassir, Arab men at the time (he did not specify their ideological affiliation) saw the women's unveiling as a betrayal of their communities.[45] Hoayek, who must have been aware of the debates, had to negotiate between these opposing beliefs and ideologies. He did not shrink from the debate by sculpting male bodies; instead, he chose to sculpt modestly dressed, mother-guardian figures and placed them on public display in Beirut's central square. Thus symbolically anchored in tradition, a Muslim and a Christian woman became the national symbol of "peaceful communitarian coexistence."[46] Hoayek had created Lebanon's first piece of national art.

CELEBRATIONS AND COMPETITIONS ON MARTYRS DAY

In 1930 the annual commemorative celebrations became an affair of state, staged with great ceremony and the involvement of government and civic institutions. When the inauguration of Beirut's Martyrs Memorial took place on September 2, 1930, Lebanon's first flag, the French blue-white-red *tricolore* with a cedar tree superimposed on the white middle panel, was affixed to the statue.[47] To further mark the occasion as a national event, members of the newly formed Lebanese military, as well as the French military, stood in attention, while spectators crowded the sidewalk, surrounding balconies, and rooftops. The Martyrs Memorial became the backdrop against which French mandate and Lebanese political elites legitimated the mandate state. The ceremony featured the laying of wreaths and the performance of national anthems—both French and Lebanese—and public speeches extolling the sacrifice of Lebanon's Muslim and Christian independence heroes.

The symbolic French-Lebanese unity enacted in Martyrs Square faced the reality of protests against the French-led mandate project that started

almost as soon as the French had opened their administrative offices in the former Ottoman Serail. Between 1925 and 1927 a revolt organized in neighboring Syrian territory spilled over into "Greater Lebanon," as it was then called.[48] In the midst of the uprising, the French granted Lebanon a constitution that transformed "Greater Lebanon" into the "Lebanese Republic" and created a Lebanese parliament that gave Lebanese more say in the government. That parliament elected Charles Debbas president. Of course, the French retained for themselves the right to suspend that constitution, which they promptly did in 1932, when in the wake of the Great Depression strikes broke out in Lebanon and Syria.[49] Throughout the 1930s local resistance against French mandate rule mounted, as was evidenced in the founding of the Syrian Nationalist Party (SNP) in 1932 and the "Congress of the Coast" in 1936. The SNP promoted the creation of a political entity called Greater Syria of which Lebanon was a part. Four years later Lebanese political elites, most of them Muslim, met for the so-called "Conference of the Coast" to demand a reintegration of Lebanon into Syria.[50] While opposition against the French became more vocal and organized, support for the French mandate congealed around the Phalange Party, also created in 1936 under the leadership of Maronite Pierre Gemayel. Amid these political developments in Lebanon, the French concluded separate treaties with Lebanon and Syria that finalized their borders (although not conclusively; see chapter 5) and promised—but did not deliver at the time—the end of the French mandate.

One space where the opposition to the mandate government made itself known was the very place where it (re)presented itself: Martyrs Square. The newspaper records of the 1930s show that Lebanese citizens disapproved of the official commemorative date. On September 1, 1920, the French had officially taken on their mandate and created the political entity of "Greater Lebanon." September 2 was therefore a date that evoked the first day of French rule. On September 2, 1933, in its first year of publication, the Arabic-language newspaper *Al Nahar* featured an article sharply attacking government officials for laying wreaths at Beirut's Martyrs Memorial. The journalist stated tersely that no martyrs had died on September 2.[51] The article went on to distinguish between "the government" and "the people," saying that the people wanted to celebrate the martyrs on May 6, the day when Jamal Pasha, in 1916, had executed the largest single group—a total of twenty-one men in both Beirut and Damascus. The 1933 article criticized Lebanon's ruling elites for being disconnected from the people, thus pointing out that the Lebanese government, which worked within the framework of the French mandate, had limited popular support. On May

6, 1936, "the people," under LCM leadership, organized their own Martyrs Day celebration in conjunction with political allies in Syria. Joining Lebanese and Syrian histories through commemoration, the Martyrs Day organizers used the publicity afforded by the festivities to demonstrate that their political platform had substantial public following.[52] In contrast, on September 2, 1936, according to *Al Nahar*, "the [Lebanese] government celebrated Martyrs Day alone."[53]

Al Nahar's reporting of popular celebrations in both Beirut and Damascus in May versus a relatively uninspired government formality in September revealed the newspaper's Arab nationalist platform. But it also showed that the May 6 ceremonies were as carefully staged as those of September 2. On May 6 members of Beirut's municipality, relatives of martyrs, and schoolchildren gathered around members of the LCM in Martyrs Square to deposit wreaths at the memorial and then proceeded to walk to the cemetery, which reportedly took an hour and a half. Next to the graves they listened to speeches by LCM members and "around sunset the crowds dispersed in reverence."[54] In contrast, the September 2 Martyrs Day was a rather short and formal affair. According to the reporter, members of Parliament and the president arrived in Martyrs Square at 9:15 AM, listened to the anthem, and watched soldiers file past. Then the president placed a wreath at the base of the martyrs statue, and the celebration ended at 9:30. Thus, whereas the president was surrounded by members of the government and security forces, the leaders of the LCM were surrounded by family members of the martyrs and schoolchildren who were taught a lesson about sacrificing their lives for liberty and independence. By holding their separate ceremony, the organizers of the May 6 events challenged the legitimacy of the government. Significantly, they criticized the government by using the government's own ceremonial language: laying wreaths, visiting the cemetery, and presenting speeches. While the government reportedly executed a formality, the LCM's event is said to have generated genuine reverence. Moreover, the May 6 event was deemed more authentic and more representative of the nation because it drew a larger crowd.

Unfortunately the *Al Nahar* records of 1937 are incomplete. But although I was unable to find reports about either one of the Martyrs Day ceremonies for that year, the two separate events must have continued, because in 1938, according to *Al Nahar* reporters, the Lebanese government finally celebrated Martyrs Day officially on May 6 and "the hearts of the rulers beat with the hearts of the ruled."[55] For the first time the ceremony in Martyrs Square is described in great detail, with an emphasis on the degree of popular participation. Preparations began in the early morning hours; a

stage was built, and soldiers and police secured the perimeter of the square and directed the press and spectators to their places. Government officials arrived at specific times according to their ranks, for example, parliament members arrived before ministers, and the president was the last to ascend the stage. Upon the president's arrival, the military and scout units paraded past the government officials. The president of the LCM welcomed everyone to Martyrs Square and briefly retold the story of the valiant men who had given their lives for independence. The president himself did not speak, but he solemnly deposited a wreath at a memorial already covered in flowers and wreaths from a wide array of civic organizations that included labor unions (hotel workers, cooks, drivers, teachers, tradesmen, journalists, etc.), the Arab Women's Association, Islamic Orphans and Scouts Associations, the Phalange Party, the Communist Party, Student Associations, and so on, whose members were present in the square. The laying of the wreath was followed by a moment of silence. The entire ceremony in Martyrs Square lasted about half an hour, after which some of the politicians and most of the people proceeded to the cemetery. Once there, speakers, including the LCM and political leaders but also leaders of civic organizations, extolled the virtues of sacrificing oneself for one's country. This was the ceremony that Kamal Salibi regretted not having been allowed to attend when he was nine years old.

While there was clear evidence of involvement of many of Lebanon's civic institutions, including Muslim and Christian organizations, not everyone was in Martyrs Square, as Kamal Salibi's childhood story suggests. As noted, some Lebanese considered the martyrs "traitors" for their collaboration with the French, but that group was a silent minority: they staged no protests but simply stayed away. Lebanon's political elite, alongside representatives of the French mandate, publicly honored civilian sacrifice and asked those attending to do their part for their country. Muslim and Christian martyrs had laid the foundation for Lebanese independence from the Ottoman Empire, and citizens and political elites alike put down wreaths as a public acknowledgment of their sacrifice. The official celebrations were part of the elites' attempts at "world-making," carried out in the center of the country's capital. Importantly, by reporting extensively on the event the next day, listing both members of the government and civic institutions in great detail, Al Nahar cast Lebanon as a community united in remembrance.

The commemorative process was not a simple mechanism of control enforced from above but instead involved struggle and negotiation. September 2 was a holiday that was chosen by the French to link the sacrifice of the 1916 martyrs to the French colonial project. As discussed earlier,

some of the men who were executed in 1916 were working with French diplomats against the Ottoman Turks. Therefore it was not unreasonable to commemorate the independence struggle following the French calendar. May 6, on the other hand, emphasized martyrdom for an independent Arab state, which was celebrated on that day in both Damascus and Beirut. Ultimately the historical record of the events of 1915 and 1916 supported both commemorative narratives. Crucially, although the narratives followed opposing ideologies, they both emphasized shared Muslim and Christian sacrifice, and both employed the memorial and the cemetery as places where they could celebrate—and further advocate—Lebanese independence. When the Lebanese government (along with members of the French mandate administration) conceded in 1938 to hold the official martyrs celebrations in May, it did not settle the question of what kind of independent nation the martyrs had died for. That question continued to occupy a central stage in Lebanon's political and ideological battles. Yet, on Martyrs Day, those differences were temporarily set aside, because a majority of Lebanese found meaning in the celebration of joint Christian and Muslim martyrdom.

SYMBOLIC BATTLES IN MARTYRS SQUARE AFTER (THE SECOND) INDEPENDENCE

Lebanon obtained its independence from France in the midst of World War II. The Lebanese held general elections in the summer of 1943, and Bshara al-Khoury became president on September 21, 1943. The French supervised these elections, citing their privileges guaranteed by the 1926 constitution. Later that year the Lebanese single-handedly abrogated these privileges when French high commissioner Jean Helleu was out of the country. Upon his return on November 11, Helleu had the defiant Lebanese politicians arrested in the middle of the night from the bedrooms of their homes.[56] Bshara al-Khoury, Riyad al-Solh, and four other politicians were jailed in the town of Rashaya, at a safe distance from the capital. Then, facing pressure from Great Britain and the United States as well as a general strike that shut down most of Lebanon, the French changed course and released the prisoners on November 22. Upon their return to Beirut, the former captives were received by a "delirious crowd."[57] November 22 became Lebanon's official Independence Day.

The Lebanese had to wait until after the end of World War II for the last French troops to leave Lebanese soil. But as soon as they did President Bshara al-Khoury unveiled a marble plaque, announcing that the

"withdrawal of all foreign troops was completed on December 31, 1946." The plaque was installed at the national heritage site of Nahr al-Kalb, a narrow and steep river valley, on whose rocky slopes foreign armies since antiquity had recorded their victories.[58] Right after adding his proclamation of independence to the historical record written in stone, he drove to downtown Beirut and placed a wreath at the base of the Martyrs Memorial, thus symbolically linking the struggle of the 1916 heroes to that day's events.[59] *This* was the independence that the men had died for. Neither November 22 nor December 31, which subsequently became Lebanon's official Independence Day holiday, diminished the role of the 1916 martyrs.[60] *Al Nahar* reported that the May 6 ceremonies continued to take place in the morning in Martyrs Square with the president, government officials, and army and scout contingents, and again in the afternoon, within the confines of Beirut's Martyrs Cemetery, under the leadership of the LCM, with members of the martyrs' families. The 1946 ceremonies were particularly festive, given that the Lebanese were anticipating the withdrawal of the last French troops later that year. Thousands of Lebanese crowded Martyrs Square, and later the cemetery, to commemorate the sacrifice of the heroes of 1916.[61] It seemed that "the people" and "the government" had reconciled, and yet there was more trouble ahead.

In 1948 the State of Israel was created, which led to the first Arab-Israeli War. Although the role of the Lebanese Army in this war was "modest," and the Lebanese and Israeli governments agreed on the terms of an armistice relatively quickly in 1949, the war profoundly impacted the course of Lebanese history.[62] In the aftermath of the 1948 War, an estimated 80,000–120,000 Palestinian refugees settled in Lebanon; some in cities, and others in refugee camps that would become their permanent homes. The Arab public and political elites across the region were very sympathetic to the Palestinian plight and rallied to the cause of Palestinian statehood. In Lebanon, the support for Palestinians had different motivations. Though most rallied under the banner of pan-Arab solidarity, some, primarily Maronite political elites, feared that the Palestinian refugees—about 90 percent of them Muslims—would tip the country's demographic balance.[63] Supporting the Palestinian cause, and particularly the return of the Palestinians to their homeland, was therefore a way to defend the Lebanese confessional status quo. Fiery speeches about Palestinians' right to independence became part of the May 6 ceremonies. At about the same time opposition mobilized against Hoayek's memorial design. The newspapers had referred to Hoayek's sculpture as the Martyrs Monument (*nasb al-shuhadā'*) or the Martyrs Remembrance Monument (*al-nasb al-tizkārī lil-shuhadā'*). After

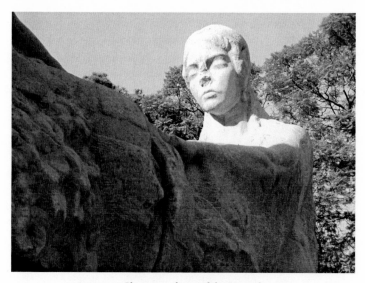

FIGURE 2.4. Close-up of one of the Hoayek statues
in the Sursok Museum, Beirut, 2008.

Lebanon's independence the memorial became "the statue of two crying women" (*nasb al-bākiyyatayn* in Arabic; *les deux pleureuses* in French). Opposition to the statue was not just expressed in the newspapers but right in front of the sculptures during commemorative ceremonies.[64]

The Hoayek sculpture no longer stands in Beirut's Martyrs Square. Instead, visitors can now admire a shorter version of the original in the garden of the Sursok Lebanese Art Museum in Beirut.[65] The memorial is shorter because the foundational pedestal is missing. Only the upper bodies of the two women and the central urn remain of Hoayek's original work. The newly re-created lower bodies of both women now double as a pedestal. Another important change: the sculpture representing the Christian woman is missing her nose. Accompanied by a simple label that spells out, in Arabic and French, "Yussef Hoayek (1883–1962) Martyrs Monument of May 6, 1930, Nicolas Sursok Museum," Hoayek's Martyrs Memorial is now one among many pieces of Lebanese art.

FROM SYMBOL OF UNITY TO UGLY IDOL

The story of the removal of Hoayek's Martyrs Memorial from downtown Beirut remains a tale of intrigue. On page 4 of Tueni and Sassine's *El Bourj*, a painting of Martyrs Square, based on a photograph, shows a truncated memorial flanked by tall palm trees and a number of pedestrians walking

about doing errands under a tranquil blue sky. The caption under the image reads "a historical moment of the Square (1948–1960) without the Martyrs Monument by Yussef Hoayek (1930) which was mutilated by an imbalanced person," (*un déséquilibré*).[66] I have read that sentence repeatedly and wondered what it meant. Twelve years—the period from 1948 to 1960—represents an extended historical *moment*. The phrase "without the Martyrs Monument" was technically incorrect, as the image showed that the memorial was not entirely gone. There, surrounded by its decorative fence, stood the middle part, which still showed the carving of the cedar tree, and the lower section that functioned as its base. The verb mutilated conjured up all sorts of violent acts involving machetes and axes. How would a mentally ill person obtain such implements and be allowed to mount a national monument? During one of my research visits to Beirut, I asked both authors of *El Bourj* to clarify how Lebanon's symbol of Christian and Muslim sacrifice for independence had disappeared. They explained briefly that the sculpture had been unstable and had fallen over. The tone in their voice suggested that there was nothing else to add, and I pressed no further.[67] In a subsequent meeting with four artists at the Center of Lebanese Artists for Sculpture and Painting, where I presented the image of the Hoayek memorial and of Martyrs Square's "historical moment," I received another verdict. The artists agreed that the Hoayek statue had been solidly anchored and that it was impossible for such a heavy sculpture to simply fall over due to the vandalism of one single person.[68] The Lebanese artists deplored the fact that a piece of Lebanese independence art would have disappeared as this one did and that no one seemed to have cared enough about it to put on record exactly what had happened.

My search for information about how the Martyrs Memorial had disappeared from its original location took me to engineer and architect Sami Abdel Baki, the LCM president for thirty years, and a record keeper of articles and photos relating to the memorial. I met him in his office on Hamra Street, a busy shopping area in Beirut, where he received me, impeccably dressed behind a large desk in an office that contained stacks of papers on every conceivable surface. When I explained that I wanted to understand how a limestone statue could have simply disappeared from a public square, he smiled and leaned back in his leather armchair. He brought the tips of his fingers together in front of his chest and said, "A university professor by the name of Salim Sleem destroyed the statue with a heavy implement in 1950." According to Abdel Baki, Sleem had been a member of the LCM, and he, like most of the members of the organization at the time, had disapproved of the mournful design of such an important national

symbol, and so he destroyed it. Abdel Baki obviously approved. The statue had indeed been mutilated and, moreover, mutilated by the hands of a university professor! I was intrigued.

I later scoured the newspapers of the period that Abdel Baki was kind enough to share with me, searching for additional secondary sources. But none of the newspapers contained any information. I subsequently found a French source relating the vandalism of the Hoayek statue, but it was dated September 9, 1948. The article confirmed the name Salim Sleem but described him as a journalist at the newspaper *Sawt al-'Arab* (Arab voice) rather than a professor.[69] After taking a hammer to the faces of Hoayek's two statues in broad daylight, he was arrested, found mentally disturbed, and condemned to a one-month jail sentence. After his release he told the press that he was not crazy but that he objected to the memorial because it symbolized tears and resignation rather than courage and heroism. Sleem said he had sent letters of protest to the Beirut municipality, to newspapers, political parties, and ministries, but to no avail. He had decided he had to do something, and so

a porter brought me a long ladder he found in Sahat al-Sour, and, armed with a hammer, here I am before these sad stone faces. With one stroke (*d'un coup*), I break off the nose, with another, I poke out the eyes (*crève les yeux*). Some more strokes and the faces exist no more.

In the article he sounded unrepentant and proud of his achievement, and he took his prison sentence in stride. He also claimed to have acted alone. If he was a member of the LCM, as Abdel Baki had claimed, he chose not to divulge it to the press. I looked for reports of angry responses to the vandalism of this central national monument, but I could find none. Instead, I came across an undated poem in Tueni and Sassine's *El Bourj*, penned by Lebanese poet Fouad Suleiman, titled "Idol" ("*Sanam*"). The first lines of the poem exhort the Lebanese to close their eyes when passing Martyrs Square so as to avoid looking at the "Idol," a reference to the Martyrs Memorial. The poet likened Hoayek's piece of art to a corpse, and urged the reader, in beautiful verse, to destroy it with a hammer.[70] Tueni and Sassine must have been aware of the local opposition to the statue, but they chose not to bring up any details during our interview, which meant that I—as well as the readers of their book—received only an incomplete picture of the memorial's disappearance.

Having confirmed the name of the culprit who had mutilated the statue (I was unable to resolve whether he was a professor or a journalist or if he

was indeed mentally ill), I was further intrigued by contradictory reports of the statue's mutilation and ultimate removal. Sleem had used a hammer in his act of vandalism, yet his claims to have made the faces of the statues disappear are exaggerated in light of the surviving evidence in the Sursok Museum. Moreover, he had not toppled the statue. Once bystanders realized that Sleem was not there to clean or otherwise maintain the monument, they interrupted his destructive plans and confined him to jail. Someone else had to come afterward to remove the damaged piece of art. The May 6, 1949, ceremony was an occasion for a public call to remove the statue because of its lack of heroism. The statue was still in the square on July 8, 1950, International Women's Day, when a group of Lebanese suffragettes gathered in downtown Beirut, demanding the right to vote.[71] It is not known if the mutilation of the statues' faces was one reason why the women staged their protest there, but it is tempting now to make the link between the damaged memorial of the two women and women's demands for full rights. The police arrested twenty-six of the protesters and confiscated the wreaths that the women had placed at the memorial's foundation. (It was two years later, in 1952, when Lebanese women obtained the right to vote.) In 1951 a letter from the LCM, addressed to "the people," announced that the government had promised to remove the structure. Yet still on May 6, 1953, Minister Muhieddine al-Nsouli publicly decried the fact that the Hoayek monument remained in the square; in his view, it did not represent the manhood (*rujūla*) of the heroes, and he asked the rhetorical question, "So is this the reward for someone who has bought freedom and independence with his blood and who has given us a dignified life?"[72] Obviously he did not think so.

One voice that does not appear in the newspaper records is that of Hoayek himself. He was still alive and working in his studio in Beirut when his sculpture was vandalized. Surprisingly he remained silent when one of his most prominent pieces of art was defaced. Also unexpected was that the government did not strongly condemn the vandalism and take swifter action to repair or replace the damaged memorial. Whoever removed the damaged sculpture in the end left two-thirds of the memorial in place, as shown in the painting displayed in *El Bourj*. Without the women's heads, torsos, and arms, and without the urn, a new sculpture had emerged: a simple stele with the engraving of the Lebanese cedar tree flanked by two fasces and a simple cylindrical frame. Technically the two women had been cut in half, yet because of the way the sculpture had been assembled, a visitor to Martyrs Square who had never seen Hoayek's memorial may not have realized that a dissection had taken place. Unclear is whether the

decision to remove the top part of the statue was motivated by a concern to protect the sculpture from further attempts of vandalism, to restore it, or simply to remove the "Idol." Even more surprising than these mysterious events is that the May 6 celebrations continued to be staged in Martyrs Square in front of the vandalized, and later dissected, statue.

Hoayek's sculpture reappeared as mysteriously as it had disappeared. In the fall of 2001 the director of the Sursok Museum, Sylvia Ajamian, found Hoayek's artwork in an unspecified warehouse; no explanation was given as to how it had arrived at this location and who exactly had notified Ajamian of its existence. "Out of appreciation for Yussef Hoayek," so the article read, she "rescued the statue from obscurity."[73] Fifty years had passed, which included two civil wars, and most Lebanese had forgotten—or had never learned—that the sculpture existed. What once had been an important public national symbol had become a piece of art that showcased the skill and ingenuity of one of Lebanon's most renowned sculptors.

REDESIGNING THE MARTYRS IN THE 1950S

Although the government was apparently dragging its feet on how to respond after Sleem vandalized the memorial, debates were taking place and plans for a new memorial were being submitted and contested. It is a story peppered with intrigue. While speaking with Sami Abdel Baki in his office, in 2003, I realized that his version of what had happened to the Martyrs Memorial was not unbiased. Not only was he the president of the LCM, whose members had organized and participated in the annual Martyrs Day celebrations since the inception of the cemetery and memorial, but he was also the originator of a new memorial design. Abdel Baki explained to me that because Hoayek's statue was a symbol of shame and weakness, he took it upon himself to create a new, more dignified design, which he submitted to an international competition organized by President Bshara al-Khoury shortly before he left office in 1952.[74] Abdel Baki won the design competition and subsequently introduced his vision to the public in an *Al Hayat* article on May 7, 1953.[75] Abdel Baki's Martyrs Memorial included three independent structures built onto a square marble platform: fourteen pillars in a semicircle, an obelisk, and a large arch spanning the pillars and the obelisk. Lit torches were to stand on either side of the obelisk. Abdel Baki explained that each of the fourteen pillars represented a martyr executed on May 6 and that the pillars were connected to one another by a beam across the top as a sign of unity and solidarity among the men. The flames symbolized sacrifice as well as "the burning revolution of justice," and the

obelisk stood for glory and idealism. The message of heroism was further strengthened by the enormous victory arch that spanned the ensemble. A painted sketch of the design was publicly unveiled by al-Khoury's successor, President Chamoun, in downtown Beirut during the annual May 6 commemorations in 1955. According to a May 1955 article in the French-language paper *L'Orient*, "many artists and educated people" subsequently formed a committee to demand an immediate halt to all work on Abdel Baki's design and the opportunity to participate in the development of a new memorial for Martyrs Square.[76]

Clearly the public objected to Abdel Baki's reinterpretation of how the 1916 martyrs should be remembered. Compared to Hoayek's memorial, the scale of this design was gigantic. An eighteen-foot statue of two female figures was being replaced by monumental art drawn from the canon of Egyptian, Greek, and Roman victory memorials. The sculpture of two women facing each other, which had created an intimate space around the central funerary urn, was to be replaced by a huge open space. A memorial of that size obviously would not fit along the perimeter of the park and would require a redesign of the entire Martyrs Square. Moreover, not only did this design remove the female symbolism of the memorial, but it replaced an explicit symbol of Muslim and Christian unity with a row of fourteen identical Greek columns, each of which was to represent a martyr in a heroic, yet abstract way. Abdel Baki also introduced an unmistakably phallic element into the commemorative landscape, with the central obelisk pointing straight into the arch that spanned the entire memorial.

Although the artistic language of the proposed design expressed the manhood that some felt was lacking in Hoayek's statue, it was devoid of any reference to Lebanese culture or tradition. As Abdel Baki presented his design to a non-receptive public, the speeches accompanying the May 6 ceremonies—as seen in the epigraph to this chapter—continued to emphasize the importance of joint Christian and Muslim sacrifice for the sake of the nation.

Whether it was the popular opposition to Abdel Baki's monumental design or the technical challenge of building a memorial on so monumental a scale is unclear, but the arch, columns, and obelisk were never realized.[77] Although, in 1955, President Chamoun is featured in various Lebanese newspapers with trowel in hand, smoothing fresh concrete under an enormous foundation stone that is about to be lowered into place in Martyrs Square, marking the beginning of the execution of Abdel Baki's design, the construction went no further.[78] As with the story of Salim Sleem who had defaced the Hoayek memorial, inconsistencies appeared in the record

about the memorial's replacement. Camille Chamoun had actually laid two foundation stones during the May 6 ceremonies in 1954 and 1955. President Chamoun's 1954 masonry act was symbolic, "because we do not yet know the definitive location of the future monument, nor its design."[79] Yet *Al Hayat* had printed Abdel Baki's winning competition design in May 1953. On May 7, 1955, *Al Hayat* further reported that members of the LCM had resigned because they objected to how the decision had been reached regarding the memorial design, an indication that it had just been made that year; moreover, public objections to the design were voiced most strongly that year. These inconsistencies, I believe, are evidence of multiple interests or lobbies for a new memorial design. After the 1948 act of vandalism the government had to contend with several parties who wanted to claim Beirut's prominent public space as their own.

Then, in April 1956, the front-page story in *Al Hayat* carried the following surprising headline, "This Is the Martyrs Memorial of Lebanon."[80] Beneath a sketch presenting a new memorial design, the caption read: "This is the statue of the martyrs which, it was decided, will be erected in al-Bourj. It depicts two giants (*'imlāqān*) carrying the torch of liberation, symbolizing the heroism of the nation's martyrs. The statue was designed by the engineer Dr. Sami Abdel Baki." The new Abdel Baki proposal showed two large, muscular men standing side by side. They step forward with their right and left legs, respectively, their nude upper bodies bending forward, and their respective right and left arms stretching upward, holding the "torch of liberation." These two giants rise up from an intricately shaped pedestal made up of uneven geometrical blocks, which tilt in the same direction as the giants above them. Although the newspaper sketch was too small to reveal specific facial features, the two giants appeared to be identical twins, donned in helmets that seemed to belong to an ancient empire. One of the men held an unrolled scroll of parchment with his free hand, and the other carried a chalice in front of his bare chest. These mythical figures could have sprung from the *Ring of the Nibelung*. Thus Sami Abdel Baki had not given up on his plan to redesign Martyrs Square, but instead had proposed a figurative, yet still heroic, memorial to commemorate the manhood of the 1916 martyrs.

Realizing that his column-arch-obelisk design was no longer feasible, which he did not discuss with me in our interview, Abdel Baki had come up with a more condensed sculpture relative to his original proposal. In an April 23, 1956, meeting in the presidential palace attended by the president, the ministers of civic education and public works, members of the Beirut municipality, and LCM members, including Sami Abdel Baki, it was

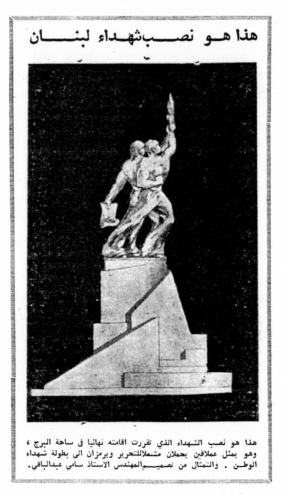

FIGURE 2.5. "Two Giants" design for Beirut's new
Martyrs Memorial, *Al Hayat,* April 27, 1956.
Reprinted with permission of Al Hayat.

decided to allocate the necessary funding and move forward with the "Two
Giants" design.[81] The same article reported that a committee would look
for an internationally renowned artist to carry out the work. On May 6
the following year, 1957, Minister of Culture George Aql spoke at the offi-
cial Martyrs Day ceremony in downtown Beirut.[82] He praised President
Chamoun for his efforts at finding a memorial replacement for Martyrs
Square and acknowledged Abdel Baki as the author of the new design.
Finally, he announced that the new Martyrs Memorial would be executed
by the Italian sculptor Marino Mazzacurati.

The men who were sentenced to death by Jamal Pasha during World War I became Lebanon's symbolic founding sons. The story of joint sacrifice of Muslim and Christian men from prominent families became an important lesson in Lebanese history books. The various eyewitness accounts of the hangings, published in the local papers at the time, spoke of the martyrs' noble and fearless demeanor. The two most important elements in the retelling of their story are the way in which the men gave their lives and the ways in which they both embraced yet transcended their ethno-religious differences. According to George Antonius, the news of the 1916 executions sparked Sharif Hussayn's Arab Revolt—which started barely a month after the men had died—giving it an iconic place in Arab nationalist narratives.[83] It would take two more years fighting on numerous fronts to decide World War I in favor of France and Great Britain. The Ottoman Empire was defeated, thereby relinquishing its rule over its Arab territories. As part of their mandate over Lebanon, the French redesigned Beirut's central plaza that would accommodate Lebanon's first Martyrs Memorial.

The narrative of sacrifice was accompanied, on the one hand, by sketched portraits of the individual martyrs and, on the other, by a limestone sculpture representing two Lebanese women, with the artists using the body to different effect. The portraits of 1955 showed the men impeccably dressed and groomed, the intellectual vanguard of Lebanon's independence. Only their heads and a part of their upper bodies are visible, an artistic choice that emphasized their cerebral qualities. They had not physically struggled for independence—they were not soldiers—but had made their opposition to the Ottoman Empire known through their writings and their organizing efforts. Another symbolic effect was achieved by focusing on just the heads and shoulders in the commemorative reproduction of the martyrs. As Esra Özyürek has argued in her study of Kemalism in Turkey, busts of the Turkish leader that appeared in offices or squares "turned everything and everyone in the surrounding space into an extension of his head—in other words, into his body."[84] The martyrs are the heads (read: leaders), the people are the body (read: followers). Together the Lebanese carried out the struggle for national independence.

When Hoayek sculpted two women reaching out toward each other, he made deliberate artistic choices that set his statue apart from the canon of nationalist figurative art. The women's faces and their hair are important as well, because they are the symbolic markers of the women's ethno-religious difference. The remaining parts of the women's bodies are almost identical,

creating balance and equilibrium. The memorial's symmetry is reinforced by the women's outstretched arms. By having the women turning toward each other and focusing their gaze onto an urn resting above the image of a cedar tree, Hoayek was participating in ongoing debates between nationalists who saw Lebanon's cultural heritage as rooted in the Arab East (mostly Muslim elites) and those who looked westward toward Europe, citing long-standing trade links and cultural affinities (mostly Christian elites). Hoayek's memorial symbolically turned everyone around to face one another and to focus on and embrace ethno-religious coexistence.

This discourse of balance between different communities carried the day in 1943, when Lebanon was created. In September of that year Lebanon's (Sunni) prime minister, Riyad al-Solh, described Lebanon as independent and sovereign within its current borders, reaffirming French mandate borders as de facto Lebanese borders, but added that Lebanon had an "Arab face" which made it integral to the larger surroundings.[85] This formula became known as Lebanon's National Pact, which would play the role of Lebanon's unofficial constitution. The formula allowed a Lebanese government to emerge that included (mostly Christian) politicians seeking alignment with the West, and (mostly Muslim) politicians who saw Lebanon as belonging to the Arab world. Lebanon, it was agreed, would be both and neither. This is not to say that a direct, causal link exists between Hoayek's memorial and the National Pact, but I argue that the depiction and commemoration of the men who died in 1915 and 1916—and the emphasis on their joint Muslim and Christian martyrdom—created a discursive framework within which the discussions that made the 1943 National Pact possible took place.

Martyrs Square became an important public space to conduct annual ceremonies of state. Photographs and descriptions in the newspapers of the day give evidence that the commemorations of Lebanon's martyrs were well attended, especially after 1938, when the government acquiesced to the May 6 date. Challenged by the LCM members, who planned separate commemorative ceremonies, and members of the press, who took sides in their reporting, government officials (both French and Lebanese) gave in to the demands to celebrate May 6 on the day it was also commemorated in Syria. Although Arab nationalists won their symbolic victory, they also had compromised because they now attended the official ceremony together with the government they still opposed. Neither camp would simply relinquish the martyrs to the other, nor would they give up the opportunity to publicly honor them.

The May 6 ceremonies drew large crowds, not only as spectators but

also as participants. Each year a number of civic organizations took part in the ceremonial honoring of the dead by sending wreaths; some representatives also spoke at the ceremony conducted beside the martyrs' graves. This gave the government the opportunity to display the state's power—through a careful staging of members of parliament, ministers, and members of the military and police forces—and have citizens publicly perform within this framework according to carefully outlined ceremonial guidelines. Conducting the ritual itself conveyed power, which is why in 1936, a time of widespread political mobilization and the sharpening of opinion, both camps held separate commemorative ceremonies, where they tried to outdo each other in terms of the ceremony's authenticity. Thus both sides confirmed Martyrs Square and the cemetery as sacred landscapes that must not be profaned, and shared the belief that Muslim and Christian martyrdom was a sacrifice that must be honored. The post-independence objection to Hoayek's memorial was not an objection to the history or memory of the men, Muslim and Christian, who had given their lives during World War I. The resentment was that their history and memory had not been rendered manly enough. Some Lebanese, as evidenced by Salim Sleem's act of vandalism and Fouad Suleiman's poem "Idol," strongly contended that the image of two women beside a funerary urn was a sign of weakness and death.

After 1950 Lebanon's foundational martyrdom was re-imagined. The process was arduous, and not all the details of the struggles between Abdel Baki, the government, various ministries, the municipality, and other interest groups are known. The issue at hand was not only the question of proper artistic form but also mundane questions of finances and feasibility. Although the available record is inconsistent and at times contradictory, it appears that a sufficient number of Lebanese cared about the symbolic space in Martyrs Square to send proposals to an international competition, oppose the design that presumably had been chosen, and participate in a memorial committee to discuss an appropriate new design. After the faces of the women were vandalized in 1948, the sculpture could simply have been removed. Lebanon had a new Independence Day, November 22, and had no need to keep celebrating May 6. Yet the narrative of the martyrs for communal coexistence was not abandoned.

Abdel Baki's abstract design of columns beside an obelisk that reaches into a large arch spanning the entire width of Martyrs Square represented a significant departure from the original memorial. Abdel Baki utilized artistic forms found in Lebanon's archaeological heritage, drawing on the Egyptian obelisk, Greek columns, and the Roman victory arch. In other

words, although not drawing on Lebanese art forms or figures, he wanted to ensure that his memorial fit into the existing historical record. Bringing together those different forms of classical art and architecture was Abdel Baki's representation of Lebanon's mixed heritage of successive empires and civilizations. Some Lebanese history books begin by defining Lebanon as a "crossroads of civilizations" (*multaqā al-hadārāt*), followed by a discussion of the many ancient empires that came to rule their territory. It bears noting that this fusion of ancient monumental forms did not include a recognition of Lebanon's Phoenician heritage—an important ancestral reference point for elites who thought that Lebanon had an identity separate from their Arab surroundings. But neither is the design Arab or Islamic, which would have endeared him to Lebanon's Arab nationalists. In the end, Abdel Baki's monumental design was not realized. Instead, he proposed a second design of "Two Giants" with hyper-muscular, nude torsos leaning forward and upward, an expression of a specific neoclassical European aesthetic. Seen through German eyes, it is tempting to interpret the twin bodies as an expression of Teutonic might. The contrast between the giants and Hoayek's modestly dressed, stoic, and upright Muslim and Christian women, as well as Yazbek's sketched portraits of intellectual revolutionaries, could not be greater.

My research into the disappearance of Hoayek's memorial uncovered missing links and inconsistencies in newspapers, interviews, and secondary sources. The details of Sleem's midday vandalism in Martyrs Square are surprisingly not easily accessible. The story does not feature in Tueni and Sassine's otherwise very detailed illustrated history of Martyrs Square, and the Sursok Museum display provides no explanation for the Christian figure's missing nose. Demonstrated here is that memories themselves are further subject to a politics of memory. I suspect that Tueni, Sassine, and the director of the Sursok Museum have their opinions about the wanton defacing of national art, and the subsequent dismantling of the original Martyrs Memorial, but they chose to keep those opinions to themselves. As with "No Victor, No Vanquished," certain kinds of violence and injury are better not discussed in public.

Finally, and importantly, after the Hoayek memorial was taken down, the majority of Lebanese, regardless of their ideological or ethno-religious differences, wanted the commemorative void filled with something new. No movement organized in order to advocate against having a memorial for the 1916 martyrs, who were (and still are) considered traitors by some Lebanese. The efforts to recreate another Martyrs Memorial rather than design a new victory or independence memorial proves that the

symbolism of shared sacrifice resonated among a sufficiently large num-
ber of Lebanese who did not want to redesignate the square that had
already carried so many names. The narrative of the defiance of Ottoman
might by a group of civilians, Maronite and Greek Orthodox, Shiite and
Sunni, who were buried by the Druze on a plot of land they donated to the
municipality, remained important.

Camille Chamoun, who twice laid foundation stones for the new
memorial and keenly wanted to become the sponsor of the new Martyrs
Memorial, did not succeed in completing Martyrs Square's commemora-
tive makeover. Instead, he had to turn his attention to more urgent mat-
ters of state, namely, a popular uprising (*al-thawra al-sha'abiyya*).[86] As a
result Beirut's Martyrs Square remained without a national symbol until
the beginning of the next decade. And, in the meantime, another Martyrs
Square was built and inaugurated outside Beirut.

Remembering Civil Wars

Fearless Faces and Wounded Bodies

(1958–1995)

*I loathe the idea of being tied to any closed society, religious or otherwise.
I believe man is of the race of God. He must seek the essence of the Truth
through religions, but he must also transcend them.*

—KAMAL JUMBLATT, *I SPEAK FOR LEBANON*

*He would have been satisfied to be a symbol, if those bullets had not gath-
ered in his body, that has been weighted down by tears and blood; those
bullets that transformed the symbol into reality and made the statue a
martyr himself.* —B.Q., "THE MARTYR-SYMBOL"

In 1958 a series of events took place in Lebanon that are variously referred
to as Crisis, Civil War, Insurrection, Sedition, Revolt, or Uprising.[1] The
perfect storm that brewed over Lebanon in 1958 was the result of several
factors: the cold war competition between the United States and the Soviet
Union jockeying for influence in the Arab world, the rise to power of Gamal
Abdel Nasser in Egypt, and a government crisis in Lebanon proper. Nass-
er's charismatic leadership and anticolonial rhetoric resonated with the
Arab public at the same time that his socialist policies scared the landown-
ing and business classes, both foreign and domestic. Nasser broke up and
redistributed large agricultural estates in Egypt to the benefit of small
peasants, and he nationalized the Suez Canal, which won him significant
sympathies among Arabs, in Lebanon and elsewhere but also prompted a
military attack from combined French, British, and Israeli forces in 1956.

A champion of nonalignment, Nasser promised to find Arab solutions to societal and economic problems, but he also turned to the Soviet Union for military aid. Looking like a statesman with a mission who delivered to the people, especially the poor, Nasser energized many different Arab nationalist movements across the Arab world. In Lebanon Nasserite Arabism united various political groups that opposed President Chamoun, whose free-market and pro-Western policies benefited the business elites in Beirut, but made him many enemies among members of the middle and lower classes. When Chamoun signaled that he intended to change the constitution to seek a second presidential term, unrest and riots in the streets erupted into an armed revolt.

THE ROAD TO CIVIL WAR:
NAVIGATING BETWEEN EAST AND WEST

In 1957 the U.S. Congress passed the Eisenhower Doctrine, which promised military aid to any country threatened by the forces of communism. President Chamoun signed on despite much domestic and regional opposition.[2] In direct response to this presidential move, twenty-three prominent Lebanese politicians across party lines and across the ethno-religious spectrum formed an opposition group called the United National Front (UNF).[3] On February 1, 1958, Egypt and Syria merged into a new political entity, the United Arab Republic (UAR), which was seen by many as a first step toward a region-wide United Arab State. Lebanon was repeatedly invited to join the Union. On February 24 Nasser made a surprise visit to Damascus, and Lebanese flocked to Syria's capital by the thousands to see the Egyptian leader, including members of the Lebanese parliament and a delegation representing the Maronite patriarch Paul Maoushi. The Nasserite enthusiasm among some Lebanese created much fear and suspicion among others, and articles in the pro-Chamoun press defensively proclaimed, "Lebanon is not Arab, but is Lebanon—a Mediterranean country whose language is Arabic." President Chamoun and his supporters felt increasingly isolated and threatened. Beginning in March 1958 Lebanese street protests and demonstrations in favor of Arabism, followed by summary arrests, became a daily occurrence.

While Arabist fervor mounted in Lebanon, George Aql, a staunch supporter of Chamoun in parliament, announced on April 10, and again on April 24, that he would propose an amendment to the constitution to enable Chamoun to serve a second term as president. On April 10, presumably in response to Aql's first announcement, fighting broke out in the Shouf

area between Chamoun supporters and opponents. On May 8, 1958, a well-known Maronite anti-Chamoun journalist, Nassib al-Matni, was assassinated, and his death sparked a general strike in Tripoli the next day. When news of the strike arrived in Beirut that evening, UNF leaders, most prominently Sunni politicians Saeb Salam and Abdallah al-Yafi as well as Druze leader Kamal Jumblatt, organized an armed revolt.[4] Violence broke out in Beirut on May 12, the day officially cited as "the beginning" of the 1958 Civil War. After seizing weapons deliveries coming into Lebanon across the Syrian border, the Chamoun government began to deport thousands of residents of Syrian nationality from Lebanese territory, accusing them of treasonous activity. The Chamoun government repeatedly launched formal complaints against the UAR before the United Nations Security Council, accusing them of plotting a takeover in Lebanon.[5] In the meantime, Kamal Jumblatt organized his followers and repeatedly, and ultimately unsuccessfully, attacked the presidential palace of Beit ed-Din in the Shouf area. One of Jumblatt's most successful battles took place from June 9 to 11, 1958, in the mountain village of Fraydiss, where he was able to inflict heavy casualties on pro-government forces and force them to retreat.[6] Fighting continued in Beirut, Tripoli, and Sidon, but it was heaviest and costliest in the Shouf region, home to both Jumblatt and Chamoun loyalists.

Then the news arrived of a revolution in Iraq. On July 14 Staff Brigadier Abdel Karim Qasim and other members of the Iraqi military overthrew Iraq's pro-Western monarchy.[7] Soldiers executed King Faysal II and the entire royal family, and some of their bodies were publicly dragged through the streets by an angry crowd. Envisioning his regime to be the next one to fall, President Chamoun invoked the Eisenhower Doctrine and called Washington for help. Washington's response was immediate: on July 15 the first marines landed on the shores of Lebanon, and within four days fifteen thousand more soldiers arrived on Lebanese soil, backed up by an additional forty thousand men on warships in the Mediterranean.[8] American troops would remain in Lebanon until October 27, 1958. The U.S. intervention did not immediately stop the ongoing violence, but it sent a strong signal to the surrounding Arab states that American interests were at stake in the region.[9] American envoys sought a diplomatic solution in consultation with Nasser in Egypt, which resulted in Chamoun's replacement with Fouad Shehab on September 23, 1958. Shortly thereafter, another Maronite journalist, Fouad Haddad, who was a staunch Chamoun supporter, disappeared, which sparked a "counterrevolution" under the leadership of the Phalangist Party leader Pierre Gemayel. The violence ended only after Gemayel was assured a post in the new government. During

this civil war an estimated three thousand Lebanese died, the country's economy was shattered, and Lebanese were distrustful of one another and of foreign interference.[10]

Under President Shehab, Lebanon's political institutions—both the parliament and the administration—grew so as to permit more people access to power and regular incomes. He also opened the first public (and Arabic-language) university, the Lebanese University, which significantly broadened access to higher education. In response to an unsuccessful coup attempt against his regime, Shehab expanded the army's intelligence units, which became a powerful and quasi-independent political force. Yet Shehab left the confessional quota system in place. Seats in the expanded government were still assigned on the existing 6:5 rule for Christian and Muslim politicians, respectively. (In addition, Shehab applied this rule to recruitment and promotion decisions in the army, which began to change its predominantly Christian makeup.) Under the banner of "No Victor, No Vanquished" (lā ghālib wa lā maghlūb), leaders of different armed groups that had fought each other in the 1958 Revolt, were invited to join the post-war government.[11] As discussed in chapter 1, Lebanon scholars have interpreted that motto as evidence of Lebanese state amnesia. I believe, however, that Lebanon's elites exercised pragmatism in the government offices in Beirut, but that does not mean that they forgot the war. It is true that no public plaza in Beirut was dedicated to memories of 1958, and those who died in the fighting in Beirut were buried among their relatives in otherwise unmarked graves, as I learned from my graveyard guide in al-Horj while looking for the 1916 cemetery (see chapter 2). But public memory did take shape outside Beirut in the Shouf. In Beqata, located halfway between Deir al-Qamar and Mukhtara—the first home to Camille Chamoun and the second home to Kamal Jumblatt—Jumblatt sponsored a martyrs memorial honoring both Muslims and Christians who died during the popular revolt of 1958.

IMAGINING ANOTHER ARABISM

Kamal Jumblatt (1917–1977) was one of the most prominent leaders during the 1958 Crisis, and one of Lebanon's main proponents of socialism and Arabism. Yet, as Philippe Lapousterle states in his introduction to Jumblatt's autobiography, this description does not even scratch the surface of the "innumerable facets" that made up his personality.[12]

As is the case with all political leaders in Lebanon, Kamal Jumblatt is a hero for some and a villain for others. He was a member of the Druze

minority in Lebanon, and his family was one of the prominent land-own-ing families in the Shouf. He participated in both Lebanese civil wars in 1958 and 1975, and, like many revolutionaries of that age, he regarded vio-lence as a justified means to an end.[13] He sought to protect the interests of his community, while at the same time forcefully advocating an end to confessional politics. He studied history, literature, art, and philosophy, both in Lebanon and France, and he obtained a law degree at the French-language University of Saint Joseph in Beirut, like many of his colleagues in parliament. But unlike other Lebanese elites, he also traveled to India to study with Buddhist gurus. He practiced yoga and also wrote prolifically. Throughout his life, he continued to wed his political pursuits to his own spiritual quest. His worldview contained evolutionary and Marxist theo-ries, and he reconciled Eastern spirituality with his belief in one God. As he sought common ground across a variety of secular and religious ideolo-gies, he sought to build a new national idea for Lebanon.[14]

In 1946 Jumblatt obtained his first ministerial post in the government of Bshara al-Khoury and Riyad al-Solh. During a stint as Minister of Edu-cation, he sought to nationalize Lebanon's school system, which he saw as promoting sectarian identities.[15] When al-Khoury sought to renew his term as president by modifying the country's constitution, Jumblatt went into opposition. In 1949 he founded the Progressive Socialist Party (PSP), based on principles of socialism and secularism and following the model of European socialist parties.[16] In the beginning he attracted Lebanese from across the sectarian spectrum into the party leadership, and during his political honeymoon with Camille Chamoun (1951–1953) he enjoyed wide support among Maronite elites.[17] Still, Jumblatt's party attracted a dis-proportionate number of Druze members. When Nasser came to power, Jumblatt recognized affinities in political views, but he was also careful to distance himself from the Egyptian leader.[18] He sought alliances with Leba-non's politically left-leaning elites, many of them Sunni, and, after the 1958 Civil War, both Druze and Sunnis were able to expand their political influ-ence vis-à-vis the Maronite establishment.

The Druze believe in the transmigration of souls, so, according to their tradition, when Kamal Jumblatt was assassinated on March 16, 1977, by unknown assailants, his spirit was reborn in the body of another Druze person.[19] Jumblatt's ideas—his unique way of fusing philosophy, religion, and politics—live on in the memorial he built to honor fifty-nine martyrs, fifty-five Druze fighters, and four Christian civilian casualties of the 1958 Revolt in the town of Beqata in the Shouf.

In 1959 Kamal Jumblatt financed and supervised the building of a cemetery memorial in the Shouf Mountains. The planning of Beqata's Martyrs Square, as it is called by locals, began right after the end of the armed struggle in late 1958, at the time when Beirut's Martyrs Square was still missing its memorial. When Jumblatt bought the land the town of Beqata did not yet exist, and the region was simply called Jdeideh al-Shouf. Today Beqata is a lively commercial center, its main road lined with shops of all kinds. The town is currently home to approximately ten thousand inhabitants, most of whom are Druze. Driving into Beqata from Deir al-Qamar, Jumblatt's Martyrs Square is on the left side of the road before one arrives at the town center. Actually Martyrs Square is somewhat of a misnomer. Unlike the wide and open space of Beirut's Martyrs Square, this site of memory resembled a municipal park. Surrounded by an old-fashioned three-foot stone wall topped by a decorative iron fence, the 1958 cemetery and memorial were hidden from view from the main street. Behind an open area right after the gate, trees had grown so tall and dense that it was impossible to see the end of the enclosure from the entrance. Although the size of Beqata's Martyrs Square was probably about the same as Beirut's, it was less a place that showed itself than one that invited discovery.

Entering Baqata's Martyrs Square through a rusty iron gate, I was greeted by a four-by-five-foot flat stone slab that carried a carved Arabic inscription. Because of water damage and mossy growth on the stone's surface, the words were difficult to read. Slowly I deciphered the poem *The Will to Live* (*Irādatu al-hayāt*) which begins with the lines, "If the people one day wanted life / destiny will answer their call. / The night will fade away / shackles will be broken." Written by Tunisian writer Abu al-Qassim al-Shabbi (1909–1934) against French colonial rule, the beginning of the poem is now part of Tunisia's national anthem. The poem is addressed to those who live under oppression and exhorts them to struggle for their independence. Schoolchildren in Lebanon's public and private schools study the poem in their Arabic literature classes. The lyrics of a popular song by the famous Egyptian singer Umm Kalthum repeat the lines of the poem. By choosing to place this poem at the entrance of his memorial, Kamal Jumblatt symbolically situated Lebanon's 1958 Revolt within a long line of anti-Western Arab nationalist struggles. By 1958 most Arab countries had obtained their independence from European rule, but Western influence persisted (as seen, for instance, in the Eisenhower Doctrine). For Jumblatt, the events in Lebanon in 1958 were an integral part of the larger

struggle against Western domination. The al-Shabbi poem additionally provided a metaphor that reappeared in other parts of the memorial: the struggle against darkness in order to reach the light.

Off to the right side past the entrance gate, near the enclosing stone wall, an even larger upright stone slab of about ten by fourteen feet carried the names of all those who had helped build the memorial. Kamal Jumblatt's name tops the list, followed by two more names, 'Arif al-Rais and Wahib al-Bteddiny; all three are given credit for the memorial's design (tasmīm). Next, several individuals are acknowledged for doing the calligraphy (khaṭṭāṭ), the masonry work (naht wa tasmīm), and the sculpting (nahāt). Seven men are credited with clearing the space to erect the cemetery memorial (maqla'aji) beside sixteen more names of otherwise unspecified workers ('ummāl). I asked my guide, a member of the local chapter of the PSP and a Jumblatt loyalist, about the stone the sculptors had used and learned that all the material in this Martyrs Square had been locally quarried in Batloun. My guide continued, with audible pride, that all the work had been done by local artisans, both Druze and Christians. To prove his point, he tapped his finger on the name Karim Abboud and explained that he was a Christian master stone mason who had supervised the work of Druze craftsmen. There were two other Abbouds on the list, as well as a Khoury, an unmistakable Christian last name, as it means "priest." Jumblatt had wanted to leave a public record of the labor that had built the site, and emphasized that it had been a group effort that had crossed ethno-religious lines. Both the al-Shabbi poem and the stone marker with the names of all the workers were the two most prominent features in the otherwise open area between the entrance by the main village road and the dense growth of trees that shaded and hid the remaining plot from view. The open space provided an area where up to two hundred people could congregate. It was here, in front of the plaque that honored the memorial makers, that the official annual commemorative ceremony was staged and where Kamal Jumblatt gave his speeches honoring the martyrs of 1958.

Stepping through the open area and toward the trees, I was met by a second, symbolic gate: two pyramid-shaped, fifteen-foot pillars, which stood in the first line of trees marked the opening through which to proceed. This second entrance to the memorial placed the visitor symbolically at the beginning of time. Passing through the pyramid gates, I stood in front of the "egg of life," a small pond in the shape of an egg, with a fountainhead shaped like a goose. Kamal Jumblatt had his sculptors install a creator-goose (al-wazza al-barriyya) in reference to ancient Egyptian mythology. In a later conversation with one of the memorial designers I learned that

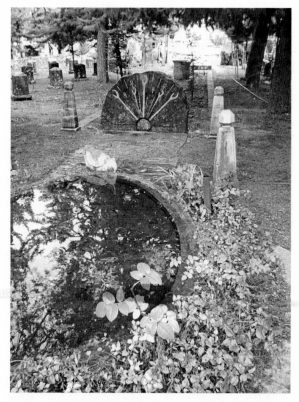

FIGURE 3.1. Egg-shaped pond with creator-goose fountainhead (missing its head); semicircular "sun stone" with "keys of life"; rows of grave markers are visible on the left in back. Beqata Martyrs Memorial, 2008.

the goose had laid the egg from which the sun and the earth emerged. At the time of my visit, the goose was missing its head, revealing the inner tubing of the fountain mechanism. The fountain still worked, the splashing sound of the water breaking the stillness that otherwise prevailed in the memorial enclosure. Immediately behind the goose was a plaster relief installed horizontally in the ground with a second origin story: the evolution of the species according to Charles Darwin.

The plaster relief displayed rows of animal and plant life, including dinosaurs, fish, and birds, and finally the imprint of two feet, symbolizing humankind. The evolutionary relief was anchored flat in the ground, and where it marked the emergence of human life, it was met by another upright stone slab engraved with the image of a sun radiating the "keys of life" (*mafātīh al-hayāt*), another reference to ancient Egyptian mythology.

Darwinian ideas about the evolution of life on earth and beliefs about life-giving creator animals and planets from one of the region's oldest civilizations were seamlessly integrated with each other.

Just beyond this symbolic narrative of the beginning of life, the cemetery began. The grave markers stood in six neatly arranged rows, two on each side of the cemetery which was divided in the middle by a narrow, rectangular reflection pool as well as a large, bell-shaped vase sculpture with the inscription "Life is a gift, a gift (given) for free. True love is a gift, a gift (given) for free."[20] Having explained the creation of life in scientific and mystical ways, Jumblatt now added a philosophical dimension: we receive our life for free, and, moreover, some people, such as the martyrs buried in the cemetery, freely gave theirs. And not only was life a gift but so was true love. These were not the usual words one heard from Lebanese politicians. The main story line of the memorial was emphasized by its spatial layout: the builders had created a central axis by the successive placement of the pyramid-shaped pillars, egg-shaped fountain, evolutionary relief, key of life, vase, and rectangular pool. This story about the evolution and the gift of life was the preface to the 1958 Revolt in Lebanon.

Only when I turned back to the creator-goose fountain did I notice two smaller stone reliefs on either side of it, both overgrown with moss and splotchy from water damage, and realized I had missed the memorial's other story line. These two stone reliefs were about three to four feet in width and were the only pieces of sculpture in the entire enclosure containing human figures. On the right, the face of Gamal Abdel Nasser was carved on top of a map of the Arab world reaching from Egypt and the Sudan to the left of Nasser's face to Palestine, Lebanon, Syria, Iraq, and the Arab Peninsula on his right. Immediately behind Nasser's head were four men identically dressed in traditional kufiya headdress and long traditional Arab robes marching in unison, their fearless faces directed at the same horizon as Nasser's in front of them. Gripping rifles in their right hands and bands of ammunition strapped across their chests, they were ready for combat. Two of the fighters' faces were cleanly shaven, and the other two wore mustaches, suggesting cross-generational unity. Both young and old men—no women were in sight—were eagerly following Nasser's lead.

The second relief stood directly across from the first on the other side of the fountain. It displayed more fighters, dressed like the ones just described, but there was no leader. Instead of marching and carrying arms, they were evenly divided into two groups that faced each other around a flagpole arising from their midst. The pole flew two different flags, and it was supported by the fighters closest to it on either side, hands clasping

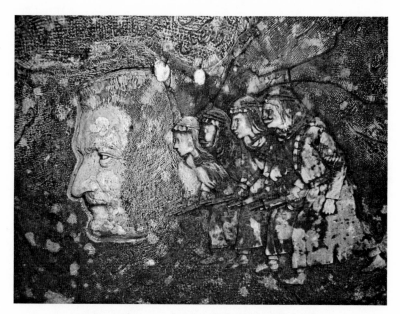

FIGURE 3.2. Close-up of stone relief of Gamal Abdel Nasser
and four fighters, Beqata Martyrs Memorial, 2008.

hands as well as the pole in the middle, a sign that the two groups of men
were united; half the men stood under the Lebanese flag, the other half
under what must have been a Syrian or United Arab Republic flag. The
second flag had been vandalized. Using mosaic technique, the sculptors
had added colored stone to the relief to render the flags more prominently;
the Lebanese flag still showed the red and white stones to mark the three
stripes of its flag, with green stones forming the cedar tree against the white
background. The vandalized outlines of the second flag revealed three hor-
izontal stripes with two stars on the middle panel, identifying it as the flag
of Lebanon's neighbor. In light of the contentious contemporary relation-
ship between Lebanon and Syria, it was not surprising that someone had
chipped away the stone inlay in the relief. It appeared to have happened
recently, as the damaged flag revealed a bright grey surface that resembled
the original, un-weathered stone.

The flag was not the only part that was missing in the picture. The bod-
ies of the first row of fighters, between their shoulders and knees, had
either never been sculpted or had been vandalized a long time ago, for
the surface was covered in moss that would not have been present had the
intervention occurred recently. As a result the fighters only presented their
heads and their feet to the viewer, and then I saw that the fighters were

barefoot. I checked the four men on the opposing relief, and, yes, they also wore no shoes. These were peasant fighters who, despite their incomplete attire, proudly carried their rifles and ammunition and were determined to fight. Clearly the actual fighters of 1958 had not looked like this, but, in memory, they were turned into members of a people's army—civilians who had taken up arms to fight for what is right. Their background was that of simple folk who rose in popular revolt not unlike people in other parts of the colonized world shaking off the yoke of foreign rule. Coming from Lebanon and Syria, they had joined forces—indeed, many Syrian Druze had heeded Jumblatt's call for reinforcements—and had bravely faced battle. However, the figures were not dressed in typical Druze garb, which meant that their fight had not been a Druze fight. The men on the relief were not following Kamal Jumblatt but rather Gamal Abdel Nasser. Since the two reliefs were placed along the sides of the fountain, it made the Nasserite, Arabist, socialist struggle a companion piece of the main narrative of mythical origins and evolutionary progress. The reliefs did not show the enemy but instead focused on the fighters, emphasizing their lower-class status, manhood, solidarity, and courage.

Thus instructed in history, I walked forward in the direction of "progress" as indicated by Nasser's gaze, the direction of the four fighters who walked in unison, and the Darwinian evolution relief to find myself among fifty-five stone markers honoring martyrs who had died in the fighting of 1958. Divided into two groups, one on each side of the central reflection pool, the same stone that had been used for the reliefs I just saw, carried a simple martyrs inscription. Under the title *al-shahīd*, the stone recorded the name, place of birth, site of death, and date of death. The grave markers, like all the other stone sculptures of the memorial, had suffered water damage, and most inscriptions were difficult to read. The most legible read: "Martyr Mas'ūd Shmīd, Alay, the battle of Alay, July 3, 1958." Other battle locations were Beit ed-Din, Batloun, and Fraydiss. That these men had died as fighters was further emphasized by the placement of decorative cannon sculptures on a low stone wall that marked the cemetery area off from the rest of the enclosure. Beyond the cannon-studded wall stood more trees, which hid the surrounding outer fence from view. The cemetery space was the central and enclosed part of the memorial, largely shaded by trees. It created an intimate, quiet space to mourn the dead, which contrasted with the open space at the entrance as well as the clearing that waited at the end of the enclosure. The gravestones marked the fate of regular civilians, who had taken up arms against forces loyal to the Chamoun government—also civilians—and they were given a burial

as comrades-in-arms, lying side by side. The Lebanese army had not par-
ticipated in the conflict on either side of the ideological divide, which then
made its general, Fouad Shehab, the only acceptable candidate to succeed
President Chamoun when the war ended.[21]

The still water of the central, rectangular pool reflected the trees on
either side and led the visitor to a large stone monument as well as an
obelisk at the end of the enclosure. The pool was framed on either side by
upright stone slabs that had been elaborately carved with Arabic texts, not
figures. The words were attributed to Jumblatt and taken from lectures he
had given or written down. He exhorted the visitor to "learn the truth, and
it will free you" or instructed that "the truth alone prevails, not the error,
and the truth provides the road that leads to God."[22] The truth (haqīqa) is
considered the ultimate reality to which those of the Druze faith aspire;
it is a mystical dimension and can be translated as God or knowledge of
God.[23] Many words had faded, but there were repeated references to light
vanquishing darkness and the search for truth. This was a different story of
struggle and progress.

As I slowly deciphered the carefully carved lines of calligraphy, I noticed
one shape that stood out from everything else. Amid Jumblatt's lectures,
one stone relief featured several lines of text that framed four names under-
neath the prominent symbol of the cross: this was another grave marker.
The first quotation beneath the cross sounded familiar, and indeed it was
a verse from the New Testament, stating, "Verily I tell you, no one can see
the kingdom of God unless he is born again."[24] On the very bottom of the
same relief, two more sentences from the scriptures proclaimed that, "the
kingdom of God is within you" and "don't be afraid, for I have overcome
this world."[25] In between the New Testament references were the names of
members of a Christian family from the village of Fraydiss: Ibrahim Rafael
Ghannam; Rafael Ibrahim Ghannam; Marta, wife of Rafael Ghannam; and
Matilda Dawud Ghannam—ages 62, 34, 23, and 40, respectively. According
to my guide, these four had died as innocent bystanders during the intense
fighting in their village in early June 1958. Kamal Jumblatt had insisted that
they be honored alongside the Druze fighters and that their commemora-
tive inscription carry the cross alongside passages from the New Testament
that he had chosen. The Christian texts spoke of the promise of rebirth,
the next world, and confirmed God's presence within each individual—
ideas that resonate with Druze teachings. The grave markers in Beqata
propounded that there were shared principles beyond the face of ethno-
religious difference. Jumblatt had carefully quoted directly from the New
Testament and had even enclosed the sentences in quotation marks. Next

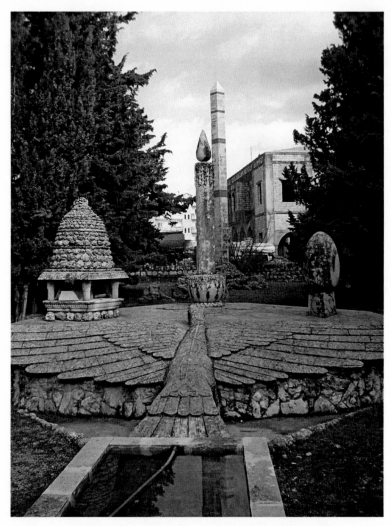

FIGURE 3.3. Eagle sculpture and symbols of world religions,
with obelisk in background, Beqata Martyrs Memorial, 2008.

to the Christian scriptures he had carved his own texts in order to point to
similarities in belief across religions. He thereby indicated that each reli-
gion had its own way at arriving at the ultimate, shared truth, which was
rendered visible in sculpted form at the end of the enclosure.

The narrow pool that divided the cemetery into two equal parts led the
visitor to a large stone sculpture depicting an eagle taking off in flight. The
tail of the bird was connected to the rim of the pool, and its body and spread
wings formed a semicircle. Another semicircle was attached to the eagle to

create a circular platform for an array of spiritual and religious symbols: a lotus flower, an egg, a burning candle, the signs of yin and yang, and a small replica of a Hindu shrine housing sculptures of Buddha, Jesus, Confucius, the Quran, and a Hindu divinity, all reflecting Kamal Jumblatt's syncretistic beliefs. On the day of my visit only the stone sculptures of Confucius and the Buddha were sitting on their small pedestals; the other three pedestals were empty. My guide explained, but refused to elaborate, that Jesus, the Quran, and the Hindu divinity had been removed because they were in need of repair. I inquired about the damage that had necessitated the repair, but he merely repeated, "They are repairing them" (*Byirja'u yisalhūhun*) and that the figures would be returned to their original site. Clearly this was not a subject he wanted to discuss with his foreign visitor. As I contemplated the serene Confucius sculpture on his pedestal proclaiming "The Golden Rule: Treat others as you would want them to treat you," I pressed no further.

I turned to examine the eagle sculpture more closely and noticed, along the bird's spine, a carving of a snake coiled around a staff which rested on a lotus blossom on its tail. This was no ordinary eagle. The head of the eagle faced toward the tall obelisk at the end of the enclosure. The obelisk, built from blocks of limestone, towered over the rest of the memorial. According to Wahib al-Bteddiny, the obelisk symbolized the "*kawkab astral*" or "spirit planet." The eagle picked up the souls of the dead from the martyrs cemetery, and then—here al-Bteddiny motioned with his right hand forward and upward, mimicking an airplane at takeoff—transported them to their final resting place in the universe.

COMMEMORATING THE MARTYRS OF 1958

Wahib al-Bteddiny, the only surviving designer of the three inscribed on the stone relief at the entrance of the cemetery memorial, granted me an interview in his palatial home in a neighboring village. A lively man, he gestured grandly while he spoke. First we sat in his large reception room in the main house, but later he walked us through his studio and gallery next door, which were the size of a warehouse. A prolific painter, mostly in oil and acrylic, he produced landscapes and portraits on canvasses of every imaginable size. When we began discussing the construction of Beqata's Martyrs Square, he took a pencil out of his pocket and drew a quick sketch of the entire memorial so he could better identify and explain each of the memorial's component parts.

In 1958 al-Bteddiny was in his late teens and worked as a stone mason apprentice for Karim Abboud. His task was to carve the martyrs' names

onto the grave markers. He told me that Kamal Jumblatt visited the construction site almost every day to speak with the workers and to develop the design. Thus there had been no master plan; the design simply evolved as the craftsmen created and placed different pieces. Although al-Bteddiny had had no formal training at the time, Kamal Jumblatt still asked for his input, as he recognized the young man's artistic talent.[26] Al-Bteddiny explained that Jumblatt had asked the relatives of the men who died in 1958 whether their bodies might be transferred from their village cemeteries to be laid to rest as a group of martyrs. Fifty-five families obliged, as well as the Ghannam family from Fraydiss.

On May 12, 1960, the second anniversary of the beginning of the 1958 Civil War and barely a week after Lebanon's official Martyrs Day, Kamal Jumblatt inaugurated his Martyrs Square in Beqata. The ceremony was attended by family members of the martyrs, residents of neighboring villages, and members of the PSP. In Beqata I met one individual who had attended the inauguration. Now in his late seventies, Jamil Saad ed-Din introduced himself as the head of the committee (al-lajne) that had been responsible for the cemetery and the annual celebrations.[27] It was his role, he told me, to help Kamal Jumblatt—whose photograph was prominently hung on the wall in the living room where he received me—to decorate the cemetery grounds and to invite villagers and relatives of the fighters to attend the ceremonies on each May 12. He was also one of a rapidly dwindling group of surviving fighters who had taken up arms in response to Jumblatt's call. He proudly remembered the days when men fought "rifle to rifle" (bunduqiyye a bunduquiyye), and he offered to locate the rifle he had fought with. I thanked him but suggested that we speak about the memorial, rather than the civil war, at which point he asked his granddaughter, who sat with us, to fetch "his book." This turned out to be a black, leather-bound, and obviously much used notebook whose pages were frayed and beginning to come loose from the binding. In his book Saad ed-Din had recorded each martyr's name, and he informed me that he would read all the names during the annual commemorative ceremony. He then began to turn the pages, carefully, and quietly read out some of the names, but then he stopped his personal reminiscing and turned his attention back to me.

I asked him to describe the ceremonies, and he explained that they would organize wreaths to decorate the graves and several speeches would be made. He was the master of ceremonies who welcomed everyone. Upon being introduced, Kamal Jumblatt would take the stage and praise the sacrifice of the fighters and the civilians, and *all* the Lebanese who had lost their lives during "the revolution" (al-thawra). Jumblatt would then call

for a moment of silence and remembrance. Saad ed-Din said that other surviving fighters would speak about their fallen comrades and publicly acknowledge that they had fought and died bravely. Saad ed-Din emphasized that the commemoration was for everyone who wanted to remember *al-thawra*. The commemorative date was May 12, when fighting broke out in Beirut, not May 13, when Jumblatt's forces attacked the presidential palace in Beit ed-Din or some other date that would have highlighted Jumblatt's role in 1958. He also said that Jumblatt could have built the cemetery on land he owned in his native Mukhtara but that he decided to buy a plot halfway between Mukhtara and Deir al-Qamar, Chamoun's hometown. He would not say if Chamoun supporters attended the annual ceremony, but he made clear that they were invited. Saad ed-Din said that he spoke concluding words at the end of the official ceremony and then everyone walked to the graves and spent some time in private reflection. It was a modest affair, Saad ed-Din told me, though in the early years about five hundred people from around the Shouf area and Beirut came to the ceremonies. It was an opportunity for the veterans of 1958 to reunite and reminisce.

When Jumblatt was assassinated in 1977 his followers held a ceremony in his honor at the Beqata memorial, although he was buried next to his family home in Mukhtara. Kamal's son, Walid, presided at several subsequent martyrs commemorations that now fused the memory of 1958 with the memory of Kamal Jumblatt's death. Jumblatt's memory—and the date of his assassination—was not the only event from the 1975–1991 Civil War that had an impact on Beqata's commemorative landscape. Ten more grave markers were added to the existing rows from 1958 by the families of Druze fighters whose sons had died in battles in the Shouf in 1976 and 1983. The new grave markers were identical in size and carving style to their 1958 predecessors. The more recent stones were less weathered, and it was easier to read the names on the rock face. But when I started to record the names of the more recent martyrs in my notebook, my guide interrupted me and shook his head, saying, "No, don't write those; these are not real martyrs." The addition of graves, an instance of commemorative accretion, had led to fierce debates between villagers who did not consider it appropriate to mix Lebanon's two civil wars and symbolically equate its fighters. For members of the old generation, like Saad ed-Din, the 1958 Revolt had been a fight for larger ideals than were at the root of the 1975–1991 Civil War. At some point during the 1980s—Saad ed-Din could not remember exactly when—the public gatherings stopped in Beqata, and they never resumed.

Saad ed-Din explained that during the much longer and far more damaging second civil war, people lost interest in the popular uprising of 1958,

and the cemetery began to fall into disrepair. The stone surfaces urgently needed cleaning and restoring, and some of the vegetation in the enclosure needed to be cut back. But he was too old to do it, and there was no money to hire someone else. So the cemetery memorial had become a public park mostly frequented by village youth, who, Saad ed-Din told me, lacked respect for the site. I assumed he referred to the various acts of vandalism that had damaged the goose, the Syrian flag, and possibly the missing statues of the world religions. The site that had honored the heroic struggles of Saad ed-Din's youth had become a playground for the new generation. As the generation of fighters aged and a second civil war drew the attention of political elites away from the events of 1958, Beqata's memorial was slowly forgotten by the public.

BEQATA'S VISION OF TRANSCENDENCE

Beqata's Martyrs Square honors men loyal to Kamal Jumblatt, who fought on his side during the 1958 Civil War. Yet the site's commemorative focus is neither the battlefield nor is it Arab nationalist victory or defeat. While honoring the sacrifice of men who had fought "rifle to rifle," the memorial also recognizes civilian victims. It is significant that Fraydiss, where Jumblatt's troops enjoyed a military victory, is also remembered as a site of civilian loss. Moreover, military struggles are only a part of larger spiritual struggles. Influenced by his readings in Eastern philosophy as well as Druze belief, Jumblatt's memorial tells a story of the efforts of those who found themselves in darkness, whether colonial oppression or a personal state of ignorance, to reach the light. Jumblatt went to great lengths to indicate that individuals traveled on different roads to pursue "the truth." Influenced by Marxist ideas, he was certain that only one direction allowed individuals to move forward, and his memorial tells a linear story that starts at the beginning of time with the creation of the sun and the earth and ends at the *kawkab astral*. But along that uni-directional narrative, ancient Egyptian symbols stand beside dinosaurs, the New Testament beside Druze spiritual writings, and Druze martyrs next to Christian martyrs, as the eagle carried the souls of all heavenward. Thus Arab nationalism was depicted not as an end in itself but as a means to the larger spiritual end.

Kamal Jumblatt used his "power of 'world-making'" to embed a particular Lebanese struggle within multiple strands of human history. His worldview was not shared by orthodox Muslims or orthodox Christians (and not even by all Druze), but that does not mean that his memorial should be dismissed as a fanciful oddity. Instead, it should surprise us

that at the heart of his carefully planned and executed memorial lies the attempt to reconcile ethno-religious differences and to bury both Druze and Christian martyrs next to each other. Symbolically he reconciled not only two of Mount Lebanon's main religious communities but also five major world religions, Darwinism, socialism, and Arabism. Though Jumblatt's fusion of religion, science, and spirituality was certainly unique, I argue that his underlying agenda—acknowledging ethno-religious and national boundaries while finding the spirit that transcends all—was not. I also contend that the choice of the cemetery location was significant, as it laid the martyrs to rest in an area that had not yet been built and that therefore did not belong to any one clan or family. The memorial's intended audience was not just Druze. It certainly appealed to members of Lebanon's left-leaning Arabist parties more than to those who had defended Chamoun in 1958, but it was not merely a story of Druze revolt. The stone reliefs portrayed an Arab, male, class-based solidarity that spanned the map of the Middle East, but it left nation-state borders intact. Beqata's martyrs were remembered as having sacrificed their lives for multiple yet interconnected struggles and ideologies, and, in the end, everyone's spirit transcended the boundaries of life in this world as their souls united in the next. The Lebanese popular uprising of 1958, and the nation that the revolutionaries sought to create, represented one step toward that ultimate and final union.

In the aftermath of a short but bloody war that had pitted Jumblatt and Chamoun loyalists against each other, particularly in the Shouf area, Jumblatt sponsored a site that was built communally, displaying the spirit of local Druze and Christian solidarity. At the entrance of the memorial, the list of the craftsmen and laborers show that Druze and Christians worked together. The speed with which the memorial was completed is evidence that people worked well together, and if there were disagreements about the design or execution of the work, they were solved quickly. Anja Peleikis, who conducted ethnographic fieldwork in a village in the Shouf in the 1990s, reported that her interlocutors would nostalgically remember the days before the 1975–1991 Civil War when Druze and Christians would celebrate each others' births, weddings, and funerals, when women would meet at the well to wash clothes and exchange gossip, and when everybody joined in to dance the *dabka,* a traditional village dance.[28] The Beqata Martyrs Square is another, material manifestation of this need to remember the peaceful coexistence of ethno-religious groups in the Shouf, especially after civil war. The memorial's team of craftsmen embodied and applied traditional (artistic) knowledge, transforming rocks from local quarries

into markers of sacrifice. The memorial made visible the deeper, underlying values shared by the residents of the Shouf.

Those shared values included an appreciation for poetry and stonemasonry. The craftsmen rendered calligraphy beautifully on their rock surfaces. Some carefully added colorful stone inlays to reliefs using a mosaic technique. Upright stone reliefs are part of a larger ancient Near Eastern artistic canon. A fountain and a reflection pool, a feature of many wealthy Arab homes, were important parts of Bequata's cemetery and memorial architecture. The entire enclosure shows a symmetrical design, involving both natural and built components to create a symbiotic whole. The memorial showcases some of the best of Lebanon's artisanal traditions. The multiple elements within the memorial itself created a strong central axis that symbolized the passage of time but also the memorial's narrative thread. The central story that began with the egg of life and ended with the spirit planet incorporated side stories that were written separately, a technique not unlike the one found in the classic *1001 Nights*. Finally, two of the stone reliefs which tell the story of Arab solidarity and Arab struggle feature the faces and bodies of Arab men. The most prominent and immediately recognizable face is that of Nasser. Similar to the sketches of the 1916 martyrs, he appears in portrait form: he is the head, the leader, of a larger movement. Nasser is followed by four ordinary Arabs in traditional garb, barefoot, rifles in hand. The faces of the 1958 fighters show idealized features of young and old determined men, their bodies tall and in motion. They represent an Arab world mobilized by nationalist, secular, and socialist ideals, yet they remain tied to their traditions, as represented by their dress. In other words, the memorial makers made deliberate artistic choices that wedded traditional artistic genres to modern political ideas, demonstrating that one did not have to give up one in order to obtain the other.

Kamal Jumblatt was an important political leader on the Lebanese stage who took the initiative to commemorate the dead of the 1958 Civil War when none of his colleagues in Beirut would. He designed his Martyrs Square at a time when there was no martyrs memorial in downtown Beirut, a fact he doubtlessly was aware of. The men who were commemorated in Beqata had fought for the idea of Arabism, similar to most of the martyrs of 1916. Like King Faysal in 1920, Nasser challenged the Western powers; his defiant stance and repeated military action, rather than military victories, earned him widespread popularity across the Arab world and inspired many to rise up against old political structures. Nasser's ideas certainly fueled Lebanon's 1958 Revolt but could only do so because of existing discontent in Lebanon. Similar to the martyrs of 1916, who were united in

their opposition to the Ottoman Empire, the martyrs in Beqata were united in their opposition to the Chamoun government which received U.S. support. The main ideological fault line that divided the opposing camps during the 1958 Revolt was the question of alignment: Should Arab countries align with Western political powers and accept their cultural values, or should they seek alternatives? Were there workable alternatives? Because of the existing distribution of political power, the camps identified with either Maronite President Camille Chamoun or Druze MP Kamal Jumblatt and other Muslim UNF leaders. Chamoun loyalists, moreover, defended and Jumblatt loyalists wanted to change Lebanon's political status quo. Yet that story does not appear in the commemorative narrative in Beqata. If there was a lesson to be learned from the cemetery memorial, it was that Muslim and Christian differences would ultimately be overcome.

RE-REMEMBERING THE MARTYRS IN DOWNTOWN BEIRUT

During the time the 1958 Civil War was fought and Beqata's Martyrs Square was conceived and built, Beirut's Martyrs Square remained symbolically empty. After several years of debate and controversy, a decision had been made in 1957 to erect a monument of two giants holding a torch, designed by Sami Abdel Baki. It was to be executed by Italian sculptor Marino Mazzacurati (1907–1969). Mazzacurati's credentials, besides his traditional Western art training, included a bronze sculpture of Riyad al-Solh, Lebanon's first prime minister after the departure of the French and one of the makers of the National Pact.[29] Al-Solh's statue was unveiled in 1957 by President Chamoun within walking distance of Martyrs Square in a plaza that was renamed Riyad al-Solh Square in his honor.[30] The statue was praised by members of his immediate family and by the public for capturing his exact likeness. Indeed, he looked alive on the pedestal and about to shake hands and start talking to a person in front of him. The bronze was mounted on a marble pedestal decorated with a two-dimensional bronze relief of a woman in toga-like dress, raising a flag with her right arm in a gesture reminiscent of Eugène Delacroix's famous painting, *Victory Leading her People*. Having successfully rendered one of Lebanon's 1943 independence heroes, Mazzacurati seemed well qualified to sculpt another monument of national significance. Two years into his presidency, on May 6, 1960, Fouad Shehab unveiled Mazzacurati's work. The memorial, however, did not display two giants and a torch. There was a torch but it was in a woman's hand, and she towered over three men.

Mazzacurati had changed the design, which now consisted of four separate bronze figures that were installed on a multi-tiered pedestal and

foundation structure. On the top level a female bronze in long flowing robes lifted a torch, and to her left stood a youthful male dressed only in a loincloth wrapped around his middle. Together the two represented the allegorical pair of Liberty and the Nation. On the lower level of the pedestal two youthful males were lying on the ground, dressed in simple shirts and pants, and both body postures suggested that they were struggling to get off the ground. The struggling two bronzes were installed on a pedestal in front and in back of the standing pair, and they presumably represented the martyrs of 1916.

While Liberty held up her torch with her right arm, her left arm, held waist-high, reached around the young man beside her roughly at the height of his shoulders. A separate piece of cloth, part scarf, part cape, was draped around her neck and cascaded down her torch-bearing arm, then wrapped itself around her left arm, across her back, and ended up enveloping her waist, as if it was a large, decorative belt. The fabric of the wrap around her middle looked similar to that of the loincloth around the young male beside her. The flame of her torch as well as her short curly hair seemed to flutter in the wind, a movement also captured in her flowing robes. Her right foot stepped forward, making her appear dynamic and strong, and she was about one head taller than the young man. The Nation stepped forward with his left leg, mirroring the movement of Liberty. He stretched both his arms slightly away from his body as if to steady himself. Because of his position on the pedestal, his right arm reached behind Liberty, his hand hovering quite close to her upper thigh. His bare upper torso, as well as his bare arms and legs, showed an athletic, muscular body modeled on classic Greek sculpture. Both figures looked straight ahead. Neither of the bronzes actually touched each other; although it looked from afar that Liberty held the Nation in her embrace, her free left arm motioned upward, her left palm turned forward (see figure 3.5).

The two young men on the lower portion of the pedestal, at the feet of the allegorical couple, had apparently fallen or been thrown to the ground and were struggling against an invisible enemy. Dressed in civilian clothing, they stretched out sideways and appeared to be asking for help. The man in front of the couple had his left hand firmly planted on the ground and pushed the top of his body upward while stretching out his right hand to an imagined person in front of him. His gaze followed the outstretched arm and his lips were parted, as if speaking. His short curly hair was combed backward. His simple long-sleeved shirt was half-unbuttoned, revealing part of his chest. His long pants covered his legs but his feet were bare. His companion lay in the opposite direction in the back of the allegorical pair,

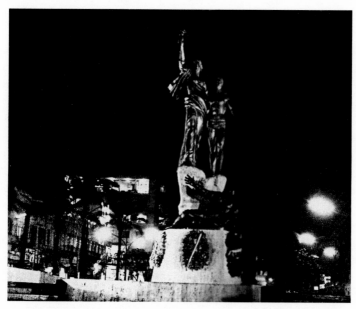

FIGURE 3.4. Marino Mazzacurati's Martyrs Memorial, Beirut, undated.
Reprinted with permission of Dar an Nahar, Beirut.

his head opposite the feet of the sculpture I just described. The second male was similarly dressed, only his shirt was entirely unbuttoned and had fallen off his left shoulder. Both arms were tied behind his back, which made his neck and head crane backward. Without the help of his hands, he had managed to push himself up on his left elbow, so that his upper body also came slightly off the ground. His gaze was trained on an imaginary person towering above him. While all four sculptures shared the same facial features and dynamic body postures, they were clearly part of different worlds. The two reclining men represented actual struggle, and the standing figures represented the values that made their struggle worthwhile.

The new memorial now rested on an elevated square platform; two stairways permitted access from all sides of the surrounding sidewalk. The memorial had been moved from the perimeter to the center of the square, which meant that the statues were now framed on either side by greenery that protected them from street traffic. Postcards with a picture of the square in the 1970s show lines of taxis and busses parked all around Martyrs Square, but the memorial stands on its own island, unperturbed by the city life surrounding it. Not only was the memorial larger and more imposing than its predecessor, but it was also more prominently staged. The foundation of the memorial had been built over the footprint of the

sunken pool and fountain that had once been in the middle of Martyrs Square. Whereas steps had led down from the street to the pool, now two stairways led up to the platform on which the memorial was staged. Those who passed the square looked up to it, and those who visited ascended the stairs toward it. In other words, the new sacred landscape now invited a different bodily interaction with the memorial and its surroundings.

In contrast to Yussef Hoayek's sculpture of two women in local attire, Mazzacurati's bronzes had foreign features. The allegorical pair belonged to the artistic genre of classical European statuary: both male and female figures were youthful, strong, and muscular, although only the male figures revealed the muscle tone of their arms, legs, back, and chests. The Nation resembled a Greek athlete waiting to receive his laurels after winning a competition. The two struggling martyrs had facial features and hair styles similar to the allegorical pair, and, like the Nation, their chests were revealed, their efforts to raise themselves having resulted in partial undress. Their attire marked them as peasants or workers in early-twentieth-century Europe. Whereas the Hoayek statue had stood in perfect balance, the four statues of Mazzacurati did not match in size. The allegorical woman was not only elevated at the top tier of the pedestal but her entire body was about twelve inches taller than her companion.[31] The two men lying at the couple's feet were larger in size compared to either Liberty or the Nation. Yet it was not only the lack in symmetry that attracted the critics. The next day the headline in *Al Nahar* read, "The Monument of Martyrs Square is a beautiful work of art, but it does not represent—either from close up or from far away—the martyrs of May 6."[32] Whereas Hoayek's sculpture had caused discontent because the Muslim and Christian statues purportedly symbolized shame (*dhull*) and submission (*khunū'*), thereby misrepresenting Lebanon's independence heroes, Mazzacurati's was blamed for not representing the Lebanese at all.[33]

Mazzacurati valiantly defended his artistic choices in a full-page article in *Al Nahar* after the inauguration of his memorial. Here he stated that the statues were indeed differently proportioned but that it was intentional. He had factored into his artistic calculations that the viewers' gaze would move upward, following the vertical lines of liberty and the nation, and therefore he needed to break the forceful ascending lines with strong horizontal counterpoints, namely, his two large reclining males. Moreover, he claimed, that it had taken him thirty months to complete the memorial. Before casting the memorial in his studio in Italy, he had traveled extensively in Lebanon and had taken hundreds of photographs to accurately capture the features of Lebanon.[34] From all his photographs, Mazzacurati concluded that Lebanese were Mediterranean people who resembled

Southern Italians or Greeks and that therefore his sculptures were representative. From his perspective, he had rendered the martyrs for Lebanese independence perfectly. Simply put, Mazzacurati did not disagree that his sculptures bore non-Lebanese features but instead made that his strong suit. The Lebanese formed part of a Mediterranean phenotype, and their features resembled his sculpture more than they seemed to be aware of themselves. This line of argument justified why Lebanon's independence heroes had lost their "Arab face."

There are reasons to doubt Mazzacurati's narrative of extended research into Lebanese features. There is some evidence supporting the assertion that the Italian sculptor had not created the Martyrs Memorial specifically for Lebanon but assembled the group from statues available in his studio.[35] The struggling men on the lower pedestal closely resemble another bronze that is part of a memorial in Parma, Italy. There the young man who struggles to raise himself from the ground with his hands tied behind his back honors the local resistance fighters against Mussolini's fascist regime.[36] The Parma memorial is dated 1956, which would have been about the time that Mazzacurati was working on the statue of Riyad al-Solh, and possibly began negotiations for his second Lebanese commission. But it seems that the figure of Liberty was sculpted specifically for Lebanon, because smaller casts of the same sculpture are still sold on the international art market under the Italian title "*La Vittoria, Monumento ai Martiri del Libano.*"[37]

We have no records that explain why Mazzacurati did not render Abdel Baki's design of the "Two Giants." Abdel Baki himself alleges improper dealings on the part of unnamed government officials who kept part of the money to pay Mazzacurati for the execution of his design, which then forced the sculptor to find a less expensive alternative. Obviously Abdel Baki had an axe to grind in this case, since he felt his designs were wrongfully cast aside—twice! But we do not know if the Italian artist ever saw Abdel Baki's original sketch, which required the casting of two semi-nude, muscular male bodies. There is no reason to believe that Mazzacurati was unable to do it. Mazzacurati must have been aware of the local demands for a larger and more heroic replacement of Hoayek's "two crying women," since he did deliver a victory memorial.

Whereas Abdel Baki's statues would have eliminated the female figures from public view, Mazzacurati retained one female and made her the central and most imposing component of his ensemble. While she remains both modestly and fashionably dressed in a long robe, not unlike her two predecessors, her posture differs significantly. Compared to Hoayek's stoic Christian and Muslim women, Mazzacurati's Liberty is in motion, her

body leaning forward and upward. She proudly flourishes her torch in the air, as if providing a guiding light to the young companion who follows her. Allegories are the artistic answer to representing what cannot actually be shown. The female body as allegory became popular in Europe as monarchies tumbled along with actual heads and statues of kings. Allegories of liberty would in many cases take the king's place on the same pedestal, thereby demonstrating that a new regime had begun.[38] In the case of Lebanon, the allegory of liberty replaced two other female statues, which had represented balance between ethno-religious communities. By losing the local reference point, Lebanon's national symbol had become more modern and more European. The message was that a modern nation moved beyond attachments to ethno-religious differences.

The European features and the European maker of the memorial gave rise to a storm of criticism, both at the time of the inauguration but also many decades later. Protests from local artists in 1960 elicited a rather defensive response from representatives of Beirut's municipality: "Not every artist, regardless of his talent, can execute bronze statues if that is not his specialty."[39] Decades later, Lebanese journalist and historian Samir Kassir, who had deplored the disfiguration and disappearance of the Hoayek statue, wrote a scathing critique about its successor, stating that it came out of a Western lineage of "pompous classicism" and reflected "nationalist pride."[40] The Lebanese sculptors I was able to interview at the Center of Lebanese Artists for Sculpture and Painting said that the decision by Lebanon's political elites to select a foreign artist to sculpt Lebanon's national symbol was evidence for their disdain of local talent. They used the expression "kill frinji brinji," which roughly translates as "everything foreign is desirable" or "we prefer anything foreign." I had heard that sentence previously in conversations about Lebanese consumption patterns. Friends would say to me that the Lebanese would buy anything as long as it was produced in Europe or the United States.

Within the context of rising sentiments of Arabism, and a government perceived as beholden to Western interests, the choice of a Western artist and Western iconography for the new martyrs' memorial in Beirut was significant. It was even more so, of course, if we compare it to the locally produced Martyrs Square in Beqata in the Shouf. Mazzacurati's memorial was evidence of the ever strengthening ties between Beirut's elite and Western markets, and the former's increasing disconnect from Lebanon itself. According to Partha Chatterjee, members of postcolonial political elites were split between their desires for what he calls the "material domain," reflected by Western tastes and Western economic achievements, and the

"spiritual domain" of beliefs and practices that capture local traditions.[41] They want both but often end up with neither. In Lebanon, different elites placed themselves firmly in either domain through their memorial design choices. Beiruti elites championed the "material domain," and Kamal Jumblatt—fluent in European political and scientific thought—remained a strong proponent of the "spiritual domain." Whereas the faces of two Lebanese mothers disappeared to make way for Liberty with a Mediterranean face, the cemetery in Beqata displayed fearless Arab faces ready to revolt. The ideological differences that had come to a head during the 1958 uprising manifested themselves in the artistic choices of martyrs' memorials, inaugurated one week apart in 1960.

LEBANON AND BEIRUT'S MARTYRS SQUARE BETWEEN CIVIL WARS

The 1960s and early 1970s have been described as Lebanon's "best years," its "Golden Age."[42] President Fouad Shehab and his successor, Charles Helou, were skillful mediators between the different Lebanese communities, and both left their posts without attempts at (unconstitutional) reelection. Shehab initiated reforms that began to turn Lebanon from a laissez-faire economy into a welfare state. He substantially increased the number of available government jobs. The gross domestic product (GDP) per capita rose from $370 to $660 between 1960 and 1971.[43]

Yet these economic data hide the increasing income inequalities in Lebanese society. During Shehab's rule, about 50 percent of the labor force was still in agriculture, producing only 10 percent of the GDP, while 30 percent of the labor force in the service sector produced more than two-thirds of the country's GDP.[44] In other words, urban areas were significantly wealthier than rural areas. As a consequence, rural-to-urban migration increased dramatically, creating a poverty belt around the city of Beirut. During the late 1960s and early 1970s Lebanon's trade deficit climbed into billions of Lebanese lira as a result of Lebanese proclivities to consume foreign goods. In addition to these sobering economic developments, the Arab-Israeli war of 1967 significantly impacted the southern regions of Lebanon. Although the Lebanese army did not take part in this war (and in the Arab defeat), it brought additional numbers of civilian refugees and armed guerrilla groups to the country (more on that in chapter 4).[45] Between 1967 and 1975 the cost of living in Lebanon doubled. Unemployment rates, especially in the agricultural sector, skyrocketed.[46] Left-leaning, class-based political movements grew and formed a loose alliance called the Lebanese National Movement (LNM), whose leadership was predominantly Druze, Sunni,

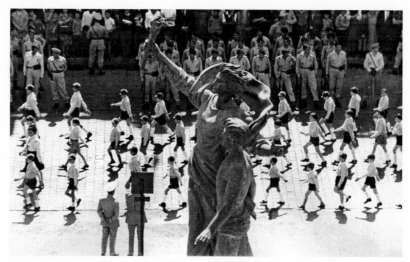

and Shiite. Like most left-leaning organizations worldwide, the LNM expressed strong solidarity with the Palestinian cause. In response, more conservative elements in Lebanese society gathered to form the Maronite-led Lebanese Front (LF).

During the 1960s and early 1970s the Lebanese continued to commemorate May 6 in downtown Beirut. Soldiers filed by the president, military and police marching bands played the national anthem, and scouts paraded through the streets. Government officials and representatives of the LCM gave their speeches about independence and heroism, and representatives of civic organizations deposited their wreaths next to the Mazzacurati statue. Schools, banks, and offices closed every year on May 6. Older Lebanese citizens told me their childhood memories of May 6, which involved either going to the square or sitting at home watching the ceremony on television, because they knew that the next day their teachers would ask them to write an essay in class about the ceremony as well as the history of 1916. In other words, the story of shared sacrifice of Muslims and Christians remained a pertinent one, even after the 1958 Revolt, when a coalition of Muslim forces fought predominantly Maronite supporters of President Chamoun. May 6 rituals became part of Lebanese collective memory, inculcated through public performances of civic duty and sacrifice.

But as the official rituals continued, Martyrs Square changed. Many of the shops that had been located downtown in the areas around the Martyrs Memorial moved to new, trendier neighborhoods. Urban planner Angus

Gavin compared what happened in Beirut to urban flight in the United States, which left many inner-city neighborhoods blighted.[47] As shops and shoppers left Martyrs Square, the area became a popular staging ground for student and labor demonstrations, demanding independence for the Palestinians and Algerians.[48] Compared to the lively protests by Lebanon's youth in response to current events, May 6 celebrations looked routine and uninspired. Despite having acquired a more heroic look and grander design, Lebanon's Martyrs Memorial did not generate much popular enthusiasm. Nobody I asked in Beirut could tell me with certainty when the last May 6 celebration took place in Martyrs Square, but most assumed that the commemorations stopped with the outbreak of Lebanon's civil war in 1975.

LEBANON'S CIVIL WAR AND THE "WOUNDING"
OF THE MARTYRS MEMORIAL

Lebanon's 1975–1991 Civil War was devastating. The violence resulted in an estimated 144,000 persons killed, 184,000 wounded, 100,000 displaced, 17,000 disappeared, and about 800,000 who fled abroad; the infrastructure damage and cost of lost revenue was estimated at $18 billion.[49] The reasons given for the war and its duration are multiple, but they fall under three main lines of argument. One theory holds that foreign powers, namely, the Palestinians, the Israelis, and later the Syrians, took control of Lebanon to pursue their own agendas: the liberation of Palestinian territory and the defense of the Israeli state or the annexation of Lebanese territory to Syria. Proponents of this point of view claim that the civil war was actually a "war of others."[50] The second theory maintains that the violence was the inevitable outcome of glaring political and economic inequalities within Lebanese society that led to unrest and, finally, armed struggle.[51] The third theory combines elements of the two previous ones, claiming that the civil war was a "war of others" but that Lebanese militias, not foreign forces, were "the others." Driven by their own political agendas and plain greed, these militias took control of the country and imposed a reign of terror on Lebanese civilians.[52] The militias established the war's sectarian reputation, as they created "closed and semi-closed enclaves. In the 'Christian areas' the militias spread slogans of a 'Christian republic,' 'Christian security,' federalism and partition. In the 'Muslim areas,' the emerging radical Islamic movements raised the slogans of an Islamic republic."[53]

Unlike other civil wars in which two main camps oppose each other over a set of core issues, Lebanon's civil war was waged by numerous participants, many of whom changed their objectives and alliances. Over the

sixteen years of the war former allies became mortal enemies, and ideological goals gave way to looting and personal enrichment. Foreign powers, including Iran, Iraq, Syria, Israel, Italy, France, and the United States, were involved at different stages and with different, at times shifting, agendas. Several peace proposals and cease-fire agreements were brokered and broken.

Finally, a Saudi-sponsored Document of National Accord, known as the Taif Agreement, was negotiated and signed by members of Lebanon's parliament who had been flown to the Saudi resort town of Taif in 1989. The agreement reiterated most of the articles of the 1926 Constitution and the principles of the 1943 National Pact, yet it was agreed that seats in Parliament should be evenly distributed among members of all Muslim communities and all Christian communities, and that the powers of the Maronite president should be reduced in favor of the Sunni prime minister's. After the signing of the Taif Agreement, Lebanese army general Michel Aoun commanded his troops to attack the Syrian army to force them to leave Lebanon in the so-called War of Liberation (*harb al-tahrīr*). He also attacked his immediate rival for leadership of the Maronite community, Samir Geagea who led the Lebanese Forces, in the so-called War of Elimination (*harb al-ilghāʾ*). At the same time both Amal and Hizballah forces engaged in deadly clashes in southern Lebanon and the southern suburbs of Beirut. The Syrian army defeated General Aoun in October 1990, and Aoun went into exile in France. It took several more months to disarm the militias. Hizballah refused to lay down its weapons, declaring it still had to liberate Lebanese territory from Israeli occupation. Other militia leaders only agreed to turn in their weapons after they had been promised amnesty that would protect them against charges of war crimes. Lebanon's parliament officially approved the postwar Amnesty Law on August 26, 1991, effectively ending the civil war.[54]

In the course of the civil war Beirut's Martyrs Square became the physical as well as metaphorical fault line of the struggle, as rival factions, entrenched in buildings on either side of the martyrs memorial tried to kill each other. The so-called line of confrontation (*khatt a-tamaas*) that ran through the middle of the square became a dangerous crossing point between neighborhoods on either side of it, causing Christian Lebanese to migrate to "their" neighborhood in East Beirut and Muslims to "their" neighborhood in West Beirut so as not to expose themselves and their families to the arbitrary whims of militia men at the checkpoints. In the Western media, the battle line through the center of Martyrs Square was called the "green line." What made a line of confrontation green was the unchecked growth of vegetation,

so that by the end of the war shepherds would take their sheep to graze below the pedestal of the Mazzacurati statue.[55] In the course of the war all four Mazzacurati statues were riddled by sniper fire. Moreover, the arm of the young man representing the nation was ripped off below the elbow by an explosion, and his right arm was neatly sawed off and disappeared. Further, the bronze material corroded, and bird excrement and dust changed its color from a shiny black to a matted rusty gray.

MEMORIES OF CIVIL WAR AND THE QUESTION OF AMNESIA

In the aftermath of this traumatic civil war, Lebanese sociologist Samir Khalaf diagnosed his fellow Lebanese citizens as suffering from "a pervasive mood of lethargy, indifference, and weariness," which he labeled "collective amnesia."[56] Subsequently other Lebanon scholars tried to verify Khalaf's assessment, and they came up with a different picture. There was widespread production and circulation of war memories, as private citizens and civic institutions produced art, films, novels, and academic symposiums to discuss the reasons and outcomes of the sixteen-year armed conflict.[57] A public memorial to the civil war was created by the Lebanese army, whose units had disintegrated by the late 1970s and whose soldiers had joined the various militias instead. Built right beside the presidential palace, the army memorial displays several tanks stacked on top of one another encased in concrete, and thereby obsolete. Moreover, first-person narratives of militia fighters were published. Admittedly few, yet widely read, these confessionals clearly showed the immoral and dehumanizing aspects of civil war. Asad Shaftari, a commander of the Maronite Lebanese Forces, publicly asked for forgiveness, when he wrote: "I apologize for the ugliness of war and what I did during the civil war in the name of Lebanon, or the cause, or Christianity. I apologize for considering myself a representative of these concepts."[58] A less redemptive but probably more widely read confession came from the bodyguard of Lebanese Forces commander Elie Hobeika, who published his book *From Israel to Damascus* under his nom de guerre "the Cobra."[59] In the book he disclosed a host of sordid details of Hobeika's activities as militia leader, including extortion, torture, kidnapping, and murder, as well as a long list of his alleged mistresses. The book dispelled any notion of the war's transcendent value such as liberty or the defense of freedom. Robert Fisk's detailed civil war analysis, *Pity the Nation,* became a postwar bestseller in Lebanon.

As texts and images about the civil war proliferated in various media, most scholars agreed upon two categories of amnesiacs: urban planners and

political elites. Eighty-five percent of war-torn downtown Beirut, including Martyrs Square, was simply razed in order to be "redeveloped."[60] For Samir Khalaf and others, this postwar urban erasure proved that the Lebanese simply wanted to forget.[61] Lebanese politicians went on record that no civil war memorial would be built.[62] The person who was a target for both strands of critique was Rafiq Hariri, Lebanon's prime minister from 1992 to 1998 and again from 2000 to 2004. Hariri championed the reconstruction of Beirut via the "master plan" of a private redevelopment corporation called Solidere (*Société libanaise pour le développement et la reconstruction*).[63] Less often discussed is that Hariri also spearheaded the restoration of the 1916 martyrs cemetery and martyrs memorial, and that he believed that those had become fitting memorials to Lebanon's civil war.

Hariri had risen from modest beginnings in the southern city of Sidon to the position of Lebanese prime minister via a meteoric business career in Saudi Arabia. Trained as an accountant, he moved to Saudi Arabia in 1964 to find work, as did many other Lebanese. During the first few years he worked for several smaller firms but joined in on a high-profile hotel construction venture for the Saudi king in 1976, which, when completed on schedule in 1977, earned him the king's friendship, Saudi citizenship, and a slew of additional contracts. By 1982 he was a multibillionaire and one of the richest men in the world. Fouad Saniyora, who went to school with Hariri and would succeed him in the position of prime minister, described Hariri's success by saying, simply, that "he was at the station when his train came in."[64] As his fortune grew, Hariri began to support charitable causes in his native Sidon. During the civil war he became involved in politics, first as envoy of the Saudi king but gradually on his own accord. Hariri helped negotiate several of the failed peace treaties as well as the final Taif Accords in 1989. In 1992 he was elected prime minister of Lebanon, both because of his political connections and his wealth. He also took over the leadership of the Council for Development and Reconstruction (CDR), an independent consultative body that had been created—prematurely—in 1977 to oversee the city's reconstruction. Fifteen years later the CDR—which became better known by its French acronym Solidere—actually began to work.

Nicknamed "the bulldozer," both for his background in construction as well as his forceful personality, Hariri made the reconstruction of downtown Beirut his first priority. His theory was that if the business center of the city was rebuilt, economic growth and prosperity would return and benefit all of Lebanon. Under his supervision, Solidere became known as a "super-ministry" where planning decisions were made very quickly,

sidestepping the parliamentary process.[65] Citing famous Prussian military theorist Carl von Clausewitz, Lebanese social scientist Joe Nasr called Solidere's way of conducting business a "continuation of war by other means."[66] Yet Hariri's determined pursuit of the future got tripped up by the past. In the course of cleaning Martyrs Square of rubble and debris and preparing it for construction, his work crews found ancient ruins.[67] Between 1994 and 1997 excavation teams unearthed remains of markets, residences, and fortification walls from the Paleolithic to the Ottoman periods. In Martyrs Square, in particular, excavators found the foundations of the medieval city's watch towers which had given the square its popular name, as well as parts of the foundations of both Fakhr Ed-Din's palace and the "Petit Serail" which had housed the Lebanese government during the French mandate.

With his reconstruction plans in downtown Beirut slowed to a halt by pre-modern history, Hariri turned his attention to Lebanon's more recent past. In the spring of 1994 he gave orders to clean up and restore the neglected and overgrown cemetery of Lebanon's 1916 martyrs. A construction crew moved in to build a protective wall around the overgrown and forgotten graves, which I had seen during my visit in 2008 (see Fig. 2.2). The crew completed the raw structure of two walls, but then, for reasons unknown, abandoned the site, leaving most of their construction equipment behind. Before they left, they installed a plaque that prematurely and incorrectly announced: "The repair of the graves of Lebanon's martyrs was completed (*tamma tahīl muqābir*) in the era of Prime Minister Rafiq Hariri, May 6, 1994." In the spring of 1995, Hariri proposed to parliament that the Lebanese resume their May 6 martyrs commemorations in downtown Beirut.[68] In addition to honoring the sacrifice of the 1916 martyrs, he proposed that May 6 also commemorate the civilian victims of the civil war. Since many of the 1916 martyrs had been journalists, he suggested that the downtown memorial honor, in particular, the eighty-three journalists who had died reporting on the civil war. In preparation for the post–civil war May 6 ceremonies, he announced he would have the Mazzacurati statues restored.

Hariri's public announcement was published in the press beside an editorial justifying the transformation of Mazzacurati's statue from a sculpture memorializing independence to a site honoring civil war victims by arguing that "bullets had transformed the symbol into reality and made the statue a martyr himself."[69] The metaphor of the living statue was picked up by other writers and continued to appear in print through March 1997, when the newspapers reported the miraculous recovery of the "Nation's" missing right arm. Wrapped in a large sheet of plastic, the severed limb

reappeared in a corner of a parking lot. The newspapers reported that Lebanon's security forces received a call reporting something "unusual" (*ghayr tabi'i*) in an empty neighborhood lot in Beirut. On the site, to their great surprise, they found a bronze body part "as if it had been waiting for the war to be over, so it could come back in search of the body from which it had involuntarily been separated."[70] Not only had the statue come alive, but so had its individual body parts. The police passed the recovered arm on to Solidere. Rafiq Hariri instructed Solidere employees to look for experts who could reattach the arm and make the necessary repairs to the remaining bodies of all four bronzes. After launching several inquiries, they decided to hire a team of restoration specialists in the Department of Sacred Art at the Maronite University of the Holy Spirit at Kaslik in the town of Jounieh.

The Department of Sacred Art's main area of expertise is the subject of sacred Christian art. The department's faculty teaches students both to create original sacred art as well as to restore existing icons, mosaics, and stain glass windows. In other words, the department was created to preserve the heritage of Eastern churches.[71] Subsequently its mandate expanded, as its restoration expertise was applicable to historic artifacts more broadly. When I asked the director of the program, Professor Abdo Badwi, about his work, he stated that it was his job to preserve Lebanon's national heritage in the broadest sense, Christian and non-Christian. Yet, when I visited his studio, all his work benches and easels were filled with Christian icons. Whether or not it was Hariri's intention, by putting a Maronite university in charge of this high profile restoration project—a university with a reputation for promoting a fierce Christian separatist ideology during the 1975–1991 Civil War[72]—the Sunni prime minister (re)infused the memorial honoring the independence martyrs of 1916 with the symbolism of Muslim and Christian coexistence that its Italian maker had stripped from his bronze design.

Over the course of ten months the restorers from the Department of Sacred Art first experimented with different restoration techniques, and then gradually removed rust and corrosion both from outside and inside each statue. Lebanese newspapers monitored the progress of their work, referring to the statues as hospitalized patients undergoing medical tests and surgery. Reporters also briefed the public on the discussions between the restoration supervisor Issam Khayrallah and the British consultant Robert Harris about the best possible course of treatment. In particular, the men disagreed about the restoration of the shrapnel "wounds" in each statue. After they had cleaned the surfaces of the bronze bodies, the

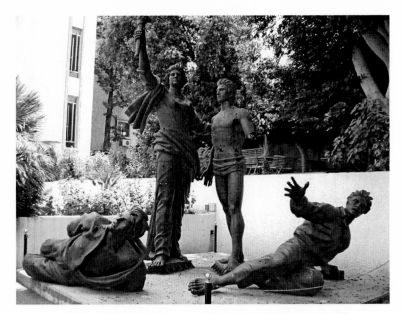

FIGURE 3.6. Restored Mazzacurati statues at the University of the Holy Spirit at Kaslik, 2003.

question arose as to whether they should preserve the bullet holes or fix them. Khayrallah was in favor of restoring the statues to their original state, which would have involved recasting the young standing male's left arm that had been ripped off, as noted, in an explosion during the civil war; on the other side, Harris advocated a "leave as is" approach. The Harris argument was, and the reporter seemed to agree, that by preserving the shrapnel damage in the bodies, the statue would more effectively remind visitors of the damage and suffering caused by the civil war. After several consultations with Solidere, the men agreed that the "wounds" would remain visible in the statues. The recovered right arm would be reattached, but the left arm that had been ripped off by an explosion would not be replaced.

After the successful "surgery," the statues were deposited for pickup in an empty lot across from the university's main administrative building. The surface of the bronzes was smooth and clean, yet the shrapnel "wounds" remained, especially in the young man representing the nation. Along the left side of his upper body from his collarbone to his upper thigh and around his navel, bullet and shrapnel damage allowed light to shine right through the sculpted body. Of course, he also was missing his left arm. The other three bronze figures showed less damage overall, yet here,

too, bullet holes left visible traces in their faces and upper bodies. Between 1996 and 2004, the period the statues were "in waiting" in the lot at Holy Spirit University, a group of students, professors, and local politicians gathered in front of them every May 6 to conduct a small ceremony to honor the martyrs for Lebanon's independence.

CONCLUSION

In 1958 Lebanon was sharply divided into two political camps: those that sought alignment with the West and those who were moved by the promises of Arabism. Those two opposing ideologies congealed in material form in the two different martyrs memorials: one recast the memory of the martyrs of 1916 and the other created a site of public memory for fighters and civilian victims of the 1958 Revolt. It is unlikely that Marino Mazzacurati spoke to Kamal Jumblatt, or vice versa, so there was no direct competition between memorial makers. However, Jumblatt must have known about the Hoayek memorial controversy and the challenges in finding a replacement, since he was a parliament member and therefore spent considerable time in downtown Beirut. His memorial may have been his way to remind his fellow Lebanese of the importance of joint Muslim and Christian sacrifice at the heart of Lebanon's national project.

Unifying the memorials in Beqata and Beirut is their heroic language, represented through struggling male bodies, either armed and dressed in traditional Arab robes or unarmed, hands tied, and in the dress of Italian partisans. Neither of these idealized male bodies, not the ones in bronze or those in stone, are representative of the actual men who did the fighting and dying in 1916 or 1958. They are symbolic bodies, in symbolic postures, and they form part of different artistic canons. Beqata's Martyrs Square honored men who rose up to arms in minute-man fashion. It was a place to honor men who fought "rifle to rifle." Beirut's Martyrs Square similarly honored civilians who opposed unjust rule with their bare hands and their intellect. Mazzacurati's own template of partisan opposition to Mussolini's fascism celebrated the courageous acts of individual men who rose up against unjust rule. And on the basis of that struggle, a nation would achieve liberty and freedom. Women appear in both memorials, either in allegorical form or as martyrs mentioned on a gravestone. But, in both sites, male bodies carry out the struggle, displayed physically in bound bodies attempting to free themselves or armed men going to battle. Neither martyrs memorial depicts urban, middle-class intellectuals but instead render peasants or working people as those who do the fighting.

Similar to the reporting of independence struggles in other parts of the world, it was "the people" who made history.

Differentiating the two memorials is their location, medium, and artistic language, as well as the fact that Jumblatt made ethno-religious differences of Lebanese communities visible and Mazzacurati did not. Jumblatt built his memorial in the Shouf, not in Beirut in an area that was uninhabited at the time. The pristine location made it an ideal site for quiet reflection, but it also meant that it was less recognized. Unlike Beirut's Martyrs Memorial that was prominently displayed in the middle of one of the liveliest squares in the capital, Beqata's Martyrs Square is remote, although open to anyone who wants to stop and visit. It was built in the area most affected by the 1958 Civil War, and though none of the martyrs was actually killed in Beqata itself, the location between Chamoun and Jumblatt loyalists has symbolic significance. For about fifteen years both Beqata and Beirut were home to annual martyrs celebrations that honored sacrifice, but Beqata drew a much smaller crowd. Beirut's martyrs were accorded a national holiday where Lebanese were given the day off. The president and members of the entire parliament attended the May 6 ceremonies, which included representatives of civic institutions, scouts, and units of the Lebanese army. May 6 was a day to stage the nation and emphasize the joint sacrifice of Lebanese, regardless of their backgrounds. In Beqata, it was friends and family members of the martyrs, both Druze and Christian, from the surrounding villages, as well as Kamal Jumblatt loyalists, including Druze and Christians, who attended the annual May 12 ceremonies. The commemorations in both locations ceased during the 1975–1991 Civil War but for different reasons. Martyrs Square in Beirut turned into a militarized zone and no-man's land that became a metaphor for the entire war. Beqata's ceremonies ceased because Kamal Jumblatt was killed, and because of new graves that were added in 1976 and 1983, creating a rift between villagers, some of whom believed that the new grave markers did not deserve this place of honor.

The definition of martyrdom expanded after Lebanon's civil war. Not only people but statues sacrificed their lives for the nation. Paradoxically Mazzacurati's statues came to life after having been wounded by sniper fire and explosions. The Nation lost both its arms: the right arm had been sawed off in an act of vandalism, and the left arm was ripped off by a bomb. The effect of the mutilations of the (bronze) bodies was the blurring of boundaries of the martyr-as-symbol and the martyr-as-person. The statues needed hospitalization; their battered bodies had to heal. The "doctors" discussed which "wounds" they would cure and which would

remain, creating a new genre of national statuary of beautiful, mutilated bodies. While the restoration workers at Holy Spirit University remedied the damaged statues by removing rust and debris, they also beautified the existing bodily mutilations. The newly restored bodies retained the evidence of civil war violence, symbolizing the injuries sustained by thousands of Lebanese citizens. Despite the wounds, the nation is still standing! The statue of the "wounded nation" represented defiance in the face of medical odds and thereby symbolized that Lebanon was a nation of survivors.

Hariri's plan was to heal the wounds of civil war by restoring the entire downtown area of Beirut. To finance the reconstruction he borrowed funds, and public debt mounted steadily from around $2 billion at the end of 1992 to $17 billion in 1998, and growth rates fell from 13 percent to 3 percent in the same period.[73] While reconstruction spending soared, the standard of living for the average Lebanese dropped. A 1995 study showed that about one million Lebanese, or about a quarter of the total population, lived below the poverty line, and about 250,000 lived in conditions of absolute poverty, defined as an income of less than $300 a month for a family of five.[74] Yet Rafiq Hariri counted on the Lebanese entrepreneurial spirit and their resilience, as he kept projecting, with some success, the image of Lebanon as a phoenix rising from the ashes. Mazzacurati's memorial was the perfect symbol for this projected rebirth.

Although the repair of the statues was concluded in less than a year, the bronzes could not be returned to their original location, as the progress of Solidere's restoration work of Beirut's Martyrs Square had been slowed. And as happened in the 1950s, during the absence of Beirut's downtown memorial, another Martyrs Square emerged, this time in the village of Qana in South Lebanon.

Reconstructing while Re-destructing Lebanon

Dismembered Bodies and National Unity (1996–2003)

Massacre sites mark those events and places where victims were killed in their own environs with little or no means of self-defense.
—JAMES MAYO, WAR MEMORIALS AS POLITICAL LANDSCAPE

He is a child unlike all the other children on earth. He lives in our memory, in our conscience. We become one with him. He is Christian, he is Muslim.
—MOHAMMAD KANSU, "TO A MARTYRED CHILD"

FROM BEIRUT TO QANA: MAPPING LEBANON'S "OTHER SPACE"

In the early 1990s tourists began to flock back to the famed beaches and restaurants of Beirut, and downtown opened again for business amid redeveloped and upscale facades. In 1996 the famed Casino du Liban reopened its doors to throngs of elegant gamblers, and the Baalbek International Festival, which stages concerts with international stars inside the Roman temples of Baalbek in the Beqa Valley, resumed its annual performances. The casino and the festival—both originally launched in the late 1950s—were icons of Lebanon's better days. Lebanon's regained glamour was heavily promoted in the press. In 1997 *National Geographic* featured a photo-essay about Lebanon, announcing that "battle lines have yielded to tan lines" next to the image of five bikini-clad women reclining in beach chairs beside a swimming pool, against the backdrop of the still war-scarred facade of the famous St. Georges Hotel in Beirut.[1] The message was clear: the Lebanese

have left the war behind and are back to having fun. However, this optimism did not extend to southern Lebanon, or *al-janūb,* because here battle lines continued to be drawn.

As briefly mentioned in the introduction, *al-janūb* became a war zone in the late 1960s within the context of the Israeli-Palestinian conflict. Palestinians had started to come to Lebanon after the war that led to the creation of Israel in 1948. Their numbers swelled significantly after the War of 1967. A political agreement concluded in Cairo in 1969 gave Palestinians the right to arm and fight for the liberation of and return to Palestine from positions on Lebanese soil. When the displaced Palestinians did fight, the Israeli army retaliated, creating a vicious cycle of attacks and counterattacks. Israel launched its first large-scale military operation into Lebanon, code-named "Operation Litani," in 1978. In response, the UN Security Council created the United Nations Interim Forces in Lebanon (UNIFIL) which have been deployed in southern Lebanon, at varying levels of troop strength, until now. Their mandate was to oversee Israeli troop withdrawal and to keep the peace between the various fighting contingents.[2] The Israeli forces did not withdraw until 2005, and yet even after they did there was no peace.

From 1978 to 2000 Israeli troops conducted surveillance, patrols, arrests, and attacks in what amounted to 12 percent of Lebanon's territory.[3] The Israelis called the area a "security zone," since they saw this military intervention as a necessary step to prevent guerrilla attacks on citizens in northern Israel. The Lebanese, on the other hand, referred to the same area as an "occupied zone," as it interrupted the regular flow of life for an estimated 100,000 to 150,000 villagers and townspeople, not only along the immediate Israeli-Lebanese border but as far north as the town of Jezzine. In the early 1980s the Israeli military managed to recruit, train, and arm at first Maronite but later also Shiite and Druze men into the South Lebanese Army (SLA) which served as their proxy force. The SLA recruits defended their home villages against what they regarded as "Palestinian military implantation."[4] In the early 1980s a newly formed and armed Lebanese group began to deploy in southern Lebanon, and they gradually replaced the Palestinian guerrilla forces. They would come to be known as "the Resistance" (*al-muqāwama*), and consisted mainly of members and loyalists of the Shiite party Hizballah. Their goal was the liberation (*tahrīr*) of "occupied territory," which, depending on who was doing the interpretation, meant solely Lebanese territory or Lebanese *and* Palestinian territory.[5] Low-level skirmishes between members of militias and armies throughout the 1980s and 1990s would be interrupted by several more large-scale

Israeli attacks, code-named the 1982 "Operation Peace for Galilee,"[6] the 1993 "Operation Accountability,"[7] and the 1996 "Operation Grapes of Wrath."[8] Each operation aimed to rid South Lebanon of its "terrorist infrastructure," but none was successful and even seemed to strengthen the Resistance resolve.[9]

When I decided to visit Qana for the first time in April 1998, there had been a period of relative calm. Reassured by local friends who knew the area, I had rented a car, as I often did on weekends in Lebanon during my dissertation research and part-time teaching year. After reaching the city of Tyre via the coastal highway, I was looking for the turn that would take me into the foothills but was unable to find any road signs to guide me. So I reached for my trusty Lebanon road map, bought during my first visit to Lebanon in 1992 and worn from countless road trips. I looked for Qana, but I looked in vain. It was not on the map.[10] The map, I only realized at that moment, had been printed in 1984, and the British map makers and the Lebanese printers had not deemed Qana large or significant enough to include it. Without directions in hand, I did what most Lebanese do: I stopped the car repeatedly and asked people by the side of the road for directions, which were always very generously, even if sometimes erroneously, given. After several wrong turns on curvy roads, I finally arrived at my destination. (On one of my more recent visits to Beirut, I went shopping for new maps of Lebanon. Leafing through the now much bigger selection, I ascertained that every single one of them has Qana on it.)

The village of Qana emerged into the limelight of international attention during the 1996 "Operation Grapes of Wrath." A sixteen-day Israeli assault on Lebanon, the operation sought to rout Hizballah forces that had been attacking its patrols and launching rockets across the border into Israel. In the course of that offensive, in the early afternoon of April 18, 1996, the Israeli military killed more than a hundred civilians and wounded hundreds more in a sandbagged compound staffed with a Fijian contingent of UNIFIL soldiers. Four UN soldiers were also wounded in the attack. The UN compound was not very large, and it was not set up as a shelter, but when refugees started to arrive from nearby villages shortly after the beginning of the operation, the Fijian soldiers agreed to take them in. The villagers assumed that the UN compound would be a safe haven, since UNIFIL was sworn to neutrality. The attack came entirely unexpectedly. The Israeli military later called the shelling the result of "operational mistakes and technical failures," an assessment disputed by UN observers who declared that the firing pattern had been too precise to be accidental.[11]

Whatever the truth may have been, the staggering death count in a single attack that lasted no longer than a few minutes, combined with the utter powerlessness of the UN soldiers and the fact that the people killed had been unarmed women, children, and elderly men, created an outcry in both the Arab and international press.[12] The Qana attack also prompted deep introspection in Israel and, subsequently, citizens' demands to pull Israeli troops out of South Lebanon—which they called "Israel's Vietnam"—became louder and more frequent.[13] According to anthropologist Augustus Richard Norton, "no incident in recent memory has inspired more hatred for the Jewish state than the Qana attack."[14] The Qana victims were reportedly on the minds of the September 11 bombers when they made their suicide pledges, and Qana was mentioned in several speeches made by Osama Bin Laden.[15] Moreover, from the Arab perspective, all Israeli military actions in the Arab world are made possible by U.S. aid to Israel, which means that many Arabs hold the United States indirectly responsible for the killings in Qana that day. In other words, Qana is one way to answer the question asked in some U.S. media: "Why do they hate us so?" It did not help that during "Operation Grapes of Wrath," the United States would "neither intervene in nor mediate an end to the fighting."[16]

So when the Western reporters wrote enthusiastically that Lebanon's civil war had ended and reconstruction efforts were in full swing, they revealed their Beirut-centered bias. *Al-janūb* remained a war zone. It was Lebanon's "other space," where laws of everyday life were suspended by bombings, attacks, imprisonment, and the ever present threat of escalating violence.[17] Physical mobility was limited, because checkpoints of the various armed contingents in their different locations only granted passage to residents of southern villages and holders of special permits. This "other space" generated its own geography of violence: the towns of Bint Jbeil and Nabatiye gained fame and notoriety as centers of resistance activities and targets of extensive Israeli bombings; the prison complex outside the town of Khiam became a symbol of Israeli state terror where suspected resistance fighters were interrogated and tortured; Beaufort Castle—the remains of an ancient crusader fortress perched on a steep cliff overlooking Lebanon's southern borderlands—became one of Israel's most famous surveillance outposts and the target of several Resistance operations.[18] In 1996 Qana became part of this Lebanese geography of violence as a symbol of tragedy, and explicitly Muslim *and* Christian tragedy. Consequently this previously obscure southern Lebanese village became the symbol of national unity.

The rise of southern Lebanon from a neglected backwater to a site of national importance is tied directly to the political mobilization of the Shiite community, which predominantly resides in the region. According to Shiite expert Shaery-Eisenlohr, many communities in Lebanon were discriminated against and neglected in the years after the country's independence, "but they [the Shiites] were the single largest community in Lebanon with the least political representation and they reacted to this marginalization most severely in the shortest period of time."[19]

To recapitulate briefly: Lebanon was created in 1920 as a result of negotiations between the French and Lebanese Maronite and Sunni elites. The famous 1943 National Pact was a deal between Maronite President Bshara al-Khoury and Sunni Prime Minister Riyad al-Solh. In Lebanon's early years, "the Sunnis took the Shiites politically for granted in the name of Arabism, while tending in general to leave them out of their inner councils."[20] Until the late 1950s the Shiite inhabitants of the South were "most notable for their invisibility and irrelevance to Lebanese politics."[21] By the late 1960s, as agricultural incomes declined and violence across the Lebanese-Israeli border intensified, significant numbers of residents of *al-janūb* (Shiites numbering prominently among them) began to leave their native villages and move to the growing poverty belt around Beirut or to the diaspora abroad.[22] Government statistics of 1974 showed that, despite being home to about 20 percent of Lebanon's population, South Lebanon only received 0.7 percent of the state budget.[23]

During this time of rural-urban migration, the Iranian-born Shiite cleric Musa Sadr (1918–?) arrived in Lebanon. In 1960 Sadr settled in Tyre and began to preach his faith to the town's sizable Shiite population. Sadr saw the Shiite community as oppressed by their traditional (feudal) leaders, on the one hand, and deserting their faith to join Lebanese leftist parties, on the other. He presented them with a third alternative: an engaged and activist Islam that responded to contemporary problems with contemporary solutions. Unlike traditional Shiite clerics, he sought out audiences with the powerful in Beirut.[24] After successful lobbying efforts, Sadr convinced the Lebanese government in 1969 to create a Supreme Shiite Council, and he became its chairman. The Council was the first official political body to represent Shiite interests to the government in Beirut as separate from those of Sunnis.[25] Next Sadr lobbied the Lebanese government to create a fund to assist residents of South Lebanon who had suffered as a result of Israeli attacks. His efforts led to the creation of the Council of the South (*Majlis*

al-janūb) in 1970. It was the first public acknowledgment that residents of southern Lebanon suffered disproportionately from ongoing violence and that the government had a role to play in alleviating that suffering.

Sadr was a charismatic speaker and drew enormous crowds. His most famous speech was held in front of seventy-five thousand Shiites in the town of Baalbek in 1974, where he openly accused the Lebanese government and the elites who ran it of grave neglect, corruption, and deliberate disenfranchisement of the Shiite community.[26] In Baalbek Sadr launched his Movement of the Deprived (*Harakat al-mahrūmīn*), a social movement whose aim was to improve the lot of the Shiites in Lebanon. Sadr's second most famous speech was given in front of a large audience of Maronite political elites, Catholic priests, nuns, and parishioners during lent of 1975, two months before the outbreak of Lebanon's civil war.[27] Standing under the cross at the altar of St. Louis Capuchin Catholic Church in downtown Beirut, he emphasized the fundamental unity of monotheistic religions (*kānat al-adiyān wāhida*) in their fight against injustice and the oppression of the weak. He warned of dangers that arose when believers separated from the idea of the common good and instead served only their own interests.[28] In other words, he publicly denounced sectarianism. After his treatise on religions, he condemned unjust rule, whether feudal, authoritarian, or colonial, and he accused Lebanon's political elites of exercising "a politics of neglect" (*siyāsat al-ihmāl*) that had disenfranchised the Shiite community. He cited money as the cause of evil and the search for riches as the biggest impediment to true faith. In his speech Sadr reminded his Christian audience of Jesus' dictum that a camel would pass through the eye of a needle before a rich man entered heaven. The speech was carefully crafted, poetic, and powerful; Sadr reportedly moved his audience to tears.[29]

When the Lebanese civil war broke out two months later, the Movement of the Deprived organized an armed militia that became known under the acronym Amal.[30] Initially Musa Sadr was aligned with the ideologically left-wing coalition of the Lebanese National Movement—led by, among others, Kamal Jumblatt—challenging Lebanon's political status quo. However, after Amal forces suffered heavy casualties during the first two years of fighting, Musa Sadr withdrew from the coalition and instead "supported the Syrian intervention against the LNM and the Palestinians in June 1978."[31] Since that time Amal has maintained close ties with Syria. Despite his ambivalence about the armed Palestinian liberation struggle from Lebanese soil, which contributed to the suffering and impoverishment of the Shiite community, Sadr held firm opinions about Israel. One of Sadr's most quoted sayings is that "Israel is an absolute evil" (*Isrā'īl sharrun mutlaq*). He

mysteriously disappeared on a trip to Libya in August 1978. Soon thereafter photographs of Sadr appeared on billboards in Beirut's predominantly Shiite neighborhoods, and the date of his disappearance became an occasion for an annual commemorative rally of his supporters, which, according to the analysis of Augustus Richard Norton, is what kept Amal alive.[32] Musa Sadr's vanishing never received a satisfactory explanation.[33] His body was never found, leading some Shiites to believe that he was their hidden imam who had temporarily shown himself but had returned into occultation. This only increased his appeal.

The Amal leadership mantle as well as the chairmanship of the Council of the South was passed on to the much less charismatic Nabih Berri, who also became Lebanon's Speaker of Parliament, uniting three powerful positions in one person. Born in 1938 in Sierra Leone of Lebanese parents, he spent part of his childhood in Lebanon, studied law in France and Beirut, and lived for several years in the United States. While abroad, he did not amass a fortune as Rafiq Hariri had done in Saudi Arabia, and since he assumed political office he has been subject to various charges of corruption, especially concerning his use of funds of the Council of the South.[34] Like Sadr, Berri showed consummate political skills in making the right alliances at the right time, and he appealed to the urban, more secular-minded middle-class segment of Lebanon's Shiite population.

Hizballah formed in the early 1980s when a group of radical Amal members decided to quit the organization (about the same time that Nabih Berri took on his leadership role).[35] Inspired by the Iranian Revolution of 1979, the Shiites who were disenchanted with Amal hoped to use religious principles and doctrine to build an Islamic state in Lebanon. They also were drawn to more radical forms of struggle. The suicide bombings of the American Embassy in Beirut in April 1983 and the U.S. Marine barracks in October 1983 occurred before Hizballah's official creation, but it is believed that Islamic Jihad, the group that claimed responsibility for the attacks at the time, had links to what became the Hizballah leadership. Hizballah and Amal were fierce political and military rivals during Lebanon's civil war. Unlike Amal and other militia forces, Hizballah did not turn in its weapons at the end of the civil war but argued that it needed them to lead the resistance against Israeli occupation of southern Lebanon.

Over the years Hizballah became increasingly sophisticated in its military attacks, and it took full credit for Israel's unilateral withdrawal from Lebanon in May 2000. Its defeat of Israeli morale, as well as its increasing success in inflicting Israeli casualties, gained Hizballah significant popularity among Lebanese of all ethno-religious backgrounds and Arabs across the

region. In the meantime, Amal focused its efforts on gaining power through the political process.[36] Both in 1992 and 1996 Amal captured a larger share of votes in parliamentary elections than Hizballah did.[37] Though Amal and Hizballah have made peace and struck up a strategic alliance on the national political stage, their rivalry continues in villages across South Lebanon, such as Qana, where both parties compete for local Shiite votes and loyalties.

THE DAY OF TRAGEDY: QANA, THE UNITED NATIONS, AND AMAL ON APRIL 18, 1996

When Israeli bombs hit the United Nations compound at Qana on April 18, 1996, the village had neither a mayor nor a municipal council. The government had stopped sending funds to provide services shortly after the outbreak of the civil war in 1975, which meant Qana's mayor's office had to close down. The mayor eventually passed away and was not replaced. In 1996 the civil war had been over for five years, but money for municipal governance had yet to reach the town. The only remaining "office" in Qana in 1996 was the home of a member of Amal, whom I will call Ali. Ali was the person to whom villagers turned when they had a request and needed aid, which he passed on to the Council of the South. Consequently it was Ali who took charge on the tragic day of April 18. On that day hundreds of refugees were in the UN compound—six hundred according to Ali. Most of those seeking shelter were from Qana, but many came from smaller surrounding villages such as Siddiqine, Jabal el-Batem, and Rashkananieh, all of which had drawn heavy fire. Ali emphasized that it was the poorest people who had ended up in the UN compound, because those who had the means had left the area and gone to Beirut or abroad. The refugees had been in line to receive lunch when the bombing started. The attack was over in a few minutes.

When I interviewed him in 2008, Ali said he had not spoken about the events in years, yet he vividly remembered the impact of the bombs, because his entire house shook in its foundations. Immediately he grabbed his cell phone and ran toward the site of the explosions. On his way Ali called other Amal members in the region to alert them that Qana had been hit. At the site he was met with great confusion, but somehow he managed to organize people to drive the wounded to the closest hospital about ten minutes away in the direction of Tyre. The bombings continued throughout the rest of the day, and despite the danger—he repeatedly used the phrase "*taht al-qasf*" (literally, under the shelling)—volunteers piled the wounded into their cars and drove back and forth to the hospital, risking their own

lives. As the Fijian UN soldiers and villagers sorted through the rubble, they piled up corpses and unattached body parts. Of the more than one hundred dead, only eighteen could be positively identified on site, according to Ali. Most of the identification happened later, after he had spoken to survivors and relatives who came looking for missing family members. Because it was impossible to do a precise body count, the media set Qana's death toll variously between 102 and 109. The magnitude of the casualties sank in as the mangled bodies and unidentifiable body parts piled up. It also became clear that it would be impossible to return the dead to their families for a traditional funeral. Ali said he spoke with other villagers and Amal members who had come to help with the rescue efforts, and they decided to build a mass grave right inside the UN compound where the people had been killed.

Abdel Majid Saleh was one of the Amal members who received a phone call from Ali that afternoon of April 18. He worked for Amal's Tyre office at the time, but when he spoke with me in January 2008 he had become a member of parliament and therefore received me in his parliamentary office in Nejme Square in Beirut. About five-foot-two with a full head of peppery grey hair and a winning smile, Saleh greeted me in a sparsely furnished office. I sat across from him at his desk and immediately noticed two TV sets mounted on a shelf to my right. They ran simultaneously, muted, on different channels. While he spoke with me Saleh would occasionally glance at the screens. During our interview we were interrupted by a phone call that there had been a bomb attack on a UN vehicle in the South. Apologizing profusely, he got out of his seat and made several calls to find out the damage—nobody had been killed, thankfully—and then he sank back into his chair, sighing, "When will this country finally come to rest?"

In the early afternoon of April 18, 1996, Abdel Majid Saleh was sitting in the Amal office in Tyre watching the news of the ongoing military operation. After he received Ali's call, he immediately rushed to the hospital that was receiving the wounded. The first person he saw when he entered the hospital was the father of a boy who was in his own son's class, who was looking for missing relatives. The initial reports he had received from Qana had set the death toll at a dozen, but as he was standing in the hospital, people kept delivering more and more dead and wounded. Saleh told me that he would never forget the stunned face of a grandfather, who was brought in under severe shock and who would later be told that he had lost sixteen family members. The dead bodies and body parts that came through the hospital doors were stored in the hospital's morgue and, because the space was quickly filled, in refrigerated food storage facilities in Tyre. That

same day Saleh volunteered to work on funeral preparations, and eventually he became the head of the Committee for the Commemoration of the Martyrs of Qana (*Lajnat takhlīd shuhadā' Qānā; takhlīd* literally means immortalization).

The Committee for the Commemoration of the Martys of Qana (CCMQ) consisted of surviving relatives of the victims and villagers who wanted to show their support to the survivors and honor the dead, many of whom belonged to the Amal party. There was no membership list. When I asked Saleh how many people worked with him, he simply said that if there was an event he would make phone calls and people just showed up. He was never short of hands. In the days immediately following the attack, Nabih Berri called surviving family members and obtained their official permission to bury the dead in a public cemetery in Qana. He promised the bereaved family members that the funeral would take place as soon as the hostilities ended.

Ali and a group of volunteers that included villagers, family members, and Amal members began to dig rows of graves large enough for one hundred bodies. Ali said that the work began only a few days after the attack, even though "Operation Grapes of Wrath" had not yet ended. He remembered how dangerous it was to bring bricks from neighboring villages (Qana did not have any) to reinforce the graves after they had removed the soil. Yet Ali and his crew kept working "under the shelling." While the graves were being prepared in Qana, Abdel Majid Saleh searched for a space to hold the official funeral ceremony. The village of Qana would not be able to accommodate the large crowds of mourners expected to attend, so Amal decided to set up a stage inside the Hippodrome, a large stadium from Roman times, in Tyre's archaeological park. Saleh and a group of volunteers decorated the Hippodrome with flags and wreaths, and a central banner prominently proclaimed, "Here Lebanon's two wings come together in a meeting of faiths."[38]

Three days after the cease-fire was declared, on April 30, 1996, at least twenty-thousand people converged on Tyre from all over Lebanon, according to Saleh's own estimates. Before the ceremony Tyre's church bells rang while muezzins were called to prayer.[39] The coffins with the bodies and body parts, which, as noted, had been stored in hospital morgues and other cooling facilities, were lined up close to the stage, covered with Lebanese

flags. Sheikh Mohammad Shams ad-Din, who had assumed the (interim) leadership of the Supreme Shiite Council after Musa Sadr's disappearance, presided over the ceremony.[40] Right next to him on the stage were Prime Minister Rafiq Hariri, Speaker of Parliament Nabih Berri, and a line of clergy from every Lebanese community: the Sunni Mufti Qabani, Shiite Mufti Qabalan, Tyre's Maronite Bishop Sadr and Beirut's Maronite Bishop Abi Nadr, Roman Catholic Bishop Haddad, Assyrian Catholic Bishop Gemayel, Greek Orthodox Bishop Jbayli, and Druze Sheikh Ghayth. *Al Nahar* additionally reported the names of seventy-four members of parliament from every political party who had made their way to the funeral ceremony. Next to this large congregation of Lebanon's political and religious elites was a line of foreign dignitaries: a representative of Syrian president Hafez al-Asad, as well as his security chief Ghazi Kanaan stood beside French and Italian diplomats. Members of a Palestinian delegation stood next to twelve soldiers representing the different UN contingents stationed in South Lebanon. Lebanon showed a united front, and some foreign governments sent delegations to register their solidarity. The U.S. government sent no representative, although two of the victims were from Dearborn, Michigan: Aboudi and Hadi Bitar, ages seven and nine, had been in Qana visiting their grandmother.[41]

Sheikh Shams ad-Din began the ceremony emphasizing "the unity that the Lebanese spirit has expressed in both Christians and Muslims, in churches and mosques, in the government and the people, in the army and other national institutions."[42] He thanked France and Syria, in particular, for their support in Lebanon's difficult times. Prime Minister Rafiq Hariri took the microphone and declared April 18 a National Day of Remembrance. At the same time he announced the creation of a second memory agency, the National Committee of Commemoration of March 14 and April 18 (NCC) (*Al-lajnat al-wataniyya li-ihiyā' 14 azār wa 18 nīsān*). The date March 14 marked the first day of Israel's "Operation Litani" in 1978. Clearly Hariri did not consider Qana an isolated incident or accident but part of a larger pattern of violence that had started eighteen years earlier.

After the funeral celebration ended in Tyre, the Islamic Scouts, a youth organization sponsored by Amal, loaded the draped coffins into ambulances and on trucks to drive them from Tyre through throngs of people to the village of Qana about six miles away.[43] Ali remembered how packed crowds in the village prevented the cars from approaching the UN compound where the graves had been prepared. Consequently the coffins were passed along over the heads of the people, by the people, until they reached their final resting place. In other words, the mourners participated actively

in laying the corpses to rest. In Qana the gravesite had been decorated with handwritten banners accusing Israel of committing atrocities and promising the dead they would never be forgotten. One banner read, "In Qana, Jesus performed his miracle, and in Qana, 2000 years later, Peres performed his massacre." The crowd began to chant "death to Israel," while family members stood by in tears, watching as the shrouded bodies and bags containing body parts were lowered into the ground. One shrouded body belonged to Afifi Hadad, the only Christian who had been killed on April 18 in Qana.[44] Her family, with the blessing of the Bishop in Tyre, consented to have her buried alongside the Muslim victims in Qana's public graveyard.

While Lebanese flags decorated the coffins and became the shrouds in which the dead were buried, the only other flag in the graveyard enclosure was Amal's green party flag. When one man tried to bring a yellow Hizballah flag, the crowd reportedly drove him away.[45] At least some mourners felt that Hizballah was partially to blame for the tragedy that occurred that day, by drawing Israeli fire onto their village where the bombs grossly missed their target. So, while the funeral provided an occasion for the display of Muslim-Christian unity, it also revealed the existing competition, and serious rift, between the two main Shiite parties and their respective followers in Qana. Amal exercised its control over the funeral proceedings, while Hizballah supporters stayed away or participated without displaying their party banners. On the day before the funeral, according to Abdel Majid Saleh's testimony, there had been a public disagreement (*mashkal*) between Hizballah and Amal supporters over who would lead the funeral ceremony. Angry words, even threats, were exchanged, but in the end the situation was resolved by allowing Hizballah to conduct its own ceremony after Amal had staged the official funeral. Hizballah's afternoon event was not publicized in the press.

The shelling of Qana constituted the deadliest day of "Operation Grapes of Wrath," and through subsequent commemorations it became its symbolic anchor. After the media broadcast the story, Lebanese of all ages and backgrounds began to organize relief efforts for refugees that kept pouring into Beirut from South Lebanon. Student and scout groups, cultural and religious organizations, as well as international relief organizations helped in the effort to provide shelter as well as medical care for those who had fled the fighting. Lebanon scholar and anthropologist King-Irani called the "unified national grief and outrage" she witnessed after the Qana attack an important indicator of post–civil war "inter-confessional reconciliation."[46] Even typically skeptical analysts of Lebanese affairs, such as political

scientist Paul Salem, saw in people's reactions to Qana a hopeful sign that the Lebanese had left their civil war rivalries behind.[47] The grave injustice of the civilian deaths and the impunity with which Lebanese lives could be taken became a platform around which all Lebanese could rally. The analysts did not comment on the rift within the Shiite community. Indeed, they did not see it either because it was not publicized widely or because they were not looking. When scholars speak about reconciliation and signs of the "unified national" in Lebanon, they tend to look for sites and events that bring together Christian and Muslim communities.

Qana's purported New Testament heritage, its Greek Orthodox community, and its predominantly Shiite population made it a powerful national symbol in post–civil war Lebanon. As in 1916, the vast majority of martyrs in 1996 were Muslims. But again, that fact was subsumed in the commemorative record under the narrative of shared Muslim-Christian suffering. Another fact, namely that the Christian exodus from southern villages had left the vast majority of South Lebanon's population Shiite was similarly not discussed in the context of the Qana commemoration. According to Deputy Mayor Ismail, Qana's original Greek Orthodox population of about 15 percent had dwindled to about 3 percent. In his words, Christian residents emigrate and "they don't come back" (*batal yirja'u*), in contrast to Muslim migrants like himself who do. But the numbers of actual Christian bodies in Qana, dead or alive, did not matter. The Israeli attack was experienced both as an attack on South Lebanon's Christian community and heritage and its Shiite population. When the marble plates had been installed to cover the graves, visitors kept covering them with flowers and candles. For Afifi Haddad, mourners additionally deposited pictures of the Virgin Mary and rosary beads to emphasize her Christian identity among the dead.[48]

COMMEMORATIVE SOLIDARITIES

Similar to what had occurred in Beirut during the early days of celebrating Lebanon's martyrs of independence, Qana's funeral ceremony was staged in two parts: one was presided over by officials of state and prominent members of the clergy, and the other was organized by the residents and a local volunteer committee.[49] But the funeral ceremony in Tyre and the actual burial in Qana were not arranged separately because of political differences. The two-part funeral arrangement was mainly a result of space limitations in the village. The two ceremonies allowed for two different kinds of public mourning, one "official" (with formal yet passionate speeches by political and religious elites) and one "popular" (with loud wails and angry

chants from the mourners). Many of the religious leaders who had been in the Hippodrome in Tyre on April 30 traveled to Qana for the customary mourning gathering held one week after the funeral (al-usbuʿ). Both Muslims and Christians observe this ritual in Lebanon, visiting the bereaved family to pay their condolences. Al-usbuʿ usually takes place at the home of relatives of the dead, but in Qana it took place in the open right next to the graves, drawing a crowd almost as large as the one attending the funeral. Religious leaders from every denomination stood side by side and jointly prayed at the martyrs' graves, thereby marking Qana as a place of religious transcendence.[50] At a time when Beirut's Martyrs Square was missing its memorial, Qana became Lebanon's new site of memory of Muslim and Christian martyrdom.

As discussed in the previous chapter, between 1996 and 2004 the Mazzacurati statues were at the University of the Holy Spirit in Jounieh. In May 1996 students and faculty conducted a small Martyrs Day ceremony, where they remembered the Qana martyrs as the incarnations of the martyrs of 1916.[51] After the standard performance of the national anthem and the deposition of wreaths in front of the statues, several speakers declared that the martyrs of Qana had joined the long lineage of Lebanese martyrs and that they had died for Lebanese independence. A member of the Jounieh municipality, Fouad al-Turk, said that the only difference between the martyrs of 1916 and 1996 was their manner of dying. "While those of 1916 had their bodies dangling from the gallows in Martyrs Square, the recent ones had their bodies crushed," al-Turk proclaimed, ending his speech by saying, "The Ottoman ruler who hung our brothers on the gallows has now been reincarnated as an Israeli occupier." The head of the university's restoration team, Issam Khayrallah, said that "the martyrs who fell at the hand of the Turkish murderer fell most recently at the hands of the Israeli murderers" and that this new tragedy made the repair and return of the Mazzacurati memorial to Beirut even more urgent. The Italian bronzes that had been erected in downtown Beirut in 1960 to mixed reviews, but that had become a symbol of Lebanese suffering and sacrifice after the second civil war, were now also a site of memory for the civilians killed in Qana. The Lebanese had called Jamal Pasha a "butcher" (al-jazzār) for his public executions in 1915 and 1916 and various other atrocities. They reserved a similar judgment for the Israeli army eighty years later when they called the events in Qana a "massacre" (al-majzara). Both words are derived from the same root (jazara in Arabic) which means "to slaughter."

In addition to Lebanese solidarity across ethno-religious divides, Qana generated a sense of Arab unity. During a second official funeral gathering

held in Qana itself on May 17, 1996, President Elias Hrawi addressed the representatives of the Arab Inter-Parliamentary Union (AIPU) (*al-Ittihād al-Barlamānī al-'Arabī*). The AIPU is a consultative political body headquartered in Damascus and includes members of all twenty-two Arab League countries. After conducting a regular business meeting in May 1996, the AIPU traveled from Damascus to Qana to express publicly their sympathy with the Lebanese. Again it was Amal and Nabih Berri who had organized the ceremony. In his introductory speech Berri stressed that Qana was a religious site for both Muslims and Christians, and a central place in Lebanon's resistance against Israel. He was followed by President Hrawi who laid a wreath on the graves and listened to the recitation of the first Sura of the Quran, the *fātiha*, after which he reportedly broke into tears.[52] A Maronite president being moved to tears at the graves while listening to a Quran recitation and the Shiite Speaker of Parliament placing Muslim and Christian Lebanese under the same banner of Lebanon's resistance illustrate how Qana produced Lebanese ethno-religious solidarity as Arab leaders from around the region looked on. Each one of the fourteen Arab heads of the delegation took turns speaking in front of the graves, expressing their solidarity with the families of the victims and residents of *al-janūb* while blaming Israel for killing innocent civilians. Qana had never seen so many prominent international politicians and national religious and political leaders, and neither was it prepared for so many average citizens who came to place a flower or some other memento on the graves.

DESIGNING QANA'S CEMETERY MEMORIAL

More than one hundred thousand people visited Qana's graveyard in the first year after the attacks. It was an unprecedented number of visitors in a village of barely eight thousand that had not even been on Lebanese maps a decade earlier. But the images of the physical destruction of the UN compound and the pictures of mutilated bodies, which had been widely circulated in print, on television, and on the Internet, turned Qana into a site of (inter)national pilgrimage. In 1996 most of southern Lebanon was still controlled and patrolled by the Israeli army and the SLA and was therefore off-limits for regular citizens. However, Qana was part of the United Nation's "buffer zone" and was therefore accessible. For many Lebanese, visiting Qana was their first foray into *al-janūb*. When I made a second trip to Qana in May 1998 with a group of Lebanese high school students from Beirut, none of them had ever been to the South, and many of them felt apprehensive about going there.[53] When we discussed our trip in class after

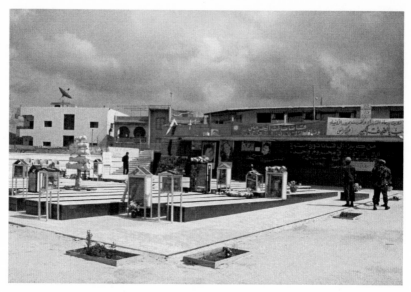

FIGURE 4.1. Qana's Cemetery Memorial, May 1998.

our return, the students shared their surprise that the South was such a pretty place—after early spring rains, many flowers had been in bloom—as well as their dismay that they had been so nervous about visiting a part of their own country.

At the entrance to Qana's Cemetery Memorial we were greeted by a poem, as in Beqata's Martyrs Square. Titled "Qana," it was carved onto a marble surface that seemed to come from the same source as the white sheets of marble covering the graves. The poem begins with Jesus greeting the residents of Qana and crying with them over the fate of Qana's children. Literally, "he wipes his tears off Qana's face." Having acknowledged the pain of the villagers and identified the dead as children, Jesus calls Muslims to prayer (*al-adhān*). With this introduction, Ajami defines Qana as a sacred Christian site where Jesus visibly expresses his solidarity and his pain, and then he prays with the Muslim villagers. In the next section of the poem, a wounded child emerges from the dirt and debris of the attack, looking for his hands in the rubble, crying, "God, our hands have been eaten" (*ukilat yadāna*). The poet continues to describe bodily injuries, which are so pervasive that it becomes impossible to tell whose blood is flowing from whose body.[54] The attack on Qana, in other words, had erased any physical distinction between individuals. In the final part of the poem Prophet Muhammad appears in the morning, and he recites (*rattala*) sacred Christian scriptures.[55] Muhammad declares that the time of liberation has arrived and that

Lebanon's youth will protect the nation. He declares: "My south has been wedded to martyrdom," (*tazawwajat al-shahada min janūbī*) with the "god of the universe" (*rabb al-kawn*) performing the ceremony. The final lines read, "Our land will live on, our land is ours."

Wahib Ajami created the image of Muslim-Christian coexistence through various poetic devices. He described Qana's victims simply as children—not women or (elderly) men—and, by virtue of their age, they transcend religious or political agendas. They are all God's children. Jesus and Muhammad explicitly cross religious boundaries by entering the other's house of worship and engaging in each other's religious rituals. Both promise a better tomorrow and equate the day of martyrdom with a wedding ceremony, which is part of the Shiite mourning ritual as well as a reference to Jesus' biblical visit to Qana. The poem begins in sadness and grief but ends in defiance, with the metaphors of liberation, youth, and a wedding, and a patriotic claim that this land belongs to all Lebanese. It is significant to note that Jesus does not read from Christian scriptures, nor

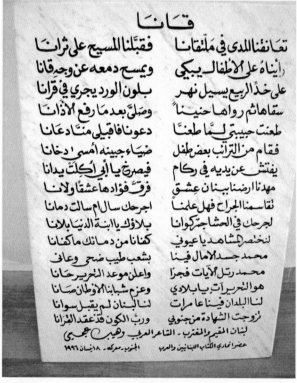

FIGURE 4.2. "Qana," poem by Wahib Ajami, Qana Memorial, 2003.

does Muhammad issue a call to prayer, which would have symbolically placed the communities as self-contained entities side by side. In Qana, religious boundaries are truly erased. This point is underscored through metaphors of the body and, in particular, of injury: hands that "have been eaten" and wounds that bleed so profusely that one cannot tell where one body begins and the other ends. The extent and the nature of the injuries inflicted on the bodies of refugees in Qana made it impossible to distinguish between Muslims and Christians. Through the metaphor of the face, Qana was anthropomorphized into a crying person whom Jesus consoles. Qana had become the new face of Lebanon.

Thus welcomed to the graveyard memorial, the visitor looked into the faces of the victims. Photographs of the dead were displayed in ten small glass cases that had been installed on the long rows of otherwise unmarked graves. The photographs were portraits, and most of them appeared to have been taken professionally in a studio. Some looked distinctly like passport photos. The portraits were unframed, and clustered together within each display case, suggesting these dead were related to one another. Most of the faces were those of children. There were various arrangements of plastic flowers, potted plants, wreaths, and vases with freshly cut flowers, which visitors had left behind. Although the place was clearly a site of personal mourning and grief, it also became evident that the graves had become a political platform. In the center of the cemetery, between two rows of graves, somebody had installed a hand-crafted cedar tree by rigging together a few pieces of plywood. Instead of displaying its customary bright green color, as it did on the Lebanese flag, this cedar tree was made of white cloth and soiled with red stains. The "bloody cedar" replica symbolized national injury and was a simple, yet effective way to connect the people who had died in Qana to the larger Lebanese community.

In addition to the cedar tree among the rows of graves, political commentary surrounded the cemetery enclosure. Most noticeable were three handwritten banners on, respectively, white, green, and black backgrounds, addressing the visitors to the cemetery in Arabic and featuring an immediately recognizable Amal party symbol. Situated at the opposite end of the graveyard, on a wall facing visitors upon entry to the site, constructed from the same black marble that enclosed the graves, the banners created a larger sacred landscape within which Qana was embedded. The white banner, the largest, was affixed to the wall on the top right corner, declaring: "The earth has been drenched with the blood of martyrs, and it has been made sacred by the passing of the prophets."[56] To the left a green banner proclaimed, "Qana is the third of Islam's holy sites."[57] These two banners described the graveyard

as sacred ground for both Muslims and Christians. Not only had the blood of martyrs been shed, but prophets had walked through the village. The first, of course, was Jesus, a prophet in the Islamic tradition, who performed his first miracle at the wedding in Qana. The other prophet was Muhammad, but his presence was conjured symbolically through Qana's designation as the third Muslim holy site after Mecca and Medina, where Muhammad lived and spread God's message. Muslim tradition refers to Jerusalem as the third holy site, because Muhammad is said to have gone on a famous night journey to heaven from that city. The location where he ascended to heaven is now marked by the Dome of the Rock. In this graveside banner, Qana is given Jerusalem's status, implying that Muhammad also visited there. Prominently displayed at the top of the cemetery enclosure, the banners established an imaginary map conflating Christian and Muslim geographies.

As in Beqata, some references were also unmistakably "sectarian." Directly underneath the banner alluding to the prophets, in bright orange script on black background, a third banner spelled out, "from Karbala to Qana, the revolution continues."[58] Karbala refers to the important battle between the forces of Hussayn, the grandson of the prophet, and Yazid, the other contender for leadership over the Muslim community in 680 CE. Shiites consider Hussayn the legitimate successor to Prophet Muhammad and his cousin and son-in-law, Ali, and they commemorate his death at the hands of Yazid's forces as one of history's greatest injustices. The Karbala banner was paired with a smaller poster proclaiming Israel a "terrorist nation" that committed massacres with the support and weapons of the United States. This last banner portrayed Israel and the United States as modern-day Yazids, and the Qana martyrs as relatives of Hussayn. This textual accusation stood right beside a three-by-six-foot exhibit of photographs of bleeding victims, smoldering corpses, crying relatives, and stunned UN soldiers, taken by reporters on the day of the attack. The combination of text and images left no doubt as to who was to blame for the deaths. Whereas the beautiful marble surfaces of the graves adorned with flowers, wreaths, and the smiling portraits of the victims allowed visitors to defer the reality of death, the press photographs transported them right back to the day of the attack, reminding them of the grisly fact of that day's carnage. These truly disturbing images were an important element of the commemoration, illustrating why the Lebanese label the event a *majzara,* a massacre.

Moreover, as in Beqata, the political elite who sponsored the site appeared as part of the display. Instead of a carving of names by the entrance, Nabih Berri's poster hung next to the handwritten banners and beside a poster of Musa Sadr. The portrait of a smiling Berri—apparently an election

poster—and a saintly looking Sadr—which probably came from one of the annual commemorations of his disappearance—looked oddly out of place at such a grim site. The posters were mounted in such a way as to make Berri and Sadr resemble a father and son. Because most of the photographs exhibited on the graves were of women and children, the summary effect was that Qana (and South Lebanon in general) was one large (Amal) family.

Whereas the four handwritten banners in the graveyard were in Arabic, addressing Lebanese and Arab audiences exclusively, a marble plaque to the left of the row of graves bore a trilingual inscription. In Arabic, English, and French, the plaque read: "The New Holocaust, 18 April 1996, 106 Victims." The marker thus described the killing of civilians in Qana in a language that a foreigner presumably would understand. It also added yet another layer of meaning to the events in Qana: the memories of the death chambers of the German Third Reich. On the memorial makers' map of human tragedy and injustice, Qana, in South Lebanon, belonged right beside Karbala, Iraq, and Nazi Germany. In all three sites, at different historical times, innocent women and children died at the hands of brutal, powerful, and morally corrupt enemies. Comparing human tragedy in this way is, of course, troubling: How can one meaningfully equate the genocide of European Jewry with Yazid's war on Hussayn, his family, and followers at Karbala and Israel's attack on refugees in a UN compound in Qana? By adding another narrative layer of violence and injustice to the modest cemetery structure in Qana—namely, the systematic extermination of the European Jewish population in concentration camps during World War II—the memorial designers not only expanded the geography of human suffering; they also turned the Israeli army into the new Nazis.

The Qana cemetery mixed private mourning with politics addressed to multiple audiences with different effects. The poetic juxtaposition of Jesus and Muhammad, who had made Qana sacred, set the stage for a politics of Muslim-Christian solidarity among the Lebanese. The joint prayers of Muslim and Christian clergy by the graves, the fact that (one) Christian and (more than a hundred) Muslim bodies—or body parts—were interred together, their differences publicly marked, again was a sign of Lebanese solidarity. Additionally, Arab delegations expressed their condolences to the Lebanese and showed public unity. Visitors from all over Lebanon and from abroad came to the graves to lay flowers next to photographs of victims, both known and unknown. The events in Qana resonated widely, and April 18 temporarily displaced May 6 as Lebanon's national Martyrs Day.

Qana's memorial, and the narrative of refugees who had sought shelter at a UN compound only to be entirely defenseless, drew on existing imagery of

joint sacrifice for the nation. For instance, Yussef Hoayek sculpted an image of ethno-religious balance through the figure of two mothers contemplating their sons' ashes. Whereas the two Hoayek statues physically framed the urn that sat between them, Jesus and Muhammad discursively embraced and framed the wounded child in the central section of Ajami's "Qana" poem. But, as stated above, in Qana Jesus and Muhammad did not simply represent two communities next to each other, but they entered each other's house of worship. The Qana martyrs were different from the 1916 martyrs in Beirut. While Hoayek contained and deferred reference to the actual death through the artistic choice of a cinerary urn, Ajami used graphic details of carnage to remind the reader not only of the age of many of the victims but also of the specific way in which the martyrs had died. His poetic imagery was reinforced by the billboard of photographs from the day of the attack. The child's missing hands represent the mutilated and injured nation, similar to the arms ripped and cut off by the civil war in Beirut's Mazzacurati Memorial. Both describe the mutilated bodies as looking for their missing limbs, symbolizing the nation looking to become whole again after the war. In other words, Ajami's poem reflected the existing thematic narratives of the Lebanese martyrs, placing Qana within a wider commemorative discourse that sought to give a visual representation of national sacrifice.

Bodies were crucial in the commemorative narrative of the events on April 18. Children, rather than adult sons, were central to the commemoration, and their faces, smiling and earnest, gazed at the visitors as they approached the children's graves. The children are shown beside images of their dead mothers or alone and therefore visually orphaned. The metaphor "mother of the nation," which used to be sculpted and deployed to project bonds of kinship solidarity onto the national community, had been transformed into the metaphor "mothers and children of the nation" and deployed through photographs of bodily injury.[59] While the new metaphor further reinforced women's traditional gender roles as mothers, who have important duties as cultural and biological reproducers of the nation, it also emphasized women's childlike vulnerabilities.[60] By uttering "women and children" in the same breath, women's adult status was diminished. Men were largely erased from the commemorative project in Qana, although some had died alongside their female relatives. If men were mentioned as part of the village's community of martyrs, they were "elderly men." Young adult men were expected to be fighter-martyrs (discussed further in chapter 5) and were therefore symbolically separated from other members of their family. The result was that the images on Qana's graveyard created a narrative of an innocent and injured female, childlike nation.

ANNUAL CEREMONIES AND MEMORY BOOKS:
COMMEMORATING AND RECORDING INJURY

The images of women and children were central in subsequent commemo-
rative ceremonies and memory books, produced annually, at the time of
the Qana massacre anniversary. The annual gatherings beside the graves
of the dead, with relatives, villagers, politicians, and the Lebanese media,
were political events not unlike the May 6 ceremonies in Beirut. They
were organized by the Committee for the Commemoration of Martys of
Qana (CCMQ) under the leadership of Abdel Majid Saleh and members of
Amal. In addition, the National Committee of Commemoration of March
14 and April 18 (NCC), the organization Rafiq Hariri had launched at the
funeral in Tyre, helped the CCMQ with the planning of some of the annual
events but mostly concentrated its efforts on producing commemorative
books in Arabic for a domestic audience, with some in French and English
for non-Lebanese and non-Arabs. Memory books appeared in two forms:
as literary collections of poems and prose pieces, and as archival docu-
ments that furnished readers with long and detailed lists of casualties and
damages as a result of continuous Israeli military attacks. Similar to the
memorial books found in Palestinian, as well as Eastern European Jewish
and Armenian communities, Qana's memory books aimed to record the
physical destruction of homes, village squares, trees, schools, and so on, as
well as the loss of human lives.[61] Lists of detailed destruction subsequently
made their way into translated brochures for foreign audiences.

Remembering death through public ceremonies and through print are
two distinct exercises at communal commemoration, working to instill
both bodily and cognitive remembrance. The aim of these commemora-
tions is to create a Lebanese national community of those who remem-
ber and honor sacrifice. A second goal of conducting annual ceremonies
and publishing memory books is to disseminate information to Western
audiences, in particular, about the destruction the Lebanese experience
as a result of Israeli military attacks. Westerners, the Lebanese believe, do
not know or understand the depth of their suffering. A strong sentiment
among Arabs is that the Western media turns a blind eye to Israeli attacks
on Arab civilians, which makes them actively—almost obsessively—seek
recognition through the collection and distribution of numbers and facts.[62]
If French travel writer Alfred D'Ancre, who visited Lebanon in the 1860s
(see chapter 1), came to interview contemporary Lebanese, he would likely
be told that they still "die as martyrs and are ignored" on the pages of West-
ern history books.

Commemorative Ceremonies

The CCMQ was in charge of the commemorative ceremonies that took place every year, with the exception of 1997, in Qana's cemetery. The April 18 ceremonies adapted many of the same rituals that were used during the official May 6 commemorations. The first anniversary commemoration was held in the Hippodrome in Tyre, where the funeral ceremony had taken place, with thousands of Lebanese in attendance.[63] Subsequently the event moved to Qana, where Amal's Islamic Scout Organization would open the commemoration with a parade through the streets that ended at the cemetery where a stage and seats were set up for the attending guests of honor. The annual lists of public mourners are extensive; they include members of the families, members of the clergy, and politicians from Tyre, Nabatiye, and Beirut, in addition to representatives from various civic institutions, most prominently labor and student unions, and charitable organizations. They publicly join as a community of mourners by laying flowers and wreaths on the graves, standing quietly during the moment of silence, or singing along with the national anthem.[64] The Sunni Mufti of Tyre recited the opening Sura of the Quran, followed by a prayer by Tyre's Maronite bishop or one of the mufti's or bishop's representatives. The clergy's invocation was followed by politicians' speeches emphasizing that Muslims and Christians had shed their blood in Qana and, through their blood, had united the nation. Abdel Majid Saleh and Nabih Berri, or another representative of Amal, spoke about the profound injustice of the 1996 attacks and the ongoing Israeli violence in Lebanon. Representatives of the families of the dead expressed their grief as they shared their personal sentiments of loss with the larger audience. *Al Nahar* faithfully reported each event, proclaiming that visiting Qana's graveyard was a duty (*wājib*) for every Lebanese.[65]

Nabih Berri presided over the annual commemorations for the first four years, but then his wife, Randa, increasingly represented him at the ceremony. Indeed, from 2001 on, Randa Berri would take the stage as one of the main speakers. However, the ceremony continued to be led by men, as members of the Amal party, often Abdel Majid Saleh, delivered the opening speech, followed by the mayor of Qana or another local politician. But Randa Berri's visibility grew as the commemorations began to include groups of scouts or schoolchildren who sang, performed, or drew pictures in honor of the martyrs. For instance, at the 2001 ceremony, a group of a hundred children representing the municipalities of Sidon, Nabatiye,

and Tyre laid down a series of wreaths in front of the graves.[66] They also brought drawings they had made showing South Lebanon under attack. From 2002 on, Randa Berri spoke regularly, often in conjunction with or addressing youths.[67] Young Lebanese would recite poems or speak about the martyrs and their own duty to remember them as well as their duty to resist Israeli aggression, a theme Mrs. Berri would reiterate. Thus the events of Qana were transformed into a potent history lesson for future generations, which engendered both classroom activities and noticeable student involvement during the annual graveside ceremony.

Another prominent female politician who promoted Qana's memory was Bahia Hariri. She coined the term "Not to Forget" (*Kay lā ninsā*) and it became Qana's official slogan.[68] Bahia Hariri had become a member of parliament in 1992, the same year her brother was elected prime minister. In May 1996 she held a ceremony in her native Sidon to recognize the martyrs of Qana on April 18. She also launched a foundation to help Qana's orphans.[69] The Association for Supporting Children of the April 96 Martyrs would take care of eighty-nine children and youths who had lost their parents during "Operation Grapes of Wrath." As head of the association, Hariri regularly visited the members of the caretaker families to ensure that the children's needs were being met. Bahia Hariri had been one of the seventy-four public officials on the stage during the official funeral in Tyre, and she had visited Qana alongside the wife of President Elias Hrawi and Randa Berri in a display of ethno-religious solidarity among Lebanese "first ladies."[70] Subsequently Bahia Hariri held annual Qana commemorations at the Hariri Foundation in Sidon and joined many of the gatherings in Qana itself. Her public work on behalf of the orphans garnered her much praise from Lebanese across the political spectrum. In contrast to previous martyrs commemorations in Beirut or Beqata, which had been almost exclusively organized and executed by men—although some women did speak during the early May 6 celebrations in Beirut as heads of civic organizations—Qana was a site where elite women were more centrally involved in conducting public memory work.

In sum, not only were images of mutilated bodies of women and children central to the commemoration of the Qana martyrs, but elite women took the stage in the public ceremonies. Bahia Hariri and Randa Berri, the sister and wife of two powerful Lebanese politicians, added their voices to commemorative ceremonies and to the image of the nation. Bahia Hariri's and Randa Berri's memory work was gendered: their efforts prominently involved children, casting them in the role of surrogate mother and teacher. But their activities went further in that their public speeches called

for support for the Resistance and indictment of Israeli military activities. They carved out a prominent public space from which to conduct their own politics. They acted out important public caretaking functions on behalf of, or instead of, elite men.

Memory Books

On the first anniversary of the Qana massacre the NCC began to publish an annual Qana Memory Book containing an array of poems, prose pieces, short stories, reprints of previously published reports and journal articles, as well as the transcript of several official speeches by Lebanon's political elites delivered during the official annual ceremony the previous year. With titles such as *Qana: The Right and the Promise, Qana: The Ink and Blood,* and *Qana: The Victory of the Blood over the Sword,* the books seek to commemorate the grave injury and injustice enacted at Qana. The books contain texts both in standard Arabic and dialect-inflected Arabic, inviting different voices—the official and the popular—to speak. The books are an exercise at providing textual evidence that Lebanese remember their martyrs as well as the suffering of residents of South Lebanon in general and of Qana in particular. In the words of one contributor, "The miracle has happened: there has been a transformation from the era of sectarianism and fighting to an era of unity and a determination for freedom, heroism, and resistance."[71] The suffering of the persons killed in Qana is described in imagery and metaphor drawn from both Islamic and Christian traditions. For instance, in a prose piece titled "To a Martyred Child," Mohammad Kansu writes,

> He is a child, unlike all the other children on earth. He lives in our memory, in our conscience. We become one with him. He is Christian, he is Muslim. His voice is in harmony with the voice of the *muezzin* [person who calls Muslims to prayer]; and his cry is in harmony with the tolling of our church bells. So don't forget him. Don't forget his blood. . . . We will never forget.[72]

Texts like these are meant to appeal to Muslim and Christian sensibilities alike, as they emphasize that both communities, each following their own traditions, speak in one voice when it comes to remembering Qana's children.

Moreover, for each anniversary date after the 1996 attacks the Beirut-based NCC issued trilingual brochures under the title "Not to Forget," listing not only casualty figures in the aftermath of Israeli attacks on Qana but figures for all of southern Lebanon. One brochure lists "massacres," starting with Deir Yassin in Palestine on April 9, 1948 to the massacre of Qana in

1996, creating a genealogy of interlinked suffering as a result of Israeli aggression. Each of the twenty-four massacres is listed with the date on which it was committed, the location, and the number of dead. In 1998 the NCC published the book *South Lebanon: The Will to Live and Resist*, detailing every single Israeli military attack in the year 1997. Between January and December there were reportedly 136 Israeli air raids on South Lebanon, a claim accompanied by detailed lists of homes (212), schools (4), and businesses (118) damaged, as well as numbers of the wounded (165) and numbers of the dead (96). Someone even counted the artillery shells fired on Lebanese targets during that time: 16,350.[73] In 2001 the NCC compiled a record of all land mines deployed in South Lebanon by the Israeli army and the resulting casualties.[74] Similar to *South Lebanon: The Will to Live and Resist*, this publication lists every person and type of injury sustained, turning the NCC into an archive of Lebanese injury, painstakingly collecting, organizing, and then publishing data collected from the residents in *al-janūb*.

Many of the statistics and the journalists' photographs were later reproduced for foreign consumption in publications distributed by Lebanon's Ministry of Information but also by Lebanese embassies abroad. The intended audience for these publications was foreigners, as Lebanese government officials hoped that international pressure would change Israeli policies. During a visit to Lebanon's Ministry of Information, I picked up two brochures, one titled *Qana Remembered: 20 Years of Israeli Occupation & Aggression in Violation of U.N. Security Council Resolution 425*, which had been produced and printed by the Lebanese Embassy in London in March 1998, and a booklet titled *Israeli Terrorism in the Correspondents' Record*, printed in Beirut in 2000. Both brochures contained maps, photos, and numbers, detailing Lebanese casualties and infrastructure damages.

Qana Remembered lists the numbers of wounded and killed, every school, hospital, and clinic destroyed, and every olive and orange tree lost in South Lebanon over a twenty-year period. Despite its prominence in the title, Qana is mentioned in only three sentences in the eleven-page booklet. *Israeli Terrorism in the Correspondents' Record*, printed in Arabic, English, and French, features articles by foreign and local journalists about an Israeli offensive in southern Lebanon in February 2000. Although focused on a military operation four years after the Qana shelling, this brochure opens with photos and a short summary of the April 18, 1996, massacre. The majority of all the other photographs show women and children huddled in their homes or wounded children in hospitals. The images condemn, and are meant to elicit the readers' condemnation of, Israel's actions against unprotected civilians. On the second-to-last page of *Israeli Terrorism*, a

قانا الجليل وأخواتها

في

الماضي والحاضر

تأليف

حميد مجيد الأنصاري

FIGURE 4.3. Book cover of *Qana of Galilee* featuring a map of Lebanon
made up of photographs of Israeli attacks on South Lebanon.

Lebanese Resistance fighter appears in uniform but unarmed. He hugs an
elderly woman, presumably his mother, closely to his chest, as they stand in
the ruins of a former house. There are no traces of armed fighters in these
records, and thus an important element of the picture is missing.

In addition to these NCC-sponsored and government-distributed pub-
lications, the Council of the South has produced its own commemorative
literature, which is sold at the site of the memorial. In 2001 they issued
The South: Memory of a Country, which contains 106 pages of photographs
taken in southern Lebanon of suffering villagers, destroyed homes, and
wounded children. Fourteen pages are devoted to "Qana: The Most Brutal
of Massacres."[75] The most extensive documentation of all commemorative
gatherings that have taken place in Qana is published under the title *Qana
of Galilee and Its Sisters in the Past and Present* by Hamid Majid al-An-
sary, a Shiite resident of South Lebanon and a member of the Amal party.

The book summarizes speeches given by various political elites when they visited the graves—making sure to emphasize the leading role of Nabih Berri—and contains a collection of their photographs, solemnly standing beside the graves or at a pulpit addressing their audience. The cover design of *Qana of Galilee* consists of the outlines of a map of Lebanon superimposed on a photograph of the cave where Jesus and his disciples presumably slept while attending the Qana wedding two thousand years ago. Inside the borders of Lebanon, the names of cities, rivers, and mountains are replaced with a collage of photographs, including, from top to bottom, an image of a minaret next to a church steeple, the head of a dead child hanging out of the broken window of a bombed-out car, the burning UN compound in Qana, and the Qana cemetery and memorial. The co-religious sacred landscape and the martyrdom of the innocent made Qana and the South a fitting symbol of all of Lebanon.

RECLAIMING QANA'S CHRISTIAN HERITAGE

About the same time that Qana became an icon of national injury and shared Muslim and Christian sacrifice, the village was being "rediscovered" and launched as an important Christian pilgrimage site. The Ministry of Tourism took an interest in the site in the early 1990s and sponsored the publication of a lengthy and glossy brochure that, for a tourist brochure, contained surprisingly few photographs. Instead, it featured a scholarly treatise, footnotes included, by Dr. Youssef al-Hourani, a scholar whose academic affiliation was specified no further. Al-Hourani gave "unquestionable" evidence in the course of twenty-four pages that Lebanon's Qana was the biblical Qana, and not the villages that made competing claims south of the border.[76] He argued that South Lebanon was the northern extension of the Galilee and part of the biblical lands that Jesus is said to have traveled. The region of South Lebanon harbored several Christian shrines that had been actively maintained by members of local Christian communities since the time of Christ. Al-Hourani argued, retrospectively, that the Southern Lebanese Qana had to be authentic because worshipers had continuously flocked to the village to light candles inside the cave and to pray near the various rock carvings. Al-Hourani called the village *Qana al-Jalīl*, Qana of Galilee, rather than simply Qana. The name Qana of Galilee was used in the memorial literature cited above, thereby linking April 18, 1996, to Qana's biblical past.

Lebanon's Directorate General of Antiquities (DGA) joined the efforts of the Ministry of Tourism in solidifying the biblical claims for Qana in the late 1990s. The DGA sponsored an excavation in 1999 under American

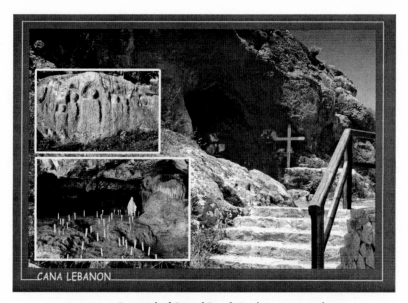

CANA LEBANON

FIGURE 4.4. Postcard of Qana [Cana]: Rock carvings and cave
where Jesus is believed to have slept when he and his disciples
attended the wedding where he transformed water into wine.

University of Beirut-trained archaeologist Sami El Masri, who docu-
mented in detail the historic reliefs next to the "Cave of Qana" (*Mugharat
Qānā*) where Jesus presumably slept while he attended and celebrated a
local wedding. Based on his findings of carvings in the rock face outside
the village of Qana, El Masri wrote that, without a doubt, "Qana is a place
of high antiquity with an important biblical tradition."[77] Subsequently the
Ministry of Tourism made a public announcement that it would dedicate
more funds to the development of Qana as a Christian pilgrimage site.[78]
Additional excavations were undertaken in 2000 in conjunction with the
construction of walkways that made the rock inscriptions and cave more
accessible to visitors. Although no further evidence of Qana's New Testa-
ment past was unearthed, DGA archeologists remain confident that, with
more time and resources, they will find what they are looking for.

TURNING THE QANA MEMORIAL
INTO AN OFFICIAL MEMORIAL COMPLEX

When I returned to Qana in 2003 the graveyard memorial had been sig-
nificantly altered, changing the way visitors experienced the site. The Qana
poem was no longer installed in front of the graves. The handwritten

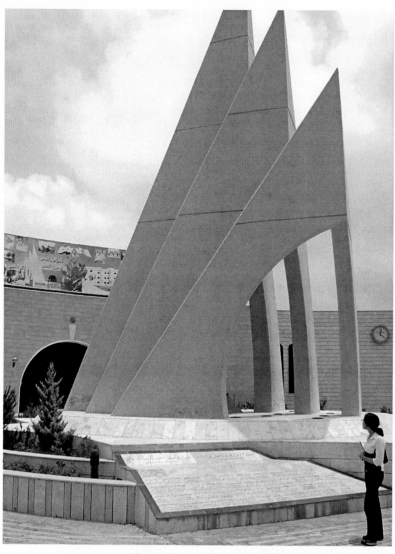

FIGURE 4.5. Qana Martyrs Monument and Museum
in the background, 2003.

banners had been taken down, as had the billboard displaying the pho-
tographic evidence of carnage on the day of the attack. Somebody had
partially (and temporarily) roofed the rows of graves with sheets of cor-
rugated iron. The fourteen rows of marble graves had been "cleaned up."
The replica of a blood-stained cedar tree had disappeared, as well as the
photographs of individuals, the bouquets and wreaths of flowers. Not only

had the graves lost their displays of personal grief and mourning, they had become an annex to a significantly larger Qana Memorial complex. From the graveyard level down two flights of stairs in an area where houses used to stand, a new concrete monument commemorating the martyrs now rose to the sky. The monument was flanked on one side by a semicircular building, the new Qana Museum, and on the other by a plaza that opened onto Qana's main street. After some research I learned that Nabih Berri had inaugurated the new complex on April 16, 2000, that his wife Randa had overseen the competition for the new memorial design, and that the Syrian people had paid for it.

In 2007 I was finally able to track down the new Qana monument's designer, and I met him for an interview in his hometown of Nabatiye. The town had sustained repeated and significant damage during several of Israel's South Lebanon operations, but when Nabil took me on a tour, he only showed me restored and newly built neighborhoods, pointing out the work he and his architectural firm had carried out. Nabil, which is not his real name, was a graduate of the architecture program at the Lebanese University in Beirut. He started his studies in 1978, as one in a class of forty. Six years later he was one of only four to graduate. He decided to return and open his business in Nabatiye, since he enjoyed "the quiet life." Clearly Nabil felt the need to establish and defend his credentials, responding to the unspoken assumption that a successful architect was expected to work in Beirut or abroad. The South, in other words, was still considered a "backward" region. Yet, there was plenty of work in the South, since expatriates used their wealth to build themselves and their local relatives new and often quite lavish homes. Nabil was a member of several civic institutions in Nabatiye, one of them an environmental organization that aimed to create more green spaces in the town. He was also a member of Amal. He invited me to coffee in one of Nabatiye's downtown coffee shops and told me the story of the reshaping of Qana's memory.

The Amal leadership, witnessing how thousands of visitors came to Qana's cemetery memorial in the first year after the massacre, decided that the site needed to be enlarged to accommodate the traffic. The person in charge of the planning committee was Nabih Berri's wife, Randa, who was also the president of the National Association for the Preservation of Archaeology and Heritage in South Lebanon. She had been promoting the restoration of Qana's biblical heritage in collaboration with Lebanon's Directorate General of Antiquities and the Ministry of Tourism. In her role as cultural and heritage ambassador of the South, she became responsible for overseeing the development of the new Qana Memorial design. In 1997 she established a committee made up of architects, artists, academics, and

members of Qana's municipality to deliberate an appropriate design. Nabil joined the committee's brainstorming sessions: some wanted a garden, others an exhibit hall, some proposed a statue, others wanted open space. They also deliberated on the best location for a memorial, and in the end decided that it should be built exactly where the massacre had occurred so that, in Nabil's own words, the "spirit would enter the matter" (*tadkhul al-rūḥ fi-l-mādda*). The historical authenticity of the site itself was a significant part of the commemorative effort.

The committee also discussed finances. According to Nabil and Deputy Mayor Ismail, with whom I spoke separately, the Lebanese government refused to contribute any money for a memorial in Qana, despite the national significance of the events of April 18, 1996. Consequently members of the planning committee had to look elsewhere for funds, which is how the Syrian Popular High Committee for the Support of Steadfastness of South Lebanon (*Al-lajnat al-sha'biyya al-āliyya li-da'am sumūd janūb Lubnān*) became involved. The Syrian committee, it turned out, had collected donations from Syrian citizens who had been outraged by the killing of innocent Lebanese civilians, and who wanted to help. I was unable to ascertain the membership of the Syrian High Committee or the exact sum of money collected. The person heading the Committee, Abdallah al-Ahmar, who conducted the transaction and attended the subsequent inauguration of the enlarged memorial is prominently inscribed on a marble plaque next to the door of the new Qana Museum. Hajj Qabalan Qabalan, the current president of the Amal-led Council of the South, told me that he used the Syrian funds to purchase the land that became the large plaza, as well as to pay for the memorial structure itself. He had to compensate homeowners for their property, which, he claimed, cost hundreds of thousands of dollars. (I was unable to verify the actual sums of money exchanged.) By taking leadership of the memorial project, Amal put itself in opposition to the government, of which it was part. It accused political elites in Beirut of grave neglect and cast Syria as the government that came to the rescue. Drawing on Lebanon's long history of disenfranchisement of the South, Amal's argument was not entirely without merit.

According to Nabil, Randa Berri held a design competition during the summer of 1997 at her home. Fifteen designs were submitted to the members of the planning committee who acted as the jury. Nabil and his business associate won. I asked Nabil to explain his design, and he recaptured his creative process from the beginning. He had started by thinking about what had happened in Qana. The attack had been so violent it required a strong statement, rendered through strong lines. He decided that the

geometric shape of a triangle reflected both simplicity and strength. Then he used the principle of the vanishing point to create the illusion of depth, stacking three triangles next to one another to emphasize the deep imprint that the attack left not only on the South but on Lebanon as a whole. He inserted rounded openings at the base of all three triangular shapes to create an unimpeded view of the place where the actual killings had occurred, which lay behind the monument. The triangular sculpture rested on a pedestal in the shape of an eight-pronged star, a basic geometric pattern from Islamic art and architecture. The pedestal would also be the place to record the names of the martyrs on marble plaques. Keeping in mind the environment, Nabil's design included flowers and trees that would frame and decorate the perimeter of the plaza.

Later, during a separate visit to Qana, I counted eighty-seven names carved onto individual marble plaques affixed side by side on the pedestal of Nabil's monument. I inquired of the guard on site why all the names of the more than one hundred victims had not been engraved, and he simply said, "They will add them" (*rah yizeeduhun*). There was certainly sufficient space on the monument for the additional names, but I wondered whether identifying some of the bodily remains had simply been impossible. Twenty-eight of the victims on the marble plaques had the last name Belhas and came from the neighboring village of Siddiqine. Two more clusters of names recorded six dead from the Deeb family from Rashkananieh and six dead from the Khalil family from Jibal al-Batem, both small towns in the vicinity of Siddiqine. Most victims, however, belonged to a number of different families from the village of Qana itself—including Hadi and Aboudi Bitar from Dearborn, Michigan—indicating that local people had felt so unsafe, that they preferred the crowded shelter of the UN compound to their own homes during Operation Grapes of Wrath. Following an identical commemorative formula, each name bore the title *al-shahīd*, and, after noting the date of birth and place of residence of each person, the inscription finished with the phrase "was martyred (*istashhad*) in the Qana massacre on April 18, 1996." The abstract central sculpture was built from inexpensive reinforced concrete, and already in 2003 water had seeped through the concrete interior from the ground and caused the external paint to peel off. The museum building behind the sculpture, which stood in a semicircle on the far end of the plaza, its arched doorway the architectural extension of the rounded openings in the monument, showed similar water damage at the corners. The museum now housed the official exhibition of the photographs taken on April 18, as well as the Qana poem. The door to the museum was locked, and only my repeated requests to the guard made him get the keys and open the door. The cream-colored

paint of the monument, museum, and plaza contrasted with the black and white graves of the original Qana Memorial. The memorial had been converted from an intimate site that emphasized injury and mourning to an official site that commemorated a less graphic and more transcendent sacrifice for the nation. The central sculpture drew the visitor's gaze toward heaven, and the openness of the plaza contrasted sharply with the newly and partially roofed rows of graves.

Instead of the handwritten banners referencing Shiite and Christian pasts, the memorial now carried Quranic inscriptions. At the entrance to the memorial a big sign welcomed the visitors with the words "In the name of God, the benevolent and merciful," and on the memorial itself visitors could contemplate a quote from Sura 3:169: "Do not consider those who die in the path of God to be dead, for they are alive with their Lord."[79] The religious quote about God's promise of the eternal life for martyrs was mirrored by eulogizing proclamations of political leaders on the opposite side of the memorial. First, Hafez al-Asad praised martyrs as the most generous people in the world and among the most noble of people (al-shuhadā' akram man fi-l-dunyā wa anbal banī al-bashar), and Nabih Berri called Qana a site of tragedy for the umma and of the birth of the watan (Qānā fāja'a umma wa inba'āth watan). Similar to what the handwritten banners had done in the original cemetery memorial, both quotations placed Qana within a much larger frame of reference— the Muslim world and all of humanity—but then provided local significance by declaring Qana the nation's birthplace. As discussed in chapter 2, umma and watan were uttered on the gallows by the martyrs of 1915 and 1916 to express their Arab nationalist aspirations. Umma usually refers to the larger Muslim community, and watan describes an ethno-linguistic and secular community (historically, the unrealized Arab state). On the new Qana Memorial, the political leaders claimed that the Muslim world was witness to the tragedy, which had resulted in Arab solidarity. No reference was made this time to Muslim-Christian solidarity. Syria's now prominent role in the commemoration of Lebanon's martyrs required a different narrative of coexistence.

Instead of Nabih Berri's portrait next to Musa Sadr's, his name was now immortalized in stone beside Hafez al-Asad's, a public acknowledgment of their close relationship. The Syrian-Lebanese relationship was further confirmed by a large billboard overlooking the plaza from the top of the museum (figure 4.5). Above the museum door, the poster showed the Syrian and Lebanese flags, their flagpoles organically intertwined as if part of one tree, not unlike the carving on the Beqata relief honoring the fighters

of 1958. On the left of the two flags was an image of the museum on which the billboard was installed, and on their right was the image of the hospital still under construction when the museum had already been completed.[80] Next to the images of the two buildings were photos from the day of the attack, but their placement at the top of the building made them difficult to decipher. Instead of drawing a comparison between Qana and Karbala, the billboard juxtaposed the destruction wrought by Israelis and the construction done by Syrians, alongside the rhymed slogan "Israel destroys and Syria repairs" (*Isrā'īl tadammar wa Sūrīyā ta'ammar*). In the lower-left-hand corner, visitors are asked not to forget the victims. Directly beneath the image of the hospital building still awaiting completion, an inscription declared: "We will stay and we will continue" (*sanabqa wa nastamirr*). Although "we" was undefined, its position juxtaposed to the images and text on the billboard clearly indicated that "we" referred to the Lebanese and Syrians. In light of the destruction wrought by the Israeli army, this billboard confirmed that Qana, a symbol for Lebanon at large, needed the protection and assistance of its Syrian neighbor.

The replica of the stained cedar tree in the middle of the graves was removed in order to hoist the Lebanese flag next to the Syrian flag. The new memorial was concrete testament to Syria's "special relationship" with Lebanon. It deemphasized intimate and personal memories of individual victims by replacing their photographs with formulaic statements recording their names, dates of birth, and the date of their martyrdom. Qana had moved away from the memory of joint Muslim and Christian sacrifice, and also from references to Qana's Christian heritage or Hussayn's martyrdom at Karbala. The martyrs were now "alive with their lord" as exemplary human beings who had made the ultimate sacrifice for the nation and for God. Through the new commemorative process in Qana, Syria and Lebanon became one community, which significantly altered Qana's original meaning. Now a public platform for Amal's pro-Syrian politics, Lebanese critical of Syrian involvement in Lebanese affairs stopped coming to Qana to pay their respects. A site that heretofore had generated unknown sentiments of Lebanese national unity, Qana was symbolically conceded to Syria (through its local ally Amal). The Lebanese government, after yielding sovereignty over the South to Palestinian guerrillas, the Israeli military, the SLA, UNIFIL, and Hizballah for more than two decades, had failed to assert itself yet again, and therefore *al-janūb* remained Lebanon's "other space."

After the re-inauguration of the larger Martyrs Memorial complex in Qana, Christian narratives were no longer part of the commemoration. However, Nabih Berri inscribed his name onto a separate, specifically

Christian Qana Memorial. On October 13, 2000, only a few months after the inaugural ceremony of the new monument and museum, Nabih Berri unveiled a carved stone plaque that gave credit to President Emile Lahoud as well as himself for restoring the historic "Cave of Cana" to Lebanon's national heritage.[81] In his speech delivered right beside the alleged biblical caves and rock carvings, Berri invited visitors to access the newly restored historical remains along the new pathways and stairs, and to remember Lebanon's important role in New Testament history. Berri advocated the restoration and safekeeping of South Lebanon's Christian past, pursuing the politics of Muslim-Christian coexistence that his predecessor, Musa Sadr, had begun. Subsequently tourists on their way through the South made two stops in Qana, paying their respects to the village's different pasts in separate sacred landscapes. Thus the sponsors of two new official sites of memory, Nabih Berri and Amal retained their symbolic hold on Qana. Moreover, Berri openly declared his political alliances—not a secret by any means—as his name now appeared twice, carved next to the names of a Syrian and a Lebanese president.

CONCLUSION

Despite the extensive media attention as well as visits by scores of both political and religious elites and average citizens, and despite the new biblical tourist infrastructure, Qana has remained a poor village. As early as April 1997 residents of Qana complained that the government was not coming through on its promises to compensate them financially for the damages and losses they had suffered.[82] In 2003 Qana's mayor, Salah Salama, went on public record, accusing the government authorities of "utter neglect."[83] When I visited the mayor's office in January 2008 the employees worked without heat, wearing jackets, hats, and gloves at their desks. Qana's deputy mayor Mohammad Ismail told me that the $200,000 that Qana now received annually from Beirut had to cover the salaries for twenty-two of his staff *and* all the services they offered.[84] The village had no sewage or garbage disposal system, and the roads needed paving (*turaat bedda tizfeed*). Like everywhere else in Lebanon, electricity was intermittent. Most residents continue to depend on remittances from relatives abroad. In other words, Qana's tragic fame in 1996, and its inclusion on scheduled bus tours through southern Lebanon—as well as on all its newly printed maps—did not produce tangible long-term improvements for the village residents.

Qana's prestige as the national symbol of Christian and Muslim sacrifice was short-lived in the end. The creation and redesign of the memorial

demonstrate that commemoration of martyrs is a contested process. The meaning of the memorial has not remained fixed. A popular pilgrimage site that united the Lebanese in the early years after the Israeli shelling of the UN compound, Qana brought together members of all ethno-religious groups. Similar to the commemorative narrative of joint Muslim and Christian sacrifice that turned the executions of 1916 into a national memory of sacrifice, the Qana cemetery memorial did not dwell on actual numbers of Muslim and Christian martyrs but included, instead, symbols of both religious traditions in the retelling of the tragedy. However, those symbols disappeared from public view only a few years later. The guard at the Qana Memorial in 2003 told me that the body of Afifi Haddad had actually *not* been buried in Qana but in her family's plot in a Christian cemetery. Mrs. Haddad's name did not appear on the marble plaques at the pedestal of the redesigned Qana Monument. While Qana's presumed Christian heritage is now more prominently on display than ever, Muslim and Christian sacred landscapes are now separate sites, located on different sides of the same road that takes visitors through Qana.

Amal's decision to include Syria prominently in the new memorial display attached the memory of Qana to a specific political project that became increasingly contested throughout the early 2000s. Moreover, Amal and Hizballah rivalries were played out, rather than reconciled, on the graveyard—Amal party insignia and Nabih Berri were the only advertised sponsors. Meanwhile Hizballah told a story that integrated Qana in its own resistance narrative against Israel. Many loyalists from the suburbs of Beirut visit the site to teach their children a lesson about Hizballah's Resistance.[85] Hizballah rarely mentions Amal's part in the rescue efforts on April 18, 1996, or its role in the subsequent commemoration.

Whereas in 1916 a group of educated urbanites stood defiantly before their Ottoman executioners, in 1996 a group of villagers died because they were at the wrong place at the wrong time. The same had happened in 1958 in the village of Fraydiss. Similar to the martyrs of 1958 in Beqata's Martyrs Square, Qana's dead are remembered as ordinary people, villagers, whose poverty made them particularly vulnerable during the military attacks of "Operation Grapes of Wrath." According to Ali, they died because they could not afford to escape quickly or far enough away. In 1916 the men publicly narrated their struggle for independence before they died; on the other hand, in 1996 the women, children, and men died without a word. Yet, subsequently, their deaths became a powerful symbol of Lebanon's narratives of unified sacrifice and resistance, generating texts on banners, in newspapers, and on pages of memory and history books. The Ottoman judge did

not permit a proper defense for the accused men in the courtrooms of Alay in 1915. Nor did the Israeli attack in April 1996 allow those sheltering at the UN compound any defense. Through the commemorative process, Israel was placed in the same position as the Ottoman Empire ninety years earlier. Moreover, Israel (and the United States) became the new Yazid, which turned the victims of Qana into righteous martyrs.[86] Additionally, the Israeli army's killing of innocents was even equated with the Nazis' "Final Solution." Memories of very different pasts appeared beside one another, creating a landscape of worldwide human tragedy that repeats itself. The Qana martyrs' religious affiliations, similar to what had occurred in Beirut and Beqata, became a focal point in the subsequent retelling of joint Lebanese sacrifice. The memory of this civilian massacre (*majzara*) garnered so much public attention in Lebanon and beyond that it also attracted the Syrian state. Syria used Amal's desire for a redesign and enlargement of the Qana Memorial to advertise its role as Lebanon's protector and reconstruction agent, thereby highlighting the Lebanese government's ongoing neglect of the country's southern borderlands.

The body, whether in its entirety or only its parts, featured prominently in the commemorative narratives in Qana. The cemetery in Qana was built as a mass grave, because the dead bodies could not be reassembled and individually identified. The photographs from the day of the attack next to the graves clearly illustrated the move from imagining the nation as a perfect body to an injured body. The rows of graves do not permit individual mourning, which is why, initially, family members added portraits of the dead in special glass cases. Those photographs emphasized the age and gender of the dead, creating a community of martyrs made up of defenseless children and women. The images of faces and mutilated bodies disappeared when Nabil's monument was built next to the cemetery, adding a prominent abstract design to the rows of graves. The redesign process in Qana was not unlike the replacement of Hoayek's two limestone sculptures with Mazzacurati's more heroic bronzes. According to some, the bodies of women—in Qana's case, women and children—were not suitable for an official state narrative of sacrifice. In Qana, as in Beirut, the image of female and child martyrs—in this case, the portraits on the graves, the poem, and photographs of the injuries suffered—disappeared from public view. Yet, unlike in Beirut, elite Lebanese women and schoolchildren in Qana took a more active role in the commemorative process. Whereas Mazzacurati's memorial drew on the canon of neoclassical nationalist art, Nabil relied on geometric shapes and the principles of Islamic architecture, anchoring the national imagination in abstraction. Ironically, as Nabil's new plaza

was able to accommodate more visitors, fewer came. By taking away references to the martyrs' injuries and their manner of dying, and by making the memorial more formulaic and official, Amal had diminished Qana's status as a national symbol. It is also ironic that at the same time Qana's memory became more heroic—similar to what had occurred in Beirut in 1960—it became less Lebanese.

Although Hoayek's Martyrs Memorial was created from Lebanese limestone, Jumblatt's from locally quarried stone, and Nabil's from reinforced concrete, all three sculptures were conceived to be centerpieces of large memorial squares, separated from the outside, "everyday" world. Visitors were invited to walk into a sacred landscape of memory, between individual or rows of graves, and around the memorial sculptures. In other words, all three martyrs memorials interrupt the regular flow of daily life and demand a moment of reflection, in the same way that a religious building reorients a worshiper away from daily preoccupations toward the sacred. Public art with lines that take the viewer's gaze upward creates transcendent and heroic spaces and bodily dispositions, while the grave markers draw the visitor's gaze to the ground, inviting mournful reflection. Combining both monumental art and enclosed cemeteries, Lebanon's three Martyrs Squares followed the same commemorative logic and spatial configuration. Clearly each site belongs in its unique surroundings—the capital, Mount Lebanon, and *al-janūb*, yet that makes their similarities even more striking.

In all three locations, commemoration committees organized and executed annual ceremonies where friends and relatives of the deceased gathered, alongside members of political parties and of the clergy, to remember martyrdom for the sake of Lebanon as specifically Muslim and Christian sacrifice. The 1975–1991 Civil War interrupted the May 6 ceremonies in Beirut as well as the May 12 commemorations in Beqata. Without the annual ceremonies, the cemetery in Beirut and the memorial in Beqata were forgotten by all but a few remaining commemorative organization members affiliated with specific parties. The Syrian appearance in Qana in 2000 similarly turned a national ceremony of remembrance into a partisan commemoration. In both Beirut and Qana, unfortunately, the sacred landscapes of martyrdom continued to expand after 2005. Yet, as I discuss in the next chapter, as each site grew larger, it competed with the other for the status of the most authentic Lebanese sacrifice. The question, "What did these martyrs die for?" became as important, if not more important, than how the martyrs had died, preventing the emergence of larger, national solidarities.

Revisiting Independence and Mobilizing Resistance

Assassinations, Massacres, and Divided Memory-Scapes (2004–2006)

You have accomplished Lebanon's long elusive miracle, the miracle of national unity, the miracle of Christian-Muslim unity that has been baptized by your blood.
—BAHIA HARIRI ABOUT HER BROTHER RAFIQ, MARCH 14, 2005

The blood of our families is splattering the faces of Bush and Rice.
—NABIL QAOUK AT THE FUNERAL OF THE QANA VICTIMS, 2006

THE RETURN OF THE "SPIRIT" TO THE "HEART" OF BEIRUT

On a Thursday morning, July 15, 2004, Abdel Monem Ariss, the mayor of Beirut, attended a public ceremony in Jounieh, a twenty-minute drive north of the capital. The previous Monday Prime Minister Rafiq Hariri had called him and requested that the restored Mazzacurati statues be brought back to Beirut from their eight-year exile at the University of the Holy Spirit at Kaslik. Hariri had sent the bronze sculptures to be restored in 1996, and although the work had been completed in less than a year, the artwork remained in an empty lot of the university's main campus. In mid-July 2004 Hariri decided it was time for the bronzes to return to Martyrs Square. Marking the historic occasion, the university president, Father Karam Rizq, arranged a departure ceremony and delivered a moving speech, declaring that "the statues represent us and symbolize national values rooted in our hearts: freedom, sovereignty, independence; and we

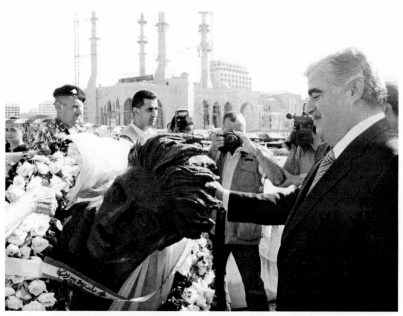

FIGURE 5.1. Rafiq Hariri at a ceremony in downtown Beirut in honor of the return of the Martyrs Memorial. *Reprinted with permission of Al Nahar.*

consider them one of the foundations of the nation. Their presence [at the university] has been a guiding light to the students."[1] He added that he was happy nevertheless to see the statues return to their original location, because they would lend meaning to an empty square. The ceremony at Holy Spirit University featured the national anthem, a speech by Beirut's mayor, a moment of silence in honor of the martyrs, and the deposition of wreaths with red and white flowers, the colors of the national flag. Considering that Father Rizq had only been given three days notice to put the event together, it was done in style.

After the ceremony workers wrapped the statues in protective plastic sheets, to which they attached the commemorative wreaths. The statues were secured onto several flatbed trucks and, accompanied by a security detail of police on motorcycles, were driven slowly from Kaslik to Beirut. The convoy surprised bystanders. The Lebanese public had not been notified that the statues were scheduled to return that day. The statues arrived in Martyrs Square in the early afternoon, where workers unloaded them and deposited them on the ground. They remained wrapped until 5:00 PM, when Prime Minister Rafiq Hariri arrived in Martyrs Square, along with Beirut's mayor and other dignitaries. In front of camera-ready journalists, Hariri proceeded to uncover the statues himself. *Al Nahar* featured a

detailed report of the Martyrs Memorial's departure ceremony in Jounieh and its historic return to Beirut the next morning under the front-page headline "The Spirit Returns to the Heart of Beirut."[2] When an *Al Nahar* reporter asked Hariri to explain the curious absence of President Emile Lahoud at a public ceremony for one of Lebanon's most important national symbols, he evasively answered that another official ceremony with the president would be held in the future. On July 15, 2004, Emile Lahoud happened to be out of the country.

It is unclear why Prime Minister Rafiq Hariri picked up the phone on that particular Monday, July 11, and told the mayor of Beirut to organize the return of the memorial, as Martyrs Square was still only "a vast empty lot of land sometimes utilized as a public space for activities such as art exhibitions, displays, sit-ins and holiday ornamentation [in reference to a large seasonal Christmas tree display]."[3] Only three weeks earlier Solidere had launched an international "design ideas competition" for the landscaping of the plaza, and the winner of the competition, a Greek design team, would not be announced until May 6, 2005. So on July 15, 2004, there was no pedestal on which to install the statues, and it was not even clear where such a pedestal might go on the empty lot. Beirut's mayor acknowledged this problem in his short speech at Holy Spirit University, but he promised that it would only take a month to build the appropriate foundation as well as plant trees and flowers, which would make Martyrs Square even more beautiful than it used to be (*kamā kānat wa ajmal*).

The only official explanation that Hariri would give for the timing of his actions was that he had received many phone calls from citizens who had asked him to bring the statues back, and he thought—and thus told *Al Nahar*—that "people were right in their demand."[4] The return of the statues was obviously important to him, as he attended the unveiling in downtown Beirut himself. By 2004 the statues had accrued multiple layers of commemorative meaning: in addition to representing World War I martyrdom of intellectual elites and 1975–1991 Civil War casualties of civilians and journalists and the sacrifice of Muslim and Christians lives in Qana, South Lebanon, the memorial—because of its prominent location in downtown Beirut—was also a symbol of Rafiq Hariri's reconstruction program. As reconstruction deadlines passed unmet and Martyrs Square remained an empty lot without landscaping or the memorial, the absent Mazzacurati's statues had become a reflection on Rafiq Hariri's (in)ability to deliver what he had promised.

As unexpectedly as the statues had appeared in downtown Beirut, they disappeared again. The very next day a group of soldiers drove to Martyrs Square in army trucks, rewrapped the statues, loaded them up, and drove

them to a storage facility in the military barracks in the nearby port neighborhood of Qarantina.[5] The soldiers were following the orders of President Lahoud, who had just returned and, according to the papers, was annoyed at seeing the statues in the middle of an unpaved Martyrs Square. He found it inappropriate to deposit symbols of national heroism in the dirt, so he decided to take them to a secure storage location until the statues could be properly installed on a pedestal. Over the course of the next week Lebanese newspapers speculated about the behind-the-scenes battles between President Lahoud and Prime Minister Hariri over what journalists had termed the "crisis of the statues."[6] That the two leaders would engage in such a petty public battle prompted analysts to wonder just how bad the relationship was between them. Although its public profile had been reduced by having stood for years at the Holy Spirit University campus in Jounieh, Beirut's Martyrs Memorial obviously still carried symbolic weight.

In the summer of 2004 the relationship between Lebanon's prime minister and president was indeed strained. Hariri vehemently opposed the Syrian-supported extension of Lahoud's presidential term that was officially to expire in the fall of 2004.[7] Hariri's decision to bring the memorial back in an official ceremony marked by Lahoud's absence could therefore be read as a public message to his political rival that neither his approval nor his presence was required on Lebanon's political stage. Emile Lahoud cared enough about his prime minister's symbolic gesture to return it in kind. As former head of the Lebanese armed forces, he mobilized army resources to remove the statues once again. He had undoubtedly been surprised by the statues' return to Martyrs Square, since he had not been given advanced warning. But he acted quickly, thereby reminding Hariri and everybody else in Lebanon that he was still very much in charge. It was a sign of what was to come: Syrian president Bashar al-Asad prevailed in the dispute over Lebanon's presidential elections and extended Lahoud's term for three more years; he also forced Hariri to introduce the controversial measure personally in Lebanon's parliament in late August 2004. Two months later, on October 20, Hariri resigned from office. Around that time—no one can remember the exact date—Mazzacurati's memorial was brought back to Martyrs Square, and the statues were installed without much fanfare on a temporary pedestal at the northern end of the square. With the restoration work and landscaping of Martyrs Square still incomplete, the final location of the restored memorial would have to be determined later.

In a cruel twist of fate, Hariri not only restored and returned the Martyrs Memorial to Beirut's downtown square, but he himself became a martyr who would be commemorated there. The photograph on the front page

of *Al Nahar* on July 16, 2004, of Prime Minister Rafiq Hariri touching the head of one of the reclining martyr statues also showed his future grave. Behind him loomed the monumental Al-Amin Mosque surrounded by cranes and scaffolding, a construction project Hariri had initiated in 2002. At the site of one of the cranes, Hariri now lies buried in a grave decorated with wreaths of red and white flowers, and he is called "the President-Martyr" (*al-ra'īs al-shahīd*). His death would add another layer of meaning to Beirut's Martyrs Memorial. It also transformed Beirut's commercial downtown, an area Hariri had worked hard to bring back to life after Lebanon's civil war, into the home of a prominent graveyard memorial.

SYRIA, THE UNITED NATIONS, HIZBALLAH, AND THE REALIGNMENT OF LEBANON'S POLITICAL ELITES

In order to provide the context for Hariri's death, it is necessary to return briefly to the end of the 1975–1991 Civil War and recapitulate some important subsequent developments. The Taif Agreement of 1989 accorded Syria a "special role" in postwar Lebanon. It was arguably the Syrian military that single-handedly ended the Lebanese civil war by making strategic alliances with some Lebanese militias and defeating others. So in Taif the mediating Arab heads of state agreed that the Syrian government would help restore a functioning government and keep its troops in Lebanon "for a limited time that would last for two years at the most."[8] Yet in 1991, rather than beginning to withdraw Syria's forces, the Syrian president al-Asad drew up additional treaties to cement the Syrian-Lebanese relationship: the Brotherhood, Cooperation, and Coordination Agreement in May was followed in September by a Common Defense and Security Agreement, both signed by Lebanon's president Elias Hrawi and ratified by the parliament. Further, in September the Lebanese parliament ratified the proposed constitutional changes of the Taif Agreement, augmenting parliamentary seats to 128 and changing the formula of six assigned Christian seats for every five Muslim seats to a fifty-fifty distribution among Lebanon's Muslim and Christian political elites. The new constitutional document iterated the formula of the 1943 National Pact that Lebanon was a sovereign and independent country, yet "Arab in its belonging."[9] The Syrian government read the latter part of the Taif Agreement more closely than the first and further elaborated on Lebanon's Arabness with its own Syrian formula: "one people in two countries" (*sha'b wahad fī baladayn*).[10]

Although Syrian rhetoric about its role in Lebanon emphasized the historical and cultural ties between the two countries—under the Ottoman

Empire much of what would become Lebanon had been administered from Damascus—as well as its own security needs in light of Israeli troops on Lebanese soil, Syria had tangible economic reasons for wanting to remain in Lebanon. Not only did Syrian immigrant workers staff most of Lebanon's postwar construction sites, earning more than double a Syrian salary for the same work, but Syrian politicians also benefited from the "special relationship" through bribery and racketeering schemes estimated to have cost the Lebanese government about $30 billion between 1992 and 2005.[11] The Syrian government needed cooperative politicians in power in Beirut, and so in August 2004, as noted above, the Syrian government forced the extension of pro-Syrian Lebanese president Emile Lahoud's term beyond the constitutional six-year limit. Rafiq Hariri, who had cultivated good relations with Hafez al-Asad during the 1990s, changed course when Bashar al-Asad succeeded his father to the Syrian presidency in 2000 and called for the full implementation of the Taif Agreement and the withdrawal of Syrian troops. In sum, in the early 2000s, Lebanese political elites were divided into two camps: those who criticized the Syrian government and demanded change, and those who—for various reasons, including their Arab nationalist ideology or Syrian support for their political ambitions in Lebanon—preferred the status quo.

Then the United Nations got involved. A few days after Lebanon's parliamentary vote to renew Lahoud's term by three years, the UN Security Council passed Resolution 1559, sponsored by the United States and France, calling for the withdrawal of all "foreign forces" from Lebanon, the implementation of free elections, and the disarmament of the remaining armed groups in Lebanon. The first two clauses were directed against Syria and the third against Hizballah, which remained the only armed militia in Lebanon and continued to be involved in resistance activities against Israel. Hariri had lobbied with French and American government officials for the first two provisions of the Security Council Resolution, but he had not asked for the third. The United States considers Hizballah a terrorist organization and a direct threat to Israeli security and therefore added the anti-Hizballah measure to the Resolution. By linking the issue of Syrian troop withdrawal from Lebanon to the issue of Hizballah disarmament, Resolution 1559 encouraged and solidified a Hizballah-Syria alliance in addition to the existing Hizballah-Iran alliance. It created a situation whereby Lebanese who believed that Hizballah's resistance activities had liberated their country in May 2000 and therefore deserved credit and support were politically aligned with those who opposed Syrian troop withdrawal. Equally, it placed those who demanded Syrian troop withdrawal into an anti-Resistance, pro-

America, and pro-Israel camp. This linking of issues provided each side with ample ammunition to discredit the political objectives of the other, contributing to a national, political stalemate.

During the 1990s Hizballah had promised to lay down its arms after achieving the liberation of Lebanese territory from Israeli occupation. Yet, when Israeli troops redeployed to Israel and padlocked the border fence behind them in May 2000, Hizballah remained armed, insisting that Israel's withdrawal had not been *complete* and that they still occupied about ten square miles of hillside next to the Syrian Golan Heights: the Shebaa Farms.[12] At that point few Lebanese had ever heard of the Shebaa Farms, an area under Israeli control since the War of 1967. The agricultural lands around the town of Shebaa are part of the Arkoub region, where Palestinian guerrillas began to deploy in the late 1960s. It is not the farmland that attracted the Israeli military but strategic mountain positions surrounding Shebaa where they installed command posts to conduct their surveillance. From the Israeli perspective the land belongs to Syria, and therefore their withdrawal from Lebanon was complete. Complicating matters was that, during the French mandate, this border area was not clearly assigned to either Syria or Lebanon, an omission that subsequently led to tensions between the two countries.[13] In a shrewd political move after Israel's withdrawal from Lebanon, the Syrian government issued an official declaration that Syria had no claim over the Shebaa Farms, thereby supporting Hizballah's claim that ongoing armed resistance was necessary and also legitimizing its continued presence in Lebanon.

Resolution 1559 had other, immediate consequences: within a month of the Security Council proclamation, a series of high-profile assassinations began in Lebanon. The first target was Minister of Finance Marwan Hamade from the Shouf region, who had openly opposed the extension of Lahoud's term. Hamade survived the attack on October 1, 2004, with severe injuries, but his bodyguard died.[14] The attack sent a clear signal to Lebanese politicians that Syrian policies were not to be criticized in public. Word spread that the Syrians had drawn up a "hit list" of Lebanese targets.[15] The most spectacular assassination occurred on February 14, 2005, when a massive roadside bomb killed Rafiq Hariri, eight of his body guards, and a dozen bystanders and wounded 220 more.[16] Hariri had been in his armored car on his way home after meeting with former colleagues at the parliament. His convoy passed the St. Georges Hotel at 12:55 PM, when it was torn apart by an explosion that created a crater in the road ten feet deep and forty feet wide and shattered the facades and windows of buildings in the entire neighborhood. The sound of the blast was heard all over Beirut. Despite

the airing of a video on al-Jazeera TV, in which a previously unheard of radical jihadist group claimed responsibility for the attack, few believed in a Muslim conspiracy.[17] Since it was public knowledge that Hariri's relationship to Bashar al-Asad had been strained, the Lebanese public immediately pointed fingers at Syria and the Syrian intelligence services, and this story was enthusiastically picked up by the Western press. Meanwhile Syria denied all involvement. The killing of vocal anti-Syrian politicians, many of them with car bombs, continued throughout the rest of the year and into the next (Samir Kassir, George Hawi, and Gibran Tueni in 2005 and Pierre Gemayel in 2006).

Car bombs were a popular weapon during the 1975–1991 Civil War, and a decade later they brought fear back to the nation's capital that had been celebrating its phoenix-like rebirth. Political elites across Beirut built large concrete barriers around their homes and increased the number of their bodyguards to protect against attacks. These highly visible security measures closed off many streets, slowed down traffic, and brought back memories of civil war checkpoints and car searches. Each assassination heightened the anti-Syrian sentiment in Lebanon; each time Syria denied involvement. Meanwhile, the Hariri family convinced members of the UN Security Council to initiate a criminal investigation into Rafiq Hariri's murder. The UN usually investigates war crimes and crimes against humanity but not the murder of individuals. In this exceptional case, the Security Council formed the UN International Independent Investigating Commission (UNIIIC) and dispatched German prosecutor Detlef Mehlis to Beirut in June 2005. On his recommendation, four officers in the Lebanese intelligence apparatus, each with close ties to Emile Lahoud, were arrested in August of the same year.[18] In October Mehlis reported to UN General Secretary Kofi Annan that strong evidence implicated members of both the Lebanese and Syrian security forces, with the blessing of members of Syria's regime, in carrying out the bombing. (In April 2009 a UNIIIC judge ordered the release of the four murder suspects for lack of evidence.)[19]

In the immediate aftermath of Rafiq Hariri's assassination, spontaneous protests in Martyrs Square were followed by more carefully orchestrated rallies. The increased level of planning was visible in the display of flags. Initially the protesters brought along party flags and banners identifying them as members of different political parties. Later the organizers of the protests asked that people bring Lebanese flags only. Two rallies in particular stood out: one sponsored by Hizballah and its allies on March 8, 2005, and a second organized by Rafiq Hariri's Future Movement and its allies on March 14, 2005. The first was a rally against UN Resolution 1559 as well as

a show of support for Lebanon's Resistance. Hizballah's leader, Hasan Nasrallah, called on his followers to oppose American and Israeli interference in Lebanese affairs. The second rally, on March 14, displayed widespread grief over Rafiq Hariri's death, as well as anger at Syria's ongoing presence in Lebanon. Western media reported the March 14 rally—a million Lebanese flag-waving protesters in Martyrs Square—as the "Cedar Revolution" which proved that democracy was stirring in the Arab world. Western media did not cover the March 8 protests as extensively—indeed, there were almost a million Lebanese flag-waving protesters—thereby underreporting the degree to which Lebanon was split into pro-Resistance (and, by default, pro-Syrian) and anti-Syrian (and, by default, anti-Resistance) camps.[20] Under increasing international pressure, and in the face of the enormous popular anti-Syria rallies in Lebanon, Bashar al-Asad began to withdraw his troops from Lebanese soil in late April 2005.

The public protests also led to a realignment of political elites that solidified into two new political blocs: the March 14 Movement and the March 8 Movement; the latter became better known as "the Opposition" (*al-mu'ārada*) after the 2005 elections. On either side, politicians that few would have expected to find common cause began working together. The most prominent parties of the March 14 alliance are the (Sunni) Future Movement, the (Druze) PSP, and the (Maronite) Lebanese Forces, under the leadership, respectively, of Rafiq's son Saad Hariri, Walid Jumblatt, and Samir Geagea. During the civil war the latter two led militias against each other in deadly battles, and Jumblatt's originally socialist PSP party platform rested uneasily next to the Hariri-promoted free-enterprise agenda. (In August 2009 Jumblatt distanced himself from March 14.) On the side of March 8 (Shiite) Amal and Hizballah joined forces, along with most of Lebanon's left-wing and Arab nationalist parties that draw members from across the ethno-religious spectrum. Amal and Hizballah had been arch enemies during the civil war and were rivals for the same Shiite designated seats in parliament. Another surprise was that former Lebanese army general Michel Aoun, who had spent fifteen years in exile in France after prolonging Lebanon's civil war by taking on and being defeated by the Syrian army, returned to Lebanon at the head of the newly formed Free Patriotic Movement.[21] He ran in the 2005 elections as part of a Change and Reform Bloc which garnered twenty-one votes, and was expected to join the March 14 coalition; in February 2006, however, he signed a Memorandum of Understanding with Hizballah and its pro-Syrian March 8 Movement.

For the first time in its history, Lebanon's Maronite community was publicly split into pro- and anti-government camps, aligned with a Sunni-

led March 14 alliance, on the one hand, and a Shiite-led March 8 coali-
tion ("the Opposition"), on the other. In response to various foreign and
domestic developments, Lebanon's political elites had transformed the tra-
ditional confessional Sunni-Maronite divide that had defined most of mod-
ern Lebanese politics into a confessional Sunni-Shiite divide. Rafiq Hariri's
death intersected with and was part of that political transformation. The
Sunni-Maronite divide had been made workable by the 1943 National Pact,
in which each side made some concession to the other (i.e., Sunni elites
would not pursue their pan-Arab/Arab Union agenda and Maronite elites
would not pursue their pro-Western/separatist agenda). This political pact
was supported by a politics of memory that acknowledged joint Muslim
and Christian sacrifice for Lebanon, as well as elite post–civil war agree-
ments to let bygones be bygones.

After 2006 Lebanon's elites were divided in such a way that the estab-
lished politics of memory was used by one political camp to discredit the
other, while the other side skillfully promoted its own martyrs and narra-
tives of sacrifice. As elaborated below, the March 14 Movement claimed
to be inheritors of the National Pact and of the politics of memory that
emphasized ethno-religious difference as part of Lebanon's national proj-
ect. On the other hand, Hizballah generated its own politics of memory
that emphasized acts of resistance (against Israel and the United States)
and suppressed mention of ethno-religious differences in Lebanon. Mar-
tyrs remained central in each of the two memory projects, but they were
now more overtly connected to the question of what they had died for—
independence from Syria or liberation of South Lebanon from Israeli oc-
cupation. Each political movement could legitimately claim to represent
Muslim and Christian communities in the country—meaning that it was
a *national* movement—and each also asserted that its political platform
represented the absolute majority of all Lebanese.

BURYING RAFIQ HARIRI IN MARTYRS SQUARE

Following the decision made by his immediate family, Rafiq Hariri was
laid to rest in the "heart of Beirut." Rather than taking his body to the
Hariri family plot in the cemetery in his native Sidon, as would have
been customary, his wife and children preferred that his body remain in
downtown Beirut, to whose reconstruction he had dedicated the latter
part of his life. On the day Hariri was killed, his family contacted the pri-
vate developer who owned the land between the Al-Amin Mosque, which
Hariri had spared no cost to build, and the international record chain

Virgin Megastore, and bought half the property for an undisclosed price.[22] At the time of the funeral, Martyrs Square and the adjacent mosque were unfinished projects, and the private plot had not yet been turned into a large apartment complex. In other words, Rafiq Hariri, the owner of a construction empire, was literally buried in the middle of three construction sites. On the fourth side Hariri's grave was flanked by an archaeological park—a plot of land that had been left excavated at about ten feet below street level—which revealed a number of ruins from different periods of Lebanon's past.

Notably the archeological park was not only a site to commemorate the many civilizations that had inhabited what would become Lebanon, it was also part of a civil war memory project-in-the-making: the Garden of Forgiveness (*Hadīqat al-samāh*). In 2001 Solidere had accepted a proposal by a British-Lebanese citizen, Alexandra Asseily, the wife of a successful and politically connected Lebanese businessman. The Asseilys were the kind of Lebanese diaspora members that Hariri hoped to attract back to Lebanon to help in its postwar reconstruction. Mrs. Asseily believed that the Lebanese needed "a public place for calm and gentle reflection," which would be in a "neutral location with a multi-communal history" in order to nurture "sentiments of peace, joy, and healing."[23] A psychotherapist by training, Mrs. Asseily had involved Prince Charles and prominent Lebanese politicians in her venture, and convinced Solidere that a site of memory such as this was indeed needed. The proposed design envisioned a public park that aimed to reintroduce trees and greenery to a bleak post–civil war Martyrs Square. Equally important, the project planners wanted to install footbridges over the archaeological park to link Martyrs Square with the Riyad al-Solh and Nejme Squares to the west, thereby connecting the main churches and mosques in the downtown area. The garden was meant to bridge, literally and symbolically, the ethno-religious divides that had been created by the war. Since the bridges would lead over the archeological park, visitors could witness Lebanon's multicultural history and reflect on its multicultural present. The Garden of Forgiveness reinforced the claim that downtown Beirut was "the heart" of Lebanon and that it could therefore generate reconciliation in the hearts of the Lebanese. The project began in the summer of 2003 but was halted in February 2005 when Hariri's grave became the center of Martyrs Square's expanding commemorative geography. Both the Garden of Forgiveness and the restored and provisionally reinstalled bronze Martyrs Memorial explicitly sought to remember all who had died during the 1975–1991 Civil War. These two projects were linked to Lebanon's foundational sacrifice of 1916. Hariri's

grave memorial was connected to this wider symbolic web of remembrance of national sacrifice and the spirit of reconciliation.

After the plot for Hariri's grave had been purchased, employees from Hariri's Beirut-based OGER Construction Company, as well as most of his residential staff, spent the next forty-eight hours working nonstop to dig the graves for their former boss and six of his bodyguards. No one left the site until the work was finished, sleeping in the unfinished mosque structure next door, if they slept at all. Muslim clerics were consulted so that the heads of the graves would point toward Mecca, in accordance with Sunni tradition. Amid the shock and confusion immediately after the assassination, a second, equally significant symbolic decision was made that affected the position of Hariri's grave. Azmi Fakhuri, one of the senior engineers and architects at OGER, who was familiar with the blueprints of Solidere's still unrealized designs for Martyrs Square, gave instructions that placed Hariri's grave on the same latitude as the planned pedestal of the permanent Martyrs Memorial. Once the reconstruction of Martyrs Square is complete, visitors to Hariri's grave will be able to turn around and look directly at the Mazzacurati statues. In order to make the symbolic connection between Hariri and the martyrs of 1916, his grave is therefore not in the geometric center of the plot that the Hariri family purchased but rather at the southern corner closest to the Al-Amin Mosque. The grave is adjacent to the Maronite St. Georges Cathedral and close to the bridgehead of one of the planned footbridges that will lead from the Al-Amin Mosque to the Greek Orthodox St. Georges Cathedral on the other side of the archeological park.[24]

Once the location and direction of the graves had been determined and the graves had been dug, two large white tents were erected: one provided a roofed reception area for the Hariri family at the funeral, and the other sheltered Hariri's grave. A third, smaller tent was added behind Hariri's grave where his bodyguards would be buried right beside one another. The graveyard memorial layout thus retained the status and class differences of the dead.[25] The Lebanese would later call the site of commemoration simply "Rafiq Hariri's grave" (*aber Rafiq al-Hariri*) rather than the "Hariri Graveyard," which would have indicated that more than one person was buried on the site. Most visitors to Hariri's grave also visited the bodyguards' graves, but Hariri was clearly the focus of attention. The temporary tents would remain in place after the funeral, as a reminder that until the persons responsible for Hariri's death were brought to justice, Hariri would not permanently rest in peace.

Hariri's family not only decided on the location of the graves and financed the entire construction but also organized Rafiq's and the bodyguards'

funeral: it would be "a popular farewell" to which members of the government, and President Emile Lahoud, in particular, were expressly not invited.[26] The Lebanese and foreign politicians who did attend, including French President Jacques Chirac, came as personal friends of the deceased rather than as state officials. On February 16, 2005, hundreds of thousands of mourners converged on Martyrs Square to witness Hariri's final journey from his Beirut home in the neighborhood of Quraytem to his grave. Similar to the funeral proceedings in 1996 in Tyre, the coffins of Hariri and his bodyguards were draped in Lebanese flags and driven in a convoy of hearses to the graves. Throngs of people lined the streets, balconies, and rooftops. The sheer size of the crowd slowed the progress of the funeral cortege considerably. The sound of the square's church bells mingled with the broadcasting of Quran recitations from neighborhood minarets. Mourners carried the Lebanese flag, flowers, and pictures of Rafiq Hariri. Some wore T-shirts with his portrait and his honorific title "the Martyr-Leader." When Hariri's coffin finally arrived at his grave, his sons carried his body to his final resting place and lowered him carefully into the ground according to religious tradition. Relatives of the bodyguards did the same with their slain family members. Sunni clergy recited passages from the Quran. Once the grave was filled with earth, mourners placed candles around Hariri's final resting place, following Christian tradition. There was no national anthem, no words on behalf or from the government. Hariri was buried as a (prominent) private citizen, next to his former employees. His death elicited public displays of sympathy from across Lebanon's ethno-religious spectrum, and for months after the funeral mourners returned by the thousands to pray, light candles, or place flowers at Hariri's grave, turning it into a national shrine.

From the beginning Rafiq Hariri's death was compared to that of the martyrs of 1916. Though few members of the public at the time knew of the symbolic connection between the placement of Hariri's grave and the future, permanent placement of Mazzacurati's Martyrs Memorial, the link between the two was made explicit by other people loyal to Hariri, who designed a popular poster carried by mourners and protesters at the March 14 rally. The poster combined three distinct images: Hariri's head superimposed on a photograph of Martyrs Square, featuring the restored Martyrs Memorial in the center and the Al-Amin Mosque surrounded by cranes and scaffolding. Similar to the images of the martyrs who had died on the gallows in 1916, Hariri's smiling portrait revealed his mustache, his thick signature eyebrows, and only part of his upper body, enough to reveal a suit, white shirt, and tie. As a sketch, it would have been possible to add Hariri's

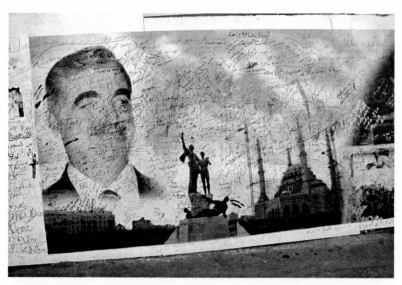

FIGURE 5.2. Poster of Rafiq Hariri next to the Martyrs Memorial and the Al-Amin Mosque, signed by mourners. *Reprinted with permission from Stewart Innes.*

face to the martyrs for Lebanon's independence represented in Yazbek's 1955 book, *The Conference of the Martyrs* (see chapter 2). Hariri's face hovered in the upper-left-hand corner above Martyrs Square. The plaza itself actually remained hidden behind a grassy knoll surrounding the Martyrs Memorial which anchored the image. The mosque appeared on the right side of the frame. Because it was surrounded by building equipment, it was as much a symbol of Hariri's reconstruction efforts as it was a symbol of his religious affiliation. Significantly it was not his face that was the central feature in the collage but the restored Mazzacurati bronzes, which still showed visible traces of war damage. No photograph of Hariri's mutilated body in the aftermath of the explosion was ever publicized in the way that the 1996 Qana victims had been portrayed, but here his portrait showed his head detached from his body, and the mutilated statues representing the struggle for Lebanon's independence and victims of civil war beside him were a sufficient reminder of the explosion that killed him.

This three-part image was later reproduced on a large scale and mounted on a wall next to Hariri's grave. Hundreds of mourners would stop by there and write down wishes, thoughts, and feelings, as part of the public mourning process. With the Martyrs Memorial at its center, Hariri's life and death was tied to a specific narrative of sacrifice for the nation—one that emphasized religious coexistence and independence from foreign rule. This iconic image, it is important to note, would later be modified to strengthen the

message of sacrifice for Muslim and Christian unity. The Al-Amin Mosque construction site would disappear from subsequent commemorative posters and images; instead the commemorative focus would become the allegorical pair Liberty and the Nation from Mazzacurati's Memorial in addition to explicit Lebanese symbols of Muslim and Christian difference.

ENSHRINING SACRIFICE FOR
MUSLIM-CHRISTIAN INDEPENDENCE

In January 2008, during my third visit to Hariri's grave, I took a guided tour with the supervisor of the shrine's staff. Mohammad, a heavy-set young man in his early thirties dressed in a beige sweater and jeans, first invited me into his office in a trailer outside the tents.[27] The room consisted of a simple desk, two plastic chairs, and a small refrigerator that doubled as a TV stand. The television was turned on, muted, and Mohammad would glance at the screen every so often while I explained my reason for wanting to learn more about Hariri's gravesite. Mohammad had started working for Hariri at age seventeen. He apprenticed to be an electrician and joined Hariri's residential staff in his palatial home in Beirut's neighborhood of Quraytem. He said he volunteered to leave Quraytem to work at the grave downtown, which he had helped build with his own hands. He was deeply devoted to Hariri and proclaimed that "until now [almost three years after his funeral], I refuse to believe he is dead."

He did not seem to be the only one with that thought. As we entered the first tent that served as a reception area, we were greeted by a five-by-ten-foot color reproduction of a painting by Canada-based Lebanese artist Antoine Bridi (b. 1971) titled *Phoenix*.[28] It depicted the statues of Mazzacurati's memorial on their pedestal; however, instead of being cast in bronze, they had come to life. Hariri, dressed in a dark-blue suit and red tie, was also very much alive, and he had joined the memorial ensemble. The struggling martyr lying at Hariri's feet on the ground used his outstretched hand to pass a Lebanese flag on to Hariri. The former prime minister of Lebanon stood tall, as did the figures of the allegorical Liberty and Nation behind him, and he held the flag pole with his left hand. Hariri's gaze did not meet that of the flag-bearer but instead was trained on the horizon to his right. In this way his gaze paralleled that of the young man representing the nation, who stood elevated directly behind him. The Lebanese flag, in a somewhat unlikely position, was unfurled behind Hariri, as if a strong breeze was blowing toward Hariri from the left. In this position the flag cradled Hariri's body in the same way that the torch-bearing Liberty

FIGURE 5.3. *Phoenix* by Antoine Bridi, 2006. Original 3 × 2 meters;
oil on canvas. *Reprinted with permission from painter.*

cradled the body of the young man with her left arm. Conveniently the flag
also covered up a good part of the young male figure's nude features—the
allegorical Nation was still dressed only in a loincloth wrapped around his
middle. The flag ensured that he was only exposed from below his knees
and above his chest. The flag was semi-transparent, so the viewer could
make out the shaded contours of the young man's body which revealed
that his left arm was missing. Liberty was now attired in a green dress that
picked up the green of the cedar tree on the Lebanese flag. The sash was the
same brilliant blue as the sky. Her torch was lit, the flame flickering in the
breeze in the same direction as the flag. Hariri was the largest of the figures
in the ensemble, and he was placed closest to the viewer. A sea of candles
surrounded the four martyrs in an arrangement that resembled the candles

placed around Hariri's grave. This was the only reference to Hariri's death. The message of this image, as reflected by the title, was that he had risen like a phoenix, a metaphor that had been used repeatedly in describing Lebanon's reconstruction efforts after the 1975–1991 Civil War. Hariri, like the martyrs of 1916, had given his life so that the nation might live, demonstrating that the Lebanese spirit of martyrdom was still very much alive. Moreover, Hariri's sacrifice was given further shape and meaning by the outline of a mosque building in the background. Its position relative to the newly animated Martyrs Memorial mirrored the position of the Al-Amin Mosque relative to the bronze figures in the actual Martyrs Square. Yet, instead of four minarets, there were two towers opposite each other across the central dome, and only one was a minaret. The other was a steeple recognizable by the cross on top. The artist had modified the Al-Amin Mosque into a building that was home to two religions. Hariri's body was artistically integrated among the bodies that represented Christian and Muslim martyrs, and next to a house of two faiths. In his life, as in his death, so read the message by his grave, Hariri had sought to embrace ethno-religious difference as part of Lebanon's national identity.

This unifying national message was later appropriated by members of the March 14 Movement who incorporated Hariri's sacrifice into their political platform. A series of bright blue and white banners, the colors of Hariri's party, the Future Movement, hung on the wall opposite the painting I just described, across an empty open space that was used to seat visitors during official functions. Bold white letters proclaimed, in Arabic, "They feared you, so they killed you" (khāfūk fa-qatalūk). At the end of the sentence, there was no picture of Rafiq Hariri, as one might have expected, but a shaded outline of the allegorical pair of the Mazzacurati Memorial: Liberty raising her torch and embracing the Nation at her side, his mutilated left arm prominently visible next to the last letter of the Arabic inscription. To the left of Liberty were two outlines of religious buildings, one a church steeple, the other a minaret. The flame of Liberty's torch was lined up exactly with the cross on the steeple and the crescent on the minaret. This was a different rendition of the same theme I had just contemplated in the *Phoenix* painting: Hariri had presumably given his life for *all* Lebanese.

I identified the steeple and minaret as those of the St. Louis Capuchin Church and the Al-Omari Mosque. Notably while both religious buildings are part of the downtown area, neither one is in Martyrs Square proper. The Al-Omari Mosque is probably the oldest mosque in Beirut, dating back to the time of the Mamluks in the thirteenth century. It used to be the

city's Grand Mosque, a title that now belongs to the Al-Amin Mosque. The St. Louis Capuchin Church, home to Beirut's Roman Catholic community and the site of Musa Sadr's famous 1975 sermon, was originally built in the eighteenth century, yet it was neither the oldest nor the most prominent church in downtown Beirut. Yet both the Capuchin church steeple and the Al-Omari minaret were topped by an easily recognizable cross and crescent, which seemed to matter most in this collage. The icon and the slogan "They feared you, so they killed you"—which accused Syria without naming it—were framed on either side with color photographs of the mourners who had flooded downtown Beirut to pay their last respects to their slain former prime minister. The newly designed icon of the two statues, the minaret, and the church steeple symbolically connected national sacrifice and Christian and Muslim parity, and this symbol of coexistence was juxtaposed to the throngs of Muslim and Christian mourners whom the icon represented.[29] Just as the memorials in Qana and Beqata had recognizable sponsors with clear affiliations to a political party, Hariri's graveyard memorial was both a site for mourning and a site for the Future Movement to conduct politics.

The message of Christian-Muslim parity was further reinforced through photographs of mourners who came to Hariri's grave. Their physical presence at the grave demonstrated Lebanese unity. On a fourteen-foot framed collage of several photographs mounted onto the horizontal beam that supported the tent's roof, grief-stricken faces of men and women documented the scope of popular mourning over Hariri's death. The collage prominently featured women in veils mourning beside women who wore none, old men with grey hair in suits next to dark-haired young men in jeans, visual proof that Hariri's death had brought Lebanese from across the generational and ethno-religious spectrum to downtown Beirut. The photographic evidence of unity-in-diversity was further supported by the various gifts the mourners had brought to the grave: mosaics, paintings, stone carvings, metal work, and so on, displayed at the entrance to the grave memorial, showcased Lebanon's arts and crafts from different regions of the country. The mementos honoring Rafiq Hariri were initially displayed around the grave, but eventually, when there was no longer space for them, Mohammad moved the gifts to a warehouse, individually labeled with the name of the person who had brought it and the date it was received. One day, and here Mohammad pointed straight across Martyrs Square, there would be a Hariri library to display all the mementos that people had brought to the grave, some even sent from abroad. In other words, both through the (photographs of the) bodies of the mourners at the grave and the artwork

FIGURE 5.4. Photograph of mourners at the entrance to
Hariri's Grave Memorial, with his grave in the background, 2007.

they left behind, those loyal to Hariri made claims that his political pro-
gram and vision for Beirut's reconstruction was an authentically Lebanese
program, since it included both Muslims and Christians.

Similar to the other memorial sites studied, Hariri's grave had "sectarian"
markers, the most obvious was that he had been buried next to an enormous
mosque that he had sponsored. Moreover, during my entire visit I could
hear the Quran being recited via loudspeakers that had been affixed to the
tent poles. Mohammad explained that the CD player was set to play con-
tinuously. Copies of the Quran were displayed on each of the seven graves at
the memorial beside Muslim prayer beads. Two large stone carvings repre-
senting the Quran, its pages open to allow readers to view the opening sura,
were displayed in the entrance of the first tent. From the ceiling dangled
hand-crafted bronze lamps with the Arabic inscription, "Do not consider
those who die in the path of God to be dead, for they are alive with their
Lord," the same sentence that was inscribed on the official Qana Monu-
ment. Rafiq Hariri was mourned in the Muslim tradition; yet, contrary to
orthodox Sunni tradition, Hariri's grave became a shrine, attracting Leba-
nese from across the country and abroad to come and pay their respects.
With its religious symbols, flags, and images of the Martyrs Memorial, as

well as its photographs of mourners in Martyrs Square, Hariri's and his bodyguards' graves became a national cemetery memorial.

Different from the marble graves at the memorials discussed previously, Hariri and his bodyguards' final resting place remained covered entirely in fresh white flowers that were replaced every week. Mohammad explained that the idea to keep the tomb covered in flowers emerged after mourners continued to bring so many flowers that, initially, Mohammad and a staff of six spent several hours removing them at night to make room for the flowers that would be brought the next day. Three years later a florist still brings fresh flowers every week, a practice that will continue until a more permanent tomb structure is built. I asked Mohammad about the plans to replace the tents with a more permanent structure, and he pointed to a lighted display case right beside Hariri's grave and shrugged his shoulders. In the glass case, as if in a museum display, was a black leather-bound book titled *The Basic Rules for the Special Tribunal for Lebanon (Al-niẓām al-asāsī lil-mahkama al-khāsa li-Lubnān).* The book was a reminder that Hariri's murder was still an unresolved and untried crime. Another indication of the transitional nature of Hariri's final resting place was a large electronic counter affixed to the beams at the grave's entrance which kept track of the days that had passed since Hariri's assassination. Other counters are mounted on Hariri-owned buildings in different neighborhoods in Beirut. Mohammad said that they would keep counting the days until justice was served. As I thanked Mohammad for the tour and said my good-byes, he leaned in close to me and said, confidentially, "You know, Syria did not kill him, it was someone *bigger.*" He then raised his eyebrows, indicating that he had let me in on a big secret. Surprised at this unexpected revelation, I asked him who he meant by "someone bigger"? He smiled knowingly and simply said that Syria was not capable of executing such a massive attack.

Rafiq Hariri's funeral and his grave memorial were sites where the public could grieve, but they also were sites where Hariri's family and the March 14 Movement could conduct politics. They were also sites that generated different theories as to who had killed him. Hariri was depicted as a martyr who sacrificed his life for a particular vision of Lebanon characterized by Christian and Muslim communities in perfect balance, which made him a direct descendant of the martyrs of 1916. March 14 added images that displayed Hariri as a champion of an anti-Syrian politics, as demonstrated by the Special Tribunal's leather-bound book and the slogan "They feared you, so they killed you," an agenda not shared by everyone who visited or worked at the graves. By burying Hariri and his guards in Martyrs Square,

a public place in the center of Beirut, Hariri's relatives and supporters connected his life's work to his tragic death. By joining the memory of his reconstruction efforts with existing symbols of national sacrifice, Hariri's followers not only enlarged a sacred memory-scape but also redefined "the national" at the core of Lebanon's project. The pursuit and protection of ethno-religious coexistence was now linked to the support for the March 14 Movement.

Rafiq Hariri was not the only martyr honored in Martyrs Square. The images of other members of the March 14 Movement who were assassinated by unknown but suspected Syrian killers were added to the facades of buildings surrounding the plaza. Most prominent were the larger-than-life images of Member of Parliament (MP) Gibran Tueni, who was killed by a car bomb on December 12, 2005, and MP Pierre Gemayel, who was shot by gunmen on November 21, 2006. Gibran, the son of *Al Nahar* newspaper owner Ghassan Tueni, had been at Rafiq Hariri's side the day that the Mazzacurati statues were returned to Martyrs Square in 2004. During the March 14, 2005, rally in Hariri's honor, he had given a rousing speech, proclaiming, "We pray to the great God, both Muslims and Christians, that we remain united forever, defending the great Lebanon." That sentence was now printed alongside his photograph, taken at the March 14 rally, and projected on a poster above the main entrance of the *Al Nahar* headquarter in Martyrs Square. On a residential building across the square from Gibran Tueni's poster, an equally large billboard displayed the image of Pierre Gemayel, standing against the background of an enormous Lebanese flag under the inscription, "So that Lebanon may live." From their billboards, Hariri, Tueni, and Gemayel gazed down at the Martyrs Memorial on its temporary pedestal on the northern end of the square. Evoking the deeds of the men who died on the gallows, here was a Sunni, a Greek Orthodox, and a Maronite member of the political, urban elite, men who became the twenty-first-century incarnations of Lebanon's 1916 independence heroes, just as the Syrians became the new Ottomans.

Photographs of martyrs and mourners standing side by side at a sculpted memorial transmitted a message of a national community unified by the sacrifice of its political elites. While the commemorative posters pictured the men alive—not wounded or mutilated—they were juxtaposed to a memorial that had suffered sniper fire and explosions. Images of the sites of their killing, without any trace of the mutilated body parts, were circulated in 2006 and 2007, and mounted on lampposts or on the walls of houses in neighborhoods that supported the March 14 Movement. In other words, the way the martyrs had died was significant to those who mourned

them, individuals who believed that the Syrian government and Lebanese and Syrian secret service agencies were to blame for the killings. The dead were not remembered in a graphic, bloody way. These were men of state who had died, and their wounds and vulnerabilities were not part of their memory in the way that the wounds of women and children were in 1996 in Qana. However, the damaged statue symbolizing liberty from Mazzacurati's memorial stood tall, holding her torch. She represented the transcendent value for which the men had given their lives.

THE JULY WAR (*HARB TAMMUZ*)
AND THE SECOND QANA MASSACRE, 2006

At the same time the March 14 Movement solidified around Saad Hariri, Walid Jumblatt, and Samir Geagea, and a new geography of fear took on concrete forms in the streets of Beirut, Lebanon's "other space" underwent its own changes. In the aftermath of Israel's 2000 withdrawal, Hizballah became more actively involved in politics in Beirut, yet it continued to plan for the next military confrontation with Israel. Over the course of five years Hizballah constructed an extensive net of bunkers, defensive positions, and arms caches all over *al-janūb,* and bought a vast arsenal of katushya rockets, anti-tank missiles, and machine guns with the support of Syria and Iran. Fighting continued in the Shebaa Farm area, but hostile exchanges along other parts of the border subsided.

The spark that ignited the next large-scale conflict between Lebanon and Israel was a daring Hizballah attack on an Israeli border patrol on Israeli territory on July 12, 2006. During the operation Hizballah kidnapped two soldiers and killed eight who subsequently entered Lebanese territory on a rescue mission. Israel's military, politicians, and public were stunned. Ehud Olmert declared the kidnapping an act of war and Israel launched what it called its "Second Lebanon War," a thirty-four-day retaliatory air war and ground offensive. The air raids targeted a combination of Hizballah and non-Hizballah targets all over Lebanon with the goal to eliminate Hizballah's fighting capabilities ahead of the planned ground assault as well as to erode Hizballah's popular support among the Lebanese citizenry at large. Hizballah leader Hassan Nasrallah explained his militia's cross-border raid on July 12 with the story of a 2004 prisoner exchange between Israel and Hizballah in which one Lebanese prisoner, Samir Kunta, had been held back at the last minute by the Israeli authorities. At that time Nasrallah had promised Kunta that he would also be freed, and therefore he ordered the kidnapping of Israeli soldiers in order to instigate another prisoner exchange.

He said that he had not intended to start a war but that he and his men were ready to fight it. Hizballah later would call the war of July and August 2006 "Operation Truthful Promise."

Lebanese political scientist Paul Salem called Israel's thirty-four-day military operation "the costliest Arab-Israeli war in Lebanon's history."[30] In Lebanon, about 1,200 civilians were killed, 4,000 wounded, and one million displaced. During the war the Israeli Air Force (IAF) flew more than 10,000 combat missions into Lebanon, which, in addition to human casualties, caused substantial infrastructure damage to electrical and water plants, roads, and Beirut's airport. Salem estimated Lebanon's economic losses at $7 billion. The 2006 war hit Lebanon at a time when the country was already $36 billion in debt as a result of post–civil war reconstruction loans and limited economic growth. The war was costly for Israel as well: Hizballah had fired about 4,000 rockets into Israel, displacing almost 500,000 Israelis, killing 43 three civilians, wounding about 100, and causing damage to more than 12,000 buildings.[31] The Israeli military sustained over 120 casualties, and many more were wounded. Its commanders commented on the sophisticated maneuvers of Hizballah's fighters, firmly entrenched in their fortified defensive positions.[32] As the ground war slowed, the aerial bombardments increased, inflicting ever higher civilian casualties on the Lebanese. On day 18 of the war, Israeli bombs struck the village of Qana, killing twenty-seven civilians, the majority of whom were children, from the resident Shalhoub and Hashem families. The Lebanese called it the "second Qana massacre."

According to conflicting Israeli military reports, the building in which the Shalhoubs and Hashems sought shelter was attacked during the night of July 29/30, because Hizballah had fired rockets from nearby or because Hizballah fighters had used the actual building or because the house had served as weapons storage.[33] Villagers refuted all three assertions, and no rocket launching equipment or bodies of Hizballah fighters were found on or near the site, which was inundated by rescue personnel and journalists in the immediate aftermath of the attack. According to the report of a sixty-one-year-old survivor, Muhammad Mahmud Shalhoub, printed in a Human Rights Watch Report, planes started attacking Qana in the early evening of Saturday, July 29, 2006, so he and his family sought shelter in their basement. Around 1:00 AM, Israeli ammunition hit the ground floor of the home: "It felt like someone lifted the house . . . When the first strike hit, it hit below us and the whole house lifted, the rocket hit under the house."[34] Five minute later there was a second explosion nearby. After relatives and rescue workers had finally worked their way through the dust and

rubble, twenty-seven people, among them sixteen children, were declared dead. Though there had been larger death tolls earlier during the 2006 Lebanon War—for instance, seventy-two people had been buried in mass graves in Tyre on July 21, 2006[35]—the news of the dead of Qana unleashed angry demonstrations in Beirut as well as elsewhere in the Arab world. Christians reportedly waved Hizballah flags in the streets of Beirut to show their support for the Resistance.[36] The Lebanese government which had been asking for an immediate cease-fire was granted a two-day break from attacks. Then the war resumed and lasted another two weeks, killing many more Lebanese and inflicting heavy losses on, but not eliminating, Hizballah. After the war ended Hizballah proclaimed "divine victory" in front of hundreds of thousands of supporters and boasted that the Resistance was stronger than ever and had weapons left over to continue their fight.[37]

When the bombs stopped falling and the Lebanese started to bury their dead, Hizballah alone organized and carried out the funeral of Qana's martyrs. Hizballah also built its cemetery memorial separately from the one that Amal, and later Syria, had sponsored in the same village a decade earlier. This happened at a time when Hizballah and Amal were political allies in Beirut, and both Lebanese parties pursued a pro-Syrian agenda.

BUILDING A SECOND QANA MARTYRS MEMORIAL

On August 18, 2006, four days after a cease-fire had brought an end to the war, mass funerals were held across southern Lebanon to bury bodies that had been kept in morgues and temporary graves until they could receive a proper burial. Numbers vary in the reports, but between a few hundred and five thousand mourners converged on Qana to bury thirty dead.[38] Twenty-seven were civilians of the July 29/30 attack and three additional coffins contained the bodies of Resistance fighters, Qana natives, who had died on different days in different locations. Two of them were members of the extended Shalhoub and Hashem families, and they were buried alongside their relatives. The third fighter, Yussef Tiba, was buried in a different cemetery, but his coffin was part of the August 18 ceremony. Similar to the funeral proceedings in Tyre ten years earlier, the coffins of the civilian dead were covered in Lebanese flags, indicating that they had died for Lebanon. Yet the three fighters' coffins were covered with the bright yellow Hizballah flag, as well as the coffin of seventeen-year-old Ali Shalhoub who had been in the basement of the collapsed building on July 29. Hizballah funeral organizers wanted to mark him as a "sympathizer."[39] Hizballah flags decorated the mounds of earth that had been dug from the graves, and yellow

flags were prominently affixed to the cars that brought mourners to the funeral.[40] No members of the Christian or Druze clergy were at the ceremony, and no reference was made to Qana's Christian heritage. Sheikh Nabil Qaouk, one of Hizballah's southern military commanders, spoke to the mourners, many of whom held framed photographs of the dead. He recited passages from the Quran and put the blame for the deaths squarely at the feet of Israel and the United States.[41] The corpses were lowered into their individual graves in a public graveyard created for the occasion near the homes of the victims' relatives, and in walking distance of the building that had collapsed on them.

I spoke with members of the Shalhoub family who live closest to the cemetery. It was January 2008, and the weather was cold and damp after seasonal rains. The entire family was sitting on cushions on the floor of the living room on the ground floor of a simple two-storey home. An iron-cast wood stove in the middle of the room radiated welcome warmth. They seemed to have been discussing the news of the day—with one eye on the television in the corner—when I knocked at their door. There were little coffee cups in front of the adults, and as I was invited to join them and offered a seat close to the oven, a young woman got up to make more coffee for everyone. I explained my academic background and said I had come to visit the memorial, and I wanted to know who had built it and why. As if on cue, a young woman who might have been twenty-five years old, called over her four-year-old son and asked him to tell me about his cousins and siblings who had died. He proceeded to do so, and as he carefully and slowly pronounced each name, he pointed to the corresponding face on a large poster that hung over the kitchen door. The poster showed sixteen children, and it was affixed beside the face of Hassan Nasrallah. When the young boy was finished with his recitation, his mother hugged him close to her chest, rocking him gently back and forth, and gave me a long hard look, "Tell me, what right does Israel have to kill women and children?" I had no answer, but she did not seem to expect any, since she turned to the young woman, who had just then reentered the room, steaming coffee pot in hand, and helped her pour and distribute the cardamom-spiced, sweet brew. When she had finished with her hosting duties, she turned to me again and said that the men of her and the Hashem family had built the memorial with their own hands. They had no designer or architect telling them what to do; they discussed among themselves what they wanted and then they did it. I asked who had paid for all the building materials, and she said that Hizballah helped cover some of the cost but that they had also received private donations. Thankfully families of the South (*ahl*

al-janūb) were generous people, although most of them were quite poor, she explained. She added that the memorial had been done in stages, as they were able to afford it.

The second Qana Memorial consisted of a cemetery with twenty-nine graves, surrounded on three sides by a five-foot limestone wall. The fourth side of the cemetery was open, allowing visitors to look back onto the main village road from whence they had come to see the graves, about two hundred yards away. A cluster of homes inhabited by members of the extended Shalhoub and Hashem clans was directly behind the cemetery. The house that had collapsed had been at the furthest end of the tight cluster of homes. When I visited the memorial the first time in January 2007, I expected to see the collapsed house, but there was just an empty lot with the remains of some broken concrete slabs suggesting that a dwelling had once been on the site. My question of why the dead had not been buried where they had been killed, as they had been in the UN compound in 1996, was answered on the spot: there was not enough space. The homes stood quite close to one another and a street wound through them, too narrow to allow two cars to pass. In 2007 the graveyard entrance had been marked by a large billboard featuring a collage of all the victims' faces, mounted in such a way that they were looking onto their own graves. In January 2008 the billboard had been replaced by a central marble grave marker, and the victims' faces were now individually displayed on the wall that enclosed the cemetery. The marble graves in the enclosure were arranged in four rows of individual tombs. Brown tiles had been laid around the graves but not all the way to the enclosing walls, which exposed a large stretch of unfinished concrete.

The graves were separated into two categories: graves of martyr-fighters and graves of civilian dead. The two male relatives who had died in battles were in the front, the civilians in three rows behind them. The fighters were honored on the black headstone that marked the front end of the cemetery. The first line of text, carved and painted in red, declared: "Martyrs of the Truthful Promise."

At the center of the polished black stone was the carving of the Hizballah symbol: a fist raising a Kalashnikov machine gun straight up into the air, the extended arm forming the letter *a* in the name of Hizb*a*llah which runs perpendicular below it. The magazine of the gun rested on the outline of a globe, suggesting world revolution. Along the barrel of the machine gun ran the Quranic quote that had given the party its name: "For the Party of God is victorious." Below the name "Hizballah" was the additional line "Islamic Resistance in Lebanon." On the bottom of the headstone, the

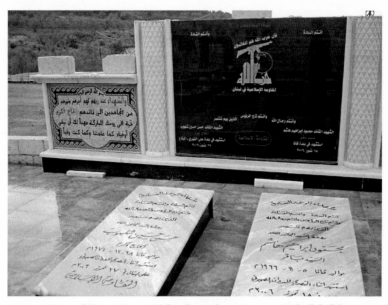

FIGURE 5.5. Second Qana Memorial, headstone honoring two Hizballah fighters, 2008.

inscription "Islamic Resistance" was repeated in red lettering. The remaining text on the marble plaque addressed the two fighter-martyrs, and this text was repeated verbatim on each man's gravestone, "You are the masters, and you are the leaders, and you are the crown of our heads; you are the men of God through whom we are victorious." The names of both fighters, Hassan Hussayn Shalhoub and Mahmoud Ibrahim Hashem, were carved on the bottom right- and left-hand corners, which placed their personal inscriptions right in front of their actual gravestones. Each man was titled "martyr-leader" (al-shahīd al-qāʾid), with an indication that they had given their lives in the Beqa Valley on July 27 or in Qana on July 18. The central marble plaque was framed on both sides by stone mosaics that contained text. First, a quote from the Quran declared that "martyrs are with their Lord and theirs is recompense and light," followed by a farewell message from fellow militia members, who vowed, "from the fighters to their leader, the most generous Hajj [title given to someone who has gone on a pilgrimage to Mecca], we salute your blessed soul and promise to stay faithful to you, as you taught us and were faithful to us." This was a military memorial, and it connected the memory of the dead fighters to surviving and new members of the Resistance, who vowed to continue their struggle.

In contrast to the military honor bestowed upon the two fighters, the civilian graves contained less text. Topped by the inscription of "Martyrs

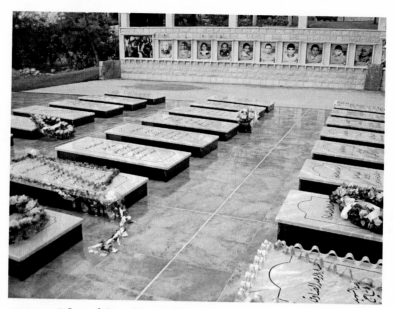

FIGURE 5.6. Second Qana Memorial, graves and portraits of civilian dead, 2008.

of the Truthful Promise," the marble plaques called each person a *shahīd*—
children were designated "child-martyrs" (*al-shahīda al-tifla* or *al-shahīd
al-tifl* for girls and boys, respectively)—and listed each person's name and
date of birth and death before closing with, "was martyred (*istashhad*) dur-
ing the Zionist aggression (*al-ʿadwān al-suhiyūnī*) on Lebanon on July 30,
2006." In 2008 the individual portraits of the twenty-seven civilian martyrs
were mounted on the enclosing wall all around the cemetery. Each person
was displayed head to shoulder against a bright yellow and orange back-
ground, which belonged to the photograph of a sunset over the sea. Each
name was spelled out after the title *al-shahīd*. The images looked like they
had been photo-shopped from passport photographs or family photos, and
they mostly showed earnest but also some smiling faces. On either end of
the display of martyrs' portraits, two larger posters enshrined images from
the day of the attack. The first showed two Red Cross rescuers pulling a
dead child out of the rubble, and the second a father crying over the dead
child in his arms beside the separate image of a dead baby, a pacifier still
tied around his neck. This poster was labeled in bold red English and Ara-
bic lettering: "Qana Massacre." The way that the civilians had died—unlike
the way the fighters had died—was graphically remembered.

In contrast to the banners at the first Qana Cemetery Memorial, at the
second there was no historical reference anywhere to Qana's Christian

heritage. The only reference to the past was a poster and a handwritten banner mounted on the wall of the closest neighboring house. Both invoked the battle of Karbala, a cornerstone in Shiite religious tradition. Similar to the banner on the first Qana Cemetery Memorial, the handwritten banner equated Yazid's killing of Hussayn in 680 CE with U.S. and Israeli aggression on Qana. In the 2006 war the United States had delivered ammunition, including cluster bombs, to the Israeli army and thus, in Hizballah's view, had directly contributed to the killing of civilians.[42] The second poster presented a different take on Yazid's defeat of Hussayn, by turning defeat into a moral victory. The poster read "The victory of blood over the sword" (*Intisār al-damm 'ala al-sayf*). The accompanying image showed blood oozing over a sword whose blade had been broken into three pieces. In other words, Hussayn might have died, but his blood was ultimately stronger than Yazid's sword, since his followers survived and his community grew. From this point of view, it is impossible to defeat a martyr.

During my visit with the Shalhoubs, I was told there was a commemorative committee (*lajne tizkariyye*) but that it had no special name. Its members were the relatives of the dead who looked after the graves and prepared annual commemorative ceremonies. On July 30, 2007, at a time when the Lebanese army was battling a group of jihadists in the Palestinian camp of Nahr al-Bared outside Tripoli,[43] two separate commemorative ceremonies were held, one in Qana and one in Beirut, to mark the anniversary of the second massacre. The Qana ceremony was organized by family members.[44] The graves had been covered by a tent as a shelter against the heat. Family members and friends brought flowers that soon spilled over the graves. Showing a united front, Amal MP Abdel Majid Saleh, who orchestrated the 1996 Qana commemorations, stood next to Hizballah MP Mohammad Fneish—but just as there were no Hizballah insignia in the 1996 memorial, no Amal insignia was present in the new cemetery. The Lebanese press covered the event, prominently reporting the presence of nine Irish peace activists who had traveled all the way to Lebanon to attend the ceremony and show their solidarity.[45] On the same day in the UNESCO Palace in Beirut, President Lahoud, in the third year of his three-year extension as president, joined by former prime minister Salim Hoss, honored the martyrs of Qana, praising "the solidarity of southerners that contributed to the downfall of Israel during last summer's war."[46] Once again, there was an official and a separate popular commemorative ceremony, both relatively modest in size and both featuring speakers aligned with the pro-Syrian March 8 Movement. Members of the March 14 Movement did not participate.[47]

But the relationship between the members of the March 8 and March 14 blocs was more complicated. For Hizballah, the war of 2006 marked its second military victory over the Israeli army; the first was the Israeli withdrawal in 2000. The popularity of Hizballah surged in 2006, as it had in 2000. Nasrallah clearly underestimated the Israeli government's determination to rid South Lebanon of armed Hizballah contingents when he ordered the cross-border raid. But even Lebanese who had voiced doubts over Nasrallah's wisdom to kidnap soldiers because of a promise given to one Lebanese prisoner held on criminal charges in an Israeli jail changed their minds when they saw Israel's disproportionate response.[48] The thirty-four-day military operation which Israel claims was aimed at Hizballah and not Lebanon as a whole nevertheless created such destruction throughout Lebanon that the Lebanese rallied in support of the Resistance and not in opposition, as Israel had hoped. So when the Israeli government finally released the Lebanese prisoner to whom Nasrallah had given his pledge in exchange for the bodies of the two Israeli soldiers kidnapped on July 12, 2008, Prime Minister Fouad Saniyora—a leader of the March 14 Movement—declared the day a national holiday, and closed all public schools and government offices.[49]

Emboldened by what Hizballah called a "divine victory" in the summer of 2006, Nasrallah began to challenge the government led by the parties of the March 14 alliance, and demanded veto power in the cabinet. Observers surmised that the goal was to stop the Special Tribunal and the ongoing investigations into the role of the Syrian Intelligence Service in Hariri's assassination. When the government would not yield to their demands, Shiite ministers both from Amal and Hizballah jointly walked out of the cabinet to force reelections. Because there was no more Shiite representation in the government, it was technically unconstitutional. Yet Prime Minister Saniyora refused to accept their resignations and continued to run cabinet meetings without the protesting ministers. So Hizballah mobilized its popular base and started a sit-in outside the parliament building. Promoting a populist, anti-American, anti-Israeli platform, as well as advocating the abolition of Lebanon's confessional system, the opposition attracted a large following, especially among younger Lebanese who were tired of the political status quo.[50] Thus began an eighteen month sit-in in downtown Beirut. Because Martyrs Square was still an empty lot at the time, it became home to the "tent city" which sheltered the participating youths. In order to prevent clashes between the antigovernment "tent city" dwellers and supporters of the March 14 Movement who returned to hold their annual rallies outside Rafiq Hariri's grave, the government laid coiled

razor wire across the middle of Martyrs Square. In other words, in 2007 Lebanese government supporters and opponents cut the "heart of Beirut" in two.

<div align="center">CONCLUSION</div>

The "crisis of the statues" in the summer of 2004 foreshadowed the deepening rift between and realignment of political elites in Lebanon, a pro-Resistance group aligned with Syria and Iran and an anti-Syria group aligned with the United States. This rift would manifest itself in Martyrs Square on March 8 and March 14, 2005, respectively. March 14 then appropriated the narrative of martyrdom for coexistence, as well as the actual image of the repaired but injured Mazzacurati statues, to promote its agenda for independence from Syria. At the same time the March 8 coalition championed resistance against Israel and the liberation of all of Lebanon's territory. March 8 members also implicated Israel in the killing of Rafiq Hariri rather than pointing fingers at Syria. (On May 23, 2009, two weeks before Lebanon's parliamentary elections, the German magazine *Der Spiegel* broke the news—not confirmed elsewhere—that there was irrefutable evidence linking Hizballah to Hariri's murder.) The question of who had killed Rafiq Hariri came to separate the Lebanese into two communities, although his funeral had been an event that temporarily united the nation.

The fault lines between the current governing and opposition blocs run deep. Though that in itself is not news in Lebanon, the formulas that made Lebanon workable previously—the 1943 National Pact, the postwar formula of "No Victor, No Vanquished," and the politics of memory embracing Christian and Muslim difference as part of the same national project—seem to have lost their ability to promote political compromise. Said differently, there is currently no unifying commemorative narrative of shared sacrifice that binds representatives of Lebanon's most powerful ethno-religious communities, Sunnis and Shiites. The March 14 Movement, led by Saad Hariri, remains attached to the commemoration of Muslim and Christian unity through sacrifice, drawing on the existing canon of martyrs symbols and narratives. The Hizballah-led opposition follows its own commemorative logic, which, I argue, suppresses Muslim and Christian difference in favor of a homogenizing narrative of the Lebanese as resisters. Moreover, at the core of Hizballah's commemorative narratives are military metaphors and imagery; the central symbol of the Resistance is the fighter-martyr or the fighter-leader, who actively combats the enemy rather than dying without means of self-defense. Civilians die and are mourned, their

wounds and dead bodies graphic reminders of the immoral and unjust enemy that call for further armed resistance.

The deaths of women, children, and elderly men seeking refuge in a basement from aerial bombardment in Qana in 2006 were as tragic as the civilian deaths in the neighboring UN compound ten years earlier, but after the initial storm of protest and grief had subsided, they did not become unifying national symbols in the way that the Qana victims of 1996 had unified the country. Amal had organized the 1996 funeral and subsequent memorial, but despite the partisan sponsorship, the Qana Memorial and its compelling story of innocent victims drew mourners from all over Lebanon. The Qana cemetery created a commemorative landscape that emphasized ethno-religious difference and joint sacrifice despite the fact that only one victim had been Christian and more than a hundred Muslim. All victims of the 2006 bombings were members of the Shiite Shalhoub and Hashem clans, but that reality need not have prevented the telling of a narrative of coexistence. Rafiq Hariri's grave memorial became a site to advocate coexistence, even though all those who were interred next to the Al-Amin Mosque were Sunnis. Qana's 2006 Lebanon War dead were not buried on their family plots, indicating that Hizballah wanted to draw a larger commemorative public to their cemetery, mirroring the developments in 1996. Yet the graveyard was built for Hizballah fighters *and* civilian dead. The sympathy and anger that the public expressed when they learned of the loss of innocent lives on July 30 did not translate into a stream of visitors to the memorial where fighters and civilians were buried.

The need for support for continuing and active resistance against Israel is at the core of Hizballah politics of memory. Although I cannot do justice to the numerous commemorative projects that Hizballah has sponsored over the past two decades—which require a separate study—I highlight here features I believe are characteristic of the party's public interpretation of national sacrifice. Anthropologist Lara Deeb argues in her recent study of two Hizballah-sponsored public memory sites that their goal is to draw visitors into an active community of resisters. Deeb analyzed the exhibition called "Men of Glory" in Beirut and the Khiam Museum in South Lebanon, which opened about a year after the Israelis withdrew from Lebanon.[51] "Men of Glory" was a multimedia event featuring dioramas, photographs, films, paintings, and memorabilia of individual soldiers. The exhibit was constructed so that it became "experiential" in that visitors actively participated in certain aspects of the exhibit. For instance, they were invited to read the first sura of the Quran to honor Hizballah's (then) 1,281 martyrs; they became part of a mourning procession painted on a wall which

became a three-dimensional diorama that moved in the same direction the visitors were going; they walked through a replica of a southern village that was just bombed. Each room suggested that visitors were engaged with the present, rather than contemplating events of the past. Similarly the Khiam Museum that operated from 2001 until it was destroyed by Israeli bombardment in 2006 was set up so that visitors received an "experiential tour." From 1978 to 2000 the museum had been a prison for the detention and interrogation of suspected and captured Resistance fighters, often housing as many as two hundred at a time.[52] When it became a museum, former prison inmates led the tours and spoke about torture they had witnessed and experienced.[53] The authenticity of an exhibit where former inmates narrate lived experience in the very walls that held them captive elicited both cognitive and embodied responses from the visitors.

Many Lebanese who traveled to see their border region for the first time in their lifetime after the Israeli withdrawal stopped at the Khiam prison complex. In the aftermath of May 2000, I received numerous e-mails from former students who had returned from their first visit to the liberated *al-janūb*, and they described walking through the prison compound as one of the most profoundly moving experiences they had had in a long time. They described specific torture instruments left behind in interrogation cells and the kinds of torture for which they had been used; they told of the inability to breathe when walking past entire cellblocks through narrow, damp hallways. Lara Deeb described her experience walking past cells where "the dank smell of pain hovered."[54] Hizballah sites of memory are constructed to create this sensation of immediacy—and the visceral feelings of "being there"—thereby emphasizing the continuing relevance of the Resistance. Similarly, in the Second Qana Memorial, surviving Resistance soldiers publicly professed their readiness to die, following the example of their two slain leaders.

Hizballah memorials do not, in my experience traveling through South Lebanon, emphasize ethno-religious difference. The most obvious example is that the designers of the poster and billboard portraying Hizballah's martyrs depicted the fallen as "fighter-martyrs" and in battle fatigues, thus portraying them in a uniform fashion. Driving along roads through South Lebanon, martyrs posters impress through their repetitiveness, conjuring the image of a large army, rather than through an emphasis on the men's diverse backgrounds. Moreover, Khiam prison inmates-turned-tour guides did not elaborate on the confessional composition of their jailors during their presentations to Khiam Museum visitors.[55] Khiam prison guards were members of the SLA, many of them Maronites. Evoking ethno-

religious difference in the context of present-minded, immediacy-producing commemorations of Resistance activities would have highlighted that the residents of the South were divided and actually fought one another. When Amal sponsored memories of Muslim and Christian coexistence at their Qana memorial, they relied on references to New Testament texts and imagined religious geographies that predated modern Lebanon. The only past that I have encountered as part of official Hizballah commemorations of martyrs in *al-janūb* is the narrative of the battle of Karbala, evoking a distinctly Shiite tale of suffering that condemns leader Yazid, the symbol for Israel and the United States, as morally corrupt, violent, and misguided.[56]

Though Hariri's burial beside a monumental mosque, which he had personally financed and helped design, clearly revealed his religious affiliation, he nevertheless managed to transcend ethno-religious boundaries to be remembered as a martyr for both Christian and Muslim communities. Following the artistic convention established by Yussef Hoayek, who had sculpted two balanced figures of a Muslim and a Christian woman facing each other, Hariri's commemorative posters and billboards included the symbols of a church steeple and a minaret in order to represent religious difference within a unified national whole. The metaphors of Jesus Christ and Prophet Muhammad praying for mutilated children, as expressed in Ajami's poem in Qana, follows a similar artistic convention. Yet in Ajami's poem, as in Kamal Jumblatt's Martyrs Square, there were actual acts of religious transcendence. Jesus visited a mosque, Muhammad a church. During his lifetime Musa Sadr made a point of visiting churches and frequenting shops whose owners were of different ethno-religious backgrounds. In Kamal Jumblatt's own writings and the passages he chose from the New Testament, as well as his inclusion of Muslim, Christian, Hindu, Buddhist, and Confucian symbols in his final monument to spiritual unity of humankind, the point is that religious beliefs are equal stepping stones to a final destiny where ethno-religious differences no longer matter.

Before Hariri's death, both the restored Mazzacurati statue and the planned Garden of Forgiveness were meant to create a sacred landscape in the center of Beirut in order to facilitate an active and compassionate engagement with civil war memories. When Hariri was assassinated, both projects were sidelined next to the construction of Rafiq Hariri's grave along with the subsequent politicization of Martyrs Square that brought soldiers, checkpoints, and razor wire to downtown Beirut. The martyrs of 1916 who had called for independence from the Ottoman Empire became the template on which to commemorate the martyrs who died demanding independence

from Syria. The mass rallies that followed Hariri's assassination were a show of popular will, but they were also carefully orchestrated by the March 14 alliance. These gatherings took place around the Martyrs Memorial, its statues covered in flags and banners. Just like Yazbek had done on the last page of his 1955 book, *The Conference of the Martyrs,* Lebanese citizens would assign blame in no uncertain terms, carrying accusatory signs, which in one case read, in bold English lettering, "Syrial Killer."

It remains unclear if Syria indeed orchestrated the murder of Hariri and his bodyguards, as well as the killing of the other Lebanese politicians. Lebanese history is filled with unresolved murders and disappearances of political elites; Kamal Jumblatt and Musa Sadr are but two other prominent examples. In the current political climate, the attempt to conduct a UN Special Tribunal, with the support of the United States, in order to condemn Syrian or Syrian-allied suspects is a political lightning rod that will further aggravate the differences between the March 14 Movement and the opposition. While there are good reasons not to conduct a trial of Hariri murder suspects in Lebanon, it is equally reasonable to believe that a verdict reached in the Netherlands by a UN court will not be an acceptable form of justice for the Lebanese.[57] In the absence of an impartial and effective legal system in Lebanon, martyrs narratives with their unambiguous assignment of right and wrong, provide their own form of justice and some consolation for mourning communities.

Memorial Politics and National Imaginings
Possibilities and Limits

The preceding chapters presented historical and contemporary evidence of the efforts of various political and cultural elites in Lebanon to conduct a politics of memory that produces national solidarity after times of violence. My argument began with the assertion that Muslims and Christians share the symbol of martyrdom, as martyrs are central to both faiths. In the particular commemorative narratives I investigated, martyrs became national symbols because they *did not* give up their ethno-religious affiliation; instead, they died and were commemorated as members of their communities who gave the ultimate sacrifice together with members from others. Rather than executing a hegemonic national project—one that sought to impose a homogeneous identity based on shared (secular) beliefs, practices, and symbols—members of different ethno-religious elites throughout Lebanon's history exercised their "power of 'world-making'" using their own community's symbolism and vocabulary in order to accommodate religious difference. The resulting images and narratives in memorials and cemeteries that honor Lebanese coexistence look quite different, but they all define the national community as a shared Muslim and Christian project.

As such, these commemorative Lebanese projects do not easily fit under the standard definition of an imagined national community promoted by Benedict Anderson: "a deep horizontal comradeship" in which members have left behind their religious or ethnic identifications and thereby managed to suppress or exclude difference.[1] Rather, Lebanon's politics of memory fits under the recently suggested category of "quasi-nationalism,"

a term coined by political scientist Lisa Wedeen who sought to explain how a weak state like the unified Republic of Yemen generates national attachments. Her research led her to conclude that national attachments "occur episodically, are often transmitted diffusely, and congeal suddenly, only to dissolve once again."[2] My research of public memorials in Lebanon would support that thesis. The public memorials that were built to last rarely did, and the public gatherings that were staged against the backdrop of the memorials eventually ceased. However, new memorials emerged as old ones weathered, and new commemorative displays and rituals kept alive the core trope of shared Muslim and Christian sacrifice, in different forms and different locales. With my findings I challenge the conventional understanding of "sectarian" identities as inherently antagonistic and conflict-generating, and therefore that such identities are "problems" needing resolution through modernization or deconstruction.

Moreover, I place the symbolic significance of martyrdom—a term that presently evokes the image of virgin-and-paradise-loving suicide bombers and assorted acts of fanaticism—in historical context in order to show the ways in which martyrdom has long been part of secular-political projects. Acts of mournful and heroic national sacrifice have been at the core of Lebanon's nation-making enterprise, because they bridged ethno-religious divides while allowing religious beliefs and practices to coexist within a secular, nationalist framework. None of the martyrs that became national symbols in Lebanon died on a suicide mission.[3] Instead, they were civilians who were rounded up, tried, and executed, or shot or bombed in military operations in which they did not participate as armed combatants. The only armed fighters on display were idealized Arab peasants who rose up in revolt against injustice and oppression. Civilian deaths constitute the single largest casualty category in Lebanon's many wars. Their loss of life was given meaning through stories that emphasized defiance against the odds, suffering, and sacrifice, and therefore made them—rather than soldiers— model citizens. Lebanese soldiers are also honored as "martyr-heroes," yet the specific history of the Lebanese army prevented it from becoming a vehicle for and symbol of national integration. In contrast, when civilians faced death together, regardless or despite of their ethno-religious differences, bonds of solidarity were created that unified the living to different degrees and for different lengths of time.

My research cannot answer the question of whether the politicians or the persons attending the ceremonies of remembrance sincerely believed that Lebanon was a nation where Muslims and Christians were equals or shared equally in power, politics, or sacrifice. Indeed, it is quite unlikely

that they did. However, many of them probably shared sentiments of sincere grief over the loss of Lebanese lives or anger at the way the deaths had occurred or both. While we cannot get into the heads of those we study, we can legitimately study and discuss the making of memorials and cemeteries, the symbols they contain and disseminate, and the gatherings that took place beside them on holidays designated by political elites. While political elites created the space and the time for the commemoration of martyrdom, artists rendered Lebanese faces and bodies to give a meaningful shape to their sacrifice. Citizens attended commemorative ceremonies, sponsored wreaths, composed poetry, published memory books, and so on to give the sacrifices lasting meaning. I argue that the purpose of building memorials and conducting commemorations was not to convince the public that Lebanese Muslims and Christians were equals but that there was value in performing rituals that celebrated and recognized shared sacrifice, "as if" they were.[4] What made the Lebanese ceremonies to commemorate martyrdom in Beirut, Beqata, and Qana compelling was that the deaths were caused by arbitrary or accidental acts of violence that could have happened to anyone.

THE POLITICS OF MEMORY: MEMORIALS, ELITES, AND NATION MAKING

Clearly borders do not automatically create nations. When Lebanon was carved out of the remains of the Ottoman Empire, there were several contrasting national visions among elites across Lebanon's different ethno-religious communities. The most forceful proponents of a Western-oriented and entirely sovereign (at times separatist) vision of Lebanese nationhood were Maronite Christians; the most vocal proponents of a Lebanon integrated within a larger Arab state, variously defined, were Sunni Muslims. Few scholars of Lebanese history would deny that the French mandate powers were more responsive to demands from Christian elites, as they saw themselves as historical protectors of Christianity in the Middle East.[5] Yet Muslim elites found receptive ears among British colonial officers at the time, exploiting the well-known rivalries between the two European powers.[6] The mechanism of "divide and conquer" worked also for the colonized. Ongoing elite rivalries led to the compromise formula of the 1943 National Pact of Lebanon as an independent and sovereign state with an "Arab face." The gentlemen's agreement between Sunni and Maronite politicians in Beirut was not the first elite attempt to create a narrative of ethno-religious coexistence. It was predated, by more than a decade, by

the foundational narrative of Muslim and Christian patriots defying Otto-man power, rendered in the form of Lebanon's first public, national cem-etery and its first martyrs memorial in the newly renamed Martyrs Square in Beirut in 1930. Rather than suppressing traditional religious identities as an anathema to modern national ones, Lebanon's political elites placed shared Christian and Muslim sacrifice at the heart of its national project.

While many scholars of Middle Eastern studies have noted the impor-tant contributions of intellectual elites to the venture of imagining "nation-ness," few have paid attention to displays of public art. Writings of local historians in Iraq and Yemen were crucial in defining narratives of shared history and geography through which politicians and citizens could imag-ine a modern Iraq or the modern Republic of Yemen.[7] Poetry and oral histories form the core of nationalist discourses in Yemen and Jordan, respectively.[8] Nineteenth-century Arabic literature (novels, novellas, and *maqamat* writings) generated a modern and national consciousness in Lebanon.[9] In other words, in the context of the Arab world, "nationness" is predominantly read in and from texts. Public art appears less frequently in these scholarly debates, with the notable exception of Beth Baron's work *Egypt as a Woman,* which linked sculpture, as well as cartoons and other visual art forms, to the creation of modern Egypt. Most discussions of Saddam Hussein's war monuments in Iraq remain limited to descriptions as they defy interpretation and classification for their sheer monumentali-ty.[10] A possible explanation for this curious oversight of public art might be the mistaken belief that Muslim societies do not permit art—unless it is abstract, geometrical, and mathematical—and that modern art (sculpture and portrait painting, in particular) is a European implantation and there-fore inauthentic.[11] Whatever the case may be, since the late nineteenth cen-tury Arab artists have engaged in the production of modern art in the Arab world, either in pure (read: classical Greek) or hybrid forms and media. Those artistic productions entered public squares, where they became texts that the public could read and backdrops that political and cultural elites used for ceremonial affairs.

By focusing on public memorials, I limit my analysis to the cultural productions by political elites. However, memorials appeared in public squares and initially were received by a larger public than were written texts. The elites I discuss chose projects that emphasized Muslim-Christian coexistence in the midst or aftermath of war that had pitted Muslims and Christians against each other (although those groups were never homo-geneous). In World War I (Sunni) Muslim elites predominantly favored an independent Arab state, whereas (Maronite) Christian elites welcomed

the French mandate powers. The civil wars of 1958 and 1975–1991 pitted predominantly Sunni, Druze, and Shiite opposition against the Maronite establishment. The victims in Qana both in 1996 and 2006 were predominantly Shiites, who as a group have suffered from a politics of neglect from both Sunnis and Maronites. Still, the memorials that emerged in response to the events were co-religious and told a story of balance, parity, and spiritual unity. The elites could have built a "sectarian" memorial and commemorated their own dead; it is significant that they chose not to do it. Instead, they wanted to create a discursive space in which different ethno-religious communities could be accommodated side by side, despite historical events (or "facts") suggesting that the opposite was true.

A new look at the cultural productions of Lebanon's political elites was also necessary because the existing literature casts them, for the most part, as agents of amnesia. Politicians are said either to be beholden to narrow communal interests or to promote a politics of erasure where bygones are bygones. Certainly some Lebanese politicians seek to build loyalty and solidarity in strictly sectarian ways; but those practices have a more limited reach and are not intrinsically more meaningful than the ceremonies that generate Muslim and Christian solidarity. For instance, after the 1975–1991 Civil War, Maronite members of the Lebanese Forces and Druze members of the Progressive Socialist Party congregated in their own cemeteries and in their houses of worship in the Shouf area to commemorate martyrs who had fallen during the 1983 Mountain War at the hands of the other community. Yet, when the new political alliances were made in the aftermath of Rafiq Hariri's death, and Samir Geagea and Walid Jumblatt joined a common political platform, both leaders simply asked their followers to stop their civil war commemorations, which they did.[12] In other words, political elites deploy different politics of memory in different contexts to different effects. Neither one is more "true" than the other, but one enables a politics of inclusion and compromise whereas the other does not.

Lebanese politicians repeatedly used the formula "No Victor, No Vanquished" (lā ghālib wa lā maghlūb) after periods of violence, granting amnesty to those involved in the hostilities. Scholars have argued that the only sites of postwar remembrance were found within the confines of village life, media, or civic organizations—in short, what we call "popular" memory.[13] While these popular sites are indeed important, I posit that the state, as represented through its political elites, has been and remains an active agent of memory in Lebanon. Indeed, Lebanese legislation outlawed the production and distribution of inflammatory or accusatory memories of the war, but it has not precluded other memories from being produced

and publicly circulated.[14] I believe it is important to overcome the dichoto-mization of "popular" (read: productive, good) and "official" (read: silenc-ing, bad) memories, and grant that different memory agents exercise their "power of 'world-making'" to create memories that can be good or bad, unifying or dividing. And though anthropologists are often expected to give voice to the voiceless and to write about those who do not make it into official history books, anthropologists also have a role in analyzing the mechanisms that create power. In the words of Edward Said, "authority can, indeed must, be analyzed."[15] Elites in the Arab world, like elsewhere, have to produce political power; they do not simply own it. They face com-petition from other political elites. They might present the public with a national memorial and then see it vandalized. They might restore a statue only to see it "kidnapped" by a political opponent. By studying the ways in which elites interact with one another, and use the politics of memory to further their goals, the workings of the state—and state agents—can be demystified and better understood.

As counterexamples to forgetful elites, Kamal Jumblatt and Rafiq Hariri engaged in public commemorative activity after the civil wars of 1958 and 1975–1991, respectively. They built or restored Martyrs Memorials that fit into an existing narrative—shared suffering of Muslims and Christians—while expressing and promoting their own philosophical and political ideas. When villagers conceived of their martyrs cemetery after Israel's 1996 attacks on Qana, they did not make the Karbala paradigm the cen-tral narrative frame for their commemoration, but instead they created a sacred geography of joint Muslim and Christian suffering and mourn-ing. These commemorative projects were not uni-linear, and they did not remain unquestioned or unchallenged. Demands to make memorial sites look more official or heroic clashed with more mournful and intimate designs. But more hegemonic projects, for instance, Mazzacurati's bronze redesign of Beirut's Martyrs Memorial or the Syrian-sponsored expansion of Qana into a memorial complex, led to its own criticism and to a less popular, and less unifying, annual commemorative ceremony.

Memorial building is one way in which political elites can publicly exer-cise power, drawing on a selective reading of history and a variety of artis-tic and narrative choices. I claim that the National Pact that was concluded in 1943 and the politics of "No Victor, No Vanquished" was underwrit-ten by a politics of memory that sought to present Lebanon as a national community that shared important struggles and sacrifices and that there-fore was able to maneuver past ideological disagreements and even armed conflict. Yussef Hoayek, nephew of the Maronite patriarch, sculpted not a

Pietà but rather the bodies of two women, one Muslim and one Christian; the martyrs were laid to rest in a public cemetery, not in the plots of their communities, which would have made them less accessible to a wider and mixed public. That particular commemorative vocabulary was reused by different political elites from Druze, Shiite, and Sunni backgrounds in different times and different places, thereby underwriting a politics of inclusion and coexistence.

SHAPING NATIONAL COMMUNITY

The human body was central to generating ideas about Lebanon as a national community, both in its sculpted and idealized as well as mutilated form. The idealized body is a symbol of transcendence, evoking the edifying feelings of patriotic sacrifice and model citizenship. In the latter form, the bodies serve as both an indictment against the perpetrator of the violence (be that perpetrator Ottoman, Israeli, or Syrian) but also as a visual trope of suffering and dying.

A recurring national symbol is the body of the mother, either mourning for or dying with her children. Motherhood, a value shared among members of Lebanon's Muslim and Christian communities, is evoked to create emotional attachments to the nation: as you love your mother, love this imagined community. However, the narrative of motherhood is also a site of contestation. As the story of Hoayek's statue shows, the faces of the two women were vandalized, their torsos severed from the rest of their bodies, and the memorial ultimately disappeared from its location because they were not deemed heroic or brave enough. It was the symbolic precursor to the mutilated bodies of the successor bronzes by Mazzacurati and the maimed bodies of mothers and children, graphically displayed in the Qana Memorial.

Male bodies do not feature prominently in the commemoration of bodily injury. When Hariri's body and those of his bodyguards were ripped apart by the February 2005 explosion, images of their dead bodies did not circulate in the media or in subsequent commemorative displays. Instead, posters or billboards showed their portraits or, in Hariri's case, photographs, paintings, and bronzes of their unharmed bodies. (In 2008 a bronze sculpture of Hariri's likeness was installed across the street from the site where he was killed.) Similarly the bodies buried in the Beqata graveyard left no traces of the violence that took the people's lives. The main message of Beqata's Martyrs Square is transcendence. There is no room for images of killed bodies, because that is not their ultimate destiny. The bodies that are represented are male, and they are depicted on the way to the struggle

rather than engaged in the struggle itself. Armed and upright, their bodies convey courage, solidarity and determination. The clothing of the 1958 fighters on the Beqata stone reliefs— traditional peasant headdress over long robes—is meant to display a unified Arab identity in front of a map of the Arab world. The secular idea of Arabism can be accommodated next to scientific and religious texts, just as Druze fighter-martyrs can be commemorated beside Christian villagers who were caught in the crossfire.

In contrast, Mazzacurati's Martyrs Memorial that took center stage in downtown Beirut in 1960 was neither Arab nor Christian nor Muslim nor Lebanese. The ensemble of four bronzes belonged to a Western canon of nationalist art that aimed to represent transcendent values of liberty and independence. Of course, the bodies were culturally specific, dressed as a Greek victory goddess, Italian World War II partisans, or minimally dressed as a Greek athlete. The un-Lebanese features of the statues became the largest contentious issue after the unveiling of the Italian memorial, as local elites had to justify why they had not drawn on Lebanese artistic talent to create a more Lebanese symbol of the country's independence. The Mazzacurati memorial would "become Lebanese" after the bodies of the bronze figures had been damaged during the 1975–1991 Civil War. Just as they had been silent witnesses of the sixteen-year violence from their pedestal on the "line of confrontation" and just as their bodies bore the physical evidence of that violence, they were reborn as national symbols in the urban space that was publicly defined as the "heart" of the capital, and the meeting point for Muslims and Christians.

Similarly, in 1996, Qana became a national symbol based on the trope of the meeting point of religions, as both the figures of Jesus and Muhammad, represented in poetry rather than sculpture, were said to have visited the village and mourned together. The bodies killed in the Israeli attack on April 18, 1996, were depicted in poetic as well as graphic form, and the emphasis was on the mutilation and dismemberment of individual bodies—prominently the bodies of children but also "women and children." The mutilated bodies of the Qana martyrs became symbols of a unified Lebanese nation. Just as the Mazzacurati statues had become Lebanese through their injuries, so did the Qana martyrs epitomize the vulnerability of Lebanon's national community, as well as its resilience. The public Lebanese memorials demonstrate that it is possible to consider martyrs as symbols of cultural pluralism within the larger context of the national community.

Downtown Beirut, the proverbial "heart" of the nation, became a metaphor for post–civil war rebirth and healing. Hariri made the restoration

of the 1916 Martyrs Cemetery and Memorial a reconstruction priority, by sending the statues off to a restoration studio at the Department of Sacred Art at the University of the Holy Spirit. There the statues came to life, as the press transformed the sculptures into living bodies that required medical treatment and the miraculous recovery of a severed arm created a powerful symbol of healing. The May 6 commemorations did not take off as Hariri proposed, and as parliament had agreed, largely because of the delays in restoring Martyrs Square—most of them technical but some legal and financial; the Martyrs Cemetery, which had fallen into disrepair, remains (at the time this book goes to press) a half-finished construction site. Yet, after Hariri's death and the construction of his grave adjacent to the future location of the Martyrs Memorial, Mazzacurati's statues became an inadvertent but central part of the protest rallies, when participants would carry banners and posters, and climb on top of the actual statues to wave their flags more visibly. Again the statues became very much alive. Yet, as Hariri's memory became a site to promote a particular anti-Syrian politics, it co-opted the Martyrs Statues and their independence narrative into a specific political camp—and cut Martyrs Square in half.

Members of the Hizballah-led opposition to the Hariri-led March 14 Movement rallied and promoted their political platform and their own martyrs. Although the pervasive Hizballah displays of portraits of young men in military fatigues along roads in South Lebanon and in urban neighborhoods with significant Shiite populations are outside the scope of this book, they are evidence that commemorating fighter-martyrs is central to Hizballah politics. Additionally Hizballah sponsored a Martyrs Memorial in Qana in 2006, built by relatives with the help of Hizballah party members. Portraits of the women and children who had been killed in Israeli bombings were displayed on bright posters, whereas images of the carnage, particularly the injured and dead bodies of children, were displayed in subdued and dark colors. Two male relatives who had fought in the Resistance were buried alongside the civilian victims, and their graves were given a prominent position in front of the other victims. The second Qana Memorial showed the vulnerable (female) faces of the newly injured nation, while at the same time honoring the armed (male) fighters of the Islamic Resistance. Young men give their written pledge in stone (the mosaic surface of the gravestones) to continue the struggle. Images of the fighters' injuries or their deaths do not appear as part of the commemorative display; instead, portraits of women and children and photographs of their dead bodies pulled out of the rubble serves as a justification for more Resistance activities.

In Lebanon today the memory of martyrs shapes politics in concrete ways. The sons, daughters, and wives of martyrs run for and win seats in parliamentary elections. February 14, the day Rafiq Hariri died, is a day when the March 14 Movement conducts political rallies. Hizballah created its own Martyrs Day on November 11 to commemorate the Resistance fighters who died. The Future Movement and Hizballah both produce and prominently display images of their martyrs in Beirut's cityscape. Clearly martyrs have political currency, and they continue to draw political elites on both sides of Lebanon's political spectrum to appropriate them.

Lebanon's current political landscape has changed the game that political elites traditionally had to play. Previously politics required the skillful negotiation of power and parity among Sunni and Maronite political elites. Now the most important players are Sunnis and Shiites, each with their Maronite allies. Whereas the compromise agreement of the National Pact relied on the give and take of Sunnis and Maronites, now it is Sunnis and Shiites who need to agree in order for the government to function. Memories of joint Muslim and Christian sacrifice underwrote political decision making during the first six decades of modern Lebanon. The Shiite party Amal has participated in that politics of memory; Hizballah has not.

Hizballah has been active in conducting politics through commemorating martyrs of the Resistance. I maintain that Hizballah's martyrs memorials are first and foremost manifestos to Hizballah's military prowess, and not testaments to Muslim-Christian solidarity. It honors its Resistance fighters as exceptional human beings, and the Resistance is characterized as Islamic. While Hizballah does include the Lebanese flag on many of its posters and displays, part of its effort to cast itself as a national resistance force rather than merely an Islamic one, it thereby does not recognize or publicly embrace ethno-religious plurality as a founding principle of Lebanon. Hizballah's politics of memory is in line with the more traditional national projects that seek to suppress difference, as discussed in chapter 1. Its main commemorative framework is the historical narrative of Karbala, which is the story of Shiites suffering at the hands of a Sunni leader. There are reasons why this particular story resonates with a community long disenfranchised by the Sunni (and Maronite) establishment in Beirut, but it also impedes, or makes difficult, the creation of symbols of shared ethno-religious (Sunni and Shiite or Muslim and Christian) solidarity. Because Sunnis and Shiites now constitute the two leading political blocs

in Lebanon, their elites need to find a unifying formula. They can choose between narratives of inclusion or exclusion, allowing or disallowing recognition of their ethno-religious differences.

But not only Sunni and Shiite elites compete on the political stage in Lebanon. The Shiite parties Amal and Hizballah, though officially allies and promoting the same political agenda in Beirut, remain rivals. The narrative of the 1996 Qana massacre is told in the southern suburbs with no mention of Amal's involvement in the rescue operation and subsequent memorial building. Equally silenced are the Hizballah efforts in narratives by Amal. In a two-hour interview with the head of the Council of the South, Qabalan Qabalan, in which I specifically asked about the different kinds of reconstruction efforts that had been undertaken to help South Lebanese families after the July War of 2006, he gave a detailed overview of Amal and international donor projects but never mentioned Hizballah. The alliance between both Shiite parties is an uneasy one, and though Hizballah certainly receives more media attention—and more external funding—that does not mean that Amal has surrendered under Hizballah leadership. During my last visit in Qana I noticed a newly constructed, enormous billboard outside the rows of martyrs graves of the 1996 Memorial, which was framed with Amal insignia. The billboard was still empty, and when I asked one of the Memorial guards what would be painted on the sign, I was told it would not be an image of Hassan Nasrallah.

That political elites compete for power is not a startling discovery, but how they compete is intriguing. It costs time and money to design and build memorials, organize and attend annual ceremonies, print and distribute memory books, and so on. There are other ways for Lebanese elites to use their limited resources. I maintain that cemeteries and memorials of Muslim and Christian martyrs successfully, if temporarily, generate attachments to a national community, which is why political elites continued to build them. And even if we can never know the genuine intent of the memorial makers, we still need to explain why and how certain memorials came to look the way they did, and in what ways they fit into existing webs of cultural meanings and shared understandings. Of course, many more questions remain to be answered. Since not all elites sponsor memorials to communal coexistence, what are the factors that make this particular politics of memory a worthwhile political pursuit? Now that political elites in Lebanon are realigned in two blocs, each one including Muslims and Christians, what other "polite fiction"—to use Kamal Salibi's term—might the Lebanese be able to tell about a shared history of sacrifice? Who will author a new narrative and who will give it a material form? Without a

unifying narrative and a set of shared symbols and practices, no matter how long-lived or contested, it is unlikely that the Lebanese will be able to forge agreements among political elites.

For as long as Lebanon remains plagued by violence—and until a far-reaching peace agreement is found that settles not only the question of Palestine and Palestinian refugees but also who has what historic right to what territory and who may and may not be armed in the region (or to what extent), to name only the most pressing issues—there will undoubtedly be more martyrs memorials and cemeteries. Political elites will continue to sponsor them in order to conduct politics and establish legitimacy. In conducting the politics of memory, elites do have choices, and it remains to be seen what images and messages we will see next on pedestals in Lebanese public squares.

CONCLUSION

My aim in analyzing commemorative processes in Lebanon was not only to scrutinize the Lebanese but also to respond critically to the Western portrayal of the role of the past in contemporary Arab societies. Two particular images come to mind, the first shown in figure 6.1. In 1983, during Lebanon's civil war, the *Los Angeles Times* ran a cartoon depicting a U.S. Marine captain briefing enlisted men newly arrived in Lebanon to be part of a multinational peacekeeping force. Standing calmly—as a bullet ricochets off his helmet—in front of an easel with a "Map of Lebanon" that looks like the inside of a volcanic crater, the officer tells his men that they face internally divided Lebanese Christian, Druze, and Shiite militias, Syrian, Israeli, and Palestinian forces, and a nonfunctioning Lebanese army. His briefing ends with, "and it's all preceded by 2000 years of bloodshed." A similar idea resurfaced in a Doonesbury cartoon a quarter of a century later during the U.S. invasion of Iraq. It depicted a Marine and a Shiite Iraqi soldier in conversation about their next target, the Iraqi urging that they kill the "Sunni scum" because of a family blood feud dating back to 1387. To this the American soldier replies with a rhetorical question, "What is the *matter* with you people?"

The message of both cartoons—perpetuated in many more newspaper articles and television reports—was that Arabs do not forget their past. Their societies are divided into an array of ethno-religious communities, whose members hold long-standing grievances against one another, which trap them in millennia-old cycles of violence. In both cartoons "the

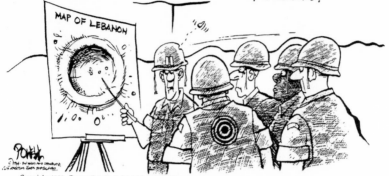

OK, MARINES-WE'RE FACED WITH DRUZE AND SHIA MOSLEMS BEING BACKED BY THE SYRIANS AGAINST THE CHRISTIAN PHALANGISTS. THE DRUZE AND SHIAS ARE DIVIDED AMONG THEMSELVES, AS ARE THE CHRISTIANS. THE ISRAELI PULLOUT IS LEAVING A GAP THAT THE "LEBANESE ARMY" PROBABLY CAN'T FILL AND THE PLO IS CREEPING BACK IN... NOBODY LIKES US, AND IT'S ALL PRECEDED BY 2000 YEARS OF BLOODSHED. ANY QUESTIONS?

MAP OF LEBANON

FIGURE 6.1. The cartoon that ran in the *Los Angeles Times* in 1983, during Lebanon's civil war, depicting a U.S. Marine captain briefing enlisted men newly arrived in Lebanon to be part of a multinational peacekeeping force. *Reprinted with Permission of Dwane Powell and Creators Syndicate, Inc.*

past" is represented to fuel present-day violence: Lebanon resembles a cauldron of communal hatreds about to spill over, and Iraqi Arabs are depicted as remembering violence that "they" had done against "us" even as far back as seven hundred years ago. Implicit in those cartoons is the value judgment that Arabs are very different from Americans in that they cling to primordial community affiliations and sentiments of injury that each community has suffered at the hands of the "other." Because of their attachment to their communities, "they" are seen as hopelessly stuck in the past, unable to progress and become modern, like "us." If nothing else, I hope that this book dispels the notion of unchanging memories of the past in the Arab world. Like people elsewhere in the world, Arabs challenge and contest their histories, create and re-create memories, and seek to answer contemporary questions by engaging in symbolic battles over the meaning of the past.

APPENDIX

Important Dates

1914–1918	World War I
1915, 1916	Executions of Lebanese "traitors" by Jamal Pasha
1920	San Remo Conference grants France the mandate over Lebanon and Syria
Sept. 1, 1920	Declaration of Greater Lebanon
1926	Constitution turns Greater Lebanon into the Lebanese Republic
1930	Inauguration of the Yussef Hoayek Memorial in Martyrs Square, Beirut
1932	Lebanon conducts its first and only population census
1939–1945	World War II
Nov. 22, 1943	Lebanon's Independence from France
Dec. 31, 1946	Completion of French troop withdrawal from Lebanon
1948	First Arab-Israeli War
1958	Lebanon's first civil war

1960	Inauguration of the Marino Mazzacurati Memorial in Martyrs Square, Beirut
	Inauguration of Martyrs Memorial in Beqata, Shouf
1967	Second Arab-Israeli War
1975–1991	Lebanon's second civil war
1978–2000	Israeli "Security Zone"/"Occupied Zone" in South Lebanon
1996–2004	Restoration of Mazzacurati Memorial, re-inauguration in Martyrs Square
1996	Operation Grapes of Wrath and inauguration of the first Qana Memorial
2000	Re-inauguration of Qana Memorial Complex
2005	Assassination of Rafiq Hariri; Hariri's Grave Memorial in Martyrs Square, Beirut
2006	July–August Lebanon War; inauguration of the second Qana Memorial

NOTES

INTRODUCTION

The epigraph to the introduction is drawn from Michel Foucault, *Language, Counter-Memory, Practice: Selected Essays and Interviews*, ed. Donald F. Bouchard (Ithaca, N.Y.: Cornell University Press, 1977).

1. Kirk Savage, *Standing Soldiers, Kneeling Slaves: Race, War, and Monument in Nineteenth-Century America* (Princeton, N.J.: Princeton University Press, 1997), 4.

2. See, for instance, Harriet F. Senie and Sally Webster, eds., *Critical Issues in Public Art: Content, Context, and Controversy* (New York: Icon Editions, 1992); or John R. Gillis, ed., *Commemorations: The Politics of National Identity* (Princeton, N.J.: Princeton University Press, 1994).

3. For instance, see "The Lebanonization of Gaza," *Israel Today*, December 31, 2006, http://www.israeltoday.co.il/default.aspx?tabid=128&view=item&idx=1196 (accessed May 24, 2009); Paul Cochrane, "The 'Lebanonization' of the Iraqi Media: An Overview of Iraq's Television Landscape," *Transnational Broadcasting Studies* 16 (2000), http://www.tbsjournal.com/Cochrane.html (accessed May 24, 2009); or Borzou Daragahi and Megan Stack, "Analysts See Lebanon-ization of Iraq in Crystal Ball," *Los Angeles Times*, February 26, 2006.

4. A mandate is a particular form of colonial rule, given legal shape by the League of Nations after World War I. Subdivided into Class A, B, and C mandates according to their perceived state of development, territories formerly ruled by Germany and the Ottoman Empire were assigned to France and Britain who were to assist them on their way to independence through administrative and military advisers. Different from other colonial ventures, the European powers were forbidden from settling their own populations in the mandate territories. Mandates were established at a time when many of the territories wanted self-rule. For more detail, see Peter Sluglett and Nadine Meouchy, *The British and French Mandates in Comparative Perspective* (Leiden, Netherlands: Brill, 2004).

5. "Famine et épidémies font plus de 150,000 morts," in Joseph G. Chami, comp.,

Le Mémorial du Liban, 6 vols. (Beirut: Chemaly and Chemaly, 2002–2006), Vol. 1, *Du Mont-Liban à l'Indépendance* (2002), 44.

6. August Richard Norton and Jillian Schwedler, "Swiss Soldiers, Ta'if Clocks, and Early Elections," in *Peace for Lebanon? From War to Reconstruction*, ed. Deirdre Collings (Boulder, Colo.: Lynne Rienner, 1994), 64.

7. Mark Landler, "Clinton says Moderation Is Lebanon's Best Hope," *New York Times*, April 27, 2009, A8.

8. See Lebanese poet and author Gibran Khalil Gibran (1883–1931), *The Garden of the Prophet* (New York: Knopf, 1967 [1933]), 14–15. The phrase was later evoked in the title of Robert Fisk's book, *Pity the Nation: The Abduction of Lebanon* (New York: Nation Books, 2002), an extensive study of the 1975–1991 Lebanese Civil War.

9. Although it is reasonable to speculate that a human tragedy brought about by a convergence of natural disaster and war poses a greater challenge for commemoration than acts of defiance or bravery, it is still not a sufficient explanation for its complete disappearance from public view.

10. Mary Hancock, *The Politics of Heritage from Madras to Chennai* (Bloomington: Indiana University Press, 2008), 4.

11. Lara Deeb, *An Enchanted Modern: Gender and Public Piety in Shi'i Lebanon* (Princeton, N.J.: Princeton University Press, 2006); and Roschanack Shaery-Eisenlohr, *Shi'ite Lebanon: Transnational Religion and the Making of National Identities* (New York: Columbia University Press, 2008).

12. Laleh Khalili, *Heroes and Martyrs of Palestine: The Politics of National Commemoration* (Cambridge: Cambridge University Press, 2007); and Julie Peteet, *Landscape of Hope and Despair: Palestinian Refugee Camps* (Philadelphia: University of Pennsylvania Press, 2005).

13. Michael Gilsenan, *Lords of the Lebanese Marches: Violence and Narrative in an Arab Society* (Berkeley: University of California Press, 1996).

14. Figures taken from Theodor Hanf, *Koexistenz im Krieg: Staatszerfall und Entstehen einer Nation im Libanon* (Baden-Baden, Germany: Nomos Verlag, 1990), 116–120. Hanf is careful to present two different census categories (not all scholars who discuss the census do), namely, "resident Lebanese" and "registered Lebanese," to distinguish between people living in Lebanon and those living abroad who still hold Lebanese papers. The latter category has been an important voting bloc in Lebanese elections. The numbers in 1932 showed that Maronites, Greek Orthodox, and Druze had slightly more registered than resident community members, and that Sunni and Shiite communities had more resident than registered persons, which corresponds to the different communities' emigration patterns. In the resident category, exactly half of Lebanon's 1932 population was reportedly Christian, and 49 percent was Muslim. In the registered category, 53 percent were Christians and 47 percent were Muslim. The latter figures were used to justify the original 6:5 power-sharing formula.

15. Norton and Schwedler, "Swiss Soldiers, Ta'if Clocks, and Early Elections," 47.

16. A *muhafaza* (roughly equivalent to a state in the United States) is further subdivided into administrative and electoral districts. Lebanon has a total of six *muhafazas*, including Beirut, Mount Lebanon, South Lebanon, North Lebanon, the Beqa, and Nabatiye.

17. Samir Khalaf, *Heart of Beirut: Reclaiming the Bourj* (London: Saqi, 2006), 114.

18. Hashim Sarkis, "A Vital Void: Reconstructions of Downtown Beirut," in *The*

Resilient City: How Modern Cities Recover from Disaster, ed. Lawrence J. Vale and Thomas J. Campanella (Oxford: Oxford University Press, 2005), 289.

19. Kamal Salibi, *A House of Many Mansions: The History of Lebanon Reconsidered* (Berkeley: University of California Press, 1988), 127ff. In the same paragraph, Salibi goes on to dispel the notion of an independent emirate under Fakhr al-Din Maan, calling him a remarkable man but not an emir or originator of a state. Salibi is similarly skeptical about founder claims for Bashir Shehab II.

20. For the most authoritative retelling of the events, see Leila Fawaz, *An Occasion for War: Civil Conflict in Lebanon and Damascus in 1860* (Berkeley: University of California Press, 1994).

21. Carole Dagher, *Bring Down the Walls: Lebanon's Post-War Challenge* (New York: St. Martin's, 2000), 83.

22. Samy Swayd, *Historical Dictionary of the Druzes* (Lanham, Md.: Scarecrow, 2006), 51, 56.

23. Salibi, *A House of Many Mansions,* 72ff.

24. Fawwaz Traboulsi, *A History of Modern Lebanon* (London: Pluto, 2007), 93.

25. Dagher, *Bring Down the Walls,* 43. Dagher uses the Arabic word *al-atrāf* in her discussion of the marginality of South Lebanon and its Shiite communities. *Al-atrāf* can be translated as "sidelines" or "extremities."

26. For detailed information about South Lebanon's Shiite community during the French mandate period, see Tamara Chalabi, *The Shi'is of Jabal 'Amil and the New Lebanon: Community and Nation State 1918–1943* (New York: Palgrave, 2006).

27. Traboulsi, *A History of Modern Lebanon,* 85–87. According to Traboulsi, the reasons for drawing Lebanon's borders larger rather than smaller primarily had to do with the famine of 1915.

28. Ahmad Beydoun, "The South Lebanon Border Zone: A Local Perspective," *Journal of Palestine Studies* 21 (spring 1992): 35–53.

29. For the narrative of Christ's miracle at Qana [Cana], see John 2:1–11. The published archaeological record does not corroborate local beliefs. See, for instance, Peter Richardson, "Kirbet Qana (and Other Villages) as a Context for Jesus," in *Jesus and Archaeology,* ed. James Charlesworth (Grand Rapids, Mich.: Eerdmans, 2006), 120–144. Richardson reviews the various Israeli contenders for the title of biblical Qana and explains why Kirbet Qana is the most likely location. He does not even mention the South Lebanese Qana.

30. Examples of histories of the Shiite community in Lebanon are Fouad Ajami, *The Vanished Imam: Musa al-Sadr and the Shia of Lebanon* (Ithaca, N.Y.: Cornell University Press, 1986); Augustus Richard Norton, *Amal and the Shi'a: Struggle for the Soul of Lebanon* (Austin: University of Texas Press, 1987), and, *Hezbollah: A Short History* (Princeton, N.J.: Princeton University Press, 2007); Chalabi, *The Shi'is of Jabal 'Amil and the New Lebanon;* and Shaery-Eisenlohr, *Shi'ite Lebanon.*

31. For a concise summary of the early years of Israeli military operations in southern Lebanon, and their recruitment of SLA members, see Beydoun, "The South Lebanon Border Zone."

32. At this point I need to acknowledge that my comparative study leaves out the Beqa Valley and North Lebanon, which might give the mistaken impression that those regions are less important than the others. I regret that I inadvertently contribute to the existing geographic imbalance in Lebanon scholarship, which focuses primarily on Beirut, Mount Lebanon, and South Lebanon. I discussed Lebanon's

scholarly geography briefly in "Martyrs at the Margins: The Politics of Neglect in Lebanon's Borderlands," *Middle Eastern Studies* 45 (March 2009): 263–282.

33. Kenneth Foote, *Shadowed Ground: America's Landscapes of Violence and Tragedy* (Austin: University of Texas Press, 2003), 7–27.

34. Ibid., 8–9. Foote's prime example for sanctification after tragedy is the Gettysburg National Cemetery.

1. THE POLITICS OF MEMORY IN LEBANON

The epigraphs to this chapter are drawn, respectively, from John R. Gillis, "Memory and Identity: The History of a Relationship," in *Commemorations: The Politics of National Identity,* ed. John R. Gillis (Princeton, N.J.: Princeton University Press, 1994); and Lara Deeb, "Exhibiting the 'Just-Lived Past': Hizbullah's Nationalist Narratives in Transnational Political Context," *Contemporary Studies in Society and History* 50, no. 2 (2008): 369–399.

1. Eric Davis, *Memories of State: Politics, History, and Collective Identity in Modern Iraq* (Berkeley: University of California Press, 2005).

2. Nadia Abu El-Haj, *Facts on the Ground: Archaeological Practice and Territorial Self-Fashioning in Israeli Society* (Chicago: University of Chicago Press, 2001).

3. Davis, *Memories of State,* chap. 7.

4. Nachman Ben-Yehuda, *The Masada Myth: Collective Memory and Mythmaking in Israel* (Madison: University of Wisconsin Press, 1995); and Yael Zerubavel, *Recovered Roots: Collective Memory and the Making of Israeli National Tradition* (Chicago: Chicago University Press, 1995).

5. Nadia Abu El Haj, "Archaeology, Nationhood, and Settlement," in *Memory and Violence in the Middle East and North Africa,* ed. Ussama Makdisi and Paul A. Silverstein (Bloomington: Indiana University Press, 2006), 215–233.

6. Lucia Volk, "When Memory Repeats Itself: The Politics of Heritage in Post–Civil War Lebanon," *International Journal of Middle East Studies* 40 (May 2008): 291–314.

7. See the various contributions to the collection edited by Philip Khoury and Joseph Kostiner, *Tribes and State Formation in the Middle East* (Berkeley: University of California Press, 1990); David Hart, *Tribe and State in Rural Morocco* (New York: Routledge, 2000); Hanna Ziadeh, *Sectarianism and Intercommunal Nation-building in Lebanon* (London: Hurst, 2006).

8. John Tierny, "Iraqi Family Ties Complicate American Efforts for Change," *New York Times,* September 28, 2003.

9. Samir Khalaf, *Lebanon's Predicament* (New York: Columbia University Press, 1987).

10. Roger Owen and Sevket Pamuk, *A History of Middle East Economies in the 20th Century* (Cambridge, Mass.: Harvard University Press, 1999), 20.

11. Ussama Makdisi, *The Culture of Sectarianism: Community, History, and Violence in Nineteenth-Century Ottoman Lebanon* (Berkeley: University of California Press, 2000).

12. Lara Deeb makes it the central thesis of her book, *An Enchanted Modern,* that Shiite Islamic practice in Beirut is a modern, authenticated, permutation of traditional Shiite practice, and that being pious and modern are coterminous. Other

work in this scholarly vein includes Saba Mahmood, *Politics of Piety: The Islamic Revival and the Feminist Subject* (Princeton, N.J.: Princeton University Press, 2005) and the contributors to Timothy Mitchell's edited volume *Questions of Modernity* (Minneapolis: University of Minnesota Press, 2000).

13. The main proponent of "collective amnesia" in Lebanon is Samir Khalaf, "Culture, Collective Memory, and the Restoration of Civility," in Collings, *Peace for Lebanon?* 273–284. But many others have since followed his lead.

14. Samir Khalaf, *Civil and Uncivil Violence in Lebanon: A History of the Internationalization of Communal Conflict* (New York: Columbia University Press, 2002), 150.

15. Fawaz, *An Occasion for War,* 229.

16. Paul A. Silverstein and Ussama Makdisi, "Introduction: Memory and Violence in the Middle East and North Africa," in *Memory and Violence in the Middle East and North Africa,* ed. Ussama Makdisi and Paul A. Silverstein (Bloomington: Indiana University Press, 2006), 13. See also Rebecca Saunders and Kamran Aghaie, "Introduction: Mourning and Memory," *Comparative Studies of South Asia, Africa, and the Middle East* 25 (2005): 16–29, for a discussion of the therapeutic value of remembering violent pasts.

17. Edward Said, *Orientalism* (New York: Vintage Books, 1979), 322; emphasis in original. The phrase I quote is taken from the following larger argument: "The methodological failures of Orientalism cannot be accounted for either by saying that the *real* Orient is different from Orientalist portraits of it, or by saying that since Orientalists are Westerners for the most part, they cannot be expected to have an inner sense of what the Orient is all about. Both these propositions are false. It is not the thesis of this book to suggest that there is such a thing as a real or true Orient (Islam, Arab, or whatever)."

18. Kanan Makiya, *The Monument: Art and Vulgarity in Saddam Hussein's Iraq* (London: Tauris, 1998); Lisa Wedeen, *Ambiguities of Domination: Politics, Rhetoric, and Symbols in Contemporary Syria* (Chicago: University of Chicago Press, 1999).

19. Pierre Bourdieu, "Social Space and Symbolic Power," *Sociological Theory* 7 (1989): 22.

20. Savage, *Standing Soldiers, Kneeling Slaves,* 7.

21. Benedict Anderson, *Imagined Communities: Reflections on the Origin and Spread of Nationalism* (London, New York: Verso, 1991).

22. James Mayo, *War Memorials as Political Landscape: The American Experience and Beyond* (New York: Praeger, 1988), 31.

23. Ibid., 33.

24. This "policy of standardization" of military graves can become a site of protest, where relatives of soldiers demand a right to express their memory of the dead. See Yael Zerubavel, "Patriotic Sacrifice and the Burden of Memory in Israeli Secular National Hebrew Culture," in *Memory and Violence in the Middle East and North Africa,* ed. Ussama Makdisi and Paul A. Silverstein (Bloomington: Indiana University Press, 2006), 73–100.

25. Anderson, *Imagined Communities,* 9; emphasis in original.

26. Antoine Proust, "Monuments to the Dead," in *Realms of Memory: Construction of the French Past,* ed. Pierre Nora, 3 vols. (New York: Columbia University Press, 1996–1998), vol. 2 (1997), 307–330.

27. See Oren Barak, *The Lebanese Army: A National Institution in a Divided Society* (Albany: State University of New York Press, 2009), 26–30. Barak compares the composition and mission of the Lebanese army from its inception in 1923, its re-creation in 1945, and its reaction to the 1958 and 1975–1991 wars, arguing that only after 1991 did the army become a truly national institution. For instance, in the 1920s Lebanon's officer corps was 72 percent Christian, 26 percent Muslim, and 2 percent Jewish. Until 1958 the army was seen as an instrument to strengthen the Maronite presidency. Even after President Shehab, who had led the army since 1945, became president of Lebanon in 1958 and began to apply the 6:5 formula that parliament used for the staffing of officers, the perception of the army as aligned with Maronite interests changed only slowly, so that when the civil war broke out in 1975, it was called a "Christian army" and treated as a partisan force by the militias affiliated with the Lebanese National Movement.

28. Athena Leoussi, *Nationalism and Classicism: The Classical Body as National Symbol in Nineteenth-Century England and France* (New York: St. Martin's, 1998).

29. Ibid., 115.

30. Silke Wenk, "Gendered Representations of the Nation's Past and Future," in *Gendered Nations: Nationalisms and Gender Order in the Long Nineteenth Century,* ed. Ida Blom, Karen Hagemann, and Catherine Hall (Oxford: Berg, 2000), 63–77.

31. Beth Baron, *Egypt as a Woman: Nationalism, Gender, and Politics* (Berkeley: University of California Press, 2005).

32. Jessica Winnegar, *Creative Reckonings: The Politics of Art and Culture in Contemporary Egypt* (Stanford, Calif.: Stanford University Press, 2006), 6.

33. See Michel Foucault, as cited in Wedeen, *Ambiguities of Domination,* 18–19.

34. Paul Connerton, author of *How Societies Remember* (Cambridge: Cambridge University Press, 1989), is the foremost scholar of the ways in which memory connects to and manifests through the body.

35. Gillis, "Memory and Identity," 11.

36. Anderson, *Imagined Communities,* 7. See also Mayo, *War Memorials as Political Landscape,* chap. 1.

37. For some of the most recent scholarship on the role of martyrdom in monotheistic religions, see Shmuel Shepkaru, *Jewish Martyrs in the Pagan and Christian World* (Cambridge: Cambridge University Press, 2005); David Cook, *Martyrdom in Islam* (Cambridge: Cambridge University Press, 2007); Elizabeth Castelli, *Martyrdom and Memory: Early Christian Culture Making* (New York: Columbia University Press, 2004).

38. Robin Wagner-Pacifici, *The Art of Surrender: Decomposing Sovereignty at Conflict's End* (Chicago: University of Chicago Press, 2005), 36–37.

39. David Cook, *Martyrdom in Islam,* 14ff.

40. For a list of the many categories of martyrdom in early Islamic history, see ibid., chap. 3. There is no unified definition or agreement among Muslim scholars on what does or does not constitute martyrdom.

41. For a comparison of Catholic passion plays and Shiite Ashura rituals, see Janet Afary, "Shi'i Narratives of Karbala and Christian Rites of Penance: Michel Foucault and the Culture of the Iranian Revolution, 1978–1979," *Radical History Review* 86 (2003): 7–35.

42. Shiites commemorate the assassination of Hussayn annually during *ashura,* a ten-day period in the first month of the Islamic calendar. See Deeb, *An Enchanted*

Modern, chap. 4. Here Deeb also discusses the controversy within Lebanon's Shi-ite community over the contemporary appropriateness of "hitting *haydar*" and its "authenticated" replacement whereby, instead of drawing blood in public, men are encouraged to donate blood in a hospital. For more background on *ashura,* see Mahmoud Ayoub, *Redemptive Suffering in Islam: A Study of the Devotional Aspects of Ashura in Twelver Shi'ism* (The Hague: Mouton, 1978); or David Pinault, *The Shi-ites: Ritual and Popular Piety in a Muslim Community* (New York: St. Martin's, 1992).

43. Haim Hillel Ben-Sasson, "Kiddush Ha-Shem and Hillul Ha-Shem," in *Ency-clopaedia Judaica,* 2nd ed., Vol. 12, ed. Fred Solnik (Detroit, Mich.: Keter, 2007), 139–145.

44. Khalili, *Heroes and Martyrs of Palestine,* 18–20.

45. As cited (in French) in Asher Kaufman, *Reviving Phoenicia: In Search of Iden-tity in Lebanon* (London: Tauris, 2004), 27.

46. Rafiq Hariri was Lebanon's prime minister, not its president, but in Arabic the word for prime minister is literally "president of ministers" (*ra'īs al-wuzarā'*). In his lifetime it was common to refer to Hariri as either *ra'īs al-wuzarā'* or simply *al-ra'īs.* After he died he became *al-ra'īs al-shahīd.*

47. See Robin Wright, *Sacred Rage: The Wrath of Militant Islam* (New York: Simon and Schuster, 2001); and Joyce Davis, *Martyrs: Innocence, Vengeance, and Despair in the Middle East* (New York: Palgrave, 2003). Also, Arjun Appadurai speaks of "religious rage" with reference to Islam in his discussion of the Rushdie affair which he regards as evidence of a collision of "liberal aesthetics and radical Islam." See Arjun Appadurai, *Modernity at Large: Cultural Dimensions of Globaliza-tion* (Minneapolis: University of Minnesota Press, 1996).

48. The first commemoration of the dead after a week is called *al-usbū';* the sec-ond after forty days, *al-arba'īn;* and the third after a year, *al-sanawiye.* Muslims and Christians both host and visit each other during these prescribed days of mourning.

49. Eric J. Hobsbawm, *Nations and Nationalism since 1790: Programme, Myth, Reality* (Cambridge: Cambridge University Press, 1990), chap. 3.

50. Pierre Nora, "General Introduction: Between Memory and History," in Nora, *Realms of Memory,* vol. 1 (1996), 15–16.

51. Roderic Matthews and Matta Akrawi, *Education in Arab Countries of the Near East: Egypt, Iraq, Palestine, Transjordan, Syria, Lebanon* (Washington, D.C.: Ameri-can Council of Education, 1949), 407–425.

52. Ibid., 422.

53. "Les écoles privées absorbent 66% de l'ensemble des élèves," *L'Orient Le Jour,* September 13, 1993.

54. "*Akthar min 15 kitāban lil-tārīkh wa kull tā'ifa tughannī ala laylahā*" (More than fifteen history books and each sect drums to its own beat), *Al Safir,* June 16, 1996.

55. Nora, "General Introduction: Between Memory and History," 1:4–5.

56. Winnegar, *Creative Reckonings,* 6.

2. SCULPTING INDEPENDENCE

The epigraph to this chapter is drawn from "*Hakadha ihtafala Lubnān bi-'īd shu-hadā'ihi*" (This is how Lebanon celebrated its Martyrs Day), *Al Hayat,* May 7, 1955.

1. "It does not exist! Don't waste your time, it does not exist!" Seeing that I was a foreigner, the book shop patron switched from Arabic to French to talk with me.

2. Al Horj is also called "the French Sector" or "Asas Fransi" in the Lebanese dialect. As described by Jens Hanssen in *Fin de Siècle Beirut: The Making of an Ottoman Provincial Capital* (Oxford: Oxford University Press, 2005), 128ff., most of Beirut's twenty-four cemeteries were moved out of the city for reasons of sanitation and hygiene around the turn of the last century.

3. Yusuf Ibrahim Yazbek, *Mu'tamar al-shuhadā': Al-mu'tamar al-ladhī adhā' al-amānī al-qawmiyya wa jarra a'dā'ahu ila al-mashāniq* (The Conference of Martyrs: The conference that spread national aspirations and dragged its members to the gallows) (Beirut: Alyawm Newspaper Press, 1955).

4. See the discussion under the heading "Sartorial Patriotism" in Ted Swedenburg, *Memories of Revolt: The 1936–1939 Rebellion and the Palestinian National Past* (Fayetteville: University of Arkansas Press, 2003), 30–36.

5. The young men might have left Mexico in the wake or midst of the country's 1910 revolution. For a short history of Lebanese migration to Mexico, see Luz Maria Martinez Montiel, "The Lebanese Community in Mexico: Its Meaning, Importance and the History of its Community," in *The Lebanese in the World: A Century of Emigration,* ed. Albert Hourani and Nadim Shehadi (London: Tauris, 1992), 379–392. For a contemporary profile of Mexico's Lebanese migrants, see Lawrence Wright, "Slim's Time," *New Yorker,* 52–67, June 1, 2009. Wright writes about (Maronite) Carlos Slim, who is believed to be the richest man in Mexico and whose father emigrated from Jezzine, South Lebanon, in 1903.

6. Yussef Ibrahim Yazbek spent most of his adult life as an author and historian, publishing, among other things, the *Lebanese Papers* (*Awrāq lubnāniyya*) about the history of Lebanon. Never formally affiliated with any university or research institution, he was both "highly knowledgeable" and "an autodidact" (personal communication with Kamal Salibi, June 22, 2009).

7. Traboulsi, *A History of Modern Lebanon,* 72, estimates that 100,000 died during the famine; Chami, in "Famine et épidémies," cites 150,000 dead (*Le Mémorial du Liban,* vol. 1).

8. Kamal Salibi cited the memoirs of the Ottoman Intelligence Chief in Beirut at the time, Aziz Beyk. According to those memoirs, the order to round up the rebels came after Kamal al-Asad, a member of the political elite from South Lebanon, had visited him. No notes of the actual exchange of the visit were in the memoirs, but Salibi thought this was a plausible explanation. This position is corroborated by Chalabi in *The Shi'is of Jabal 'Amil,* 48–50. See also Robert Fisk, "A Typically Lebanese Story of Betrayal at the Hands of So-Called Civilised [*sic*] Nations," *The Independent,* May 21, 2005.

9. For instance, Abdel Karim al-Khalil, hanged in 1915, was one of those men who overtly maintained close relations with Ottoman authorities, and Jamal Pasha in particular, while secretly organizing an armed revolt. See Chalabi, *The Shi'is of Jabal 'Amil,* 49.

10. Traboulsi, *A History of Modern Lebanon,* 68–71.

11. Kaufman, *Reviving Phoenicia,* 79–80. Kaufman explains how Paris became home to many Turkish and Arab dissidents who sought change or reform of the Ottoman Empire. In 1913 members of a number of Arab nationalist secret societies met in Paris to discuss their political agendas.

12. George Antonius, *The Arab Awakening: The Story of the Arab National Movement* (New York: Capricorn Books, 1965 [1946]), chaps. 7–9.

13. Dagher, *Bring Down the Walls*, 19–24.

14. Based on an eyewitness account of Ahmad Nasser, reported by Michel Zakkur, *Al Barq*, February 1919. Republished in *"Shuhadā' al-sāha, 1915–1916: 'abr thalātha nusūs"* (Martyrs of the square, 1915–1916: Across three texts), in *El Bourj: Place de la liberté et porte du Levant*, ed. Ghassan Tueni and Fares Sassine (Beirut: Dar An Nahar, 2000), 24–33. The information in subsequent paragraphs is from the same source unless otherwise cited.

15. According to eyewitness accounts the men sang, *"Nahnu abnā' al-ūla, shādū majdan wa 'ula"* (We are the sons of the first men [literally, the first ones], who built glory and excellence [literally, the highest]). (Tueni and Sassine, *El Bourj*, 27).

16. Yazbek, *The Conference of the Martyrs*, 178.

17. Eyewitness account, based on a 1919 newspaper report by Ahmad Nasser, as cited in Tueni and Sassine, *El Bourj*, 27.

18. Antonius, *The Arab Awakening*, 190. A photograph of the executions superimposed on a photograph of Beirut's Place des Canons is shown on the front page of a magazine in Tueni and Sassine, *El Bourj*, 30.

19. Antonius, *The Arab Awakening*, 187–189.

20. Tueni and Sassine, *El Bourj*, 27.

21. Ibid.

22. Based on the eyewitness account of priest Yussef Estafan, in ibid., 29.

23. Yazbek, *The Conference of the Martyrs*, 179.

24. Ibid.

25. Robert Fisk, "Dead Heroes and Living Memories," *The Independent*, March 4, 2006.

26. Tueni and Sassine, *El Bourj*, 25.

27. Doris Francis, Leonie Kellaher, and Georgina Neophytou, "The Cemetery: A Site for the Construction of Memory, Identity, and Ethnicity," in *Social Memory and History: Anthropological Perspectives*, ed. Jacob Climo and Maria Cattell (Walnut Creek, Calif.: AltaMira, 2002), 100.

28. See, for instance, the five-sentence byline in the *Hawl al-madīna* (Around town) section of *Al Hayat*, May 7, 1957.

29. Fares Sassine, "Une place, mais que de noms!" in Tueni and Sassine, *El Bourj*, 234–235.

30. Ibid., 224–225.

31. George Antonius reports that the 1916 martyrs were hanged in Liberty Square, whereas the eyewitness accounts in El Bourj refer to the plaza as Unity Square.

32. Tania Mehanna, "Une foire au centre de la ville," in Tueni and Sassine, *El Bourj*, 180–181. The Beirut Fair opened in April 1921 and showcased Lebanese art and industry.

33. Tueni and Sassine, *El Bourj*, 24.

34. Ibid.

35. The first generation of Lebanese painters and sculptors, trained in European classical fine arts, include David Corm (1852–1930), Habib Srour (1860–1938), and Khalil Salibi (1870–1928), who mostly produced paintings. They were the models for (and at times teachers of) Hoayek and his contemporaries. See "Artists of the Past," http://onefineart.com/en/pastartists/ (accessed July 14, 2009).

36. "1930: Les martyrs ont leur monument," in Chami, *Le Mémorial du Liban*, 1:124–125. Yussef Hoayek's obituary is featured on October 23, 1962, in "Décès de Youssef Hoyeck," *Le Mémorial du Liban*, Vol. 4, *Le mandat Fouad Chéhab (1958–1964)* (2003), 211.

37. Tueni and Sassine, *El Bourj*, 24.

38. "1930: Les martyrs ont leur monument," in Chami, *Le Mémorial du Liban*, 1:124.

39. Helga Seeden, "A Tophet in Tyre?" *Berytus* 39 (1999). Available at http://ddc .aub.edu.lb/projects/archaeology/berytus-back/berytus39/seeden-tophet/index. html (accessed June 4, 2009). Seeden describes a variety of Phoenician, Greek, and Roman cinerary urns and votive vessels discovered in the environs of Tyre. The urn on Hoayek's statue is not identifiable as a specifically Phoenician, Greek, or Roman urn, as he did not render it in much detail.

40. See the photograph on the cover of Samir Khalaf, *Heart of Beirut: Reclaiming the Bourj* (London: Saqi, 2006).

41. Wenk, "Gendered Representations of the Nation's Past and Future," 64–65. See also Baron, *Egypt as a Woman*, 7–9.

42. Henry Pickford, "Conflict and Commemoration: Two Berlin Memorials," *Modernism/Modernity* 12 (2005): 133–173.

43. Khalaf, *Heart of Beirut*, 210.

44. Baron, *Egypt as a Woman*, 2, 67–68.

45. Samir Kassir, *Histoire de Beyrouth* (Poitiers, France: Librairie Arthème Fayard, 2003), 376–377.

46. Ibid., 377. In French Kassir's statement reads, "La célébration symbolique d'une coexistence communautaire pacifique faisait droit à la représentation archétypique du clivage vestimentaire, emblématisé en 1930 par le sculpteur Youssef Hoyek dans sa statue des Martyrs, qui mettait en communion deux pleureuses, l'une voilée, l'autre pas."

47. "1930: Les martyrs ont leur monument," in Chami, *Le Mémorial du Liban*, 1:124.

48. Philip Khoury, *Syria and the French Mandate: The Politics of Arab Nationalism, 1920–1945* (Princeton, N.J.: Princeton University Press, 1987), chaps. 7 and 8.

49. Also in 1932 the French wanted to prevent the election of a Muslim president in Lebanon. The placement of Mohammad al-Jisr, a prominent Sunni from Tripoli, on the presidential ballot was partially a result of a deep rivalry between two Maronite presidential hopefuls, Bshara al-Khoury and Emile Edde. See Kamal Salibi, *The Modern History of Lebanon* (Delmar, N.Y.: Caravan Books, 1977), 175–176.

50. Salibi, *The Modern History of Lebanon*, 180.

51. "'īd al-shuhadā' al-rasmī: Yawm al-hukūma lā yawm al-umma" (Official Martyrs Day: The government's, not the nation's, day), *Al Nahar*, September 2, 1933.

52. "Al-ihtifāl bi-dhikrā al-shuhadā' bi-Bayrūt wa Dimashq" (Celebrating the memory of the martyrs in Beirut and Damascus), *Al Nahar*, May 6, 1936.

53. "Al-hukūma tahtafal 'wahdiha' bi-'īd al-shuhadā'" (The government celebrates Martyrs Day alone), *Al Nahar*, September 3, 1936.

54. "Celebrating the Memory of the Martyrs in Beirut and Damascus."

55. "Dhikrā al-shuhadā' al-abrār: Ihtifāl qawmī rā'i' khafaqat fihi qulūb al-hukām ma' qulūb al-mahkūmīn" (Remembrance of the dutiful martyrs: A beautiful national

celebration where the hearts of the rulers beat with the hearts of the ruled), *Al Nahar*, May 7, 1938. The following year the headline was similarly emphatic, "*Dhikrā al-sādis min ayār: Lubnān, hukūma wa sha'ban yakram al-shuhadā' al-abrār*" (Remembrance of May 6: Lebanon, both government and people, honors its dutiful martyrs), *Al Nahar*, May 7, 1939.

56. Stories of the politicians' mortified wives who stood in front of foreign soldiers in their nightgowns made the rounds among the public, adding insult—the dishonor of honorable families—to injury, namely, the arrests. The next day Beiruti women organized in protest: first a group of Christian women began marching toward Martyrs Square, but they were later joined by a group of Muslim women, who, at one point in the rally, jointly unveiled. For details, see Elizabeth Thompson, *Colonial Citizens: Republican Rights, Paternal Privilege, and Gender in French Syria and Lebanon* (New York: Columbia University Press, 2000), 250–257.

57. "Confronté à un ultimatum britannique, Catroux fait libérer les prisonniers de Rachaya et annule les arrêts," in Chami, *Le Mémorial du Liban*, Vol. 2 (2002), *Le mandat Béchara el Khoury (1943–1952)*, 40–41.

58. Volk, "When Memory Repeats Itself," 296–298.

59. "Plaque commémorative et cérémonies pour célébrer l'évacuation," in Chami, *Le Mémorial du Liban*, 2:188–189.

60. The holiday of December 31, which Lebanese simply call *al-jalā'* (the withdrawal), coincides every year with New Years celebrations. On November 22 the Lebanese president, surrounded by members of the military, deposits a wreath at the Tomb of the Unknown Soldiers.

61. "*Lubnān, hukūma wa sha'ban yukarrim shuhadā'ihi*" (Lebanon, government and people, honors its martyrs), *Al Nahar*, May 7, 1946.

62. Barak, *The Lebanese Army*, 4 and 80. The armistice led to the creation of the Israeli-Lebanese Mixed Armistice Commission (ILMAC), which convened regularly and jointly monitored the Lebanese-Israeli border. Traboulsi, in *A History of Modern Lebanon*, called the Lebanese engagement in the 1948 War "symbolic" (113). Barak estimates that 80,000–110,000 Palestinian refugees came to Lebanon at that time, and Traboulsi's estimate is 120,000.

63. Elizabeth Picard, *Lebanon, A Shattered Country: Myths and Realities of the Wars in Lebanon* (New York: Holmes and Meier, 2002), 79. The Lebanese government selectively granted Christian Palestinians citizenship in the decade after 1948 but did not extend the same privilege to Muslim Palestinians. According to Picard, 140,000 Palestinian refugees came to Lebanon in 1948.

64. "*Lubnān yukarrim dhikrā shuhadā'ihi*" (Lebanon honors the memory of its martyrs), *Al Nahar*, May 7, 1949.

65. The Sursoks were a prominent Greek Orthodox merchant family in Beirut. They donated their family mansion to the municipality of Beirut in 1952, and it was turned into the Museum of Lebanese Art.

66. Tueni and Sassine, *El Bourj*, 17. The French original reads "Captant ce moment de l'histoire de la Place (1948–1960) sans monument aux Martyrs, celui de Youssef Hoayek (1930) ayant été mutilé par un déséquilibré."

67. Interview with Ghassan Tueni and Fares Sassine at the *Al Nahar* newspaper office, Beirut, June 26, 2003.

68. The interview with four Lebanese artists who wished to remain anonymous

took place in the main office of the Center of Lebanese Artists for Sculpture and Painting (*Markez jami'at al-fannānīn al-lubnāniyīn lil-naht wa-l-rasm*) near Tell ed-Druze, Beirut, June 30, 2003.

69. "Le jugeant laid, un journaliste défigure le monument aux martyrs," in Chami, *Le Mémorial du Liban*, 2:257.

70. Cited in Tueni and Sassine, *El Bourj*, 31. The poetic image of the destruction of the idol evokes the story of Prophet Muhammad who broke the idols in the Kaaba in Mecca when he began preaching the monotheistic faith of Islam.

71. "26 manifestantes feministes arrêtées," in Chami, *Le Mémorial du Liban*, 2:331.

72. "*Lubnān, hukūma wa sha'ban, yahtafal bi-dhikrā al-shuhadā'*" (Lebanon, government and people, celebrates the memory of the martyrs), *Al Nahar*, May 7, 1953. In Nsouli's own words, "The memorial is not even remotely connected to manhood—their manhood" (*Timthāl la yamuttu ila al-rujūla—rujūlatihim—bi-sila*).

73. May Abboud Abi Aql, "*Intishāl nasb al-shuhadā' al-qadīm min ghaiyāhib al-mastawda'āt*" (Pulling the old martyrs statue from warehouse gloom), *Al Nahar*, October 18, 2001.

74. Tueni and Sassine, *El Bourj*, 34.

75. "*Dhikra shuhadā' sādis ayār*" (Memory of the martyrs of May 6), *Al Hayat*, May 7, 1953.

76. The 1955 *L'Orient* article is cited in Abi Aql, "Pulling the Old Martyrs Statue from Warehouse Gloom."

77. "*Tasmīm nasb al-shuhadā' tār bayn al-ashghāl wa al-tarbiyya*" (The design for the Martyrs Memorial disappears between the ministries of public works and culture), *Al Hadaf*, January 8, 1956.

78. "*Lubnān yuhyī dhikra shuhadā' al-sādis min ayār: Ra'īs al-jumhūriyya yarsī al-hajar al-asāsī lil-nasb al-jadīd*" (Lebanon celebrates the memory of the May 6 martyrs: The president lays the foundation for the new memorial), *Al Nahar*, May 7, 1955; see also the *Daily Star* and *Al Hayat* articles on the same day.

79. "Première pierre d'un nouveau monument aux martyrs," in Chami, *Le Mémorial du Liban*, Vol. 3 (2002), *Le mandat Camille Chamoun (1952–1958)*, 83.

80. "*Hadhā hwa nasb shuhadā' Lubnān*" (This is Lebanon's Martyrs Statue), *Al Hayat*, April 27, 1956.

81. "'*Umlāqān wa mash'al: Ramz al-shuhadā'*" (Two giants and a torch: The symbol of the martyrs), *Al Hayat*, April 24, 1956; and "*Majlis al-nawāb yadrus fi al-usbū' al-muqbil mashrū' i'tiād 100 alf li-nasb al-shuhadā'*" (Parliament reviews next week the project of allocating 100,000 for the Martyrs Memorial), *Al Hayat*, May 13, 1956.

82. Byline in the *Hawl al-madīna* (Around town) section of *Al Hayat*, May 7, 1957.

83. Antonius, *The Arab Awakening*, 191

84. Esra Özyürek, *Nostalgia for the Modern: State Secularism and Everyday Politics in Turkey* (Durham, N.C.: Duke University Press, 2006), 113.

85. "Solh réaffirme ses positions sur l'indépendance," in Chami, *Le Mémorial du Liban*, 2:43. On November 29, 1943, Riyad al-Solh declared that "Lebanon must remain completely independent and sovereign in its current borders. It has an Arab face and must collaborate with Arab countries" ("Le Liban doit rester totalement indépendant et souverain dans le cadre de ses frontières actuelles. Il a un visage arabe et il doit collaborer avec les pays arabes").

86. Tueni and Sassine, *El Bourj*, 34.

The epigraphs to this chapter are drawn from Kamal Jumblatt, *I Speak for Lebanon* (London: Zed, 1982); and B.Q. [abbreviated in original], *"Al-ramz al-shahīd"* (The martyr symbol), *Al Nahar,* May 6, 1995.

1. Khalaf, *Civil and Uncivil Violence in Lebanon,* 144.

2. Salibi, *The Modern History of Lebanon,* 198.

3. Fahim Qubain, *Crisis in Lebanon* (Washington, D.C.: Middle East Institute, 1961), chap. 4. Most of the subsequent information in this paragraph stems from Qubain.

4. The United National Front included a significant number of Christian politicians and had the blessing of the Maronite patriarch. See Qubain, *Crisis in Lebanon,* 49–50.

5. Qubain, *Crisis in Lebanon,* 141. In his appendix, Qubain printed the transcript of Lebanese Foreign Minister Charles Malik's June 6, 1958, presentation to the UN Security Council, asking the international community for help against the UAR-instigated insurrection in Lebanon. In his rebuttal on the same day, the UAR representative Omar Loutfi proclaimed that none of the accusations was true and that Malik tried to pass off a domestic government crisis—Chamoun's attempt to extend his presidential tenure—as a foreign policy crisis.

6. Jumblatt's forces reportedly killed 40 and wounded 120 government loyalists in and around Fraydiss during fighting that lasted thirty-six hours, ten of which were in the village itself. Jumblatt's forces engaged in a much larger battle over Beirut's International Airport two weeks later, but that battle was not similarly remembered.

7. Chamoun saw the events in Iraq as proof of the spread of anti-Western, pan-Arab revolutionary ideology. While Abdel Karim Qasim was a revolutionary, he was actually an Iraqi nationalist who had the support of most left-leaning Iraqi parties, which included many Kurds and Shiites. Qasim's regime and life were repeatedly threatened by (predominantly Sunni) pan-Arabists who ultimately came to power through a military coup in 1968. See Davis, *Memories of State,* 109–113.

8. Traboulsi, *A History of Modern Lebanon,* 136. All subsequent information in this paragraph is from this source.

9. For more details on U.S. and Soviet foreign policy in the Arab world at the time, see Fawaz Gerges, *The Superpowers and the Middle East: Regional and International Politics, 1955–67* (Boulder, Colo.: Westview, 1994).

10. Khalaf, *Civil and Uncivil Violence,* 144. Khalaf calls the events of 1958 "a significant watershed in the political history of Lebanon."

11. Oren Barak, "'Don't Mention the War?' The Politics of Remembrance and Forgetfulness in Postwar Lebanon," *Middle East Journal* 61 (2007): 53.

12. Jumblatt, *I Speak for Lebanon,* 1.

13. In his interview with Philippe Lapousterle, he expresses regret at the violent excesses of the younger fighters of the National Movement during 1975–1976. He said he should have done more to prevent them from stealing and looting. Yet it is clear that he condoned their actions in the end (Jumblatt, *I Speak for Lebanon,* 111).

14. The interpretations of Jumblatt's intentions differ widely. Salibi considers Jumblatt's demands for secularism and spiritualism a purely self-motivated endeavor aimed to limit Maronite power in Lebanon (see Salibi, *A House of Many Mansions,*

194). On the other hand, Leila Fawas calls Jumblatt the only traditional leader on the Lebanese stage that adopted and credibly presented a nonsectarian (secular, socialist) political ideology to a broad-based following beyond his own community (Fawaz, *An Occasion for War*, 225). It is obviously impossible to know Jumblatt's true intentions.

15. Hasan Halaq, *Dirasāt al-mujtamaʿ al-lubnāniyya* (Studies of Lebanese society) (Beirut: Dar al-Nahda al-Arabiya, 2006), 57.

16. While Kamal Jumblatt studied in France he joined a French Marxist organization. See Nazih Richani, *Dilemmas of Democracy and Political Parties in Sectarian Societies: The Case of the Progressive Socialist Party of Lebanon, 1949–1996* (New York: St. Martin's, 1998), 35.

17. Ibid., 37–39, 95. Only after Kamal Jumblatt's assassination in 1977 did Druze become the absolute majority in the party, indicating that Kamal Jumblatt personally drew followers from across Lebanon's ethno-religious communities.

18. Jumblatt, *I Speak for Lebanon*, 100–101.

19. When Jumblatt was assassinated—many suspect Syrian involvement in the killing—he was not buried alongside the revolutionary fighters of 1958, although he, too, was called a martyr. Instead they laid him to rest at his home in Mukhtara along with the two body guards who died with him. His shrine is fenced in and carefully maintained. A guard keeps the key and, upon request, opens the gate for visitors who come to light candles and say prayers at Jumblatt's grave.

20. The Arabic reads: "*Al-hayat ʿadaʾ, ʿadaʾ bedūn muqābil. Al-hubb al-haqīqī ʿadaʾ, ʿadaʾ bedūn muqābil.*"

21. For a detailed explanation of the neutral position of the Lebanese army during 1958, see Barak, *The Lebanese Army*, chap. 4.

22. The Arabic reads, respectively: "*Ālamu al-haqq wa al-haqq yuharrirkum*" and "*Al-haqīqa wahdihā tantasir, la al-dalāl. Bil-haqīqa yamtad al tarīq al-ladhi yūsil ila allah.*"

23. Swayd, *Historical Dictionary of the Druze*, 71.

24. The Arabic reads "*Aqūl lakum haqqan, inna ma min ahad yastatiʿa an yabsar malkūt allah in huwa lam yūlad min jadīd.*" See John 3:3.

25. The Arabic reads "*Inna malkūt allah huwa fī nufūskum. La akhāfu liannanī intasartu ala hadha al-ʿālam.*" See Luke 17: 21 and John 16:33, respectively. *The Kingdom of God Is Within You* is also the title of a book by Leo Tolstoy, in which he advocates pacifism and nonviolence. It is conceivable that Kamal Jumblatt read it as well.

26. After the memorial was completed, Kamal Jumblatt awarded Wahib al-Bteddiny a scholarship to study at an art institute in Moscow, where he remained for six years.

27. Interview with Jamil Saad ed-Din, Baqata, January 9, 2008.

28. Anja Peleikis, "The Making and Unmaking of Memories: The Case of a Multi-Confessional Village in Lebanon," in *Memory and Violence in the Middle East and North Africa*, ed. Ussama Makdisi and Paul Silverstein (Bloomington: Indiana University Press, 2006), 133–150.

29. "La statue de Riad el Solh," in Chami, *Le Mémorial du Liban*, 3:213. The Italian sculptor made the statue in his atelier in Rome and shipped it to Lebanon in December 1956. The al-Solh statue reportedly cost approximately 58,000 Lebanese lira at the time compared to 188,000 Lebanese lira for the Martyrs Memorial (ibid., 300).

30. "Riad el Solh a sa statue," in Chami, *Le Mémorial du Liban*, 3:273.

31. "*Izmīl Mazzacurati yujassid al-istishhād al-lubnānī*" (Mazzacurati's chisel portrays Lebanese martyrdom), *Al Nahar*, May 6, 1960. The article states that the statue

symbolizing freedom is 4.3 meters tall and that the statue of the martyr next to her is 4 meters tall. The measurements of the sculptures at their feet are not reported.

32. Ibid., as well as "*Nasb al-shuhadā 'amal fannī rā'i'a illa annahu lā yarmuz—lā min qarīb wa lā min ba'īd—ila shuhadā' 6 ayār*" (The monument of Martyrs Square is a beautiful work of art, but it does not represent—either from close up or far away—the martyrs of May 6), *Al Nahar,* May 7, 1960.

33. Tueni and Sassine, *El Bourj,* 24.

34. "Mazzacurati's Chisel Portrays Lebanese Martyrdom," *Al Nahar,* May 6, 1960.

35. I heard this theory first from Oussama Kabbani, personal communication, June 26, 2003. At the time Kabbani worked for the Council for Development and Reconstruction (CDR) in Beirut, and he had been involved in planning the restoration of the Martyrs Memorial.

36. See a short biography of the artist at http://www.scultura-italiana.com/ Biografie/Mazzacurati.htm (accessed August 3, 2005).

37. In 1999 a bronze cast of Mazzacurati's allegorical Liberty went on sale in Rome for six million Italian lira. The cast measured 18 x 88.5 x 62 cm. Document available at http://web.artprice.com/ps/artitems.aspx?view=all&idarti=NzUzNTAw MDA1NTIoNTQt&page=1&refGenre=C (accessed August 3, 2005).

38. Wenk, "Representations of the Nation's Past and Future," 70–71.

39. "Le nouveau monument des martyrs," in Chami, *Le Mémorial du Liban,* 3:300.

40. Kassir, *Histoire de Beyrouth,* 501–502. Having written prolifically about the history of Lebanon and reported on current events, Kassir was assassinated in Beirut on June 2, 2005, at the age of forty-five and is now remembered in a public memorial in downtown Beirut.

41. Partha Chatterjee, *The Nation and Its Fragments: Colonial and Post-Colonial Histories* (Princeton, N.J.: Princeton University Press, 1993), 7.

42. Charles Winslow, *Lebanon: War and Politics in a Fragmented Society* (New York: Routledge, 1996), chap. 6.

43. Ibid., 289.

44. Hashim Sarkis and Peter Rowe, "Introduction: Projecting Beirut," in *Projecting Beirut: Episodes in the Construction and Reconstruction of a Modern City,* ed. Hashim Sarkis and Peter Rowe (Munich: Prestel, 1998), 13.

45. Picard, *Lebanon, A Shattered Country,* 81–82. In Picard's words, "the war it did not take part in, and the defeat that was not actually its own, had more dramatic consequences for Lebanon than any other Arab country."

46. Fawwaz Traboulsi provides extensive economic data for Lebanon before the civil war, beginning with the concentration of wealth in only a few hands, the rise in demand for foreign goods which undercut local industry, the crisis in agriculture, and high costs of living (*A History of Modern Lebanon,* 157–161).

47. Angus Gavin, "Heart of Beirut: Making the Master Plan for the Renewal of Central Beirut," in *Projecting Beirut: Episodes in the Construction and Reconstruction of a Modern City,* ed. Hashim Sarkis and Peter Rowe (Munich: Prestel, 1998), 219.

48. Sarkis, "A Vital Void," 292. Also see the photographs and the article by Mohammad Farid Mattar, "The Square for the Students," in Tueni and Sassine, *El Bourj,* 76–78.

49. Nicholas Blanford, *Killing Mr. Lebanon: The Assassination of Rafik Hariri and Its Impact on the Middle East* (London: Tauris, 2006), 41, as well as footnote 2 in Norton and Schwedler, "Swiss Soldiers, Ta'if Clocks, and Early Elections," 45–65.

50. Volker Perthes, "Myths and Money: Four Years of Hariri and Lebanon's Preparation for a New Middle East," *Middle East Report* 203 (1997): 19. Perthes credits the expression "a war of others on our territory" to President Elias Hrawi, cited in *Al-Hayat*, October 11, 1993. Others credit the expression to Ghassan Tueni, *Laissez vivre mon peuple! Le Liban à l'ONU* (Paris: Librairie d'Amérique et d'Orient, 1984).

51. See Picard, *Lebanon: A Shattered Country*; Traboulsi, *A History of Modern Lebanon*; and Halim Barakat, *Lebanon in Strife: Student Preludes to the Civil War* (Austin: University of Texas Press, 1977).

52. Georges Corm, "The War System: Militia Hegemony and Reestablishment of the State," in Collings, *Peace for Lebanon?* 215–230.

53. Hassan Krayem, "The Lebanese Civil War and the Taif Agreement," in *Conflict Resolution in the Arab World: Selected Essays*, ed. Paul Salem (Beirut: American University of Beirut, 1997), 416.

54. Barak, "'Don't Mention the War?'" 53; and Sune Haugbolle, "Public and Private Memory of the Lebanese Civil War," *Comparative Studies of South Asia, Africa, and the Middle East* 25 (2005): 195–196.

55. See photograph in Tueni and Sassine, *El Bourj*, 95.

56. See Khalaf, "Culture, Collective Memory, and the Restoration of Civility," 273–285, as well as many of his subsequent writings, including his recent *Heart of Beirut: Reclaiming the Bourj* (London: Saqi Books, 2006).

57. The long list of commemorative activities includes symposiums (five academic colloquiums on *The Next Generation* [*La génération de la relève*] between 1991 and 1996, and *Memory for the Future* [2001]); popular movies (Ziyad Doueiry's *West Beirut* [1998], Randa Sabag's *Civilisées* [1999], and Jean Khalil Chamoun's *In the Shadows of the City* [2000]); and civil war novels by an illustrious group of authors, including Hanan al-Shaykh, Etel Adnan, and Elias Khoury, who eloquently filled pages with stories about the gradual disintegration of society as well as the individual under the strain of war (al-Shaykh's *The Story of Zahra*, Adnan's *Sitt Marie Rose*, and Khoury's *Little Mountain* and *The Kingdom of Strangers* to name but a few of the better-known works in English translation). A concise summary of Lebanese women's civil war literature can be found in Miriam Cooke's two anthologies, *War's Other Voices: Women Writers on the Lebanese Civil War* (Cambridge: Cambridge University Press, 1988); and *Women and the War Story* (Berkeley: University of California Press, 1997).

58. "*Shaftari fi risālat ila dahāyāihi*" (Shaftari in a letter to his victims), *Al Nahar*, February 10, 2000. See also Charles M. Sennott, "Apology of Lebanese Figure Breaks Silence on Civil War," *Boston Globe*, February 27, 2000, A1, A6.

59. Robert Maroun Hatem, *From Israel to Damascus: The Painful Road of Blood, Betrayal and Deception* (La Mesa, Calif.: Vanderblumen, 1999). Banned from publication and distribution in Lebanon, the book was photocopied, faxed, and passed on by hand from reader to reader. For commentary, see Robert Fisk, "Notebook: The 'Cobra' Strikes at the Heart of His Master," *The Independent*, May 23, 1999.

60. See Sarkis, "A Vital Void," 281–297.

61. Khalaf, *Heart of Beirut*, chap. 1.

62. Haugbolle, "Public and Private Memory of the Lebanese Civil War," 192; Barak, "'Don't Mention the War?'" 57.

63. Lebanese Society for Development and Reconstruction.

64. Blanford, *Killing Mr. Lebanon*, 18.

65. Ahmed Sbaiti, "Reflections on Lebanon's Reconstruction," in Collings, *Peace for Lebanon?* 170.

66. Joe Nasr, "Reconstruction," in *Reconstruction et Réconciliation au Liban: Négations, lieux publics, renouement du lien social*, ed. Eric Huybrechts and Chawqi Douayhi (Beirut: CERMOC, 1999), 15. The theme was picked up by Nabil Beyhum, "La Place des Canons et la guerre," 95. Other critics charged that Solidere was turning "the messy, noisy melting pot that was the old center of Beirut" into "a sterile urban ideal of cobble-stoned streets, art galleries and boutiques where only the wealthy could afford to live and shop." See Blanford, *Killing Mr. Lebanon*, 44.

67. Helen Sader, "Ancient Beirut: Urban Growth in the Light of Recent Excavations," in *Projecting Beirut: Episodes in the Construction and Reconstruction of a Modern City*, ed. Hashim Sarkis and Peter Rowe (Munich: Prestel, 1998), 23–40.

68. "*Timthāl al-shuhadā' fī 6 ayār*" (The Martyrs Statue on May 6), *Al Nahar*, May 6, 1995.

69. B. Q., "*Al-ramz al-shahīd*" (The martyr symbol), *Al Nahar*, May 6, 1995.

70. Ziyad Harfoush, "*Timthāl min nasb al-shuhadā' yasta'īd yamanāihi: Ikhtafat fī-l-harb wa tahrat fī marab*" (A statue from the Martyrs Memorial retrieves its right arm: It disappeared during the war and appeared in a parking lot), *Al Nahar*, March 13, 1997.

71. See the official Department of Sacred Art Website at the University of the Holy Spirit at Kaslik, http://www.usek.edu.lb/catalogue/framework.asp?pageName=&language=fr (accessed June 23, 2008).

72. Picard, *Lebanon, A Shattered Country*, 164.

73. Marwan Iskandar, *Rafiq Hariri and the Fate of Lebanon* (London: Saqi, 2006), 93.

74. Blanford, *Killing Mr. Lebanon*, 48. In the mid-1990s the average monthly wage for white-collar work—for example, a teacher's salary—was $500.

4. RECONSTRUCTING WHILE RE-DESTRUCTING LEBANON

The epigraphs to this chapter are drawn, respectively, from James Mayo, *War Memorials as Political Landscape: The American Experience and Beyond* (New York: Praeger, 1988); and Mohammad Kansu, "*Ilā tifl shahīd*" (To a martyred child), in *Qānā: Al-hibr wa al-damm* (Qana: The ink and the blood), ed. Yussef Deeb, 156 (Beirut: National Committee for the Commemoration of March 14 and April 18, published 1999).

1. Peter Theroux, "Beirut Rising," *National Geographic* 193 (September 1997): 100–123. Similar articles about Lebanon's rebirth were featured in the late 1990s and early 2000s in the travel sections of assorted Western newspapers and magazines.

2. "Operation Litani" killed at least 2,000 Lebanese and displaced 250,000 residents from southern Lebanon. See Picard, *Lebanon, A Shattered Country*, 206.

3. The area controlled by Israeli forces comprised 1,200 square kilometers (~460 square miles); Lebanon's total territory stretches over 10,400 square kilometers (~4,000 square miles). For more detail, see Nicholas Blanford, "The Economy, Infrastructure and Administration of the Israeli Controlled Area (ICA) in South Lebanon," *Lebanon Report* 1(1998): 26–36.

4. Ahmad Beydoun, "The South Lebanon Border Zone," 36–40. Beydoun explains that when the Lebanese army dissolved in early 1976, hundreds of demobilized Maronite soldiers returned to their native border villages. These soldiers had been "politicized and confessionalized" and therefore joined Israel, via the SLA, in their fight against the Palestinians. Because the Israelis paid a fixed salary at a time when there were few income opportunities in Lebanon, Shiite and Druze joined the rank and file as well, so that by 1998 the SLA was made up of 70 percent Shiites and Druze, and 30 percent Christians, most of them officers. See Nicolas Blanford, "The Economy, Infrastructure, and Administration of the ICA in South Lebanon," 28.

5. Many of the Hizballah posters that honor Resistance activities and individual leaders or fighters feature the Dome of the Rock with Jerusalem in the background, linking Lebanese and Palestinian liberation agendas. However, Hizballah officials have also made it clear that the Party of God is a national liberation organization of Lebanon.

6. During "Operation Peace for Galilee," the Lebanese death toll was around seventeen thousand, with an additional thirty thousand wounded. There were an estimated one million refugees and infrastructure damage of about $2 billion. See Hanf, *Koexistenz im Krieg,* 437. The year 1982 was the deadliest single year of the entire Lebanese civil war. It was also one of the costliest military operations for Israel since its War of Independence. See Picard, *Lebanon, A Shattered Country,* 124.

7. "Operation Accountability" reportedly killed 120 Lebanese civilians, wounded 500, displaced 300,000 residents from South Lebanon, causing an estimated $28.8 million in infrastructure damages. See Blanford, *Killing Mr. Lebanon,* 66.

8. Israel's "Operation Grapes of Wrath" resulted in 165 dead, 400 wounded, and 400,000 refugees as a result of six hundred air raids that dropped an estimated 23,500 shells on Lebanese territory over a sixteen-day period. See Rosemary Hollis and Nadim Shehadi, eds., *Lebanon on Hold: Implications for Middle East Peace* (London: Royal Institute of International Affairs, 1996), xii.

9. Lara Deeb, "'Hizbullah Strongholds' and Civilian Life," *Anthropology News* 47 (2006): 10–11. Deeb critiques the use of the term "terrorist infrastructure," because it fails to recognize Hizballah's health, education, and economic development projects which create a much needed social services infrastructure in South Lebanon.

10. GEO Projects Ltd., *Map of Lebanon with City Map and Guide of Beirut* (Beirut: All Print Distributers and Publishers, 1984). When I purchased the map in a bookstore on Hamra Street in 1992, my choices were limited; tourists were still few and the demand for maps was negligible.

11. Letter dated May 7, 1996, from Secretary-General Boutros-Ghali addressed to the President of the UN Security Council, based on the report by Military Adviser Major-General Franklin van Kappen. Available at http://domino.un.org/UNISPAL. nsf/db942872b9eae454852560f6005a76fb/62d5aa740c14293b85256324005179be!Open Document (accessed May 15, 2008). The document details both Israeli and Lebanese versions of events. Many questions remain as to what led up to the Israeli attack on Qana. As Israeli military documents are declassified, they may help to shed light on the matter in the future.

12. Laurie King-Irani, "Petition Charges Israel with War Crimes: The Case of the Qana Massacre Survivors," *MERIP Online,* December 8, 1999, http://www.merip.org/mero/mero120899.html (accessed June 2, 2008).

13. Charles Sennott, "In Lebanon, A Memorial to Mayhem," *Boston Globe,* December 1, 1997.

14. Norton, *Hezbollah,* 85.

15. Muhammad Atta, one of the pilots in the September 11 attacks, reportedly watched the news of the Qana attack on television in Germany, and he pledged to kill himself in revenge that same week. See Juan Cole, "Informed Comment: Al-Fakhoura School Bombed, 42 Killed, Including Children," http://www.juancole .com/2009/01/al-fakhoura-school-bombed-42-killed.html (accessed June 10, 2009). Also see Bruce Lawrence, ed., *Messages to the World: The Statements of Osama Bin Laden,* trans. James Howarth (New York: Verso, 2005), 25, 40.

16. Richard W. Murphy, "The Costs of Wrath: An American Perspective," in Hollis and Shehadi, *Lebanon on Hold,* 7.

17. Michel Foucault, "Of Other Spaces," *Diacritics* (spring 1986): 22–27.

18. For a review of the symbolic significance of Khiam in Lebanon, see Deeb, "Exhibiting the 'Just-Lived Past,'" 369–399. Beaufort became the site of critical Israeli reflections on Israel's Lebanon operations in Joseph Cedar's acclaimed 2007 film *Beaufort.*

19. Shaery-Eisenlohr, *Shi'ite Lebanon,* 23.

20. Salibi, *A House of Many Mansions,* 51–52. According to Salibi, the Sunnis treated the Druze in the same way.

21. Norton, *Amal and the Shi'a,* 14.

22. Majed Halawi, *A Lebanon Defied: Musa al-Sadr and the Shi'a Community* (Boulder, Colo.: Westview, 1992).

23. Norton, *Amal and the Shi'a,* 18.

24. Ajami, *The Vanished Imam,* 86–87. In the early years Sadr worked very closely with Fouad Shehab, who granted Sadr Lebanese citizenship. Sadr's government activism gained him many enemies among political and religious rivals who accused him of being a "vassal of the regime."

25. Norton, *Amal and the Shi'a,* 44.

26. Ibid., 47.

27. Ajami, *The Vanished Imam,* 134–135. Sadr sought out Christian audiences repeatedly, inside and outside churches, and he befriended many Christian urban elites—for example, Michel al Asmar, Bishop George Haddad, and Ghassan Tueni—who considered him a progressive political voice.

28. Musa Sadr, *Ijtama'anā min ajl al-insān* (Beirut: Imam Musa Sadr Center for Research and Studies, n.d.). Transcript of speech delivered on February 18, 1975, in the St. Louis Capuchin Church in Beirut.

29. Majed Halawi, *A Lebanon Defied,* 194.

30. Amal is an acronym for the Arabic *Afwāj al-muqāwama al-lubnāniyya* (Lebanese resistance detachments). See Ahmed Nizar Hamzeh, *In the Path of Hizbollah* (Syracuse, N.Y.: Syracuse University Press, 2004), 21.

31. Hamzeh, *In the Path of Hizbollah,* 21.

32. Norton, *Amal and the Shi'a,* 56.

33. Ajami, *The Vanished Imam,* chap. 5. Musa Sadr was last seen alive on August 31, 1978, when he left his hotel in Tripoli, the capital of Libya, to attend a meeting with Libyan president Muammar Qaddafi. Representatives for Qaddafi told the press that the president had warmly received Sadr and, on his request, arranged for a flight to Rome that same day. There is no record of Sadr's arrival in Italy.

34. In some Lebanese circles, the *Majlis al-janūb* is called the *Majlis al-juyūb,* which translates to "Council of (Deep) Pockets." This is a reputation about which

the Council is sensitive, as is evidenced by the recently published five-hundred-page book titled *Al-ayādī al-bayḍa: Injāzāt majlis al-janūb 1992–2002* (White hands: The achievements of the Council of the South) (Beirut: Dar Bilad, 2003). The book showcases every house, school, and electricity and water plant that the Council has built over the past fifteen years as proof of its faithful use of government funds.

35. Amal Saad-Ghorayeb, *Hizbu'llah: Politics and Religion* (London: Pluto, 2002), 14. For additional analysis of the Party of God and its origins, see Hala Jaber, *Hezbollah: Born with a Vengeance* (New York: Columbia University Press, 1997); or Judith Palmer Harik, *Hezbollah: The Changing Face of Terrorism* (London: Tauris, 2004).

36. Rather than engaging in armed struggle, Amal defines "resistance" as the will of residents of southern Lebanon "to keep rebuilding and starting their lives again." See Shaery-Eisenlohr, *Shi'ite Lebanon,* 38. Shaery-Eisenlohr's book presents a detailed comparison between Amal and Hizballah, especially in chapters 2, 3 and 4.

37. Saad-Ghorayeb, *Hizbu'llah,* 112.

38. The most extensive English-language coverage of the event was given in David Hirst, "Lebanese Dead Laid to Rest," *The Guardian,* May 1, 1996, and Robert Fisk, "Israel's Victims Buried to Wails of Rage," *The Independent,* May 1, 1996.

39. David Hirst counted eighty-three coffins, and Robert Fisk counted ninety-one. Both explained that it had been impossible to reassemble all the victims' bodies because of the way in which they had been killed.

40. Ismail Sabrawi, *"Lubnān dafana shuhadā' Qānā fī ma'tam watanī wa sha'abī"* (Lebanon buried Qana's martyrs at a national and popular burial), *Al Nahar,* May 1, 1996. All subsequent information in this paragraph comes from this article.

41. John Conyers Jr., "Commemorating the 10th Anniversary of the Civilian Deaths at Qana, Lebanon," *Congressional Record* 152 (46), April 25, 2006. Forty-five Lebanese-American households in Dearborn, Michigan, lost relatives in Qana on April 18, 1996.

42. Sabrawi, "Lebanon Buried Qana's Martyrs."

43. See Shaery-Eisenlohr, *Shi'ite Lebanon,* 81ff. for a description of Amal's Islamic Scouts Youth Movement.

44. Hirst, "Lebanese Dead Laid to Rest."

45. Fisk, "Israel's Victims Buried to Wails of Rage."

46. Laurie King-Irani, "Commemorating Lebanon's War amid Continued Crisis," *MERIP Online,* April 14, 2005, http://www.merip.org/mero/mero041405.html (accessed June 2, 2008).

47. Paul Salem, "In the Wake of 'Grapes of Wrath': Meeting the Challenge," in Hollis and Shehadi, *Lebanon on Hold,* 76.

48. Fawwaz Traboulsi, "Variations on an Andalusian Theme: Undated Letters to Etel," in *Etel Adnan: Critical Essays on the Arab-American Writer and Artist,* ed. Lisa Suhair Majaj and Amal Amireh (London: McFarland, 2001), 103–112.

49. Sabrawi, "Lebanon Buried Qana's Martyrs."

50. Photographs of the various Muslim and Christian clerics standing together before the graves were published in local newspapers and subsequent memorial books, such as Hamid Majid al-Ansary, *Qānā al-jalīl wa ikhwātuha fi-l-mādi wa-l-hādir* (Qana of Galilee and its sisters in the past and present) (Beirut: International Bookbinding Association, n.d.), 166–168. One prominent photo caption reads, "The Children of Muhammad and Jesus (one heart) at the Graves of the Martyrs." The

Arabic book title includes a play on words—*Kāna wa ikwātuha*—which is used to teach a particular set of grammar rules in the Arabic language.

51. "*Bi-intizār 'awdat al-timthāl . . . asbahū al-ramz*" (Awaiting the return of the statues . . . they became the symbol), *Al Diyar,* May 6, 1996. All subsequent direct quotes in this paragraph are from this source.

52. Al-Ansary, "Qana of Galilee and Its Sisters in the Past and Present," 145–147.

53. Lucia Volk, "Missing the Nation: Lebanon's Post-War Generation in the Midst of Reconstruction" (Ph.D. diss., Harvard University, 2001), 257–266.

54. The Arabic reads, "*taqasamnā al-jiraha fa hal 'ālimnā ajurhuki sāla am sālat dimāna,*" which literally translates as "We've shared the wounds . . . and, oh, if we only knew. Is it your wound bleeding or is it our blood flowing?"

55. The verb *rattala* in Arabic is associated with chanting Christian psalms or hymns.

56. The inscription read: "*Ard rūiyat bi-dimā' al-shuhadā' wa taqaddasat bimurūr al-inbiyā'.*"

57. The inscription read: "*Qānā thālith al-haramayn.*"

58. The inscription read: "*Min Karbalā' ila Qānā, thawra mustaqirra.*"

59. Baron, *Egypt as a Woman,* 1–2.

60. For the most cogent argument about women as biological and cultural reproducers of the nation, see Rhoda A. Kanaaneh, *Birthing the Nation: Strategies of Palestinian Women in Israel* (Berkeley: University of California Press, 2002).

61. Susan Slyomovics, *The Object of Memory: Arab and Jew Narrate the Palestinian Village* (Philadelphia: University of Pennsylvania Press, 1998), xiii–xiv, and chap. 1.

62. These two separate commemorative goals are similarly discussed in Deeb, "Exhibiting the 'Just-Lived Past,'" 370–371, 390.

63. "*Alūf ahiyū dhikrā al-majzara fi al-mal'ab al-rūmānī fi Sūr*" (Thousands commemorated the massacre at the Hippodrome in Tyre), *Al Nahar,* April 19, 1997.

64. Newspapers noted the wreath donors dutifully, and they included members of various Lebanese parties, labor and student unions, as well as politicians and relatives of the dead. See "*Al-'īd al-thānī li-majzara Qānā*" (The second anniversary of the Qana massacre), *Al Nahar,* April 21, 1998, as well as articles cited in note 67 below.

65. "*Majzara Qānā, ihtifālāt wa mawākib fi-l-mantaqa: Ziyārat Qānā wājib*" (Qana's massacre, celebrations, and marches in the area, visiting Qana is a duty), *Al Nahar,* April 19, 1999.

66. "*Fī-l-'īd al-khāmis li-mazjara Qānā, Qānā tatadhakkar alāmihi*" (On the fifth anniversary of the Qana massacre, Qana recalls its pains), *Al Nahar,* April 19, 2001.

67. "*Ihtifāl wa mawkab fi Qānā wa ihtijāj sāmit wa shumū' fi Bayrūt*" (Ceremony and march in Qana, and silent protest and candles in Beirut), *Al Nahar,* April 27, 2002; "*Amal wa ahl al-janūb yahyūn fi Qānā*" (Amal and the people of the South commemorate Qana), *Al Nahar,* April 19, 2004; "*Al-'īd al-tāsi' li-dhikrā Qānā*" (The ninth anniversary of the commemoration of Qana), *Al Nahar,* April 19, 2005.

68. May Manassa, "*Kay lā ninsā Qānā*" (So we don't forget Qana), *Al Nahar,* April 18, 2000.

69. Mouna Bassili Sehnaoui, *Qānā: Kay lā ninsā* (Qana: So we don't forget) (Beirut: Anis Commercial Printing Press, 1997). The organization paid school fees and living stipends for the children all the way through high school.

70. Al-Ansary, "Qana of Galilee and Its Sisters in the Past and Present," 164.

71. Qassi al-Hussayn, "*Kas Qānā*" (Qana's cup), in *Qānā: Intisār al-damm 'ala al-sayf* (Qana: The victory of blood over the sword), ed. Yussef Deeb (Beirut: National Committee for the Commemoration of March 14 and April 18, published 2000), 33.

72. Mohammad Kansu, "*Ilā tifl shahīd*" (To a martyred child), 156.

73. *South Lebanon: The Will to Live and Resist* (Beirut: National Committee for the Commemoration of March 14 and April 18, published 1998), 63–114.

74. Yussef Deeb, *Israeli Mines in Lebanon: Violation of International Law and Continuous Occupation of the Land* (Beirut: National Committee for the Commemoration of March 14 and April 18, published 2001).

75. Council of the South and Press Photographers' Syndicate in Lebanon, *The South: Memory of a Country* (Beirut: n.p., 2001), 28–42.

76. Youssef El-Hourani, *Cana of Galilee in South Lebanon* (Beirut: Ministry of Tourism, 1995), printed in Arabic, English, and French.

77. Sami El-Masri, "Qana: Introduction to an Archaeological Project in South Lebanon," *Berytus* 44 (1999–2000): 205–206. A more extensive report is awaiting publication in the Lebanese journal *Bulletin d'Archéologie et d'Architecture Libanaises (BAAL)*.

78. "Lebanon to develop Qana into Christian Tourist Site," *Agence France Press*, December 7, 1999.

79. In Arabic, "*Wa lā tahsabanna al-ladhīn qutilū fi sabīl allah amwātan, bal ahiā' 'and rabbihim yurzaqūn.*"

80. At the time of my last visit to Qana in 2008 the guard told me that the hospital had still not been completed and that they were hoping to finish construction with funds from the government of Qatar, a big donor after the 2006 Lebanon War.

81. Al-Ansary, "Qana of Galilee and Its Sisters in the Past and Present," 40.

82. "*Al Nahar fi Qānā fi awal layla li-'īd al-majzara*" (*Al Nahar* at Qana on the eve of the first anniversary of the massacre), *Al Nahar*, April 17, 1997.

83. Mohammad Zaatari, "South Lebanon Requests Tourism Aid," *Daily Star*, July 31, 2003.

84. Mohammad Ismail, Interview, Municipality of Qana, January 3, 2008.

85. Norton, *Hezbollah*, 85.

86. Deeb, *An Enchanted Modern*, chap. 4.

5. REVISITING INDEPENDENCE AND MOBILIZING RESISTANCE

The epigraphs to this chapter are drawn, respectively, from "Biggest Opposition Demo Swears to Break Syria's Stranglehold and Lahoud's Regime," *Naharnet News Desk*, March 14, 2005, www.naharnet.com/domino/tn/NewsDesk.nsf/getstory?open form&4929DFD096D103CDC2256FC40052773D (accessed August 24, 2008); and Judy Mathewson and Bill Varner, "Bush, Lebanon Seek Greater French Role in UN Force," *Bloomberg News*, August 18, 2006, www.bloomberg.com/apps/news?pid=206 01087&sid=ag8mjtz6odDQ&refer=home (accessed July 3, 2009).

1. May Abboud Abi Aql, "*Timthāl al-shuhadā' min hidn al-Kaslīk ila qalb Bayrūt*" (The Martyrs Statue [returns] from the bosom of Kaslik to the heart of Beirut), *Al Nahar*, July 16, 2004.

2. Sami Ayad, "*Awdat al-rūh ila qalb Bayrūt*" (Return of spirit to the heart of Beirut), *Al Nahar*, July 16, 2004.

3. Nadine Khayat, "Solidere Kicks off Martyrs' Square Competition: Contest Will Redesign Beirut's City Center," *Daily Star,* June 23, 2004.

4. Abi Aql, "The Martyrs Statue [Returns] from the Bosom," 8.

5. Maya Abou Nasr, "Martyrs' Monument on the Move Again: Army Relocates Statue Less Than a Day after Its Long-Awaited Return," *Daily Star,* July 17, 2004.

6. Nada Raad, "Lahoud, Hariri Rift over Martyrs' Statue Boils Over," *Daily Star,* July 19, 2004.

7. Blanford, *Killing Mr. Lebanon,* chap. 5.

8. Barak, *The Lebanese Army,* 164.

9. Traboulsi, *A History of Modern Lebanon,* 244.

10. Volker Perthes, "Syrian Predominance in Lebanon: Not Immutable," in Hollis and Shehadi, *Lebanon on Hold,* 31.

11. Blanford, *Killing Mr. Lebanon,* 64.

12. William Harris, "Crisis in the Levant: Lebanon at Risk," *Mediterranean Quarterly* 18 (2007): 48.

13. "Conflit de souveraineté sur Chébaa," in Chami, *Le Mémorial du Liban,* 3:261. The September 1957 article explains that "three sections of the border with Syria have been contested since 1948: Akroun-Akkar, Majdel Anjar, and Shebaa. A commission that was formed in 1949 to resolve these disputes did not achieve any results."

14. Blanford, *Killing Mr. Lebanon,* 110–112. Bou Karoum's remains—his brain, teeth, and tongue—were reportedly handed back to the family in an envelope by Lebanese security forces, and Hamade, after months of surgery and physical therapy, returned to politics.

15. News of the hit list rumors made it into the U.S. press after the assassination of Samir Kassir in June 2005. See Steven Weisman, "U.S. has 'credible' word of Syrian plot to kill Lebanese," *New York Times,* June 10, 2005.

16. Blanford, *Killing Mr. Lebanon,* 139.

17. Ibid., 141. The group called itself "Victory and Jihad in Greater Syria," and the video claimed that this attack was the "beginning of many martyrdom operations against infidels, renegades, and tyrants in Greater Syria."

18. William Harris, "Crisis in the Levant: Lebanon at Risk," *Mediterranean Quarterly* 18 (2007): 44.

19. "Lebanon Releases Hariri Suspects," *BBC News,* April 29, 2009, http://news .bbc.co.uk/2/hi/middle_east/8024463.stm (accessed April 30, 2009).

20. Samir Khalaf, *Heart of Beirut,* published in 2006, is an example of this lopsided analysis that celebrated members of the March 14 Movement as harbingers of democracy but barely touched upon the March 8 Movement.

21. General Aoun had fought the Syrian army after Lebanese political elites signed the 1989 Taif Agreement in Saudi Arabia, saying that he would not allow his country to be ruled by a "society that lives in the Middle Ages." See Traboulsi, *A History of Modern Lebanon,* 242.

22. For more details on the history and construction of the Al-Amin Mosque in Martyrs Square, see Ward Vloeberghs, "The Genesis of a Mosque: Negotiating Sacred Space in Downtown Beirut," *EUI Working Papers* RSCAS 2008/17 (Florence: European University Institute, 2008).

23. Alexandra Asseily, as cited in the twelve-page *Hadīqat As-Samah* (Garden of forgiveness) brochure issued by Solidere in 2003.

24. Personal Interview, Azmi Fakhuri, January 13, 2008. Fakhuri also showed me the blueprint of a Martyrs Square design he had submitted to Solidere, but he said he did not expect his design to be chosen.

25. Extra effort was required to prepare a separate burial ground for the bodyguards behind Rafiq Hariri's grave, because the soil that bordered the archaeological section needed additional reinforcement. I do not know if the graveyard construction crew (all Hariri employees) ever contemplated a more unified graveyard design or if it was simply understood that the status differences had to be acknowledged through a separate placement of the graves.

26. Blanford, *Killing Mr. Lebanon,* 144.

27. The man spoke to me on the condition that I not use his real name. Mohammad is a pseudonym.

28. Antoine Bridi was born in Ashrafiye, a predominantly Christian neighborhood in Beirut, in 1971. He grew up in Lebanon during the civil war, and studied architecture and painting at the Lebanese Academy of Fine Arts. He currently lives with his family in Montreal, Canada.

29. I later realized that the "two martyrs–bell tower–minaret ensemble" had been issued in color on a postage stamp. On the stamp the portrait of Rafiq Hariri was carefully aligned with the top of the minaret, church tower, and torch. Hariri was explicitly not a martyr for the Sunni cause but for Muslim and Christian coexistence.

30. Paul Salem, "The Future of Lebanon," *Foreign Affairs* 85 (2006): 18. Salem further details the damage: "thousands of small businesses, hundreds of roads, 300 factories, 80 bridges, dozens of schools and hospitals, and the country's electricity network were destroyed or damaged." Human Rights Watch reported that 860 civilians and 250 combatants were killed ("Why They Died: Civilian Casualties during the 2006 War," Human Rights Watch Report 19(5E) (September 2007): 79, http://www.hrw.org/reports/2007/lebanon0907/10.htm (accessed July 2, 2009).

31. "Operation Change of Direction," Global Security, http://www.globalsecurity.org/military/world/war/lebanon-change-of-direction.htm (accessed July 6, 2009).

32. Andrew Exum, "Hizballah at War: A Military Assessment," Washington Institute for Near East Policy, http://www.washingtoninstitute.org/pubPDFs/Policy Focus63.pdf (accessed July 15, 2009).

33. Human Rights Watch, "Why They Died," 121.

34. Ibid., 120.

35. Nasser Nasser and Hamza Hendawi, "Lebanon Victims Buried in Mass Graves," *Washington Post,* July 21, 2006, http://www.washingtonpost.com/ (accessed June 2, 2008).

36. Ulrike Putz, "Wütende Demonstranten in Beirut: Christen schwenken Hisbollah-Flaggen," *Der Spiegel Online,* July 30, 2006, http://www.spiegel.de/politik/ausland/0,1518,429251,00.html (accessed August 4, 2006).

37. Michael Slackman and John O'Neil, "Hezbollah Stages a Massive 'Victory' Celebration," *New York Times,* September 22, 2006. At the time, Nasrallah claimed that his militia still had twenty thousand rockets in its arsenal. Rearmament since that time leads analysts in 2009 to believe that Hizballah now has forty thousand rockets at its disposal.

38. Paul Richter, "U.S., Israel Seek to Prevent Rearming of Hezbollah," *Seattle Times,* August 19, 2006, http://seattletimes.nwsource.com/html/nationworld

/2003209847_lebanon19.html (accessed July 20, 2009); "Israel Denies Attacking Eastern Lebanon," *ABC News Online,* August 19, 2006, http://www.abc .net.au/news/newsitems/200608/s1718905.htm (accessed July 20, 2009).

39. Human Rights Watch, "Why They Died," 122.

40. Kathy Gannon and Lauren Frayer, "Mass Funerals in Southern Lebanon," *Associated Press,* August 18, 2006, http://www.americanintifada.com/2006/08/08-18-05.htm (accessed July 20, 2009).

41. Judy Mathewson and Bill Varner, "Bush, Lebanon Seek Greater French Role in UN Force," *Bloomberg News,* August 18, 2006, http://www.bloomberg.com/apps/ news?pid=20601087&sid=ag8mjtz6odDQ&refer=home (accessed July 3, 2009).

42. David Cloud, "Inquiry Opened into Israeli Use of U.S. Bombs," *New York Times,* August 25, 2006.

43. Souad Mekhennet, Michael Moss, and Michael Slackman, "Chaotic Lebanon Risks Becoming Militant Haven," *International Herald Tribune,* July 6, 2007.

44. Hani Bathish, "Qana Stronger on Anniversary of Israeli Attack," *Daily Star,* July 30, 2007, http://www.dailystar.com.lb/ (accessed July 16, 2009).

45. Damien Moran, "Irish Activists in Lebanon on 1st Anniversary of Israel's War," *Indymedia Ireland,* August 5, 2007, http://www.indymedia.ie/article/83681?con dense_comments=true (accessed July 3, 2009).

46. "Remembering Qana," *Daily Star,* July 31, 2007, http://www.dailystar.com.lb/ (accessed July 16, 2009).

47. During an interview with Walid Jumblatt, January 8, 2008, in Beirut, he told me that he dare not go to Qana anymore—he had attended several ceremonies after the 1996 attacks—because he felt he was "no longer welcome."

48. Salem, "The Future of Lebanon," 15.

49. See "Feiern für Freigelassene: Kuntar will Kampf gegen Israel fortsetzen," *Der Spiegel Online,* July 17, 2008, http://www.spiegel.de/politik/ausland/0,1518,566254,00 .html (accessed June 2, 2009). The 2008 prisoner exchange, like the two previous exchanges in 2004 and 1996, were the outcome of German-led negotiations between Hizballah and Israel.

50. Should Lebanon abolish its confessional voting system and permit individual politicians to run for seats—rather than the current system where they are grouped on lists according to their prescribed numbers—it is likely that the number of Hizballah parliamentarians would increase based on demographic realities. In other words, the parties that currently advocate the abolition of the confessional system are those who stand most to gain from it.

51. Deeb, "Exhibiting the 'Just-Lived Past,'" 377ff.

52. Blanford, "The Economy, Infrastructure and Administration of the Israeli Controlled Area in South Lebanon," 27.

53. A similar choice to use former prison inmates as tour guides was made in Berlin's Stasi Museum, which opened in the former prison where the GDR's secret service—known by the acronym Stasi—used to detain and torture "enemies of the state."

54. Deeb, "Exhibiting the 'Just-Lived Past,'" 393.

55. I am grateful to Laleh Khalili for sharing her story about her visit to and guided tour of the Khiam prison camp.

56. In my visits to the first Qana Memorial in 1998, 2003, 2007, and 2008, I only saw one Karbala banner in 1998. After the cemetery memorial was given a more

official look and attached to the monument and museum in 2000, handwritten banners had disappeared. The banners that were subsequently affixed on walls around the graves were professionally printed billboards or banners that quoted or depicted Nabih Berri.

57. For a critical look at the Hariri Special Tribunal, see Muhamad Mugraby, "The Syndrome of One-Time Exceptions and the Drive to Establish the Proposed Hariri Court," in *The Politics of Violence, Truth and Reconciliation in the Arab Middle East,* ed. Sune Haugbolle and Anders Hastrup (New York: Routledge, 2009), 21–43.

6. MEMORIAL POLITICS AND NATIONAL IMAGININGS

1. Anderson, *Imagined Communities,* 7.

2. Lisa Wedeen, *Peripheral Visions: Publics, Power, and Performance in Yemen* (Chicago: University of Chicago Press, 2008), 220. The current Republic of Yemen was created in 1990 out of the Yemen Arab Republic (YAR) and the People's Democratic Republic of Yemen (PDYR). The YAR had been created out of the territory ruled by the Ottoman Empire and the PDYR out of the territory under British colonial control.

3. Norton (*Hezbollah,* 80–81) and Deeb ("Exhibiting the 'Just-Lived Past,'" 377) argue that suicide missions are rare incidences of martyrdom in Lebanon.

4. Wedeen, *Ambiguities of Domination,* chap. 1.

5. Fawaz, *An Occasion for War,* chap. 5.

6. A. B. Gaunson, *The Anglo-French Clash in Lebanon and Syria, 1940–45* (London: Macmillan, 1987). Also see the discussion of French and British rivalries over placing commemorative inscriptions in Lebanon, in Lucia Volk, "Fighting Symbolic Battles at Nahr el-Kalb: The Politics of Public Memory and the Making of Modern Lebanon," *Bulletin d'Archéologie et d'Architecture Libanaises (BAAL),* Special Issue 5 (2009): 327–344.

7. Davis, *Memories of State;* Wedeen, *Peripheral Visions.*

8. Steven Caton, *"Peaks of Yemen I Summon": Poetry and Cultural Practice in a North Yemeni Tribe* (Berkeley: University of California Press, 1990); Andrew Shryock, *Nationalism and the Genealogical Imagination: Oral History and Textual Authority in Tribal Jordan* (Berkeley: University of California Press, 1997).

9. Stephen Sheehi, *Foundations of Modern Arab Identity* (Gainesville: University Press of Florida, 2004).

10. Davis, *Memories of State,* chap. 7; Makiya, *The Monument.*

11. Winnegar, *Creative Reckonings,* 4, 16.

12. Interview with Walid Jumblatt, January 8, 2008.

13. See Haugbolle, "Public and Private Memory of the Lebanese Civil War"; Peleikis, "The Making and Unmaking of Memories"; and Barak, "Don't Mention the War." All three authors address how "popular" memories fill the presumed silence of the government.

14. Lebanon's 1994 Media Law made incitement of sectarian violence a punishable crime.

15. Said, *Orientalism,* 20.

BIBLIOGRAPHY

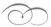

ABC News Online. "Israel Denies Attacking Eastern Lebanon," August 19, 2006. http://www.abc.net.au/news/newsitems/200608/s1718905.htm (accessed July 20, 2009).

Abi Aql, May Abboud. "*Intishāl nasb al-shuhadā' al-qadīm min ghaiyāhib al-mastawda'āt*" (Pulling the old martyrs statue from warehouse gloom). *Al Nahar,* October 18, 2001.

———. "*Timthāl al-shuhadā' min hidn al-Kaslik ila qalb Beirut*" (The martyrs memorial [returns] from the bosom of Kaslik to the heart of Beirut). *Al Nahar,* July 16, 2004.

Abou Nasr, Maya. "Martyrs' Monument on the Move Again: Army Relocates Statue Less Than a Day after Its Long-awaited Return." *Daily Star,* July 17, 2004.

Abu El Haj, Nadia. "Archaeology, Nationhood, and Settlement." In *Memory and Violence in the Middle East and North Africa,* ed. Ussama Makdisi and Paul A. Silverstein, 215–233. Bloomington: Indiana University Press, 2006.

Afary, Janet. "Shi'i Narratives of Karbala and Christian Rites of Penance: Michel Foucault and the Culture of the Iranian Revolution, 1978–1979." *Radical History Review* 86 (2003): 7–35.

Ajami, Fouad. *The Vanished Imam: Musa al-Sadr and the Shia of Lebanon.* Ithaca, N.Y.: Cornell University Press, 1986.

al-Ansary, Hamid Majid. *Qānā al-jalīl wa ikhwātuha fi-l-mādi wa-l-hādir* (Qana of Galilee and its sisters in the past and present). Beirut: International Bookbinding Association, n.d.

al-Hussayn, Qassi. "Kas Qānā" (Qana's cup). In *Qānā: Intisār al-damm āla al-sayf* (Qana: The victory of blood over the sword), ed. Yussef Deeb, 33–35. Beirut: National Committee for the Commemoration of March 14 and April 18, 2000.

Anderson, Benedict. *Imagined Communities: Reflections on the Origin and Spread of Nationalism.* New York: Verso, 1991.

Antonius, George. *The Arab Awakening: The Story of the Arab National Movement.* New York: Capricorn Books, 1965 [1946].

Appadurai, Arjun. *Modernity at Large: Cultural Dimensions of Globalization.* Minneapolis: University of Minnesota Press, 1996.

Art Price. "Marino Mazzacurati." http://web.artprice.com/ps/artitems.aspx?view=all &idarti=NzUzNTAwMDA1NTIoNTQt&page=1&refGenre=C (accessed August 3, 2005).

Ayad, Sami. "*Awdat al-rūh ila qalb Bayrūt*" (Return of spirit to the heart of Beirut). *Al Nahar,* July 16, 2004.

Ayoub, Mahmoud. *Redemptive Suffering in Islam: A Study of the Devotional Aspects of Ashura in Twelver Shi'ism.* The Hague: Mouton, 1978.

B. Q. [abbreviated in original]. "*Al-ramz al-shahīd*" (The martyr symbol). *Al Nahar,* May 6, 1995.

Barak, Oren. "'Don't Mention the War?' The Politics of Remembrance and Forgetfulness in Postwar Lebanon." *Middle East Journal* 61 (2007): 49–70.

———. *The Lebanese Army: A National Institution in a Divided Society.* Albany: State University of New York Press, 2009.

Barakat, Halim. *Lebanon in Strife: Student Preludes to the Civil War.* Austin: University of Texas Press, 1977.

Baron, Beth. *Egypt as a Woman: Nationalism, Gender, and Politics.* Berkeley: University of California Press, 2005.

Bassili Sehnaoui, Mouna. *Qānā: Kay lā ninsa.* Beirut: Anis Commercial Printing Press, 1997.

Bathish, Hani. "Qana Stronger on Anniversary of Israeli Attack." *Daily Star,* July 30, 2007.

BBC. "Lebanon Releases Hariri Suspects." *BBC News.* http://news.bbc.co.uk/2/hi/middle_east/8024463.stm (accessed April 30, 2009).

Ben-Sasson, Haim Hillel. "Kiddush Ha-Shem and Hillul Ha-Shem." In *Encyclopaedia Judaica,* ed. Fred Solnik, 2nd ed., Vol. 12, 139–145. Detroit, Mich.: Keter, 2007.

Ben-Yehuda, Nachman. *The Masada Myth: Collective Memory and Mythmaking in Israel.* Madison: University of Wisconsin Press, 1995.

Berytus, "A Tophet in Tyre?" *Berytus.* http://ddc.aub.edu.lb/projects/archaeology/berytus-back/berytus39/seeden-tophet/index.html (accessed June 4, 2009).

Beydoun, Ahmad. "The South Lebanon Border Zone: A Local Perspective." *Journal of Palestine Studies* 21 (1992): 35–53.

Beyhum, Nabil. "La Place des Canons et la Guerre." In *El Bourj: Place de la liberté et porte du Levant,* ed. Ghassan Tueni and Fares Sassine, 146–147. Beirut: Éditions Dar An Nahar, 2000.

Blanford, Nicholas. "The Economy, Infrastructure, and Administration of the Israeli Controlled Area (ICA) in South Lebanon." *Lebanon Report* 1 (1998): 26–36.

———. *Killing Mr. Lebanon: The Assassination of Rafik Hariri and Its Impact on the Middle East.* London: Tauris, 2006.

Blight, David. *Race and Reunion: The Civil War in American Memory.* Cambridge, Mass.: Harvard University Press, 2001.

Bourdieu, Pierre. "Social Space and Symbolic Power." *Sociological Theory* 7 (1989): 22.

Castelli, Elizabeth. *Martyrdom and Memory: Early Christian Culture Making.* New York: Columbia University Press, 2004.

Caton, Steven. "*Peaks of Yemen I Summon*": *Poetry and Cultural Practice in a North Yemeni Tribe.* Berkeley: University of California Press, 1990.

Chalabi, Tamara. *The Shi'is of Jabal 'Amil and the New Lebanon: Community and Nation State, 1918–1943.* New York: Palgrave, 2006.

Chami, Joseph G., comp. *Le Mémorial du Liban,* 6 vols. Beirut: Chemaly and Chemaly, 2002–2006. Vol. 1 (2002), *Du Mont-Liban à l'Indépendance (1861–1943;* Vol. 2 (2002), *Le mandat Béchara el Khoury (1943–1952);* Vol. 3 (2002), *Le mandat Camille Chamoun (1952–1958);* Vol. 4 (2003), *Le mandat Fouad Chéhab (1958–1964);* Vol. 5 (2004), *Le mandat Charles Hélou (1964–1970);* Vol. 6 (2006), *Le mandat Sleiman Frangié (1970–1976).*

Chatterjee, Partha. *The Nation and Its Fragments: Colonial and Post-Colonial Histories.* Princeton, N.J.: Princeton University Press, 1993.

Cochrane, Paul. "The 'Lebanonization' of the Iraqi Media: An Overview of Iraq's Television Landscape." *Transnational Broadcasting Studies* 16 (2000). http://www.tbsjournal.com/Cochrane.html (accessed May 5, 2009).

Cole, Juan. "Informed Comment: Al-Fakhoura School Bombed, 42 Killed, including Children." Informed Comment. http://www.juancole.com/2009/01/al-fakhoura-school-bombed-42-killed.html (accessed June 10, 2009).

Connerton, Paul. *How Societies Remember.* Cambridge: Cambridge University Press, 1989.

Conyers, John, Jr. "Commemorating the 10th Anniversary of the Civilian Deaths at Qana, Lebanon." *Congressional Record* 152 (46), April 25, 2006.

Cook, David. *Martyrdom in Islam.* Cambridge: Cambridge University Press, 2007.

Corm, Georges. "The War System: Militia Hegemony and Reestablishment of the State." In *Peace for Lebanon? From War to Reconstruction,"* ed. Deidre Collings, 215–230. Boulder, Colo.: Lynne Rienner, 1994.

Cronin, Stephanie. *Tribal Politics in Iran: Rural Conflict and the New State, 1921–1941.* New York: Routledge, 2007.

Cook, David. *Martyrdom in Islam.* Cambridge: Cambridge University Press, 2007.

Cooke, Miriam. *War's Other Voices: Women Writers on the Lebanese Civil War.* Cambridge: Cambridge University Press, 1988.

———. *Women and the War Story.* Berkeley: University of California Press, 1997.

Council of the South. *Al-ayādi al-bayda: Injāzāt majlis al-janūb 1992–2002* (White hands: The achievements of the Council of the South). Beirut: Dar Bilad, 2003.

Council of the South and Press Photographers' Syndicate in Lebanon. *The South: Memory of a Country.* Beirut: n.p., 2001.

Dagher, Carole. *Bring Down the Walls: Lebanon's Post-War Challenge.* New York: St. Martin's, 2000.

Daragahi, Borzou, and Megan Stack. "Analysts See Lebanon-ization of Iraq in Crystal Ball." *Los Angeles Times,* February 26, 2006.

Davis, Eric. *Memories of State: Politics, History, and Collective Identity.* Berkeley: University of California Press, 2005.

Davis, Joyce. *Martyrs: Innocence, Vengeance, and Despair in the Middle East.* New York: Palgrave, 2003.

Deeb, Lara. *An Enchanted Modern: Gender and Public Piety in Shi'i Lebanon.* Princeton, N.J.: Princeton University Press, 2006.

———. "'Hizbullah Strongholds' and Civilian Life." *Anthropology News* 47 (2006): 10–11.

———. "Exhibiting the 'Just-Lived Past': Hizbullah's Nationalist Narratives in

Transnational Political Context." *Comparative Studies in Society and History* 50 (2008): 369–399.

Deeb, Yussef. *Israeli Mines in Lebanon: Violation of International Law and Continuous Occupation of the Land.* Beirut: National Committee for the Commemoration of March 14 and April 18, 2001.

Der Spiegel. "Feiern für Freigelassene." *Der Spiegel Online.* http://www.spiegel.de/politik/ausland/0,1518,566254,00.html (accessed June 2, 2009).

El-Hourani, Youssef. *Cana of Galilee in South Lebanon.* Beirut: Ministry of Tourism, 1995.

El-Masri, Sami. "Qana: Introduction to an Archaeological Project in South Lebanon." *Berytus* 44 (1999–2000): 205–206.

Exum, Andrew. "Hizballah at War: A Military Assessment." Washington Institute for Near East Policy. http://www.washingtoninstitute.org/pubPDFs/PolicyFocus63.pdf (accessed July 15, 2009).

Fawaz, Leila. *An Occasion for War: Civil Conflict in Lebanon and Damascus in 1860.* Berkeley: University of California Press, 1994.

Fisk, Robert. "Israel's Victims Buried to Wails of Rage." *The Independent,* May 1, 1996.

————. "Notebook: The 'Cobra' Strikes at the Heart of His Master." *The Independent,* May 23, 1999.

————. *Pity the Nation: The Abduction of Lebanon.* New York: Nation Books, 2002.

————. "A Typically Lebanese Story of Betrayal at the Hands of So-Called Civilised [*sic*] Nations." *The Independent,* May 21, 2005.

————. "Dead Heroes and Living Memories." *The Independent,* March 4, 2006.

Foote, Kenneth. *Shadowed Ground: America's Landscapes of Violence and Tragedy.* Austin: University of Texas Press, 2003.

Foucault, Michel. *Language, Counter-Memory, Practice: Selected Essays and Interviews.* Ithaca, N.Y.: Cornell University Press, 1977.

————. "Of Other Spaces." *Diacritics* (spring 1986): 22–27.

Francis, Doris, Leonie Kellaher, and Georgina Neophytou. "The Cemetery: A Site for the Construction of Memory, Identity, and Ethnicity." In *Social Memory and History: Anthropological Perspectives,* ed. Jacob Climo and Maria Cattell, 95–110. Walnut Creek, Calif.: AltaMira, 2002.

Gannon, Kathy, and Lauren Frayer. "Mass Funerals in Southern Lebanon." Associated Press. http://www.americanintifada.com/2006/08/08-18-05.htm (accessed July 20, 2009).

Gaunson, A. B. *The Anglo-French Clash in Lebanon and Syria, 1940–45.* London: Macmillan, 1987.

Gavin, Angus. "Heart of Beirut: Making the Master Plan for the Renewal of Central Beirut." In *Projecting Beirut: Episodes in the Construction and Reconstruction of a Modern City,* ed. Hashim Sarkis and Peter Rowe, 217–234. Munich: Prestel, 1998.

Gerges, Fawaz. *The Superpowers and the Middle East: Regional and International Politics.* Boulder, Colo.: Westview, 1994.

Geo-Projects Ltd. *Map of Lebanon with City Map and Guide of Beirut.* Beirut: All Print Distributers and Publishers, 1984.

Gibran, Khalil. *The Garden of the Prophet.* New York: Knopf, 1967 [1933].

Gillis, John R. "Memory and Identity: The History of a Relationship." In *Commemorations: The Politics of National Identity,* ed. John R. Gillis. Princeton, N.J.: Princeton University Press, 1994.

Gilsenan, Michael. *Lords of the Lebanese Marches: Violence and Narrative in an Arab Society.* Berkeley: University of California Press, 1996.

Global Security. "Operation Change of Direction." http://www.globalsecurity.org/ military/world/war/lebanon-change-of-direction.htm (accessed July 6, 2009).

Halaq, Hasan. *Dirasāt al-mujtamaʿ al-lubnāniyya* (Studies of Lebanese society). Beirut: Dar al-Nahda al-Arabiya, 2006.

Halawi, Majed. *A Lebanon Defied: Musa al-Sadr and the Shiʿa Community.* Boulder, Colo.: Westview, 1992.

Hancock, Mary. *The Politics of Heritage from Madras to Chennai.* Bloomington: Indiana University Press, 2008.

Hanf, Theodor. *Koexistenz im Krieg: Staatszerfall und Entstehen einer Nation im Libanon.* Baden-Baden: Nomos Verlag, 1990.

Hanssen, Jens. *Fin de Siècle Beirut: The Making of an Ottoman Provincial Capital.* Oxford: Oxford University Press, 2005.

Harris, William. "Crisis in the Levant: Lebanon at Risk." *Mediterranean Quarterly* 18 (2007): 48.

Harfoush, Ziyad. *"Timthāl min nasb al-shuhadāʾ yastaʿīd yamanāihi: Ikhtafat fī al-harb wa taharat fī marab"* (A statue from the Martyrs Memorial retrieves its right arm: It disappeared during the war and appeared in a parking lot). *Al Nahar,* March 13, 1997.

Hart, David. *Tribe and State in Rural Morocco.* New York: Routledge, 2000.

Hatem, Robert Maroun. *From Israel to Damascus: The Painful Road of Blood, Betrayal, and Deception.* La Mesa, Calif.: Vanderblumen, 1999.

Haugbolle, Sune. "Public and Private Memory of the Lebanese Civil War." *Comparative Studies of South Asia, Africa, and the Middle East* 25 (2005): 191–203.

Haugbolle, Sune, and Anders Hastrun, eds. *The Politics of Violence, Truth, and Reconciliation in the Arab Middle East.* London: Routledge, 2009.

Hirst, David. "Lebanese Dead Laid to Rest." *The Guardian,* May 1, 1996.

Hobsbawm, Eric J. *Nations and Nationalism since 1790: Programme, Myth, Reality.* Cambridge: Cambridge University Press, 1990.

Hollis, Rosemary, and Nadim Shehadi, eds. *Lebanon on Hold: Implications for Middle East Peace.* London: Royal Institute of International Affairs, 1996.

Human Rights Watch. "Why They Died: Civilian Casualties during the 2006 War." Human Rights Watch Report 19(5E). http://www.hrw.org/reports/2007/ lebanon0907/10.htm (accessed July 2, 2009).

Iskandar, Marwan. *Rafiq Hariri and the Fate of Lebanon.* London: Saqi, 2006.

Israel Today. "The Lebanonization of Gaza." http://www.israeltoday.co.il/default.aspx? tabid=128&view=item&idx=1196 (accessed May 24, 2009).

Jaber, Hala. *Hezbollah: Born with a Vengeance.* New York: Columbia University Press, 1997.

Jumblatt, Kamal. *I Speak for Lebanon.* London: Zed, 1982.

Kanaaneh, Rhoda A. *Birthing the Nation: Strategies of Palestinian Women in Israel.* Berkeley: University of California Press, 2002.

Kassir, Samir. *Histoire de Beyrouth.* Poitiers, France: Librarie Arthème Fayard, 2003.

Kansu, Mohammad. *"Ilā tifl shahīd"* (To a martyred child). In *Qānā: Al-hibr wa al-damm* (Qana: The ink and the blood), ed. Yussef Deeb, 156. Beirut: National Committee for the Commemoration of March 14 and April 18, published 1999.

Kaufman, Asher. *Reviving Phoenicia: In Search of Identity in Lebanon.* London: Tauris, 2004.

Khalaf, Samir. *Lebanon's Predicament*. New York: Columbia University Press, 1987.
———. "Culture, Collective Memory, and the Restoration of Civility." In *Peace for Lebanon? From War to Reconstruction,* ed. Deidre Collings, 273–285. Boulder, Colo.: Lynne Rienner, 1994.
———. *Civil and Uncivil Violence in Lebanon: A History of the Internationalization of Communal Conflict.* New York: Columbia University Press, 2002.
———. *Heart of Beirut: Reclaiming the Bourj.* London: Saqi, 2006.
Khalili, Laleh. *Heroes and Martyrs of Palestine: The Politics of National Commemoration.* Cambridge: Cambridge University Press, 2007.
Khayat, Nadine. "Solidere Kicks Off Martyrs' Square Competition: Contest Will Redesign Beirut's City Center." *Daily Star,* June 23, 2004.
Khoury, Philip. *Syria and the French Mandate: The Politics of Arab Nationalism, 1920–1945.* Princeton, N.J.: Princeton University Press, 1987.
Khoury, Philip, and Joseph Kostiner, eds. *Tribes and State Formation in the Middle East.* Berkeley: University of California Press, 1990.
King-Irani, Laurie. "Petition Charges Israel with War Crimes: The Case of the Qana Massacre Survivors." *MERIP Online* (December 8, 1999), http://www.merip.org/mero/mero120899.html.
La Scultura-Italiana. "Marino Mazzacurati." http://www.scultura-italiana.com/Biografie/Mazzacurati.htm (accessed August 3, 2005).
Landler, Mark. "Clinton Says Moderation Is Lebanon's Best Hope." *New York Times,* April 27, 2009.
Lawrence, Bruce, ed. *Messages to the World: The Statements of Osama Bin Laden.* Translated by James Howarth. New York: Verso, 2005.
Leoussi, Athena. *Nationalism and Classicism: The Classical Body as National Symbol in Nineteenth-Century England and France.* New York: St. Martin's, 1998.
Mahmood, Saba. *Politics of Piety: The Islamic Revival and the Feminist Subject.* Princeton, N.J.: Princeton University Press, 2005.
Makdisi, Ussama. *The Culture of Sectarianism: Community, History, and Violence in Nineteenth-Century Ottoman Lebanon.* Berkeley: University of California Press, 2000.
Makdisi, Ussama, and Paul Silverstein, eds. *Memory and Violence in the Middle East and North Africa.* Bloomington: Indiana University Press, 2006.
Makiya, Kanan. *The Monument: Art and Vulgarity in Saddam Hussein's Iraq.* London: Tauris, 1998.
Manassa, May. "*Kay lā ninsā Qānā*" (So we don't forget Qana). *Al Nahar,* April 18, 2000.
Mathewson, Judy, and Bill Varner. "Bush, Lebanon Seek Greater French Role in UN Force." *Bloomberg News.* http://www.bloomberg.com/apps/news?pid=20601087&sid=ag8mjtz6odDQ&refer=home (accessed July 3, 2009).
Mattar, Mohammad Farid. "*Al-saha lil-tullāb*" (The square for students). In *El Bourj: Place de la liberté et porte du Levant,* ed. Ghassan Tueni and Fares Sassine, 76–78. Beirut: Éditions Dar An Nahar, 2000.
Matthews, Roderic, and Matta Akrawi. *Education in Arab Countries of the Near East: Egypt, Iraq, Palestine, Transjordan, Syria, Lebanon.* Washington, D.C.: American Council of Education, 1949.
Mayo, James. *War Memorials as Political Landscape: The American Experience and Beyond.* New York: Praeger, 1988.

Mehanna, Tania. "Une foire au centre de la ville." In *El Bourj: Place de la liberté et porte du Levant,* ed. Ghassan Tueni and Fares Sassine, 180–181. Beirut: Éditions Dar An Nahar, 2000.

Mekhennet, Souad, Michael Moss, and Michael Slackman. "Chaotic Lebanon Risks Becoming Militant Haven." *International Herald Tribune,* July 6, 2007.

Mitchell, Timothy, ed. *Questions of Modernity.* Minneapolis: University of Minnesota Press, 2000.

Montiel, Luz Maria Martinez. "The Lebanese Community in Mexico: Its Meaning, Importance and the History of its Community." In *The Lebanese in the World: A Century of Emigration,* ed. Albert Hourani and Nadim Shehadi, 379–392. London: Tauris, 1992.

Moran, Damien. "Irish Activists in Lebanon on 1st Anniversary of Israel's War." Indymedia Ireland. http://www.indymedia.ie/article/83681?condense_comments=true (accessed July 3, 2009).

Mugraby, Muhamad. "The Syndrome of One-Time Exceptions and the Drive to Establish the Proposed Hariri Court." In *The Politics of Violence, Truth, and Reconciliation in the Arab Middle East,* ed. Sune Haugbolle and Anders Hastrup, 21–43. New York: Routledge, 2009.

Murphy, Richard W. "The Costs of Wrath: An American Perspective." In *Lebanon on Hold: Implications for Middle East Peace,* ed. Rosemary Hollis and Nadim Shehadi, 7–10. London: Royal Institute of International Affairs, 1996.

Naharnet News. "Biggest Opposition Demo Swears to Break Syria's Stranglehold and Lahoud's Regime." *Naharnet News Desk.* http://www.naharnet.com/domino/tn/NewsDesk.nsf/getstory?openform&4929DFD096D103CDC2256FC40052773D (accessed August 24, 2008).

Nasr, Joe. "Reconstruction." In *Reconstruction et Réconciliation au Liban: Négations, lieux publics, renouement du lien social,* ed. Eric Huybrechts and Chawqi Douayhi, 1–25. Beirut: CERMOC, 1999.

Nasser, Nasser, and Hamza Hendawi. "Lebanon Victims Buried in Mass Graves." *Washington Post.* http://www.washingtonpost.com/ (accessed June 2, 2008).

Nizar Hamzeh, Ahmed. *In the Path of Hizbollah.* Syracuse, N.Y.: Syracuse University Press, 2004.

Nora, Pierre. "General Introduction: Between Memory and History." In *Realms of Memory: Rethinking the French Past,* Vol. 1, ed. Pierre Nora, 1–20. New York: Columbia University Press, 1996.

Norton, Augustus Richard. *Amal and the Shi'a: Struggle for the Soul of Lebanon.* Austin: University of Texas Press, 1987.

———. *Hezbollah: A Short History.* Princeton, N.J.: Princeton University Press, 2007.

Norton, Augustus Richard, and Jillian Schwedler. "Swiss Soldiers, Ta'if Clocks and Early Elections." In *Peace for Lebanon? From War to Reconstruction,* ed. Deirdre Collings, 45–65. Boulder, Colo.: Lynne Rienner, 1994.

One Fine Art. "Artists of the Past." http://onefineart.com/en/pastartists/ (accessed July 14, 2009).

Owen, Roger, and Sevket Pamuk. *A History of Middle East Economies in the 20th Century.* Cambridge, Mass.: Harvard University Press, 1999.

Özyürek, Esra. *Nostalgia for the Modern: State Secularism and Everyday Politics in Turkey.* Durham, N.C.: Duke University Press, 2006.

Palmer Harik, Judith. *Hezbollah: The Changing Face of Terrorism*. London: Tauris, 2004.

Peleikis, Anja. "The Making and Unmaking of Memories: The Case of a Multi-Confessional Village in Lebanon." In *Memory and Violence in the Middle East and North Africa*, ed. Ussama Makdisi and Paul Silverstein, 133–150. Bloomington: Indiana University Press, 2006.

Perthes, Volker. "Syrian Predominance in Lebanon: Not Immutable." In *Lebanon on Hold: Implications for Middle East Peace*, ed. Rosemary Hollis and Nadim Shehadi, 31–34. London: Royal Institute of International Affairs, 1996.

———. "Myths and Money: Four Years of Hariri and Lebanon's Preparation for a New Middle East." *Middle East Report* 203 (1997): 16–21.

Peteet, Julie. *Landscapes of Hope and Despair: Palestinian Refugee Camps*. Philadelphia: University of Pennsylvania Press, 2005.

Picard, Elizabeth. *Lebanon, A Shattered Country: Myths and Realities of the Wars in Lebanon*. New York: Holmes and Meier, 2002.

Pickford, Henry. "Conflict and Commemoration: Two Berlin Memorials." *Modernism/Modernity* 12 (2005): 133–173.

Pinault, David. *The Shiites: Ritual and Popular Piety in a Muslim Community*. New York: St. Martin's, 1992.

Prost, Antoine. "Monuments to the Dead." In *Realms of Memory: Construction of the French Past*, Vol. 2, ed. Pierre Nora, 307–330. New York: Columbia University Press, 1997.

Putz, Ulrike. "Wütende Demonstranten in Beirut: Christen schwenken Hisbollah-Flaggen." *Der Spiegel Online*, July 30, 2006. http://www.spiegel.de/politik/ausland/0,1518,429251,00.html (accessed August 4, 2006).

Qubain, Fahim. *Crisis in Lebanon*. Washington, D.C.: Middle East Institute, 1961.

Raad, Nada. "Lahoud, Hariri Rift over Martyrs' Statue Boils Over." *Daily Star*, July 19, 2004.

Richani, Nazih. *Dilemmas of Democracy and Political Parties in Sectarian Societies: The Case of the Progressive Socialist Party of Lebanon 1949–1996*. New York: St. Martin's, 1998.

Richardson, Peter. "Kirbet Qana (and Other Villages) as a Context for Jesus." In *Jesus and Archaeology*, ed. James Charlesworth, 120–144. Grand Rapids, Mich.: Eerdmans, 2006.

Richter, Paul. "U.S., Israel Seek to Prevent Rearming of Hezbollah." *Seattle Times*, August 19, 2006.

Saad-Ghorayeb, Amal. *Hizbu'llah: Politics and Religion*. London: Pluto, 2002.

Sabrawi, Ismail. "*Lubnān dafana shuhadā' Qānā fī ma'tam watanī wa sha'abī*" (Lebanon buried Qana's martyrs at a national and popular burial). *Al Nahar*, May 1, 1996.

Sader, Helen. "Ancient Beirut: Urban Growth in the Light of Recent Excavations." In *Projecting Beirut: Episodes in the Construction and Reconstruction of a Modern City*, ed. Hashim Sarkis and Peter Rowe, 23–40. Munich: Prestel Verlag, 1998.

Said, Edward. *Orientalism*. New York: Vintage Books, 1979.

Salem, Paul. "In the Wake of 'Grapes of Wrath': Meeting the Challenge." In *Lebanon on Hold: Implications for Middle East Peace*, ed. Rosemary Hollis and Nadim Shehadi, 75–78. London: Royal Institute of International Affairs, 1996.

——— "The Future of Lebanon." *Foreign Affairs* 85 (2006): 18.

Salibi, Kamal. *A House of Many Mansions: The History of Lebanon Reconsidered*. Berkeley: University of California Press, 1988.

————. *The Modern History of Lebanon*. New York: Caravan Books, 1993.

Sarkis, Hashim. "A Vital Void: Reconstructions of Downtown Beirut." In *The Resilient City: How Modern Cities Recover from Disaster*, ed. Lawrence J. Vale and Thomas J. Campanella, 281–297. Oxford: Oxford University Press, 2005.

Sarkis, Hashim, and Peter Rowe. "Introduction: Projecting Beirut." In *Projecting Beirut: Episodes in the Construction and Reconstruction of a Modern City*, ed. Hashim Sarkis and Peter Rowe, 9–18. Munich: Prestel Verlag, 1998.

Sassine, Fares. "Une place, mais que de noms!" In *El Bourj: Place de la liberté et porte du Levant*, ed. Ghassan Tueni and Fares Sassine, 234–235. Beirut: Éditions Dar An Nahar, 2000.

Savage, Kirk. *Standing Soldiers, Kneeling Slaves: Race, War, and Monument in Nineteenth-Century America*. Princeton, N.J.: Princeton University Press, 1997.

Sbaiti, Ahmed. "Reflections on Lebanon's Reconstruction." In *Peace for Lebanon? From War to Reconstruction*, ed. Deirdre Collings, 163–177. Boulder, Colo.: Lynne Rienner, 1994.

Schenk, Bernadette. "Crisis and Memory: The Case of the Druze." In *Crisis and Memory in Islamic Societies*, ed. Angelika Neuwirth and Andreas Pflitsch, 331. Würzburg, Germany: Ergon Verlag, 2001.

Senie, Harriet F., and Sally Webster, eds. *Critical Issues in Public Art: Content, Context, and Controversy*. New York: Icon Editions, 1992.

Sennott, Charles M. "In Lebanon, A Memorial to Mayhem." *Boston Globe*, December 1, 1997.

Shaery-Eisenlohr, Roschanack. *Shi'ite Lebanon: Transnational Religion and the Making of National Identities*. New York: Columbia University Press, 2008.

Sheehi, Stephen. *Foundations of Modern Arab Identity*. Gainesville: University Press of Florida, 2004.

Shepkaru, Shmuel. *Jewish Martyrs in the Pagan and Christian World*. Cambridge: Cambridge University Press, 2005.

Shryock, Andrew. *Nationalism and the Genealogical Imagination: Oral History and Textual Authority in Tribal Jordan*. Berkeley: University of California Press, 1997.

Silverstein, Paul A., and Ussama Makdisi. "Introduction: Memory and Violence in the Middle East and North Africa." In *Memory and Violence in the Middle East and North Africa*, ed. Ussama Makdisi and Paul A. Silverstein, 1–24. Bloomington: Indiana University Press, 2006.

Slackman, Michael, and John O' Neil. "Hezbollah Stages a Massive 'Victory' Celebration." *New York Times*, September 22, 2006.

Sluglett, Peter, and Nadine Meouchy. *The British and French Mandates in Comparative Perspective*. Leiden, Netherlands: Brill, 2004.

Slyomovics, Susan. *The Object of Memory: Arab and Jew Narrate the Palestinian Village*. Philadelphia: University of Pennsylvania Press, 1998.

South Lebanon: The Will to Live and Resist. Beirut: National Committee for the Commemoration of March 14 and April 18, published 1998).

Swayd, Samy. *Historical Dictionary of the Druzes*. Lanham, Md.: Scarecrow, 2006.

Swedenburg, Ted. *Memories of Revolt: The 1936–1939 Rebellion and the Palestinian National Past*. Fayetteville: University of Arkansas Press, 2003.

Tierny, John. "Iraqi Family Ties Complicate American Efforts for Change." *New York Times*, September 28, 2003.

Theroux, Peter. "Beirut Rising." *National Geographic* 193, September 1997.

Thompson, Elizabeth. *Colonial Citizens: Republican Rights, Paternal Privilege, and Gender in French Syria and Lebanon.* New York: Columbia University Press, 2000.

Traboulsi, Fawwaz. "Variations on an Andalusian Theme: Undated Letters to Etel." In *Etel Adnan: Critical Essays on the Arab-American Writer and Artist,* ed. Lisa Suhair Majaj and Amal Amireh, 103–112. London: McFarland, 2001.

———. *A History of Modern Lebanon.* London: Pluto, 2007.

Tueni, Ghassan. *Laissez vivre mon peuple! Le Liban à l'ONU.* Paris: Librarie d'Amérique et d'Orient, 1984.

Tueni, Ghassan, and Fares Sassine, eds. *El Bourj: Place de la liberté et porte du Levant.* Beirut: Éditions Dar An Nahar, 2000.

University of the Holy Spirit at Kaslik. "Catalogue." Department of Sacred Art. http://www.usek.edu.lb/catalogue/framework.asp?pageName=&language=fr (accessed August 6, 2009).

van Kappen, Franklin. "Report dated 1 May 1996 of the Secretary-General's Military Adviser concerning the Shelling of the United Nations Compound at Qana on 18 April 1996." In letter, dated May 7, 1996, addressed to the UN Security Council, http://domino.un.org/UNISPAL.NSF/0/62d5aa740c14293b85256324005179be?OpenDocument (accessed May 15, 2008).

Vloeberghs, Ward. "The Genesis of a Mosque: Negotiating Sacred Space in Downtown Beirut." *EUI Working Papers* RSCAS 2008/17. Florence, Italy: European University Institute, 2008.

Volk, Lucia. "Missing the Nation: Lebanon's Post-War Generation in the Midst of Reconstruction." Ph.D. diss., Harvard University, Cambridge, Mass., 2001.

———. "When Memory Repeats Itself: The Politics of Heritage in Post Civil War Lebanon." *International Journal of Middle Eastern Studies* 40 (2008): 291–314.

———. "Fighting Symbolic Battles at Nahr el-Kalb: The Politics of Public Memory and the Making of Modern Lebanon." *Bulletin d'Archéologie et d'Architecture Libanaises* (BAAL), Special Issue 5 (2009): 327–344.

———. "Martyrs at the Margins: The Politics of Neglect in Lebanon's Borderlands." *Middle Eastern Studies* 45 (2009): 263–282.

Volker, Perthes. "Myths and Money: Four Years of Hariri and Lebanon's Preparation for a New Middle East." *Middle East Report* 203 (1997): 16–21.

Wagner-Pacifici, Robin. *The Art of Surrender: Decomposing Sovereignty at Conflict's End.* Chicago: University of Chicago Press, 2005.

Wedeen, Lisa. *Ambiguities of Domination: Politics, Rhetoric, and Symbols in Contemporary Syria.* Chicago: University of Chicago Press, 1999.

———. *Peripheral Visions: Publics, Power, and Performance in Yemen.* Chicago: University of Chicago Press, 2008.

Weeks, Jim. *Gettysburg: Memory, Market, and an American Shrine.* Princeton, N.J.: Princeton University Press, 2003.

Weisman, Steven. "U.S. Has 'Credible' Word of Syrian Plot to Kill Lebanese." *New York Times,* June 10, 2005.

Wenk, Silke. "Gendered Representations of the Nation's Past and Future." In *Gendered Nations: Nationalisms and Gender Order in the Long Nineteenth Century,* ed. Ida Blom, Karen Hagemann, and Catherine Hall, 63–77. Oxford: Berg.

Winnegar, Jessica. *Creative Reckonings: The Politics of Art and Culture in Contemporary Egypt.* Stanford, Calif.: Stanford University Press, 2006.

Winslow, Charles. *Lebanon: War and Politics in a Fragmented Society.* New York: Routledge, 1996.

Wright, Lawrence. "Slim's Time." *New Yorker Magazine,* June 1, 2009.

Wright, Robin. *Sacred Rage: The Wrath of Militant Islam.* New York: Simon and Schuster, 2001.

Yazbek, Yusuf Ibrahim. *Mu'tamar al-Shuhadā': Al-mu'tamar al-ladhī adhā' al-amānī al-qawmiyya wa jarra a'dā'ahu ila al-mashāniq* (The Conference of Martyrs: The conference that spread national aspirations and dragged its members to the gallows). Beirut: Alyawm Newspaper Press, 1955.

Zaatari, Mohammad. "South Lebanon Requests Tourism Aid." *Daily Star,* July 31, 2003.

Zerubavel, Yael. *Recovered Roots: Collective Memory and the Making of Israeli National Tradition.* Chicago: Chicago University Press, 1995.

Ziadeh, Hanna. *Sectarianism and Intercommunal Nation-building in Lebanon.* London: Hurst, 2006.

ARABIC AND FRENCH NEWSPAPER SOURCES

Al Diyar (1993–1996)
Al Nahar (1933–2006)
Al Hayat (1953–1958)
Al Safir (1993–1996)
L'Orient and *L'Orient Le Jour* (1952–1955, 1993–1996)

INDEX

Page numbers in italics refer to illustrations.

Martyrs Square); "Greater Beirut,"
13, 103, 199; Hamra district of, 39, 66,
104; as "the heart" of Lebanon, 12, 154,
164, 196–197; history and mapping of,
9–10, *11*, 54; and Lebanese indepen-
dence (1943), 63–64; municipality of,
52, 54, 67, 102; as "Paris of the Middle
East," 9. *See also under* commemora-
tions; martyrs memorials in Beirut
Beit ed-Din, 80, 88, 93
Beqa Valley, *11*, 115, 180, 207n32
Beqata, *11*, 83. *See also* martyrs memori-
als in Beqata
Berri, Nabih, 121, 125, 129, 133, 137, 145,
148, 150, 229n56
Berri, Randa, 137–138; as sponsor of the
new Qana Memorial, 145–146
Bint Jbeil, *11*, 118
bodies (representations of): male vs.
female, 27, 59, 73, 112, 197; of moth-
ers, 2, 27, 57–59, 135, 195; mutilated,
32, 110–114, 128, 135, 152–153, 184–185,
195–196; national, 26–28, 58–59,
86–88, 96–100, *99*, 195; sculptures vs.
photographs; 27–28; of the Unknown
Soldier, 26. *See also* photography
Bridi, Antoine, 168–170, *169*, 228n28
British mandate, 12–13, 40, 191

caliphate, 48
Cana. *See* Qana
car bombs, 161
Cedar Revolution, 162
cedar tree, 56–57, 59, 68, 74, 87, 132, 144,
149, 169
cemeteries: foreign veterans, 40; national
(or public), 3, 8–9, 16, 19–20, 32, 35,
37, 52, 139, 153, 209n24; religious, 35,
49, 51–52, 92, 193, 212n2; as rhetorical
spaces, 25–28; as ritual spaces, 28–29
cemetery memorials. *See martyrs
memorials*
census, 6–8, 206n14
ceremonies. *See* commemorations
Chamoun, Camille, 12, 70, 77–82, 88–89,
97, 104, 217n7
checkpoints, 106, 118, 161, 187
children: citizens as, 27, 58; lessons of

national sacrifice for, 4, 61, 137–138,
151; as martyrs, 31–32, 115, 130–131, 135,
139, 152, 177, 181, 185; as orphans, 138,
141; raising, 7, 36, 138
civil marriage, 7–8, 36
civil war. *See* Lebanese Civil War (1958);
Lebanese Civil War (1975–1991);
United States, 1861–1865 Civil War
civil war amnesia, 4, 81, 107–108
cluster bombs, 182
coexistence. *See* narratives, of
coexistence
colonialism, 44, 62; anti-colonialism,
27, 31, 58–59, 78–79, 83, 94, 120; post-
colonialism, 102–103. *See also* British
mandate; French mandate
commemorations: in Beirut, 55, 59–63,
68, 70–71, 104, 113, 162, 166–167; in
Beqata, 92–93, 113; display of national
identity through, 3, 28–29, 32, 38,
74–75, *104*, 136, 152–153; in Qana, 137–
139, 145, 182, 224n50; in Sidon, 138
Committee for the Commemoration of
the Martyrs of Qana (CCMC), 124,
136–137
confessionalism, 7, 163, 183, 229n50
constitution, 6; article 10 of, 36; rewriting
of, 8, 106, 158. *See also* Taif Agreement
Council for Development and Recon-
struction (CDR), 108. *See also*
Solidere
Council of the South, 122, 141, 223n34;
establishment of, 119
crisis of the statues, 157, 184
cross-communal solidarity, 2–3, 6, 17,
23–24, 29, 95, 126–129, 134, 138, 151,
164–165, 190
crossroads of civilization, 19, 164

Damascus, 9, *11*, 45, 47, 60, 63, 79, 129, 159
D'Ancre, Alfred, 32, 136
Darwinism, representations of, 83, 85–88,
95
Debbas, Charles, 55, 60
Deeb, Lara, 5, 17, 34, 185–186
Deir al-Qamar, *11*, 83, 93, 181
diaspora, 119, 164, 212n5
divine victory, 177, 183

Dome of the Rock, 133, 222n5
Druze community, 52, 81–82, 92–93, 95;
 census data and electoral represen-
 tation, 6, 206n14; center in Beirut
 (Tell ed-Druze), 50–51; conflict with
 Maronite community (1860), 10, 33;
 emigration of, 8; history of, 10–12; in
 Syria, 86–88. *See also* Shouf district

Eastern (Orthodox) Churches, 6, 48, 110
Egypt: Fatimid, 10; and mythology,
 84–86, 94–95; and nationalism,
 58–59, 78–79; and nationalist art, 27,
 58, 192. *See also* Nasser, Gamal Abdel
Eisenhower Doctrine, 79–80, 83
elites. *See* political elites
endogamy, 7
epistemology, 23
ethno-religious: definition of, 7; diver-
 sity as national symbol, 19, 22–24, 29,
 38, 48–50, 56–57, 63, 94–96, 110, 139,
 170–171, 187, 189–192, 198–199

Fakhuri, Azmi, 165, 228n24
famine of 1915, 3–4, 43–44
fighter-martyrs. *See under* martyrs
Fisk, Robert, 49, 107
Fneish, Mohammad, 182
France, 106, 159; centralized school
 curriculum, 35; as destination for
 Lebanon's elites, 42, 54, 82, 106, 121,
 218n16; and Egypt, 78; Lebanese
 independence from, 3, 63–64, 75; and
 martyrdom in Lebanon, 32–33; and
 Qana, 125
Fraydiss, *11,* 80, 88–89, 92, 94, 151, 217n6
Free Patriotic Movement, 162
French mandate, 3, 5, 13, 21, 26, 31, 40,
 46, 53–55, 59–63, 74, 109, 160, 191–192,
 207n26
funerals, 35, 49–50, 123–128, 138, 154,
 163–166, 177–178, 184–185
Future Movement: and March 14, 2005
 rally, 161–162; and representations of
 Rafiq Hariri, 170–171, 198

Galilee: mapping of, 12–13; in New Tes-
 tament history, 142; *Qana of Galilee,*

141–142, *141. See also* Israel, attacks on
 Lebanon
Garden of Forgiveness, 164, 187
Geagea, Samir, 106, 162, 175, 193
Gemayel, Pierre (d. 1984), 60, 80
Gemayel, Pierre (d. 2006), 161, 174
Gettysburg cemetery, 25–26, 208n34
Gibran, Gibran Khalil (d. 1931), 54,
 206n8
Greek Orthodox community: census
 data and electoral representation, 6,
 206n14; emigration of, 8, 206n14; and
 martyrs of 1916, 47–48, 52, 77; as pro-
 ponents of Arab nationalism, 45; in
 Qana, 127; and Sunni community in
 Beirut, 9, 215n65

Haddad, Afifi, 127, 151
harb tammuz. See Lebanon War (2006)
Hariri, Bahia, 138, 154
Hariri, Rafiq: assassination of, 1, 5, 16, 33,
 160–161, 173, 184, 187–188, 194–195,
 198; as builder/"bulldozer," 108, 114;
 family of, 161, 163, 165; funeral of,
 163–166, 173; grave memorial of, *11,*
 158, 168–173, *172,* 187; at Hippodrome
 in Tyre, 125; life of, 108–109; party of,
 see Future Movement; as president-
 martyr, 33, 158, 166–167, 173, 211n46;
 and return of Mazzacurati memorial,
 154–158, *155,* 174; Special Tribunal for,
 173, 183, 188
Hariri, Saad, 162, 175, 184
Helou, Charles, 103
heroism: narratives of, 32, 68–71, 104,
 139; vs. sacrifice, 2, 58
hitting *haydar,* 31
Hizballah, 34, 149; attacks on Israel, 117,
 126, 175–176, 183; civilian and military
 infrastructure of South Lebanon, 175,
 222n9, 228n37; emergence of, 13, 121–
 122; and the March 8 Movement, 161–
 163, 183; and the 1975–1991 Civil War,
 106, 162; politics of memory, 185–187,
 198; response to 1996 Qana attack,
 126; response to 2006 Qana attack,
 177–182, 185; ties with Iran, 159; ties
 with Syria, 159; and UN Resolution

Mount Lebanon, 6, 9–14, *11*, 33, 36, 44, 95, 153
mourning practices, Christian and Muslim, 34–35, 127–129, 166, 171
mu'ārada. See March 8 Movement
Muawwad, Rene, 51
Mukhtara, *11*, 81, 93, 218n19
muqāwama. See Resistance
mutasarrifate, 10

Nabatiye, *11*, 13, 118, 137, 145
nahda (awakening), 44. *See also* Arab Nationalism
Nahr al-Bared, 4, 182
Nahr al-Kalb, 19, 64
narratives: of coexistence, 24, 59, 74–75, 95, 131, 150, 171, 185–187, 189–195; of exclusion, 17–18, 22, 193; of opposition, 17–19, 163, 191
Nasrallah, Hasan, 162, 175, 178, 183, 199, 228n37
Nasser, Gamal Abdel, 78–80, 82, 86, 96
National Committee of Commemoration of March 14 and April 18 (NCC), 125, 136, 139
national identity, 6, 14, 17–18, 24; vs. sectarianism, 2–3, 20–24, 189–190. *See also* Arab Nationalism; sectarianism
National Pact (of 1943), 9, 14, 74, 97, 106, 119, 158, 163, 184, 191, 194
national sacrifice: of civilians, 14, 19, 26, 29, 33–34, 46–53, 55–59, 73–77, 112–113, 122–123, 151, 160–161, 176–177, 185, 190; of soldiers, 25–26, 29, 190
Nazi Germany, 134
New Testament, 13, 89, 187
"No Victor, no Vanquished," 22–23, 76, 81, 184, 193–194
Nora, Pierre, 37
Nsouli, Muhieddine, 39

OGER Construction Company, 165
Old Testament, 10, 18
Operation Accountability (1993). *See* Israel, attacks on Lebanon
Operation Grapes of Wrath (1996). *See* Israel, attacks on Lebanon

Operation Litani (1978). *See* Israel, attacks on Lebanon
Operation Peace for Galilee (1982). *See* Israel, attacks on Lebanon
Operation Truthful Promise (2006). *See* Lebanon War (2006)
Orthodox Christianity. *See* Eastern (Orthodox) Churches
Ottoman Empire, 5, 9–10, 21, 45–46, 62, 73, 97, 152, 158–159, 187, 191; executions of 1915 and 1916, 44, 46–49, 52–53, 60, 152; and sectarianism, 21–22; and secular identity, 42. *See also* Pasha, Jamal (d. 1922)

Palestine, 3, 12, 44, 46, 86, 116, 139, 200
Palestinian: delegation in Qana, 125; liberation struggle, 3, 13, 105, 116–117, 120, 149, 222n5; refugee camps in Lebanon, 4, 32, 64, 182; refugees, 3–4, 6, 64, 103, 116, 200; right of return, 3, 64
parity, 8, 23, 171, 198
parliament, 6–8, 9, 53, 61, 79, 109, 123, 158; quota system in, 7–8, 81
Pasha, Jamal (d. 1922), 41–43, 50, 52–53, 60, 73, 128
photography: at Hariri's grave memorial, 171–172, *172;* of injury, 28, 135, 195–197; in Martyrs Square, 174–175; in memory books, 140–142; at 1996 Qana Memorial, 132–135, 152, 195; and public art, 27–29; at 2006 Qana Memorial, 181–182, 195
Pietà, 57, 195
Pity the Nation, 4, 107, 206n8
political authority, 6, 194
political elites: under the French mandate, 59–63; as perpetrators of sectarianism, 3, 21, 76; as postcolonial subjects, 102–103; as sponsors of memorials, 2, 6, 8, 19–20, 23–24, 37, 81, 102, 191–193; struggle over power between, 4–5, 74, 82, 146, 183–184, 194, 198–200
politics of memory, 4, 16, 17–20, 22–23, 163, 185, 199–200
politics of neglect, 120, 146, 150, 152, 193

LUCIA VOLK is Associate Professor of Anthropology
and co-director of Middle East and
Islamic Studies at San Francisco State University.